PAINTING AND THE POLITICS OF CULTURE

PAINTING AND THE POLITICS OF CULTURE

New Essays on British Art 1700–1850

EDITED BY
JOHN BARRELL

Oxford New York
OXFORD UNIVERSITY PRESS
1992

Oxford University Press, Walton Street, Oxford OX2 6DP

Oxford New York Toronto
Delhi Bombay Calcutta Madras Karachi
Petaling Jaya Singapore Hong Kong Tokyo
Nairobi Dar es Salaam Cape Town
Melbourne Auckland

and associated companies in
Berlin Ibadan

Oxford is a trade mark of Oxford University Press

Published in the United States
by Oxford University Press, New York

British Library Cataloguing in Publication Data
Data available

Library of Congress Cataloging in Publication Data
Painting and the politics of culture: new essays on British art,
 1700–1850/edited by John Barrell.
 Includes bibliographical references and index.
 1. Art, British. 2. Art, Modern—17th–18th centuries—Great
Britain. 3. Art, Modern—19th century—Great Britain. 4. Art and
society—Great Britain. 5. Exoticism in art—Great Britain.
I. Barrell, John.
N6766.P35 1992
709'.41'09033—dc20 *91–44565*

ISBN 0–19–817392–X

Printed and bound in Great Britain by Butler & Tanner Ltd, Frome and London

For John Murdoch

ACKNOWLEDGEMENTS

The authors are grateful to the following institutions and companies, who kindly supplied the photographs reproduced as follows: British Library, London (Figs. 4.4, 4.5, 4.6, 4.7, 6.5, 6.6, 9.3, 9.5, 9.6, 9.7, 9.8, 9.10); Courtauld Institute of Art, London (Figs. 2.1, 4.1, 4.3); Messrs. Hazlitt, Gooden & Fox (Fig. 2.9); National Gallery of Art, Washington (Fig. 5.1); National Library of Australia, Canberra (Figs. 4.8, 4.9); National Maritime Museum, London (Fig. 4.10); Wedgwood Museum, Barlaston, Stoke-on-Trent (Fig. 5.3); Yale Center for British Art (Figs. 2.12, 5.4, 5.5, 7.23); Jeffery Bates Antiques, Boroughbridge (Fig. 9.11).

CONTENTS

LIST OF ILLUSTRATIONS

LIST OF CONTRIBUTORS

John Barrell is Professor of English at the University of Sussex. He is the author of *The Idea of Landscape and the Sense of Place* (1972); *The Dark Side of the Landscape* (1980); *An Equal, Wide Survey* (1983); *The Political Theory of Painting from Reynolds to Hazlitt* (1986); *Poetry, Language and Politics* (1988); *The Infection of Thomas De Quincey* (1991), and *The Birth of Pandora* (1992).

Ann Bermingham is Associate Professor of Art History at the University of California, Irvine. She is the author of *Landscape and Ideology: The English Rustic Tradition 1740–1860* (1986).

Stephen Copley is Lecturer in English at University of Wales College of Cardiff. He has edited *Literature and the Social Order in Eighteenth-Century England* (1984) and has published articles on literature, polite culture, and economic writing in eighteenth-century England and Scotland.

Stephen Daniels is Senior Lecturer in Geography at the University of Nottingham. He is the author of many articles on the politics of landscape representation and design, including several on the landscape gardening of Humphry Repton. He is co-editor (with Denis Cosgrove) of *The Iconography of Landscape* (1988) and (with Nicholas Alfrey) of *Mapping the Landscape* (1990). He is currently directing a research project on the making of 'Constable Country', and completing a book, *Landscape and National Identity*.

Harriet Guest is Lecturer in the Department of English and Related Literature, University of York. She is the author of *A Form of Sound Words: The Religious Poetry of Christopher Smart* (1989). She is currently working on a book about late eighteenth-century representations of India and the South Pacific, focusing on the art of William Hodges. She is also writing a book on femininity and women's writing in the eighteenth century.

Alun Howkins is Senior Lecturer in History at the University of Sussex. He is the author of *Poor Labouring Men: Rural Radicalism in Norfolk 1870–1923* (1985), and *Re-shaping Rural England 1850–1925* (1991).

Marcia Pointon is Professor of the History of Art at the University of Sussex. She is the author of *Milton and English Art* (1970); *William Dyce R.A. 1806–64: A Critical Biography* (1979); *History of Art: A Student's Handbook* (1980; rev. edn. 1986); *The Bonington Circle: English Watercolour and Anglo-French Landscape 1790–1855* (1985); *Bonington, Francia and Wyld* (1985); *Mulready* (1986); and

Naked Authority: The Body in Western Painting 1830–1908 (1990). She is the editor of *Pre-Raphaelites Re-viewed* (1989).

Michael Rosenthal is Senior Lecturer in the History of Art at the University of Warwick. His books include *British Landscape Painting* (1982); *Constable. The Painter and his Landscape* (1983), and *Constable* (1987). He is completing a study of Gainsborough and the arts in later eighteenth-century Britain.

David Solkin is Lecturer in the History of Art at the Courtauld Institute of Art, University of London. The author of *Richard Wilson: The Landscape of Reaction* (1982), he has written on various aspects of British art, and is currently completing a book on painting and the public sphere in eighteenth-century England.

INTRODUCTION

John Barrell

I

W HEN this volume was first conceived, its aim was to
exemplify a new kind of approach, though not a rigidly uniform one, to
the history of art and, more specifically, to the history of British art.
This approach has been developing over the past ten or fifteen years, in
opposition to a more traditional version of art history (*especially* traditional
in the field of British art), which seems to have lost touch with the interests
of students and scholars in other disciplines. The idea was for a series of
essays on painting in Britain in the period 1700–1850, its theory and
practice, in which a wide range of topics, artists, and genres would be
considered, and which would be unified by the shared concern of all the
contributors with what has come to be called the politics of culture. Because
a good deal of the most interesting work on British art in recent years had
been done by scholars in other disciplines, and because the idea of the
volume was to exemplify and to encourage an interdisciplinary approach,
only half of the contributors were to be historians of art; of the others, one
was a social historian, one a historical geographer, and the remaining three
were historians and critics of literature.

Now that all the essays are in, however, I am not sure whether they
exemplify a new kind of approach to the history of art, or a new kind of
departure from it. Most of the contributors have chosen to discuss indi-
vidual paintings in very considerable detail, and some of them focus on
what have come to be regarded as canonical works in the history of British
art: Thomas Gainsborough's *Diana and Actaeon*, for example, or Sir Joshua
Reynolds's group portraits of the Society of Dilettanti, or Joseph Wright
of Derby's *Experiment on a Bird in the Air Pump*, or Turner's Petworth
landscapes. They address these paintings as texts which, if interpreted, will

tell us a great deal about the culture and society of eighteenth- and early nineteenth-century Britain. In what we usually think of as art history, interpretation is often regarded with suspicion; where it is attempted, it is usually with the aim of revealing that a work of art hangs together, has a coherent meaning. In these essays, however, paintings are regarded as in need of interpretation precisely because they appear to offer more or less incoherent representations of the society in which they were produced; and in attempting to understand that incoherence, the authors are often obliged to explore aspects of contemporary culture and society very remote indeed from the usual concerns of art historians. The result is a collection of essays which, though mostly starting from and returning to the discussion of paintings, do not seem to me to belong within any established discipline. On the other hand, they seem to take too little for granted about any of the disciplines they move between to be described as 'interdisciplinary'. I would describe this kind of work as 'cultural criticism', except that as that term is more and more exclusively applied to the analysis of the modern and post-modern, it seems to leave out of account the concern with history exemplified in these essays, and the attempt they make to construct the meanings of images in terms of contemporary practices, discourses, and events.

To approach painting in terms of the politics of culture is to ask such questions as these: What, at any particular period, are acknowledged to be the social and political functions of painting, and the meanings that painting is imagined to be capable of generating? What are the functions of painting, and the meanings it can generate, that at any particular period remain unacknowledged, either because they cannot easily be articulated within the available language, or because they involve the encoding and transmission of ideology too unconscious or invisible to be articulated or acknowledged as such? How does painting represent those who are not in a position to represent themselves? and how do those whose power to represent themselves is limited nevertheless seem to exert a pressure on the works in which they are represented? To ask these questions is not to imply that there is at any time only one answer to any of them. The functions attributed to painting, for example, are at all times various, and often in competition with one another, and their differences may represent the different interests, conscious or unconscious, which compete to appropriate the area of the 'cultural', and of painting in particular, to their own purposes. The competing theories of the place of painting in culture discussed in Stephen Copley's essay are a case in point: should it teach us to be more virtuous or more polite? is it endangered or encouraged by the

growth of commerce? The answers to such questions are different according to who 'we' think we are, what we think we are doing in asking them, and the institutional context in which they are asked.

The 'meaning' of paintings, in the widest sense of the term, cannot be discussed except by recognizing that they exist in a space defined for them by the various surrounding practices and discourses of a culture, outside which they have no meaning. The story of art cannot be written as the story of art alone; that is why these essays so often situate the paintings they discuss in the context of contemporary writings entirely unconcerned with painting itself, or with what has hitherto appeared to be the manifest content of the works in question. Philip de Loutherbourg's *Coalbrookdale by Night*, for example, has come to be regarded as *the* canonical image of the first industrial revolution. In his discussion of the painting, Stephen Daniels shows how very precise and well informed an image it is of the industrial scene it represents. He also shows, however, that the painting can be understood in relation to a whole range of apparently extraneous practices and discourses, from tourism to freemasonry, which combine and compete to provide it with meaning.

But because paintings do not (or not often) use words to communicate meaning, they cannot simply reproduce the meanings available to be articulated in language; as a result they may communicate meanings which cannot easily be articulated, at a particular period, in words. To interpret paintings becomes a matter of trying to understand them in terms of a complex two-way economy of supplementation, appropriation, and excess: how images appeal to the discourses of language to fill them with meaning they cannot embody; how those discourses appropriate images to their own meanings; how images continually exceed the meanings made available to them by language. That excess may be especially open to be appropriated by those who, by virtue of their class, gender, or race, are usually without the power to determine how they are represented. Marcia Pointon's essay, for example, on a series of portraits of Lady Mary Wortley Montagu in Turkish dress, argues that they enable us to see beyond the vocabularies of idealization and orientalism, which seem to define them, to discover an instance of a woman determined to intervene in the conventions that usually govern the female society portrait. Alun Howkins's analysis of Turner's landscapes of the park at Petworth shows how, in spite of themselves, they reveal the disadvantages as well as the advantages enjoyed by the tenants or employees of a great paternalist landlord.

More usually, however, the paintings and the theories of painting discussed in these essays seem to disclose the process of exclusion by which

the public for painting was constituted. Throughout the period covered by this book, the public for art was being described and defined in more and more capacious terms; in 1700 it was possible to write as if painting should address itself only to the male members of an aristocratic ruling class; by 1850 it would have been very difficult to argue openly that it should not address itself even to female members of the middle class. But the language in which this extension of the public is discussed and defended—the vocabulary of sentiment, of nature, of sympathy, discussed by David Solkin in his essay on Wright of Derby—is also a vocabulary of exclusion: people belong, only because they are different from others who do not.

Throughout the period, women are implicitly (if not always explicitly) excluded from full membership of the 'republic of taste': Ann Bermingham's essay reveals just how limited the capacity of women for artistic endeavour was assumed to be. Similarly excluded are the 'vulgar', a capacious and ill-defined term which can include almost anyone, but which always includes the working class and the lower middle class; indeed the term could be applied even to artists themselves, whose manual skill might be acknowledged, but who were often presumed to lack the taste of their social betters. Non-Europeans are excluded out of hand, and where they are considered at all it is usually so that their supposed barbarousness or savagery can serve as a figure for other excluded groups. In her essay on the strange relations of difference and identity in late eighteenth-century representations of Pacific peoples and Pacific explorers, Harriet Guest calls attention to just such a figure, by which Sir Joshua Reynolds manages to represent both Tahitians and women as barbarians, as equally incapable of membership whether of the nation state or of the republic of taste.

As I have already suggested, an approach to painting which is informed by a concern with the politics of culture will concern itself with the disunity, the incoherences, the loose ends, the unstable excess in the images it examines. Or else it will attempt to juxtapose different images, in such a way as to illuminate the disunity, the incoherences within the culture that produces them. It regards these instances of incoherence as the signs of a contest over what is to be represented and how, and it attempts to show that there is, precisely, a political conflict at stake in that contest: a conflict between those with more or less control over the means of representation; a competition between the discourses in which different interests are constructed and find expression. It is only by a careful attention to history, by the attempt to recover the institutional and discursive contexts in which

paintings were made and looked at, that we can understand the nature of such conflicts and what is at stake in them. As I hope these essays show, however, there is nothing merely antiquarian about such an approach. The conflicts of the past are not the same conflicts as those of the present, nor are they absolutely different. If they were either, it would be harder to recognize them, for the value of historical study lies in the opportunity it provides for self-estrangement, the chance to recognize ourselves in what we are not.

II

Many of the contributors to this volume began their researches into British painting and the politics of culture by looking at landscape painting, no doubt because so much of what it is to be British—and still more of what it means to be English—has come to be staked on the landscape and on the representations offered of it by artists like Gainsborough, Capability Brown, Constable, and Turner. Ann Bermingham, Stephen Daniels, Marcia Pointon, Michael Rosenthal, David Solkin, and I have all written at length on the politics of images of landscape in Britain, and in this volume that concern is represented by Alun Howkins's essay on a sequence of paintings by J. M. W. Turner. These were commissioned in the 1820s by the 3rd Earl of Egremont, who was famous as an improving landowner and a paternalist employer and landlord, and who commissioned Turner to produce an image of the ideal georgic life and landscape he had realized on his estates at Petworth in Sussex. As Howkins points out, however, the fabled benevolence of Egremont could work its magic only because his authority on his estate was absolute. He controlled the lives of his dependants with a careful blend of generosity and coercion; his improvements in Petworth town included a new gaol as well as a new workhouse. The signs of the absolute and unquestioned ruler, Howkins reveals, are as evident in the paintings of Petworth as are the signs of the benevolent improver; the pictures speak to us of both sides of life on the great early nineteenth-century estate. And they speak to us also of both sides of the life of the professional painter in the same period: apparently the servant-painter, commissioned to confirm the self-image of a great and powerful aristocrat; at the same time the established professional, the free agent, who in celebrating Egremont's values is also articulating his own.

An opposite image of England is depicted in *Coalbrookdale by Night*, the blast furnaces known as Bedlam in the Shropshire valley which by 1801, the year de Loutherbourg's painting was first exhibited, was well established as

one of the most energetic centres of industrial enterprise in Britain. It can be read, as Stephen Daniels points out, as an almost programmatic image of modernity, of Enlightenment. The painting calls attention to the very precise empirical study and knowledge that went into its making, the careful and accurate delineation of industrial processes and products. It represents an area that was already being publicized as a modern tourist attraction, by virtue of the spectacle it offered of the power of fire and steam. At the same time, however, the painting seems to belong to an entirely different world, one which appears to have nothing to do with new technology or tourism, with the workaday or holiday culture of modernity. This other world is a place of apparently 'occult' belief: of freemasonry, of alchemy, of the alchemical version of geology known as 'subterraneous geography', of the millennial religion which saw in the blast furnaces of Coalbrookdale a true image of the fallen world or of the fire of the resurrection. In part, as I have already suggested, Daniels's essay is an attempt to demonstrate the extraordinary cultural density of the painting, and therefore the sheer range of the archaeological work to be done if it is to be understood in terms of the historical moment that produced it. His main point, however, is to point out the ahistoricism that can recognize the Enlightenment only in discourses and practices which seem to relate to our modernity also, and which still seem 'rational and useful', while it dismisses whatever in the philosophy and religion of the Age of Reason seems irrational or arcane.

Several of these essays are concerned with the various and competing terms in which, throughout this period, the public for art was imagined, and the social and political functions of art were defined. Stephen Copley's essay is an attempt to understand how the aristocratic theory of painting set out at the beginning of the eighteenth century by the 3rd Earl of Shaftesbury was modified in order to acknowledge and define a new public for painting. The 'civic humanist' or 'classical republican' terms of Shaftesbury's theory were based in the belief that history painting, the highest genre of the art, was concerned to address a patrician audience, which expected painting to represent the public virtues of a ruling, a senatorial class. But in eighteenth-century periodical writing, Copley argues, a different account of taste and of the visual arts was being developed, and a new audience for painting was being defined, one which might include men of the professional and commercial middle class and perhaps even their wives. One aim of the periodicals was to shape and educate this new audience into a new public, well informed about painting, and able to converse about matters of taste in a manner both polite and

informal. In this process, much of the exclusiveness that characterized the civic humanist account of painting was preserved: a disdain for mere manual dexterity, for example, could instantiate the polite character of a middle-class public as well as of a public supposedly composed of aristocrats. In various subtle and indirect ways, however, the periodical writers were able to define a new audience of polite consumers, who were imagined to combine or conflate an understanding of the aesthetic value of paintings with an appreciation of their market value. There is no simple linear movement, Copley argues, from a civic humanist to a more consumer-oriented account of painting: both emerged at the start of the century, and continued to coexist in uneasy symbiosis.

Some similar issues are addressed in the essays by David Solkin and Michael Rosenthal. Solkin compares a portrait of the 3rd Earl of Shaftesbury and his younger brother, painted by John Closterman around 1700 to the precise design of the Earl himself, and Joseph Wright's *Experiment on a Bird in the Air Pump* of 1768. Solkin reads the portrait as an image of the true citizen as envisaged in the English version of classical republicanism: a gentleman-philosopher, the owner of landed property, who looks out at the world with a disinterested and benevolent concern for the public interest and a wise distrust of commerce. How far do those values and virtues survive, asks Solkin, into the final third of the eighteenth century, by which time the audience for the visual arts had come to include more of the expanding commercial middle class? We can read Wright's picture, he argues, as one from which almost everything that Shaftesbury valued has vanished. It is the work not of a painter working to the orders of an aristocratic patron, but of an independent professional artist. The society it represents and addresses is no longer aristocratic but middle class; no longer landed but commercial; no longer concerned with the public world, but enclosed within its own private circle, its own little platoon. And yet in one crucial respect the civic values of Shaftesbury have survived, and are enjoying an active life in the *Experiment*. For the primary concern of Shaftesbury and Wright alike is to teach the values of social life by representing, in the interaction of human beings, the processes of social formation and consolidation. What has survived the transformation of social values and of the audience addressed by polite culture is the concern of painting to present its audience with an image of itself and of what it should aspire to be—though Wright's painting (as Solkin ends by arguing) does this much less confidently, more ambiguously, than does Closterman's.

Michael Rosenthal's essay is a discussion of what is probably Thomas Gainsborough's most puzzling picture, the *Diana and Actaeon* painted in

the mid-1780s. As Rosenthal points out, this work, which Gainsborough never exhibited, may well be unfinished; but it may simply be the most extreme example of the characteristic 'lack of finish' which was the hallmark of his art. It is also the only example in Gainsborough's *œuvre* of mythological painting, and his only exercise in the genre—history painting—which Reynolds among others was still insisting was the highest branch of the art. Rosenthal's essay is an attempt to understand what Gainsborough was doing in painting a subject so remote from his usual concerns; he may, the essay suggests, have been attempting to improve his status as an artist, by attempting a kind of subject that he regarded as both absurd and unsaleable, in a version of the abstract, generalizing style which according to Reynolds was the mark of the highest art. He may also, however, have been engaged in an elaborate joke at the expense of academic theories of High Art. And whatever he intended, Rosenthal argues, the painting seems to pose a series of fundamental questions to the grand style as described by Reynolds, in particular about the nature of perceived reality and the limits of abstraction. The effect of these questions is to suggest that the true public—the public defined by Reynolds, in civic terms, as capable of appreciating the representation of universal, abstract nature—might no longer exist, if it ever had existed. *Diana and Actaeon* addresses itself to the mixed and plural audience that is arguably the only audience to be found in modern commercial societies.

As both Copley and Solkin point out, notions of painting more hospitable to the values of a commercial society were also marginally more hospitable to the private values often gendered as feminine. The republic of taste envisaged among the middle class was one to which women might be admitted—but only as second-class citizens, as Ann Bermingham demonstrates. Her essay also starts from a painting by Joseph Wright of the Corinthian maid, who, to preserve the image of her parting lover, traced the shadow of his profile on the wall of her house; her father, a potter, then filled in the outline by modelling the features in clay. The story was popular among neo-classical painters in the last third of the eighteenth century, as a way of imagining the origin of drawing. Wright's painting, however, was commissioned by Wedgwood, who may have thought of the story as an account of the origin of bas-relief sculpture, and thus as a most appropriate design for his newly invented jasper ware, in which white moulded reliefs were applied to coloured grounds. The Corinthian maid has a double life in the late eighteenth century, as a motif of interest to the fine and to the industrial artist alike; but wherever it is found, argues Bermingham, the story is understood as one which represents the maid not as an inventor

but as a mere copyist; it reinforces the notion of a sexual division of aptitude in the arts, by which women are associated with low-level reproductive technologies. And it is the same story where art was taught as an 'accomplishment' for women of the polite classes. Women were usually taught to paint in water-colours by copying the works of their male teachers; such other 'artistic' practices as they were encouraged to take up were no less mechanical and still more mindless. And as routine copying was increasingly perceived as a feminine activity, so the artisans of the early industrial period, Bermingham argues, can be thought of as undergoing a process of feminization, as they were increasingly relegated to executing the designs of a professional designer.

The essay by Marcia Pointon, on the other hand, has a different story to tell about women's access to the art of painting, a story in which one woman, at least, is able—partly by virtue of her aristocratic class position— to control her own representation. Pointon discusses the various portraits of Lady Mary Wortley Montagu in Turkish dress, which all provide her with an ideal and desirable body, after her 'real' body, ravaged by smallpox, was thought to have lost its beauty. Idealization in portrait-painting is usually discussed in terms of an exchange of cash for flattery, but in these images, Pointon suggests, something much more interesting is going on. It seems likely that these 'Turkish' portraits of Montagu were staged by her, and executed according to her own design. The body they depict, both ideal and exotic, is not simply an object to be gazed at by others; it is the sign of Montagu's determination to represent herself, to be the object, first and foremost, of her own gaze. By the early eighteenth century sexual pleasure was already a strong component of the meaning attributed by the European imagination to things Turkish. The portrait of a European woman in Turkish dress would therefore seem to represent her body as a site of pleasure and desire; and though Montagu's costume departs from the Turkish in various details, it does so only to enable more of the body to be seen, to make her body still more an object of pleasure. It would be easy enough, Pointon acknowledges, to account for this articulation of the oriental with the feminine as simply one more instance of the eroticization of each in terms of the other, and these portraits may well have been enjoyed on just those terms. But they may speak to us also of the notion that a woman might take a much more active role in the production of her own image. Montagu's self-orientalization, the essay argues, should be understood as the means by which she was able to re-imagine her own body as other to itself; it is part of a process of narcissistic self-estrangement, by which that body could be re-presented as an object of desire.

Harriet Guest's essay is also concerned with the idea and meaning of the exotic, and with the interaction between notions of race and gender in the period of Sir Joshua Reynolds and James Cook. Her starting-point is the strange portrait by Sir Joshua Reynolds of Omai, the Tahitian who was brought to England on board one of the ships taking part in Cook's second expedition to the Pacific. Omai is represented by Reynolds in the authoritative attitude of a patrician orator, an attitude, however, which serves to display the tattoos which mark him as a figure not of authority but of curiosity. The attempt to understand this contradiction, to arrive at a reading of the portrait's oddly illegible character, develops into a more general account of attitudes to tattoos and of how they figured in the attempt to distinguish the civilized from the barbarian, the European self from the exotic other. To Reynolds, for example, marks on the body seemed to mark the boundary between an acceptable and an intolerable otherness. On the one hand, there were the removable fashions and ornaments that could articulate national difference without concealing the universality of human nature; on the other hand, there were ornaments incised so deeply that they marked out those who bore them as beyond the limits of the cultural and therefore of the human. But more was at stake in this distinction, Guest argues, than the issues of national and racial difference. Implicit in the distinction between civility and barbarousness was a further attempt to define a polite, polished, and therefore feminized notion of what it was to be a man of culture, by contrast with a femininity which could also be represented as beyond the cultural, as barbarous, as exotic. The essay becomes a study of the incoherence of theories of culture which could articulate differences of race and gender only in terms of each other.

My own essay can be read as something like an epilogue to these eighteenth-century debates, and in particular to the attempt of the civic discourse to insist that painting was to represent manly virtues to an exclusively male audience. It is an account of Benjamin Robert Haydon's painting of 1843, *Curtius leaping into the Gulph*, which depicts a favourite hero of classical republicanism: Marcus Curtius was a legendary Roman who, in the early history of the republic, sacrificed his life to prevent the ruin of the city. The essay starts as an attempt to reconstruct the meanings that Haydon himself seems to have attached to this strange work, in which the features of the hero leaping to his death were modelled on the artist's own. It sees the painting as constructing an identity for its author at the intersection of public history and private fantasy, an identity that can be pushed into revealing the sexual anxieties and uncertainties so nervously

disavowed by the civic image of manly virtue. And in the context of the exclusive masculinity of civic notions of painting, the essay attempts to suggest why the epic image of Curtius—and the classical republican values it appeals to—was apparently such an anachronism in the Britain of the 1840s. The painting, it suggests, can be thought of as an image of the death of the civic discourse itself, the discourse that had legitimized this notion of heroism and the heroic genre—the civic history painting—which had been invented for its representation.

There was to have been a tenth essay, by John Murdoch of the Victoria and Albert Museum, entitled 'The Permissibility of Images' and addressing the problem for a Protestant culture in coming to terms with painted, drawn, and engraved images. Murdoch was to have written in particular about the discovery and development, in the third quarter of the seventeenth century, of a specialized language for the analysis and criticism of paintings, by which certain special forms of knowledge were invented, and which conferred a special status on those able to articulate it. Pressure of work meant that he had no time to write what would certainly have been a very important essay indeed. This collection is dedicated to him as a gesture of solidarity with our colleagues in galleries and museums, who are increasingly being obliged to become managers at the expense of being scholars, by a false economy which ensures that much of their expensively acquired knowledge will never be shared.

1

The Fine Arts in
Eighteenth-Century
Polite Culture

STEPHEN COPLEY

I

T HE development of interest in art in eighteenth-century
Britain, as reflected in the spectacular growth of the market for painting
from its relatively small scale in the seventeenth century, has recently been
traced by Iain Pears.[1] It was a development that inevitably involved changes
in the status of art and of the artist, and alterations in the composition of
the public for artistic productions, which were shaped by and represented
in publications of the period. At the centre of Pears's survey of the debates
that surround these changes is his account of the evolution of a new
eighteenth-century vocabulary of polite taste. As numerous commentators
have pointed out, this vocabulary is ubiquitous in the period, providing
the terms in which manners and standards of social conduct are debated,
and informing discussion of larger social and political issues, as well as
defining the bounds of aesthetic criticism in periodicals and related general
publications. Examination of the place of painting in the aesthetic debates
of the period thus inevitably involves consideration of the position of the
aesthetic alongside the other concerns of polite writing, and of the status
of polite culture itself in society. In this perspective painting stands at the
centre of three broad and overlapping areas of debate, concerned with the
relative valuation of the different fine arts and their moral effects in society,

[1] Iain Pears, *The Discovery of Painting: The Growth of Interest in the Arts in England, 1680–1768*
(New Haven, Conn., 1988).

the appropriate audiences for them, and the place of art in a commodity economy.

Recently there has been considerable critical discussion of the ideological implications of the eighteenth-century definition of polite culture. In a substantial contribution to this debate, John Barrell has argued that polite discussions of art theory are grounded in a discourse of civic humanism, which conceives of a republic of fine arts and taste as a political republic, and sees its productions as being justified in social terms through their role in cultivating the public civic virtues of the republican citizen. However, Barrell suggests, the terms of this civic discourse are undermined from within as the period develops, with the establishment of a new order of priorities in political and cultural debate, in which 'public virtues' are transformed into 'social virtues', as the category of 'the public' is increasingly displaced from its position of centrality, and as its concerns are privatized.[2]

As Barrell acknowledges, there is a danger in representing this change simply as a linear development. The relation between the humanist tradition and the new vocabulary of politeness is susceptible to many readings as the more or less active or residual terminology of the former is recast or displaced in the individual texts that make up the new polite literature. In this context, alternative readings of the period can offer useful qualifications to Barrell's account. Nicholas Phillipson, for instance, has attempted to identify a coherent discourse of politeness in Addison and Steele and the early periodical writers, which he sees as being based in the cultivation of apolitical social practice, and he has argued that this vocabulary is specifically politicized in civic terms only later in the century, as part of the deliberate programme of Hume's essays.[3] The attraction of Phillipson's position in the context of this essay is that it draws attention to the variety of strands, other than those derived from civic humanism, that run through

[2] John Barrell, *The Political Theory of Painting from Reynolds to Hazlitt: 'The Body of the Public'* (New Haven, Conn., 1986). See also Lance Bertelsen, *The Nonsense Club: Literature and Popular Culture 1749–1764* (Oxford, 1986); Ralph Cohen (ed.), *Studies in Eighteenth-Century British Art and Aesthetics* (Berkeley, Calif., 1985); Lawrence Lipking, *The Ordering of the Arts in Eighteenth-Century England* (Princeton, NJ, 1970); Ronald Paulson, *Popular and Polite Art in the Age of Hogarth and Fielding* (Notre Dame, Ind., 1979); Ronald Paulson, *Breaking and Remaking: Aesthetic Practice in England, 1700–1820* (New Brunswick, NJ, 1989).

[3] Nicholas Phillipson, 'Politics, Politeness and the Anglicisation of Early Eighteenth-Century Scottish Culture', in *Scotland and England 1286–1815*, ed. Roger A. Mason (Edinburgh, 1987), 226–46. See also Michael G. Ketcham, *Transparent Designs: Reading, Performance and Form in the Spectator Papers* (Athens, Ga., 1985); Lawrence Klein, *The Rise of Politeness in England, 1660–1715* (Ann Arbor, Mich., 1985); Michael Meehan, *Liberty and Poetics in Eighteenth-Century England* (Beckenham, 1986); Kathryn Shevelow, *Women and Print Culture: The Construction of Femininity in the Early Periodical* (London, 1989); Peter Stallybrass and Allon White, *The Politics and Poetics of Transgression* (London, 1986).

aesthetic debate from the beginning of the century, and that provide powerful, if at times apparently inchoate, alternative rationales of the place of painting in society in polite texts. It thus reinforces the impression that the more elaborate defences of painting in humanist terms in the period—whether mounted by Jonathan Richardson, George Turnbull, the Scots, or mid-century advocates of the need for a British Academy—often have a self-conscious and embattled air, as they respond not only to attacks on visual art launched from within the civic tradition, but also to previous—and inconvenient—apologias couched in the terms in which other aspects of the new polite culture are justified.

In this essay I want to draw on the case put by Barrell, leavened by Phillipson, to trace something of the relation between the inherited, mutating, and ultimately undermined civic humanist vocabulary of eighteenth-century art theory, and the vocabulary of politeness as social practice developed in periodicals and subsequent polite literature. Working on the assumption that the civic tradition continues to supply much of the terminology of aesthetic debate in the period, in however qualified a form, I will outline some of the ways in which that terminology is modified in use in two contexts: in the periodicals, where it is transected by other vocabularies and terminologies within a discourse whose organizing principle is the definition of polite sociality; and in more specialized treatises on art and painters' defences of painting, whose initial allegiance to the civic tradition as the source of the most elevated claims for the dignity of painting is itself progressively compromised by the new vocabulary of politeness. My survey will not seek to deny the large historical changes plotted by Barrell, but will aim to add riders to his account, emphasizing in particular the discontinuous and fragmented nature of the discursive changes he outlines, in the continuing flux of eighteenth-century aesthetic debate.

II

The civic tradition of aesthetics faces considerable challenges in the eighteenth century. Although it continues to provide the basic vocabulary of art theory, the hierarchy of artistic forms and the model of artistic context that are proposed within it are far removed from the prevailing conditions of production, distribution, and reception of art in the period. The ideal context for civic art, in public display to the citizenry, lies outside the realm of commercial exchange. Writers of the period generally recognize the lack of availability of such means of display in contemporary society,

in the absence of extensive ecclesiastical or state patronage. However, they cannot lament this absence unreservedly, as the most admired historical examples of ecclesiastical patronage usually involve the Catholic Church, while state patronage is often associated with monarchical absolutism and set against the English spirit of liberty. Instead of these models, writers intent on defending both the role of art in the *polis* and the liberties of a Protestant, increasingly market-oriented society must cope with the predominance of the market as the prime means of dissemination of works of art, and must negotiate the consequent dual problems of the commodity status of paintings, and of the waywardness of the taste expressed by the public in purchasing them.

In this context the definition of politeness plays a formative role in shaping the terms of aesthetic debate, and its main features are well worth outlining. The coherence of polite discourse depends on the linkage made in polite writings between the cultivation of non-vocational, non-specialized knowledge or practical and discriminatory skill, and the social practices of civility. The areas of knowledge and skill deemed appropriate to the consideration of the polite are defined and limited by this linkage. In this sense instruction in polite taste is in large part instruction in discriminating consumption, the fundamental qualification for which is leisure, which will enable the polite to acquire standards of taste to guide their manners and their social and economic behaviour. The vocabulary of taste must therefore serve to moralize pleasure and legitimize leisure and luxury expenditure. This it does in part by avoiding and in part by appearing to transcend these categories, so that the status of the polite as leisured consumers is habitually mystified, as their consumption is translated into aesthetic terms. However, discussion of taste remains intensely problematic for many eighteenth-century commentators precisely because of its suspiciously close relation to these difficult areas.

Although the exercise of taste of course depends upon and stimulates the activity of economic production in society, considerable effort is made to define the domain of politeness as being outside commerce and commodity exchange altogether. The social practice of polite civility can readily be figured in these terms. Polite aesthetic appreciation of literary and artistic productions poses more complex problems, which are at their most pressing in relation to the visual arts. The characteristic Augustan representation of the production and reception of literary texts as a species of non-material aesthetic exchange between writer and patron or reader is unsustainable in the context of painting and sculpture, where the commodity status of the individual work of art is inescapable. In reaction, commentators repeatedly

seek to bypass or efface the materiality of the works of visual art they discuss in order to avoid the problem of their relation to the luxury economy, and in doing so they refigure their reception either in terms of the less problematic, more abstract arts, or as an integral part of polite social exchange itself.

The project of defining polite taste owes much of its initial impetus to the writings of the Earl of Shaftesbury, but its terms are most widely and influentially expounded—and in the process modified—in early eighteenth-century periodicals such as the *Spectator*. These periodicals continue to play a considerable part, directly or indirectly, in polite debates throughout the period. As well as stimulating the development of a considerable body of later general and specialized literature on manners and aesthetics in England and Scotland, they provide that literature with the basis of its working vocabulary, and themselves remain as reference points in discussions for much of the century. In the 1760s, for instance, Hugh Blair can still comment that the *Spectator* is 'in the hands of everyone'.[4]

As it appears in Shaftesbury, the rhetoric of humanism is deployed in defence of an exclusively aristocratic polite culture, within which visual art has a particular significance in the hierarchy of the fine arts. In Shaftesbury's Neoplatonic philosophical system moral consciousness, and with it the capacity for civic action, is based in and in many ways synonymous with the capacity for aesthetic perception, which is perfected only in polite culture. Both capacities in turn depend on a combination of innate capability and social position that can only be found in the aristocratic gentleman; the cultivation of polite aesthetic taste is accordingly represented as the essential and exclusive preserve of the ruling élite.

Shaftesbury's account of the place of visual art in polite culture reveals a problem in traditional humanism which Ronald Paulson describes succinctly when he writes that 'What characterized the tradition of civic humanist aesthetics was the absence of material art objects. The position of the actually made object was usurped in this tradition by ideal hypotheses such as the Shaftesburyian Judgement of Hercules.'[5] In the example he cites, Shaftesbury's aristocratic embarrassment at the undignified physical labour involved in the production of works of art is resolved by his commissioning workmen to execute his own abstract philosophical designs for a picture. Within his vocabulary of aesthetic taste the polite subject can only have a particular and restricted social identity as a leisured aristocratic

[4] Quoted in Ketcham, *Transparent Designs*, 4.
[5] Paulson, *Breaking and Remaking*, 3.

virtuoso and patron. In contrast, he cannot offer a justification for the activities of professional artists, or place them among the ranks of aesthetically competent gentlemen, even when they are of the social standing of Sir Godfrey Kneller, and by extension he must remain at least in part suspicious of their productions.

Eighteenth-century polite literature is directed to a new audience in a new context. Through the medium of the periodical, and then through an expanding volume of general publications, professional commentators seek to form and address an extended polite public, embracing members of the middle classes as well as the traditional gentry and aristocracy, women as well as men, in the context of a newly commercial society. As Jon Klancher has argued,[6] this project involves the periodical writers in constant adaptation of the aristocratic terminologies that they inherit. In formulating the vocabulary of politeness, they thus redeploy earlier models of courtly address and exchange, apparently in much more democratic terms, in the literary market-place. At the same time, however, they continue to defend in various ways the exclusivity of the models of politeness they have imitated, as they attempt to establish communities of polite readers from their unknown audience, and to discipline their reactions into those of a coherent public. Their treatment of painting exposes some of the problems in their project in an extreme form.

The nearer polite writers remain to the standards of classical humanism, the more urgently do they represent the threat to social order posed by commerce and luxury and the more pressing is the need for the workings of these forces to be negotiated by the operation of taste. In a treatise on painting published in 1740, George Turnbull writes that 'Wealth in a State is a Nusance, a poisonous Source of Vileness and Wickedness, if it is not employed by publick Spirit and good Taste in promoting Virtue, Ingenuity, Industry, and all the Sciences, and Arts, which employ Men's noblest Powers and Faculties';[7] while in another treatise, published in 1759, Alexander Gerard insists that it is essential to society that 'Taste stamps a value upon riches'.[8]

In this context the appeal of an ideal—whether constructed historically or not—in which the production and appreciation of painting occurs quite outside the domain of the economic, is overwhelming to many commentators of the period. Writing in 1734, for instance, Hildebrand

[6] Jon P. Klancher, *The Making of English Reading Audiences 1790–1832* (Madison, Wis., 1987).
[7] George Turnbull, *A Treatise of Ancient Painting, containing Observations on the Rise, Progress, and Decline of that Art amongst the Greeks and Romans* (London, 1740), 124.
[8] Alexander Gerard, *An Essay on Taste* (London, 1759), 194.

Jacob is nostalgic for an ideal civic past in which artists could be regarded as servants of the public good without the need to take account of their problematic role as producers of luxury commodities. He writes that 'A *Painter* was of old look'd on as a *common Good* ... Some of them chose rather to give their *Labours gratis* to their Country, than to set any Value upon them.'[9] This case is reiterated throughout the century: in 1800 John Robert Scott echoes it when he claims that among the Greeks the arts 'were not deemed the lucrative trades of mechanical men, by which some fame and much money might be procured; but the ennobling occupations of the best-deserving citizens', and argues for public support for artists so that they will not need to 'lay out their whole attention on the low and subordinate but gainful branches of their *trade* in contempt of the superior features of their ART'.[10]

The critique of the deleterious effects of commercial society in these texts extends, however, beyond its disablement of the civic artist. Comparing the present with classical times, Jacob writes of the inherent dangers in the proliferation of commodities in commercial society for consumers as well as producers, spectators as well as artists; he claims that

the *Scene* which is now carrying on upon the *Theatre* of what we call the *Polite World*, is of quite a different Nature from what it was in those Days; and the Increase of *Luxury*, and new *Inventions* have made, at present, so many things necessary ... that the Condition of our Affairs seem to put Men rather upon providing for the *Conveniencies* of Life, than to afford them *Leisure*, to finish any considerable Work in these *Arts*, as it ought to be; or Opportunity of thinking *justly* and *sublimely* of Things which are chiefly intended for *Ornament*.[11]

Writing fifty years after Jacob in the preface to a treatise on the fine arts, Thomas Robertson employs a characteristic later eighteenth-century extension of this critique of commerce when he compares a primitivist ideal of undifferentiated savage life with the present, and writes: 'If there be men, busied about necessaries, more than about any other things, it is the bulk of men in the most refined times', including in this not only 'the stupid labourer and mechanic', but 'the merchant and his book' and 'the liberal and learned themselves, amid the tasks of study and the functions of office: their pleasures, properly so called, being snatched at intervals; for all their other amusements, however genuine, arise merely from their being

[9] Hildebrand Jacob, *Of the Sister Arts, An Essay* (London, 1734; repr. Los Angeles, 1974), 9.

[10] John Robert Scott, 'A Dissertation on the Progress of the Fine Arts' (1800), in *Dissertations, Essays and Parallels* (London, 1804; repr. Los Angeles, 1954), 176.

[11] Jacob, *Of the Sister Arts*, 32.

employed'.[12] In this context, the privilege implied in the leisure of the polite is very considerable: the leisured polite spectator is in some senses the only figure in society who can preserve a capacity for judgement by his or her (albeit temporary) non-engagement in the economic process; and a formulation such as John Armstrong's claim in 1770 that 'mere good taste is nothing else but genius without the power of execution' can be seen to have a double edge. On the one hand the lack of the 'power of execution' in taste may represent impotence, but on the other it implies liberation from the toils of economic engagement that would compromise it.[13]

III

In his *Two Discourses* on painting of 1719 and *An Essay on the Theory of Painting* of 1725, Jonathan Richardson is much preoccupied with the relation between art and economics. At the most straightforward level, his attempts to distinguish investment in art from luxury often serve merely to reveal the incompatibility of two of the persuasive ends that he wishes to urge: the commodity value of paintings and their exemplary function. In a passage from the *Discourses*, for instance, the market value of old masters depends precisely on their scarcity, their non-proliferation, which would be threatened by an upsurge of civic spirit and the art that accompanies it, and which Richardson only manages to link very imprecisely with an acceptable source of material value by calling on an image of the improving estate. He writes that

If Gentlemen were Lovers of Painting, and *Connoisseurs*, many Summs of Money which are now lavish'd away, and consum'd in Luxury would be laid up in Pictures, Drawings, and Antiques, which would be, not as Plate, or Jewels, but an Improving Estate; Since as Time, and Accidents must continually waste, and diminish the Number of these Curiosities, and no New Supply (Equal in Goodness to those we have) is to be hop'd for, as the appearances of things at present are, the Value of such as are preserv'd with Care must necessarily encrease more and more.[14]

More generally, for him, as for Shaftesbury, the workmanship employed in paintings is worryingly close to that involved in creating any other luxury commodity: 'the Mechanick Parts of Painting ... require no more Genius, or Capacity, than is necessary to, and frequently seen in Ordinary Workmen, and a Picture, in this respect, is as a Snuff-Box, a Fan, or

[12] Thomas Robertson, *An Inquiry into the Fine Arts* (London, 1784), i. 4.
[13] John Armstrong, 'Of Taste', in *Miscellanies*, 2 vols. (London, 1770), ii. 136.
[14] Jonathan Richardson, *Two Discourses* (London, 1719), Discourse 2, 47–8.

any other Toy', while for consumers 'Because Pictures are universally Delightful, and accordingly made one part of our Ornamental Furniture, many, I believe, consider the Art of *Painting* but as a pleasing Superfluity'.[15] In this context he repeatedly attempts to establish that the criteria of genuine aesthetic judgement necessarily demand that true art be distanced from its association with luxury or mere sociality. He thus laments 'that there are so Few Lovers of Painting; not merely for Furniture, or for Ostentation, or as it represents their Friends, or Themselves; but as it is an Art capable of Entertaining, and Adorning their Minds As Much as, nay perhaps More than Any other whatsoever'.[16]

In Richardson himself, and in many other writers of the period, this set of dangers produces a model of art in polite culture in which artistic production often seems to be validated only by discriminating reception— a model that can at times lead to oddly apologetic formulations when he or artists after him argue for the dignity of their own profession. For most commentators the subordinate 'mechanics' involved in the production of works of art clearly have no capacity to appreciate the works to which their skills contribute, but even artists may be disabled from extensive appreciation by their mechanical specialization. In both cases the skills of discrimination are supplied elsewhere, in aesthetic appreciation. The writer of the *World* (63 (1753)) thus dismisses the capacity of 'the labourer' out of hand in the course of an attack on the social habits of members of the superior classes. Noting that the latter often prefer to attend assemblies rather than learning to appreciate the polite arts, he pointedly demands: 'Is it no reproach to them to look upon a picture of Raphael, or a Medicean Venus, with the same stupid eye of indifference, as the labourer who ground the colours, or who dug the quarry?'[17] Related doubts about the capacity of the artist are equally clear when Daniel Webb insists in an essay of 1760 that the polite spectator is invariably a better judge than the 'professors' of any art, because artists 'seldom, like gentlemen and scholars, rise to an unprejudiced and liberal contemplation of true beauty', as 'the difficulties they find in the practice of their art, tie them down to the mechanick', while 'self-love and vanity' lead them to admire only work that resembles their own.[18]

Even when the artist is acknowledged to be on a par with the

[15] Jonathan Richardson, *An Essay on the Theory of Painting*, 2nd edn. (London, 1725), p. vi, 1.

[16] Richardson, *Two Discourses*, Discourse 2, 6.

[17] *The British Essayists; with Prefaces, Biographical, Historical, and Critical*, pref. R. Lynam and others, 30 vols. (London, 1827), xxvi. 267.

[18] Daniel Webb, *An Inquiry into the Beauties of Painting; and into the Merits of the Most Celebrated Painters, Ancient and Modern* (London, 1760), 18.

discriminating spectator, the acknowledgement is often hedged with quali-
fications, particularly in relation to the mechanical aspects of artistic
creation. Writing in 1771, for instance, Reynolds claims that 'The value
and rank of every art is in proportion to the mental labour employed in it,
or the mental pleasure produced by it. As this principle is observed or
neglected our profession becomes either a liberal art, or a mechanical
trade.'[19] The mental labour of the producer and the pleasure of the
consumer are thus offered jointly as origins of value in terms that accom-
modate the possibility of naïve artistic production being valorized by the
intelligence applied to its reception, and that distinguish the positives of
both equally firmly from the mechanics of artistic workmanship. Varying
the terms somewhat, a discussion of 'Whether the artist or *connoisseur* have
any advantage over other persons of common sense or common feeling',
published in the *Mirror* in 1779, accommodates the painter's activities only
by translating them into other and more tractable terms—in this case
the literary ones mentioned above—and by introducing a metaphor of
employment that in some ways sets the artist alongside the polite consumer.
The essayist thus accepts history painting as valuable—but only because
it can be seen as a species of 'poetical composition', and only because in
that genre 'it is the imagination of a poet that employs the hand of a
painter'.[20]

 The argument for the dignity of the painter, pursued not least by painters
themselves throughout the period, only moves firmly in their favour in the
later part of the century, partly as a reflection of a general proto-Romantic
tendency to celebrate the life of the artist, but also in response to the
new valuation of labour in political economy. Among the later Scottish
commentators on taste, James Beattie suggests this latter influence par-
ticularly strongly. His admiration for the 'dexterity' of the producers of art
thus leads him to shift the criteria of artistic judgement somewhat towards
them, and to relegate the consumers to a secondary status. In 1783 he
writes that

None but a painter is a competent judge of painting. In every art, certain materials
and instruments are employed; and they only, who have handled them, are entitled
to decide upon the dexterity of the artist.

 Yet, without having been a practitioner, one may acquire such taste in the fine
arts, as shall yield a high degree, and a great variety, of entertainment.[21]

[19] Sir Joshua Reynolds, *Discourses on Art*, ed. Robert R. Wark, 2nd edn. (New Haven, Conn., 1975),
55.
 [20] *British Essayists*, xviii. 189.
 [21] James Beattie, *Dissertations Moral and Critical* (London, 1783), 189.

Equally, his insistence on retaining a general meaning for the increasingly aesthetically appropriated term, 'artist', suggests the possibility of a newly positive evaluative linkage between the aesthetic and the mechanical arts. In the course of his discussion of the imagination, for instance, he echoes a formula from the first chapter of *The Wealth of Nations*, in which Adam Smith lists 'how many' different professions, forms of labour, and mechanical 'arts' are involved in the production of 'The woollen coat . . . which covers the day-labourer'.[22] When Beattie adapts Smith's formula to his own ends, he pointedly insists that it is possible to exclaim on 'How many artists are employed in furnishing what is necessary to the composition of that common article, Bread!' only because 'genius is not confined to particular professions, or to any one rank of life'. However, he does not develop the suggestion, implicit in his formulation, that his argument might ultimately involve him in an attack on the special status of aesthetic production itself.[23]

IV

The terms in which the dominance of the consumer is figured in polite writing are particularly clear in the periodicals of the early eighteenth century. A notional correspondent thus writes to the *Spectator* (244) urging that 'It should be methinks the Business of a SPECTATOR to improve the Pleasures of Sight'.[24] In this comment he endorses the offer of educative instruction in the 'improvement'—by which will be understood both refinement and moralization—of one of the pleasures of his leisure by a professional literary commentator whose 'Business' it is to do so, but who is none the less himself also defined as 'a SPECTATOR'. The ironies that play around the terms employed bear witness to the problems involved in the move from the world of professionalism and 'business' to that of a polite leisure that notionally embraces commentator and audience alike. In both these garbs, 'the spectator' of art is at the centre of the concerns of the text, dominating discussion of the privileges of polite culture, and in large measure dictating the assessment of the role of the artist offered within it.

In this context taste is usually represented as a generally available and cultivable rather than an innate capacity. Indeed, the whole educative

[22] Adam Smith, *An Inquiry into the Nature and Causes of the Wealth of Nations*, ed. R. H. Campbell and A. S. Skinner, 2 vols. (1776; repr. Oxford, 1976), i. 22–4.

[23] Beattie, *Dissertations*, 153.

[24] *The Spectator*, ed. Donald F. Bond, 5 vols. (Oxford, 1965), ii. 446.

project of the periodical rests on the assertion of this potential generality. The *Spectator* thus defines polite taste as the expression of a general capacity guiding aesthetic discrimination, which is manifested equally in relation to all the arts, and which is not based in specialized knowledge or practice on the part of the audience that sets its standards. Mr Spectator thus insists (*Spectator*, 29) that 'Musick, Architecture and Painting, as well as Poetry and Oratory, are to deduce their Laws and Rules from the general Sense and Taste of Mankind, and not from the Principles of those Arts themselves; or in other Words, the Taste is not to Conform to the Art, but the Art to the Taste.'[25]

The double problems in this formulation are clear when claims for the generality of mankind's taste are echoed by polite writers later in the century. On the one hand, Daniel Webb's suggestion in 1760 that 'we have all within us the seeds of taste, and are capable, if we exercise our powers, of improving them into a sufficient knowledge of the polite arts'[26] opens up the possibility of a dangerously unrestricted access to the arts, which threatens the efforts of polite writers intent on preserving the exclusivity of polite culture. On the other hand, claims for the range of areas in which taste is exercised can become equally problematic. In 1759, for instance, Alexander Gerard writes that 'scarce any art is so mean, so entirely mechanical, as not to afford subjects of taste', and he includes under this heading dress, furniture, and equipage. Despite his insistence that 'Music, painting, statuary, architecture, poetry, and eloquence constitute its peculiar and domestic territory, in which its authority is absolutely supreme',[27] he leaves visual art at the crux of a series of difficult problems, involving the appropriate boundaries of polite culture and the qualitative distinctions that must be made between the production of aesthetic and other commodities, and more particularly between the terms in which the two are to be received by the polite, if artistic production and taste are not to be seen as hopelessly bound up with the luxury economy.

The first problem is of particular interest. In the *Spectator* itself the acquisition of taste may well be represented as an educative process, but its results are repeatedly naturalized as a sense that confers privileges of its own on its possessors, and that, in doing so, confirms the special status of the polite in society. As Addison writes (*Spectator*, 93), 'A Man that has a Taste of Musick, Painting, or Architecture, is like one that has another

[25] *The Spectator*, i. 123.
[26] Webb, *Inquiry*, 18.
[27] Gerard, *Essay on Taste*, 188.

Sense, when compared with such as have no Relish of those Arts.'[28] In this light the strength and danger of painting is its universal—or promiscuous— appeal. On the one hand, this universality makes it a potentially powerful medium of exemplary humanist address, and it is celebrated as such. On the other, as visual art makes its primary appeal to the senses rather than to the intellect, and thus to the commonly shared lower rather than to the higher faculties, it cannot be said only to address the discerning, but may also affect the vulgar, who are not included within the definition of the citizen, and for whom its effects may be morally and socially dangerous. As George Turnbull puts it in 1740, modern painting operates directly on 'the Sentiments and Feelings of the Vulgar, in whom Nature expresses herself just as she is moved, without any Affectation or Disguise', and painters themselves can see the 'Effects which their Pictures [have] even on ordinary Women and Children'.[29] In response, polite writers must impose limiting conditions in their discussions of painting to differentiate polite spectators from the herd, qualify them peculiarly to view art, and distinguish the quality of their viewing from common perception. In doing so, they must adopt rather different strategies to counter the danger of the various potentially invasive groups of spectators mentioned by Turnbull.

In this respect Alexander Gerard identifies what for many polite writers is a considerable problem when he acknowledges that 'Great sensibility of taste is generally accompanied with lively passions. Women have always been considered as possessing both in a more eminent degree than men.'[30] The humanist tradition cannot find any place for women in the ranks of its active citizens. In contrast, as recent feminist criticism has demonstrated, the position of women in polite culture is ambiguous, as they are offered 'simultaneous enfranchisement and restriction'[31] in polite texts that appear at first sight committed to the celebration of thoroughly 'feminized' values. Nowhere is this clearer than in the area of taste, and in the practice and appreciation of the fine arts.

Richard Leppert has described the constraints of gender in the practice of amateur music-making in the period[32]; very similar social constraints operate in relation to the practice of painting under the discipline of polite decorum. As Dr Johnson puts it, 'Miss [Frances] Reynolds ought not to paint. Publick practice of staring in men's faces is inconsistent with

[28] *The Spectator*, i. 397.
[29] Turnbull, *Treatise*, 45.
[30] Gerard, *Essay on Taste*, 200.
[31] Shevelow, *Women and Print Culture*, 2.
[32] See Richard Leppert, *Music and Image: Domesticity, Ideology and Socio-Cultural Formation in Eighteenth-Century England* (Cambridge, 1988).

delicacy.'[33] At the same time, the care with which female reactions to painting are circumscribed so as to remain within the bounds of patriarchal order is very clear when discussion of the appreciation of painting is incorporated into larger accounts of polite domestic manners. In a description of an ideal couple in the *Spectator* (506), the husband, Erastus, maintains an exemplary masculine combination of public and private engagements, which endears him particularly to his wife Laetitia by providing him with 'a Part to act, in which a Wife cannot well intermeddle', in addition to his role in her domestic sphere. He is 'in a Post of some Business, and has a general Taste in most Parts of polite Learning'. In the latter he takes the opportunity of 'continually improving her Thoughts', and in response Laetitia 'is transported at having a new World thus opened before her'. Her improvement in polite taste is represented as a carefully policed education of her naïve perception into self-recognition: 'Erastus finds a Justness or Beauty in whatever She says or observes, that Laetitia her self was not aware of, and, by his Assistance, she has discovered an hundred good Qualities and Accomplishments in her self, which she never before once dreamed of.' However, Erastus's apparent validation of her perceptions is openly celebrated for its manipulation of them, as he 'with the most artful Complaisance in the World, by several remote Hints, finds the Means to make her say or propose almost whatever he has a Mind to, which he always receives as her own Discovery, and gives her all the Reputation of it'. In this context Erastus's decision to share his own 'perfect Taste in Painting' with his wife is vindicated and validated only when her instilled reflection of his own judgement is reincorporated into his masculine conversation in the public domain of economic transaction, which is beyond the scope of her domestic concerns. He thus tells Mr Spectator that '*I have lately laid out some Mony in Paintings ... I bought that* Venus and Adonis *purely upon* Laetitia's *Judgement: it cost me Three-score Guineas, and I was this Morning offer'd an hundred for it.*'[34]

In a more general sense, distinctions between vulgar and polite reactions to art are often presented in terms of the transformation of the sensual into the intellectual. In this process taste plays the crucial mediating role. As Blair puts it in 1783, 'Providence seems plainly to have pointed out this useful purpose to which the pleasures of taste may be applied, by interposing them in a middle station between the pleasures of sense, and those

[33] Quoted and discussed in Morris R. Brownell, *Samuel Johnson's Attitude to the Arts* (Oxford, 1989), 81.
[34] *The Spectator*, iv. 297–8.

of pure intellect.'[35] For him and others the evidence of the operation of polite taste appears either in the effacement of sensual reactions to visual representation by more elevated ones, or in their refinement, or, as Pears puts it, in the transformation of an initial sensual reaction, which may be commonly shared with the vulgar, into a discriminating intellectual recognition of the nature of that reaction, which is the property only of the polite élite.[36]

<p style="text-align:center">V</p>

The problems faced by commentators in preserving the distinction of the polite are at their most extreme in relation to the lower genres of painting, and are exacerbated throughout the period as the taste that is expressed in the art market continues to differ radically from the standards proposed in the humanist programme. Although that programme postulates an unequivocal hierarchy of forms descending from history painting, and values individual paintings accordingly, writers agree that the growth in consumption in the eighteenth century is for portraits, conversation-pieces, and landscapes, for which the tradition can offer no adequate justification. One striking result is that in many publications the lower forms of art are simply not discussed, or they are relegated to dismissive or condemnatory asides in texts that preserve the ideal hierarchy unquestioned. In other texts aesthetic debate is shaped and limited more insidiously by the continuing presence of the tradition. In the *Spectator* (226), for example, Steele represents the discursive absence of justificatory terminology for the lower genres as a personal incapacity of his own. Assuming that the function of painting is to inspire 'Passion' in the viewer, and that this task is only fulfilled in history painting, he is left with no terms in which to describe the other genres, writing instead that 'My skill in Paintings, where one is not directed by the Passion of the Pictures, is so inconsiderable, that I am in very great Perplexity when I offer to speak of any Performances of Painters of Landskips, Buildings, or single Figures'.[37] Problems such as these are particularly apparent in the writings of contemporary artists. Despite their economic dependence on portraiture, for instance, a sequence of painters from Jonathan Richardson to Hogarth and Reynolds insist on the operation of a hierarchy of kinds below history painting in which, as

[35] Hugh Blair, *Lectures on Rhetoric and Belles Lettres*, 2 vols. (London, 1783), i. 4.
[36] Pears, *Discovery of Painting*, esp. ch. 2.
[37] *The Spectator*, ii. 381.

Richardson puts it, although 'Heads' can be historical and therefore laudable, they are mainly 'an Inferiour Class'.[38]

The valuations entailed in humanist aesthetics are not entirely accepted as constraints on discussion in the century, however, and it is possible to find examples from early on in which they are substantially and explicitly renegotiated. In the *Tatler* (209 (1710)), for instance, Steele describes a projected 'History-Piece' on the subject of Alexander and his physician. In sharp contrast to Shaftesbury, here the focus is firmly on the artists involved: Steele describes the 'Noble Painter', drawing on his own literary advice as a fellow professional for 'a Subject on which he may show the utmost Force of his Art and Genius' to his patron, and the writer celebrates a relation in which 'my Painter is employed by a Man of Sense and Wealth to furnish him a Gallery, and I shall join with my Friend in the Designing Part'.[39] When he continues by offering the reader some 'Chat' about painting, he redefines and domesticates the priorities of the civic system he begins from considerably. Most notably, he departs from the ethical priorities that can cause Turnbull, later in the century, to insist that 'The Ancients delighted in martial Pieces, and these are truly moral Pictures',[40] and claims instead that 'Battle-Pieces, pompous Histories of Sieges, and a tall Hero alone in a Crowd of insignificant Figures about him, is of no consequence to private Men'. At the same time he quietly reduces the public exemplary function of painting itself to a secondary place after its role in celebrating familiar social contact, writing that 'It is the great Use of Pictures to raise in our Minds either agreable Idea's of our absent Friends, or high Images of eminent Personages'.[41]

The low forms of painting none the less continue to excite deep distrust in most commentators, largely for social reasons. In the higher forms the exemplary function of a painting's design can be seen to override the vulgar accessibility of its mimetic representationality, and it can be seen to operate on the spectator on a level of abstraction beyond the reach of the rabble. In this light, it is not surprising that commentators and artists generally distance themselves from the lower representational aspects of all forms of painting and instead dwell wherever possible on its potential for abstraction. Jonathan Richardson, for instance, suggests that what is required in art is not necessarily exact representation, as 'A fine Thought, Grace, and Dignity, will abundantly atone for the want of even a Due Application to

[38] Richardson, *Two Discourses*, Discourse 1, 46, 50.
[39] *The Tatler*, ed. Donald F. Bond, 3 vols. (Oxford, 1985–7), iii. 106–7.
[40] Turnbull, *Treatise*, 65.
[41] *The Tatler*, iii. 107.

the Lesser, to the Mechanical Part of a Picture';[42] Reynolds echoes this sentiment in 1771 when he suggests leaving 'the meaner artist servilely to suppose that those are the best pictures, which are most likely to deceive the spectator';[43] and Joseph Highmore confirms the social basis of the judgement when he stresses in 1766 that the problematic recognizability of painted images is most disturbing in low genres such as portraiture because 'Children, servants, and the lowest of the people are judges of likeness in a portrait'.[44] In this light Maurice Brownell's claim that Dr Johnson's celebrated philistinism in relation to the arts is a studied pose is particularly convincing, and Johnson's claim that 'I had rather see the portrait of a dog that I know than all the allegorical paintings they can shew me in the world'[45] is very well read as a calculated attack on the exclusive privilege implied in the polite perception of art.

VI

Analogies between painting and language offer considerable attractions for commentators intent on marking the bounds of politeness. Linguistic communication offers a model of abstract and potentially exclusive expression that avoids many of the worrying problems in visual representation outlined above. This analogy obviously has a long history: traditional civic discourse maintains a hierarchy in which the rhetorical address of oratory provides a model for all the other arts, and this model remains powerful throughout the eighteenth century. Thomas Reid's version of it, in a lecture of 1774 that owes much to the civic tradition, indicates very clearly the reasons for valuing each of the other arts below oratory, when he claims that eloquence 'is undoubtedly the noblest of the fine arts, for it unites the beauties of them all. It joins the harmony of sound, the beauty of action, comeliness of composition, to good breeding ... Orators have in every age been more scarce than Poets. As Poetry requires more genius, more elevation of mind than statuary, painting, or music, so eloquence requires more great abilities than even poetry.'[46] The unproblematic union of art, manners, genius, and good breeding in oratory, and to a lesser extent in poetry, serves to highlight the difficult relation between them in the other arts.

[42] Richardson, *Essay*, vi.
[43] Reynolds, *Discourses on Art*, 50.
[44] Joseph Highmore, *Essays, Moral, Religious, and Miscellaneous*, 2 vols. (London, 1766), ii. 88.
[45] See Brownell, *Samuel Johnson's Attitude to the Arts*, 79.
[46] Thomas Reid, *Lectures in the Fine Arts*, ed. Peter Kivy, International Archive of the History of Ideas, Ser. Min. 7 (The Hague, 1973), 51.

For some commentators the division between the literary and other arts remains unbridgeable. Goldsmith's insistence on downgrading the visual arts, for instance, reveals the continuing grounds for suspicion of polite justifications of them in the period. In the *Citizen of the World* (34 (1762)) the narrator, Lien Chi Altangi, concedes that 'the painter can undoubtedly fit up our apartments in a much more elegant manner than the upholsterer', but insists: 'I should think a man of fashion makes but an indifferent exchange, who lays out all that time in furnishing his house which he should have employed in the furniture of his head; a person who shews no other symptoms of taste than his cabinet or his gallery, might as well boast to me of the furniture of his kitchen.' His satirical narrative insists on distinguishing between an intellectually demanding literary culture and the 'vacancy' of fashionable interest in music and painting, and he charts the decline of the former, brought about through the fatal desire of audiences for simultaneous improvement and ease—precisely the combination else-where celebrated as characteristic of polite culture. 'I am told there has been a time when poetry was universally encouraged by the great,' he writes, 'when men of the first rank not only patroniz'd the poet, but produced the finest models for his imitation', but

The nobility are ever fond of wisdom, but they also are fond of having it without study; to read poetry required thought, and the English nobility were not fond of thinking; they soon therefore placed their affections upon music, because in this they might indulge an happy vacancy, and yet still have pretentions to delicacy and taste as before ... Music having thus lost its splendour, Painting is now become the sole object of fashionable care.[47]

In a parallel account in the *Bee* (5 (1759)), the cultural decadence that is signalled by the popularity of painting is seen as having its roots in the prior development of a market for literature that has encouraged a danger-ous proliferation of literary texts, destroying the capacity of readers for engagement and preparing them for other, easier pleasures:

As writers become more numerous, it is natural for readers to become more indolent; from whence must necessarily arise a desire of attaining knowledge with the greatest possible ease. No science or art offers its instruction and amusement in so obvious a manner as statuary and painting. From hence we see, that a desire of cultivating those arts generally attends the decline of science. Thus the finest statues, and the most beautiful paintings of antiquity preceded but a little the absolute decay of every other science.[48]

[47] *The Works of Oliver Goldsmith*, ed. Arthur Friedman, 5 vols. (Oxford, 1966), ii. 146–51.
[48] Ibid., i. 453.

In both cases the result is the collapse of a genuine cultural élite into undiscriminating, undemanding, and socially undifferentiated fashionableness. In the *Bee*, 'from the lord, who has his gallery, down to the prentice, who has his twopenny copper plate, all are admirers of this art', while in the *Citizen of the World*, 'the title of connoisseur in that art is at present the safest passport into every fashionable society; a well timed shrug, an admiring attitude, and one or two exotic tones of exclamation are sufficient qualifications for men of low circumstances to curry favour'.

In cases where writers take a more positive view of this relation, they often run together analogies between painting, oratorical address, and its written equivalents in the higher forms of literature—poetry and history. In the *Spectator* (226), for example, Steele asks of painting 'What strong Images of Virtue and Humanity might we not expect would be instilled into the Mind from the Labours of the Pencil?' and claims in reply that visual art can outstrip both poetry and oratory in its effects. He writes that painting 'is a Poetry which would be understood with much less Capacity and less Expence of Time, than what is taught by Writings', so that if painters painted moral subjects 'we should not see a good History-Piece without receiving an instructive Lecture'. Indeed, in outstanding examples such as Raphael's 'Carto[o]ns' at Hampton Court, 'all the Touches of a Religious Mind are expressed in a manner much more forcible than can possibly be performed by the most moving Eloquence', and this effect occurs in terms that will survive dissemination via an engraver, who 'is to the Painter, what a Printer is to an Author'.[49]

As I have already argued, appeals such as this on behalf of visual representation as a form of *Biblia Pauperum* are usually countered in texts of the period (including the *Spectator* itself) by claims for the need to distinguish the appeal made by art to qualified polite spectators from its effects on the vulgar. For Charles Lamotte, writing in 1730, although 'Pictures are the Books of the ignorant, where they may learn what they ought to practice and follow', this effect compromises the position of the painter, whose following, though often numerous, is not made up of the 'knowing and judicious', while in comparison the poet's select readership contains 'more true Admirers'.[50] Only rarely, as in the *Connoisseur* (48 (1754)), is the general appeal of art endorsed in relatively unqualified terms. There, the essayist reiterates the typical argument that public display of art will 'animate the bosom with a love of excellence' without insisting

[49] *The Spectator*, ii. 378–9.
[50] Charles Lamotte, *An Essay upon Poetry and Painting, with Relation to the Sacred and Prophane History* (London, 1730), 19, 31

on the exclusions found elsewhere. He suggests that 'Every one who can
see, is able to collect the meaning of an obvious picture', and substantiates
this by concluding that 'it is one peculiar advantage [of painting], that this
effect may be produced on the rude and vulgar, on those who have never
been improved by education, and who are neither able nor inclined to
improve themselves by reading and reflection'.[51]

In the more guarded texts of the period, the analogy between painting
and linguistic communication is often severely qualified in the interests of
restricting the audience for art. A good example appears in a piece of special
pleading from the preface to Horace Walpole's *Anecdotes of Painting in
England* (1762), in which Walpole defends religious paintings against the
charge of encouraging superstitious beliefs in the spectator by suggesting
that the responses of spectators of different classes to art are hierarchically
differentiated. In doing so, he also makes a sharp distinction between the
transmission of meaning in oratory and its material inscription in painting,
in terms that both call on and write out the effects on the spectator of
mimetic representation:

Painting has seldom been employed to any bad purpose. Pictures are but the
scenery of devotion. I question if Raphael himself could ever have made one
convert, though he had exhausted all the expression of his eloquent pencil on a
series of popish doctrines and miracles. Pictures cannot adapt themselves to the
meanest capacities, as unhappily the tongue can. Nonsense may make an apprentice
a catholic or a methodist; but the apprentice would see that a very bad picture of
St Francis was not like truth; and a very good picture would be above his feeling.[52]

For the vulgar, bad representation is taken to be ineffectual, while for the
refined, mere representational accuracy is not part of the interest of viewing,
which instead derives entirely from a quality of feeling.

In another example, Turnbull extends the analogy between spoken
language and the visual and plastic arts to the extent of suggesting that in a
true appreciation of the latter the immateriality of linguistic communication
effaces the concrete representationality of the art, so that it is only the
abstract ideas conveyed by painting, sculpture, or design that can have any
meaning. In his *Treatise* of 1740 he writes that

the didactick Style, Oratory, Poetry, and likewise all the Arts of Design, Painting,
Statuary and Sculpture, fall properly under the Idea of Language ... Pictures
which neither convey into the Mind Ideas of sensible Laws and their Effects and

[51] *British Essayists*, xviii. 201.
[52] Horace Walpole, *Anecdotes of Painting in England ... Collected by the Late Mr. George Vertue and
Now Digested and Published from the Original Manuscript by Mr. Horace Walpole*, 4 vols. (Strawberry-
Hill, 1762), i. p. x.

Appearances, nor moral Truths, that is, moral Sentiments and corresponding Affections, have no Meaning at all: They convey nothing because there is nothing else to be conveyed. But, on the other Hand, such Pictures as answer any of these Ends, must for that reason speak a Language.[53]

Further restrictions on the potential audience for art are clear in commentaries of the period when the suggestion that painting speaks a language to its spectators is modified into the claim that it appears to them as a species of writing. This suggestion serves several important ends. The qualification of literacy limits the spread of the new print culture and so forms a pragmatic boundary of politeness as a non-material index of distinction in society. At the same time literacy can be taken as the fundamental requirement for admission to the exclusive political rights that come with citizenship in the republic. The extended deployment of the term to cover those qualified for readership of visual art can be seen in a series of examples.

In his *Two Discourses*, Jonathan Richardson develops the analogy between painting and literature, while suggesting its extended applicability. In one respect his argument is simply part of his attempt to sustain his claim for the seriousness of painting as against literature—the claim that 'We PAINTERS are upon the Level with Writers, as being Poets, Historians, Philosophers and Divines, we Entertain, and Instruct equally with Them'.[54] He thus writes that 'Painting is another sort of Writing, and is subservient to the Same Ends as that of her younger Sister. That by Characters can communicate Some Ideas which the Hieroglyphic kind cannot, As This in other respects supplies its defects.'[55] On the basis of this claim he can then insist that reading painting involves a combination of intellectual and sensual faculties rather than simply gratifying the sensual ones, so that 'To consider a Picture aright is to Read. You have at once an Intellectual and a Sensual Pleasure.'[56]

At a functional level Richardson follows the arguments of the periodical writers, and behind them the Society for the Reformation of Manners, in celebrating the extension of literacy and general education to the common people. He writes: 'Our Common People have been exceedingly Improv'd within an Age, or two, by being Taught to Read, and Write; they have also made great Advances in Mechanicks, and in several Other Arts, and Sciences.' Adding drawing to the syllabus would leave children 'qualify'd

[53] Turnbull, *Treatise*, p. ix.
[54] Richardson, *Two Discourses*, Discourse 1, 42.
[55] Ibid., Discourse 2, 17.
[56] Ibid., Discourse 2, 39.

to become better Painters, Carvers, Gravers, and to attain the like Arts immediately, and evidently depending on Design', so that 'they would thus become better Mechanicks of all kinds'.[57] As in my earlier examples, however, the appreciation of painting remains a more exclusive talent on the part of the connoisseur, which will only ever operate indirectly on the common people: 'If Gentlemen were Lovers of Painting, and *Connoisseurs* This would help to Reform Them, as their Example, and Influence would have the like Effect upon the Common People.'[58] The continued non-accessibility of the skills of connoisseurship is then particularly clear when Richardson rewrites the analogy of painting and writing later in the *Discourses* and claims that:

Painting is but another Sort of Writing, but like the Hieroglyphicks anciently 'tis a Character not for the Vulgar: To read it, is not only to know that 'tis such a Story, or such a Man, but to see the Beauties of the Thought, and Pencil; of the Colouring, and Composition; the Expression, Grace, and Greatness that is to be found in it: and not to be able to do this is a sort of Illiterature, and Unpoliteness.[59]

VII

The suggestion that specialized modes of reading painting act as mechanisms of exclusion in the selection of the appropriate public for it is important throughout the eighteenth century, as the true pleasures of appreciation are distinguished from vulgar recognition of mimetic likeness in painted images. In a parallel development, polite writers also extend the analogy between art and spoken language as an aspect of sociality in a way peculiar to the period. Recently scholars have highlighted the extent to which, in polite texts, conversation challenges the place reserved for oratory in classical humanism, and have traced the ways in which the periodical form itself develops as an extension of the conversational mode. As Nicholas Phillipson has written, 'Conversation was the essential skill Mr Spectator sought to inculcate, of as much importance to his conception of moral education as eloquence had been to Cicero and to Renaissance humanists.'[60] In the most straightforward usage of the word, rendered in Dr Johnson's *Dictionary* as 'familiar discourse, chat, easy talk', the establishment of polite culture as an exclusive domain of conversational freedom within society confirms the non-material privilege of its members, noted earlier, while

[57] *Two Discourses*, Discourse 2, 46.
[58] Ibid., Discourse 2, 44.
[59] Ibid., Discourse 2, 221–2.
[60] Phillipson, 'Politics, Politeness', 234.

offering a model of social exchange particularly applicable to the private domestic arena, and a means of disciplining the conduct of the polite through the demands of conversational decorum. However, the extended meanings of the term in the period, which include not only 'behaviour' but also 'cohabitation' or 'intercourse' with material objects and surroundings,[61] are also crucial in the definition of politeness. This range of meanings is of particular interest in relation to painting, where its components are often intriguingly elided. Knowledge of painting is thus repeatedly proposed and justified as a necessary qualification for the closed circle of polite conversation, while the process of appreciation itself is figured as a species of conversational exchange in terms that at times blur the distinctions between the material and social associations of the term.

The meanings of 'conversation' play off each other interestingly in Richardson's *Discourses*. Dragooning the reader into an interest in painting, Richardson dwells on the social delight or embarrassment of conversational success or failure on the subject:

in Conversation (when as it frequently does) it turns upon Painting, a Gentleman that is a *Connoisseur* is distinguish'd, as one that has Wit, and Learning, is; That being the Subject of Discourse.

On the contrary, Not to be a *Connoisseur* on such occasions either Silences a Gentleman, and Hurts his Character; Or he makes a much Worse Figure in pretending to be what he is Not to those who see his Ignorance.[62]

At the same time he insists that the Gentleman 'cannot fail by perpetually conversing with Good Pictures, and Drawings always to Improve',[63] because 'By conversing with the Works of the Best Masters our Imaginations are Impregnated with Great, and Beautiful Images'.[64] The metaphor of appreciation as conversation recurs throughout the period, allowing even the experience of viewing sublime art to be represented in terms of this form of familiar but exclusive exchange. Beattie, for instance, writes of Raphael that 'When we study his Cartoons, we seem to be conversing with a species of men, like ourselves indeed, but of heroick dignity and size'.[65] In this context it is clear to see the attractions for the period of the new genre of painting that realizes this emphasis in practice—the conversation-piece, which can incorporate group portraiture and perhaps landscape

[61] See definitions of 'conversation' and 'converse' in Samuel Johnson, *A Dictionary of the English Language* (London, 1755).

[62] Richardson, *Two Discourses*, Discourse 2, 222.

[63] Ibid., Discourse 2, 219.

[64] Ibid., Discourse 2, 204.

[65] Beattie, *Dissertations*, 620.

without necessarily falling victim to the doubts of commentators about either of those forms, and which can be justified as a species of domesticated history painting for its representation of civility in its images of ideal conversational sociality.

In the *Spectator* (411), Addison's combination of the conversational analogy with others typical of the period provides a striking example of the main features of the polite aesthetic writing that I have been examining. He begins from the premiss that 'Our Sight is the most perfect and most delightful of all our Senses. It fills the Mind with the largest Variety of Ideas [and] converses with its Objects at the greatest Distance.' Enumerating the advantages of politeness, he then offers a series of examples of the privileges of polite perception, concluding with a claim for the exclusive aesthetic appropriation of the seen object by the polite that extends the eighteenth-century regard for property massively. He thus writes that

A Man of a Polite Imagination, is let into a great many Pleasures that the Vulgar are not capable of receiving. He can converse with a Picture, and find an agreeable Companion in a Statue. He meets with a secret Refreshment in a Description, and often feels a greater Satisfaction in the Prospect of Fields and Meadows, than another does in the Possession. It gives him indeed a kind of Property in everything he sees, and makes the most rude uncultivated Parts of Nature administer to his Pleasures.[66]

The polite capacity for aesthetic appreciation is figured in terms that apparently confirm the non-material interests of the polite: aesthetic appreciation is represented as social exchange and seems in the third sentence to transcend material possession of property altogether. In the last sentence, however, it is translated into the most ambitiously extended expression of that possession, as the polite observer appropriates and is serviced by all he observes.

A final passage from Richardson's *Discourses* reveals the full extent of the territorial claims made for polite aesthetic perception in the period:

A *Connoisseur* has this farther Advantage, He not only sees Beauties in Pictures, and Drawings, which to Common Eyes are Invisible; He Learns by these to see such in Nature ... The noblest Works of *Rafaelle*, the most Ravishing Musick of *Hendell*, the most Masterly Strokes of *Milton*, touch not People without Discernment: So the Beauties of the Works of the great Author of Nature are not seen but by Enlighten'd Eyes.[67]

In this formulation, the ability to see natural objects—the basis of the

[66] *The Spectator*, iii. 535–6, 538.
[67] Richardson, *Two Discourses*, Discourse 2, 203.

general appeal of visual images for many writers of the period—is itself presented as the exclusive outcome of an education in aesthetic perception. Richardson guarantees the privileges of the polite, and confirms them as extensions and expressions of the privileges of the property-owning consumer. His claims are typical of the claims that run through the aesthetic writings of the period. As I have tried to suggest, direct appeals to material interest and privilege may be eschewed in these writings. The place of such appeals is, however, more than adequately supplied by the accounts that are offered within them of the less tangible but no less potent privileges of the polite spectator, as the consumer of art, and as the exclusive arbiter of artistic taste.

2

Killing Pictures

MARCIA POINTON

I

ONE of the most striking images displayed in 1987 at the Tate Gallery exhibition 'Manners and Morals' was a full-length portrait attributed to Jonathan Richardson of Lady Mary Wortley Montagu, regally attired in Turkish style, accompanied by a black servant, and with a view of Constantinople in the background (Fig. 2.1).[1] The subject displays a perfect complexion from her forehead to her scarcely concealed breasts. Her brown hair is loosely arranged under a turban-like head-dress made of loops of pearls and adorned with a feather. Her eyes are clear and bright and her expression—solemn rather than amused—conforms to the view expressed by Addison that the pleasure experienced in viewing 'the Picture of a Face that is beautiful, . . . is still greater, if the Beauty be softened with an Air of Melancholy or Sorrow'.[2]

In writing thus I am responding in my own time and space to an image produced in another time and space and viewed by a succession of audiences from that time to this. In writing I interpret. For there is no way of describing an image that is not also already an act of interpretation. Paintings of people and, in particular, portraits of individuals known to have lived in the past appear to invite us to understand them as visual

I would like to thank Patrick Conner, Jenny Elkan, Susan Lambert, and Messrs Hazlitt, Gooden, and Fox of London for their help with this essay, and John Barrell for his encouragement and supportive editorship.

[1] *Manners and Morals: Hogarth and British Painting 1700–1760* (Tate Gallery, London, 1987), no. 36. The standard topography of Constantinople is encoded through the characteristic mass of the seraglio, St Sophia, and the hippodrome as it appears in engravings in travel books from the 16th century. Throughout this chapter 'Turkey' and 'Turkish' will be used to denote the European construction of Ottoman history, geography, and culture. The term 'Ottoman' was that used by the court society in Constantinople to describe itself; 'Turk' was used to describe the non-urban population.

[2] J. Addison, 'The Pleasures of the Imagination', p. 9, *Spectator*, 418 (30 June 1712).

biographies. Thus, if we were to read that Montagu was not very happily married, we might see, in the full but unsmiling mouth, an image of this fact—though, as I have suggested, it could just as well be accounted for by reference to a popular aesthetic. The known facts of an individual's life, however, if unreliable in terms of illustration, may serve in the process of defining the relational character of an imagery of class and sex, the cultural evaluation of which must depend upon an understanding of that to which it is other.

This portrait is thought to have been painted around 1725 when Montagu was 36, an advanced age in a period when girls were married at 15. She was worried about her age, wishing she were ten years younger and anxiously examining her wrinkles.[3] In 1715 she had suffered and survived an attack of smallpox; it left her with a severely pitted skin and no eyelashes. People thought that her 'good eyes' would compensate for her scarred face,[4] but those eyes, in that worn face, were by 1725 frequently the cause of fatigue and distress to their owner as she struggled to write her celebrated correspondence in inadequate lighting.[5]

I have proposed here two contrasting bodies, which define each other through opposing terms in a relationship of interdependency. On the one hand, there is a mythicized and idealized body, which has performed the function of helping to define the historical character of Montagu (it is one of a group of portrait images frequently reproduced in biographies). On the other hand, there is a biological body subject to decay, a body that is apparently 'natural' but that is equally the site of interpretation and projection. In the one we have a faultless complexion, in the other a badly scarred skin. In the one we have 'limpid orbs', in the other bad eyesight. In the one we have eternal youth, in the other advancing age. At an empirical level the first might be dismissed under the general heading of flattery—a social imperative in eighteenth-century portraiture—and the second as reality, as truth. I want, rather, to suggest that the 'realities' of the biological body (for such truths are also subject to encoding and interpretation as forms of historical knowledge) should be understood in relation to the mythic body that is staged in portraiture. Those 'realities', retrieved by the present from the traces of a past life, gain currency and

[3] See Montagu to her sister, Lady Mar, June 1725 ('I would fain be ten years younger'); July 1725 ('despising [the world] is of no use but to hasten wrinkles'); May 1727 ('For my part I pretend to be as young as ever'). *The Complete Letters of Lady Mary Wortley Montagu*, ed. R. Halsband, 3 vols. (Oxford, 1966), ii. 52, 53, 76.
[4] R. Halsband, *The Life of Lady Mary Wortley Montagu* (Oxford, 1956), 51–2, quoting Lady Loudon and other contemporary sources.
[5] See *Complete Letters*, numerous references.

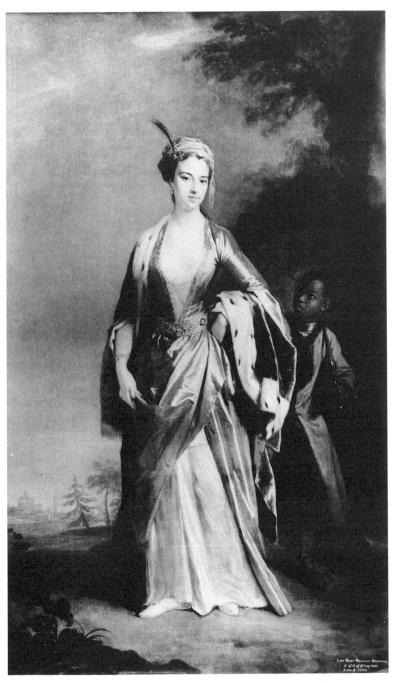

2.1 Attributed to Jonathan Richardson Senior, *Lady Mary Wortley Montagu c.*1725, oil on canvas, 94 × 57 in.; reproduced by courtesy of the Earl of Harrowby.

power because the fiction, in working against them, also defines them conceptually and historically and vice versa.

Lady Mary Wortley Montagu is chiefly remembered for her letters (and particularly for those she wrote when accompanying her husband to Constantinople) and for her introduction of smallpox inoculation into England from the Ottoman territories. Her brother had died of the disease only a few years before she herself contracted it. The horror of this illness is hard now to imagine. Here is a description of the symptoms:

On the third day the characteristic eruption begins to make its appearance. It is almost always first seen on the face, particularly about the forehead and roots of the hair, in the form of a general redness The eruption, which is accompanied by heat and itching, spreads over the face, trunk and extremities in the course of a few hours—continuing, however, to come out more abundantly for one or two days. It is always most marked on the exposed parts On the third day after its appearance the eruption undergoes a change—the pocks become vesicles filled with a clear fluid. These vesicles attain to about the size of a pea, and in their centre there is a light depression, giving the characteristic umbilicated appearance to the pock. The clear contents of these vesicles gradually become turbid, and by the eighth or ninth day they are changed into pustules containing yellow matter, while at the same time they increase still further in size and lose the central depression. Accompanying this change there are great surrounding inflammation and swelling of the skin, which, where the eruption is thickly set, produce much disfigurement and render the features unrecognizable, while the affected parts emit an offensive odour, particularly if, as often happens the pustules break. The eruption is present not only on the skin but on mucous membranes, that of the mouth and throat being affected at an early period The voice is hoarse and a copious flow of saliva comes from the mouth On the eleventh or twelfth day the pustules show signs of drying up (dessication) and along with this the febrile symptoms decline. Great itching of the skin attends this stage. The scabs produced by the dried pustules gradually fall off and a reddish brown spot remains which, according to the depth of skin involved in the disease, leaves a permanent white depressed scar—this 'pitting' so characteristic of the smallpox being specially marked on the face.[6]

The appalling experience of smallpox, the body distorted as it is invaded by sickness, was transposed into art by the patient in one of her *Six Town Eclogues*, written and circulated between 1715 and 1717 and published in 1747. Here the looking-glass and the portrait appear as analogues and both are rejected: the one shows a face the author can no longer bear to look upon while the other reveals a lost resemblance which by comparison only

[6] *Encyclopaedia Britannica*, 11th edn. (Cambridge, 1911), xxv.

serves to underscore her pain. As a consequence the mirror must be hidden and the portrait must be disfigured to match its subject:

> The wretched FLAVIA on her couch reclin'd,
> Thus breath'd the anguish of a wounded mind;
> A glass revers'd in her right hand she bore,
> For now she shunn'd the face she sought before.
>
>
>
> As round the room I turn my weeping eyes,
> New unaffected scenes of sorrow rise!
> Far from my sight that killing picture bear,
> The face disfigure, and the canvas tear!
> That picture which with pride I us'd to show,
> The lost resemblance but upbraids me now.
>
>
>
> Ye cruel Chymists, what with-held your aid!
> Could no pomatums save a trembling maid?
> How false and trifling is that art ye boast;
> No art can give me back my beauty lost.[7]

Montagu has long been acknowledged as a significant figure in Whig society, a beautiful blue-stocking who 'held sway not only over men's hearts but also over their intellects',[8] as one of a trio of feminist Marys (the others being Astell and Wollstonecraft) but one who 'did not enunciate feminist principles in boldly signed pamphlets and books ... yet states or clearly implies this doctrine in her private correspondence'.[9] What interests me here are not those personal qualities and gifts that entitled her to 'a place in European "Enlightenment" '[10] but the network of representation— of her by others, of others by her—which, while particular rather than general, may none the less allow us access to a set of relations that are typical rather than unusual. In other words, I propose that though Montagu's travels, which made her name, were unique, and though her education, which enabled her to profit from those experiences, was unusual, her situation was in other ways typical of a woman of her class. She is a

[7] 'Saturday. The Small-Pox. Flavia', in *Six Town Eclogues with some other Poems by the Rt. Hon. L. M. W. M.* (London, 1747), stanzas 32, 34, 35. It is suggested in E. Rothstein, *The Routledge History of English Poetry* (Boston, 1981), iii, that the *Town Eclogues* were written with the help of Gay but it is not clear what the evidence for this partial disattribution might be.

[8] B. Williams, *The Whig Supremacy 1714–1760* (Oxford, 1939), 142.

[9] R. Halsband, ' "Condemned to Petticoats": Lady Mary Wortley Montagu as Feminist and Writer', in R. B. White Jr. (ed.), *The Dress of Words: Essays on Restoration and Eighteenth Century Literature in Honor of Richmond P. Bond* (Lawrence, Kansas, 1978), 35.

[10] *Complete Letters*, i. p. xiv.

woman about whom, unusually, we know a considerable amount, but that knowledge may enable us to ask questions paradigmatic to women's history, questions that pivot upon the complex link between society and enduring psychic structures.[11] This network of representation permits, therefore, an assessment of the relational nature of woman's position in regard to sex and class in the early eighteenth century and of how that position was ideologically produced and reproduced.

The body was a work of art in eighteenth-century ruling-class society: how one wore one's patches, how one held one's fan, the cut of one's clothes, the shape of one's wig—all these made of the body a mobile cluster of signifiers indicating party-political affiliation, class, gender, and sexuality. The body was strictly differentiated for indoor or outdoor wear, formal or informal, court dress or other attire. The boundaries were clearly defined and the crossing of those boundaries constituted transgressions that could sometimes become orthodoxies. Thus the gradual adoption in women's fashion of loose clothing like a nightgown represented the inscription into the regulations of fashion of what had begun as an act of daring.[12] But if the body in its signifying apparel, performing significant motions, was the site of public discourse, at another level this body also claimed the power of sight and hence also of knowledge. The oscillation between possessing the power of the gaze and being the object of the gaze depended upon a narcissistic relationship between viewer and her or his own body. This relationship was not only private and personal, it was collective and coercive, and was experienced through orthodox modes of representation.[13] It is the breakdown of that relationship that is recounted with such anguish by Flavia recovering from smallpox. This relationship held for masculine as well as feminine subjects, but in a society where woman generically was powerless—she had no right to own anything, no vote, no access to education, and no place in the rationale of civic humanism that governed

[11] I have been assisted in this proposition by reading Joan W. Scott's 'Gender: A Useful Category of Historical Analysis', *American Historical Review*, 91 (1986), 1053–75.

[12] For the wearing of patches see J. Addison in the *Spectator*, 81 (2 June 1711); for the notion of the body as work of art see D. C. Stanton, *The Aristocrat as Art: A Study of the Honnête Homme and the Dandy in Seventeenth- and Nineteenth-Century French Literature* (New York, 1980); R. Sennett, *The Fall of Public Man* (Cambridge, 1977); A. Ribeiro, *Dress and Morality* (London, 1986). At a religious level, the idea of life as a stage is a familiar trope in Shakespeare and formulated with a particular asperity by Erasmus: 'Now what else is the whole life of mortals but a sort of comedy, in which the various actors, disguised by various costumes and masks, walk on and play each one his part, until the manager waves them off the stage?' Erasmus, *In Praise of Folly* (1510), trans. H. H. Hudson (New York, 1941), 37.

[13] The Venus with a mirror theme was treated as a non-mythological commonplace in 18th-century art; see e.g. Carle Van Loo, *Woman with a Mirror*, Metropolitan Museum of Art, New York.

matters of taste—the intricate balance between exercising sight and controlling how one was seen was crucial.

Seizing the right to look, articulating and interpreting the seen, was one way in which woman could exercise power. It was, after all, Montagu's interpretation of what she saw that made her reputation. But, arguably, the conditions that made that attainment possible were prepared by her reproduction of herself in society. And the question of representation was always overdetermined. At a theoretical level the pre-eminence of sight was established by Addison in 1712 in 'The Pleasures of the Imagination', where he points out that 'our sight is the most perfect and most delightful of all our Senses'.[14] Sight is important in Addison's scheme of things because it furnishes the imagination with its ideas 'so that by the Pleasures of the Imagination or Fancy (which I shall use promiscuously) I here mean such as arise from visible Objects, either when we have them actually in our View, or when we call up their Ideas into our Minds by Paintings, Statues, Descriptions, or any the like Occasion'.

In political terms, seeing and being seen were crucially important, whether this meant appearing at the right occasion at court or the circulation of an engraved image of a particular person in the interests of a particular cause. The theological implications of these processes were, however, never far from people's minds. In *The Vanity of Human Wishes* (1749), Johnson uses the vicissitudes of the portrait as an image of the making and unmaking of worldly reputations:

> From every Room descends the painted Face,
> That hung the bright Palladium of the Place,
> And smoak'd in Kitchens, or in Auctions sold,
> To better Features yields the Frame of Gold;
> For now no more we trace in ev'ry Line
> Heroic Worth, Benevolence Divine:
> The Form distorted justifies the Fall,
> And Detestation rids th'indignant Wall.[15]

The redundancy of the form (of the individual and of the representation) is here understood to be interdependent. The form that is distorted is the portrait painted in a now unfashionable style *and* the human subject whose distortion from the divine (and benevolent) model is a measure both of the fall of reputations and of the Fall which resulted in the expulsion of Adam and Eve from Paradise.

[14] Addison, 'The Pleasures of the Imagination', pt. 2, *Spectator*, 411 (21 June 1712).
[15] S. Johnson, *The Vanity of Human Wishes*, stanza 8, in *Johnson: Prose and Poetry* (London, 1963).

Woman had a particular commodity value in a system where appearances counted for so much, her beauty being both her own possession and a sign value in the system of exchange between her father and her husband.[16] Montagu's suitor and father—locked in this exchange system—haggled unsuccessfully over the question of her dowry and in the end she and Edward Wortley Montagu eloped. One of the most frequently repeated stories of Montagu's early years, and one that has exercised a fascination over biographers and artists, tells of the 7-year-old Lady Mary exhibited and toasted at the newly formed Kit-Kat Club (Fig. 2.2).[17] It is a story that brings together patriarchy in its most undiluted cultural rituals and patriarchy in its familial and sexual manifestations: the pre-pubescent female child is paraded by her father for a company of ruling fathers and translated into symbol by the masculine ritualized act of a toast to her beauty. The event of the smallpox and the consequent destruction of Montagu's face was construed as rendering her unsuitable as an object of the (ultimate patriarchal) royal gaze, which she had already begun to attract by her beauty and her witty poetry. The damage was not understood to be to herself here but rather to her husband, who was reported 'inconsolable for the disappointment this gives him in the [career] he had chalked out for his fortunes'.[18]

At one level we might read Flavia's command that the 'killing picture' be removed from her sight, disfigured and mutilated, as an act of vicarious self-mutilation, lacerating the mythic body and subjecting it to effects

[16] See C. Lévi-Strauss, *The Elementary Structures of Kinship* (1949), trans. J. H. Bell and J. R. von Sturmer, and ed. R. Needham (London, 1969), e.g. 32–3: 'It is impossible to approach the study of marriage prohibitions if it is not thoroughly understood from the beginning that such facts [as the system of the scarce product] are in no way exceptional, but represent a particular application, within a given field, of principles and methods encountered whenever the physical or spiritual existence of the group is at stake. The group controls the distribution not only of women, but of a whole collection of valuables. Food, the most easily observed of these, is more than just the most vital commodity it really is, for between it and women there is a whole system of real and symbolic relationships, whose true nature is only gradually emerging, but which, when even superficially understood, are enough to establish the connexion.'

[17] For an account of this event, see Halsband, *The Life*, 4, quoting Lady Stuart: 'At one of their meetings when they wished to elect a beauty as their toast for the year, Lord Kingston nominated Lady Mary; and when other Club members objected to judging a candidate they had never seen, he ordered the girl to be finely dressed and brought to the tavern. There she was unanimously voted the reigning beauty. In this company "she went from the lap of one poet, or patriot, or statesman, to the arms of another, was feasted with sweetmeats, overwhelmed with caresses, and, what perhaps already pleased her better than either, heard her wit and beauty loudly extolled on every side. Pleasure, she said, was too poor a word to express her sensations; they amounted to ecstasy: never again, throughout her whole future life, did she pass so happy a day." ' For images of this event, see Andrew Garrick Gow, *The Introduction of Lady Mary to the Kit-Kat Club*, signed and dated 1873, Christie's 2 July 1971 (187); L. Melville, *Lady Mary Wortley Montagu: Her Life and Letters* (London, 1925), frontispiece by Aubrey Hammond, 1925.

[18] Halsband, *The Life*, 52, quoting Lady Loudon.

2.2 Aubrey Hammond, frontispiece to L. Melville, *Lady Mary Wortley Montague, her Life and Letters* (London: Hutchinson, 1925).

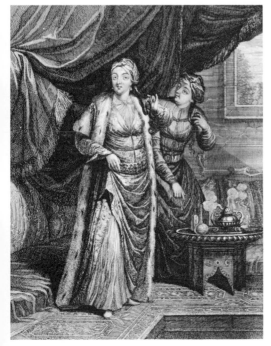

2.3 G. Scotin after Jean-Baptiste Vanmour, *La Sultane Asseki, ou Sultane Reine*, engraving, plate 3 from *Explication des cent estampes qui représentent les différentes nations du Levant* (Paris: Jacques Collombat, 1714–15); reproduced by kind permission of the Trustees of the Victoria and Albert Museum, London.

analogous to those that disease has upon the physical body, and upon the face in particular, which, as Neoplatonic philosophy and psychoanalysis both aver, is where the subject's sense of selfhood resides.[19] It is interesting to note here that the word 'face' derives from *facere*, meaning 'to make', or from a root *fa*—, meaning 'appear'. The face can be made and unmade; in an era when the possibility of a grammar of human expression was widely explored, the face was a chosen site of knowledge. No art can give back the beauty lost—certainly not the art of medicine (though Montagu was to try a renowned cosmetic remedy in Turkey to no avail)[20]—and the mirror that (as in Flavia's sick-room) made available the self to the self is reversed. What, however, is implicitly acknowledged in this poem is the power of representation and its function in the formation and well-being of the individual. If, as Lacan has argued, misrecognition is a crucial stage in the construction of identity,[21] what the painted portraits of Montagu in Turkish dress offer is an extended or restaged form of misrecognition, a solution that re-empowers the subject not only by the actual restoration of her beauty in paint but by that beauty's allusions to the oriental other. It is through this second misrecognition that the subject, scarred (mis-recognized) and ego-damaged, re-entered the public domain, and in triumph.

Just as I propose that the idealization of Montagu in the portrait attributed to Richardson is more than what is (and was) popularly under-stood to be the flattery necessarily accompanying society portrayals, I shall argue that the question of orientalism in the network of representation through which Montagu is historically defined cannot be explained by reference to notions of the importation of taste, of fancy dress, of an appetite for the exotic, or indeed by the assumption that colonialist power is homogeneous and undifferentiated. But first a few more things need to be said about 'Richardson's' portrait and its subject.

Questions of patronage have been paramount in the forms of historical analysis that have characterized recent discussion of eighteenth-century painting.[22] Under the terms of those investigations, what I have so far suggested would be liable to the criticism that there is no evidence available

[19] Lacanian psychoanalysis, with its concern with the mirror metaphor, implies the centrality of the human face. For a discussion of the clinical and symbolic importance of the face see M. Eigen, 'On the Significance of the Face', *Psychoanalytic Review*, 67 (winter 1980–1), pt. 4.

[20] Montagu to Lady—17 June 1717, *Complete Letters*, i. 368–9.

[21] See J. Lacan, *Ecrits: A Selection* (1966), trans. A. Sheridan (London, 1982), ch. 1.

[22] See e.g. S. Deuchar, *Sporting Art in Eighteenth-Century England. A Social and Political History* (New Haven, Conn., 1988), and I. Pears, *The Discovery of Painting: The Growth of Interest in the Arts in England, 1680–1768* (New Haven, Conn., 1988).

as to who directed the portrait painter in this instance, who controlled the commission. Although I do not believe that at the level of issues of identity and identification such a question is germane, it is none the less worth observing that women of the ruling class in the eighteenth century do seem to have been actively involved in the commissioning of portraits. Moreover, inscribed in the literature of the age was an assumption that the subject determined the format of a portrait. Lady Wentworth in 1711 commissioned a series of portraits from Charles Jervas and so disliked the results that she refused to take delivery unless the paintings were reworked or improved.[23] In the same year Steele has Sir Roger Coverley discoursing on the portraits of ancestors in his gallery, one of which shows a 'soft Gentleman'. Sir Roger instructs his visitor to 'Observe the small Buttons, the little Boots, the Laces, the Slashes about his Cloaths, and above all the Posture he is drawn in (*which to be sure was his own chusing*)'.[24] It is apparent from Montagu's letters that she was well informed about painting; she also sent her own portrait 'wrapped up in poetry without Fiction' to Algarotti in the course of her intense relationship with him in 1736.[25] It is therefore possible that Montagu at some level controlled the images produced of her by Richardson and by other established society artists who depicted her as a mature adult.

The format of the 'Richardson' painting conforms to the pattern of full-length society portraits established by Kneller, though in this case the *plein-air* setting, the low horizon, and the dramatic lighting anticipate the work of Ramsay and Reynolds in the 1740s and 1750s. The sitter's dress consists of a Europeanized version of Ottoman costume as popularized through engravings after Vanmour, first published in Paris in 1712 and frequently reissued (Fig. 2.3).[26] The foundation is an ankle-length white silk *salvar*, from beneath which Montagu's embroidered slippers with

[23] Pears, *Discovery of Painting*, 143.

[24] R. Steele, *Tatler*, 109 (5 July 1711); my italics.

[25] Montagu was a collector of antique gems and medals and displayed considerable knowledge when travelling in Europe. The portrait for Algarotti is mentioned in a letter to him of Dec. 1736, *Complete Letters*, ii. 110.

[26] See J. Scarce, *Women's Costume of the Near and Middle East* (London, 1987), 59–63. Engravings by le Hay after Jean–Baptiste Vanmour (1671–1737; variously spelt Vanmor/Vanmoeur/Van Mour) are published in *Recueil des cent estampes représentant les différents nations du Levant tirées sur les tableaux peints d'après nature en 1707 et 1708 par les ordres de M. de Férriol Ambassadeur du Roi à la Porte. Et gravées en 1712 et 1713 par les soins de M. le Hay* (Paris, 1712 and 1713); the plates then went to Laurent Cars, who published a new edition in 1714; the 3rd edition was published in 1715 with a slightly different title, *Explication des cent estampes* For Vanmour and other Western artists in Constantinople, see A. Boppé, *Les Peintres du Bosphore au dix-huitième siècle* (Paris, 1911). For 18th-century British costume see A. Ribeiro, *A Visual History of Costume: The Eighteenth Century* (London, 1983).

turned-up toes emerge. Over this is worn the close-fitting *anteri* in a gold colour with slashed sleeves and a deep 'V' neck into which a 'modesty piece' is inserted. The filling of the cleavage ensures that the dress approximates more closely to the waisted appearance of English female fashion at the time, as does the side rather than central opening to the *anteri*. The finishing touches are provided by the deep jewelled belt and the *kirk*, a kind of ankle-length, fur-lined coat with short sleeves. The fact that Montagu's *kirk* is lined with ermine lends the portrait a regal air. The dress depicted differs in precise details from that which the sitter described herself as wearing in Constantinople, especially in that the *salvar* seems to be in the form of a skirt rather than a pair of drawers and the material of her *anteri* is a stiff kind of lustrous satin rather than a white and gold patterned damask. Moreover, the overall shape of the costume in the portrait does not fit as closely to the body as her description suggests.[27]

But the most noticeable difference between the 'Richardson' portrait and the images of Ottoman women engraved in collections like Le Bruyn's *A Voyage to the Levant* (1702) and *Recueil des cent estampes*[28] lies in the relative restraint of the head-dress and in the slenderness of Montagu's fashionable figure in contrast with the corpulent figures represented in the travel books. The overall effect of the dress in the 'Richardson' portrait is, however, highly distinctive, suggesting in its varying layers and levels a degree of undress that would have been striking if not titillating at this time. Defoe's description of the heroine of his novel *Roxana* 'dressed in the Habit of *a Turkish Princess*' and dancing in a figure she had learned in France but which the company all thought was Turkish was first published in 1724. The erotic charge of the description must have depended on its novelty, and provides some indication of how the kind of attire adopted by Montagu in the 'Richardson' portrait of *c.* 1725 might have been viewed, well before the wearing of Turqueries as masquerade dress became the rage.[29]

[27] Montagu to Lady Mar, 1 Apr. 1777, *Complete Letters*, i. 325–30.
[28] Corneille Le Bruyn, *A Voyage to the Levant: or Travels in the Principal Parts of Asia Minor, the Islands of Scio, Rhodes, Cyprus, &c. with an Account of the most Considerable Cities of Egypt, Syria and the Holy Land, done into English by W. J.* (London, 1702).
[29] D. Defoe, *Roxana, or The Fortunate Mistress* (London, 1964), 173–6. Ribeiro points out that the prominence given to the breasts by the tight-fitting dress and the thrusting belly emphasized by the girdle would have been thought ungenteel through most of the 18th century, when the shape of women was well concealed by boned stays and stiff petticoats. A. Ribeiro, 'Turquerie: Turkish Dress and English Fashion in the Eighteenth Century', *Connoisseur*, 201 807 (May 1979), 18. Elsewhere Ribeiro quotes a verse published in 1724 that indicates the risqué nature of the Turkish style in dress: 'O Jesu—Coz—why this fantastick Dress?/ I fear som Frenzy does your Head possess;/ That thus you sweep along a Turkish Tail,/ And let that Robe o'er Modesty prevail. J. Arbuthnot, *The Ball, stated in a Dialogue betwixt a Prude and a Coquet* (London, 1724), quoted in A. Ribeiro, *The Dress worn at*

The regal air noted above is doubly reinforced by the second figure in the portrait. Montagu is accompanied by a black slave bearing a parasol. Hugh Honour, pointing out that by the 1760s England had a population of blacks estimated at around 15,000, by far the largest of any European country, and that slavery arguably remained legal in Great Britain until 1833, remarks that 'whether the blacks dressed in smart livery in English portrait groups were technically slaves or free servants is indeterminate and was probably of little concern to their painters'.[30] But this begs the question: the boy depicted in Richardson's painting wears a metal collar and, given the setting, imparts grandeur to Montagu through his position of inferiority in the manner of Van Dyck's *Henrietta of Lorraine* (1634).[31] He connotes slavish devotion and, by extension, slavery. Pictorially he serves as the ideal complement to Montagu, situated in shadow behind her, the red of his coat and stockings setting off the brilliance of her clothing, his dark skin contrasting with her faultless white complexion, forming a visual trope in which white woman is empowered in colonial and sexual terms.[32]

The introduction of a black slave (rather than the more appropriate Circassian slave) into a portrait in which the subject wears a specifically Turkish costume deprives the painting of something of its aura of ethnicity; it Europeanizes the image and further serves to enhance the subject's status as a woman of great wealth and power, for it was upon the traffic in blacks— the buying and selling of African peoples and their enforced labour—that eighteenth-century commerce was based.[33] While trade with the Ottoman

Masquerades in England 1730–1790, and its Relation to Fancy Dress in Portraiture (New York, 1984), 31. Ribeiro is of the view that Richardson adapted an earlier portrait of Montagu, attributed to Liotard (coll. Capt. Seymour Watson) and also suggests that Montagu brought back dresses, some of which have survived, at the V. & A. and in the possession of the Earl of Harrowby. The craze for Turqueries really caught on only in the 1760s when the Tambour frame facilitated the production at home of Turkish silks and embroideries. Henry Hoare erected a Turkish tent at Stourhead in the 1770s and for his coming of age party in 1781 Beckford transformed Fonthill into a Turkish palace.

[30] H. Honour, *The Image of the Black in Western Art, 4. From the American Revolution to World War I*, 2 vols. (Cambridge, Mass., 1989), i. 30–1.
[31] Kenwood House. For an analytical survey of such types see D. Dabydeen, *Hogarth's Blacks: Images of Blacks in Eighteenth-Century English Art* (Manchester, 1987).
[32] There is a substantial literature on the connotations of such juxtapositions. See e.g. S. Gilman, 'Black Bodies, White Bodies: Towards an Iconography of Female Sexuality in Late Nineteenth-Century Art, Medicine and Literature', *Critical Inquiry*, 12 (Autumn 1985).
[33] Although the Ottoman Empire at this time still included North African territories (notably Tripoli and Barca) and the presence of black eunuchs was an essential ingredient of the Turkish narrative. Montagu mocked a correspondent who asked her to bring back a Greek slave, pointing out that the fine slaves that wait upon the great ladies and serve the pleasures of the great men are commonly Circassians, who are never sold except as a punishment. Montagu to Lady——, 17 June 1717, *Complete Letters*, i. 367–8.

Empire was important,[34] the connotations of Turkey for British audiences were essentially those of pleasure rather than commerce, of amusement rather than the exercise of power, of fancy rather than reason.[35] Mozart's *Die Entführung aus dem Serail*, written for the Archduke Maximilian in 1782, manifests an ease with an enemy culture that had threatened Europe at least since Mehmet Fatih conquered Constantinople in 1453, and reinforces through its courtly medium the idea of the Ottoman Empire as a pleasure ground.[36] Contemporary beliefs about the origin of pastoral also served to direct attention to the East as a location of pleasure. It was thought that pastoral originated in the East and was transplanted by the Muses to Greece. William Collins not only defended this theory but sought to compensate for the lack of oriental compositions from pastoral's prehistory by composing a sequence of eclogues spoken by characters such as Selim the shepherd and Abra the Georgian sultan.[37] In Adrianople (now Edirne), on the borders of Bulgaria and present-day Turkey, Montagu discovered— in a city founded by Hadrian—the seductive home of pastoral. Writing in flirtatious vein to Pope from a house on the banks of the Hebrus, she describes the cooing of turtle doves:

[34] The Levant Company, which held a monopoly of trade in the area, was established in 1512. Trade issues were still significant enough in 1716 for Edward Montagu to be dispatched to Constantinople to prevent Austria coming to the assistance of the Venetian Republic by going to war on Turkey. The Ottomans had lost their supreme position in central Europe since the relief of Vienna in 1683 by the Polish army led by King John Sobieski.

[35] Montesquieu's *Lettres persanes* were not published until 1721 but may have been known earlier. One popular account of Turkey of the sort that Montagu was at pains to refute was *Nouveau Voyage du Levant par le Sieur D. M.* [Dumont] *contenant ce qu'il a vu de plus remarquable en Allemagne, France, Italie, Malthe, & Turquie* (La Haye, 1694). Dumont stresses that '*la grande passion des Turques est pour les belles femmes*' (the grand passion of the Turks is for beautiful women) (214) and describes how dancers '*font mille postures lubriques, que les femmes les plus perdues ne voudroient faire en Europe*' (make a thousand lewd gestures, which the most abandoned women in Europe would not wish to make) (236). Montagu is dismissive of Aaron Hill's *A Full and Just Account of the Present State of the Ottoman Empire in all its Branches* (London, 1709) with much less justification. The identification of Turkey with sensuality and an ongoing collusion with the object of critique persists in popular and 'serious' publications. A. Grosrichard in *Structure du serail: La Fiction du despotisme asiatique dans l'occident classique* (Paris, 1979), concludes: '*cet homme donc, qui est censé être le seul à détenir le pouvoir, n'est que l'instrument de celle qui, comme femme, est censée en être privée. Dans cet univers saturé par le sexe, n'hesitons pas à écrire que celui qui, en apparence a le phallus, est le phallus pour sa mère*' (thus this man, who is considered the only one to hold power, is no more than the instrument of her who, as woman, is deemed to be deprived of it. In this universe saturated by sex, let us not hesitate to write that the one who, seemingly, *has* the phallus, *is* the phallus on behalf of his mother) (208). See also N. Russell, 'Steamy Nights at the Turkish Baths', *Times Higher Education Supplement*, 28 (July 1989).

[36] Recent books that deal particularly with cultural relations and contain bibliographies are J. Raby, *Venice, Dürer and the Oriental Mode* (London, 1982), and Hazlitt, Gooden, and Fox, *At the Sublime Porte: Ambassadors to the Ottoman Empire (1550–1800)*, exhibition cat. (London, 1988).

[37] *The Poetical Works of William Collins, with the Life of the Author by Samuel Johnson, L.L.D.* (London, 1807). Collins died in 1756. The 1807 edition of *Bell's British Poets* also contains (87–92) his 'Observations' on the origins of pastoral.

How naturally do boughs and vows come into my head at this minute? And must not you confess to my praise that tis more than ordinary Discretion that can resist the wicked Suggestions of Poetry in a place where Truth once furnishes all the Ideas of Pastorall I no longer look upon Theocritus as a Romantic Writer; he has given a plain image of the Way of Life amongst the Peasants of his Country, which before oppression had reduc'd them to want, were I suppose all employ'd as the better sort of 'em are now.[38]

<center>II</center>

Access to 'Montagu' has been via her letters. A word about these is therefore necessary. Montagu's letters from the Ottoman Empire have been seen variously as a combination of truth and fiction,[39] as a major source for orientalist artists of the nineteenth century, and, particularly, as a source for Ingres's *Le Bain Turque*.[40] She is regarded as 'interpreting Moslem culture for Western Europe',[41] as 'a pioneer woman traveller and/or feminist',[42] as 'one of the earliest Ethnographers of Middle Eastern Women ... remarkably free of ethnocentrism',[43] and as a philosopher encountering at a peculiarly transitional moment a culture of contradiction and contrast.[44] The letters, and particularly the letter describing the women's public baths at Sophia,[45] have often been used as an authenticating device or as a foil against which the orientalist extravagances of artists can be measured.[46]

The account of the Ottoman Empire offered by Montagu became available from the moment her voluminous correspondence left her pen and was dispatched by land and sea to her correspondents in London and Paris.

[38] Montagu to Alexander Pope, 1 Apr. 1717, *Complete Letters*, i.p 331. John Barrell has drawn my attention to the fact that Montagu's last remark reflects back to Pope his most famous contribution to pastoral theory, namely that pastoral need not be written in rustic loamshire because it imitates a prehistorical, patriarchal time 'when the best of men follow'd the employment', A. Pope, 'A Discourse on Pastoral Poetry' in J. Butt (ed.), *The Poems of Alexander Pope* (London, 1963), p. 120.

[39] Halsband's footnotes to *The Complete Letters* frequently draw attention to misrepresentations, exaggerations, and factual inaccuracies.

[40] Halsband's care in footnoting those passages that Ingres copied into his notebooks has the effect of valorizing Montagu by reference to Ingres. See also N. Schlenoff, *Ingres, ses sources littéraires* (Paris, 1986). Most of the secondary literature on orientalist art refers to Montagu's letters; see e.g. Royal Academy of Arts, *The Orientalists: Delacroix to Matisse, European Painters in North Africa and the Near East* (London, 1984); W. Leeks, 'Ingres Other-Wise', *Oxford Art Journal*, 9 1 (1986), 29–37.

[41] Halsband, 'Condemned to Petticoats', 49.

[42] D. Murphy and C. Pick, *Embassy to Constantinople: The Travels of Lady Mary Wortley Montagu* (London, 1988), 7.

[43] E. W. Fernea, 'An Early Ethnographer of Middle Eastern Women: Lady Mary Wortley Montagu 1689–1762', *Journal of Near Eastern Studies*, 40 4 (Oct. 1981), 330.

[44] A. M. Moulin and P. Chauvin, *L'Islam au peril des femmes* (Paris, 1981), 20–2.

[45] Montagu to Lady——, 1 Apr. 1717, *Complete Letters*, i. pp. 312–15.

[46] The question of the account's authenticity is dealt with by P. Conner in 'On the Bath: Western Experience of the Hamman', *Journal of Renaissance and Modern Studies*, 31 (1987), 34–41.

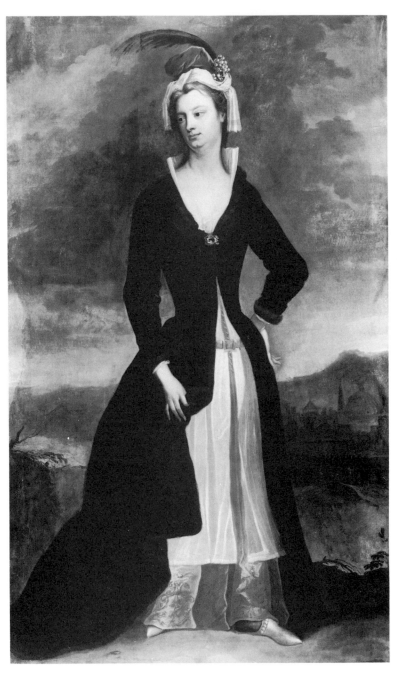

2.4 Charles Jervas (?), *Portrait of a Lady* (Lady Mary Wortley Montagu?), *c*.1730, oil on canvas, 79 × 46 in.; reproduced by courtesy of the National Gallery of Ireland.

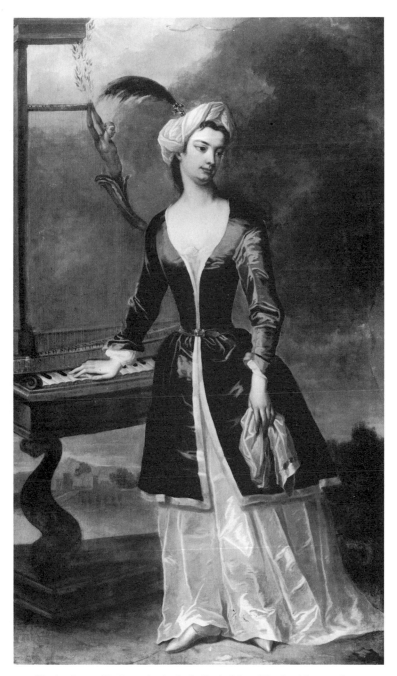

2.5 Charles Jervas (?), *Portrait of a Lady* (Lady Mary Wortley Montagu?) *c*.1730, oil on canvas, 79 × 46 in.; reproduced by courtesy of the National Gallery of Ireland.

There it was circulated 'privately' and thus became public knowledge among the literati of both capitals. Publication took place posthumously in a controversial manner,[47] but by that time the view of the Ottoman territories that she had constructed had served also to define her. In addition to the portrait attributed to Richardson, there are at least seven other portraits of Montagu in Turkish-style dress authenticated by provenance and executed during her lifetime. Kerslake lists six false portraits but in fact there are a multitude of these, as almost every unidentified portrait of a woman in Turkish dress that comes up at auction tends to be labelled 'Lady Mary Wortley Montagu', a testimony to the powerful mythology of the subject.[48] A pair of pendants in the National Gallery of Ireland, for example, one with a view of Constantinople in the background (Fig. 2.4) and the other showing the subject with her right hand resting on a mechanical harp (Fig. 2.5), are typical of the family of Montagu portraits deriving from Charles Jervas, which show her in a close-fitting black *anteri* with a stand-up white collar.[49]

From the start the letters were also highly invested in terms of gender. In her preface to Montagu's letters, Mary Astell declares:

I confess, I am malicious enough to desire, that the world should see, to how much better purpose the LADIES travel than their LORDS; and that, whilst it is surfeited with *Male-Travels*, all in the same tone, and stuft with the same trifles; a lady has the skill to strike out a new path, and to embellish a worn-out subject, with variety of fresh and elegant entertainment.[50]

It is a popular engraving of Montagu as 'The Female Traveller' that I

[47] Montagu loaned the albums containing copies of letters and actual letters to Mary Astell in 1724; Astell's preface was written in the blank pages at the end of the second volume and included in the published version, which appeared without the family's permission in 1763, less than a year after her death. Halsband gives a summary of editions in *Complete Letters*, i. pp. xvii–xix. A row over the ownership of Montagu's manuscripts is recorded in *A Narrative of what passed between General Sir Harry Erskine and Philip Thicknesse, Esq.; in consequence of a Letter written by the latter to the Earl of B——relative to the publication of some Original Letters and Poetry of Lady Mary Wortley Montague's then in Mr. Thicknesse's possession* (London, 1766).

[48] J. Kerslake, *Early Georgian Portraits*, National Portrait Gallery (London, HMSO, 1977), no. 3924.

[49] These appear variously as full-length, three-quarter-length, and half-length with a variety of backgrounds, e.g. Sotheby's, 13 July 1988 (34); Mappin Art Gallery, Sheffield (ex Wharncliffe Collection),as J. Richardson; Boughton Collection (as Duchess of Montague with two small boys to left); Ribeiro (*Dress worn at Masquerades*, 222) attributes to Liotard the miniature of Montagu (coll. Capt. L. Seymour) engraved by Greatbach and frequently reproduced (e.g. in I. Barry, *Portrait of Lady Mary Wortley Montagu* (London, 1928), 165). E. H. Humbert and A. Revilliod, *La Vie et les Œuvres de Jean-Etienne Liotard, 1702–1789* (Amsterdam, 1897), refer to a portrait of Montagu (27) but do not include it in their catalogue.

[50] M. Astell, 18 Dec. 1724, preface to *Letters of the Right Honourable Lady M——y W——y M——e: written, during her Travels in Europe, Asia and Africa*, 3 Vols. (London, 1769), i. p. viii.

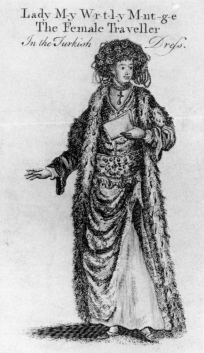

2.6 Anon., *The Female Traveller*, engraving; reproduced by kind permission of Princeton University Library, Dept. of Rare Books and Special Collections.

.7 G. Scotin after Jean-Baptiste Vanmour, *Dame Greque dans son Apartement*, engraving, Plate 68 from *Explication des cent estampes qui représentent les différentes nations du Levant* (Paris: Jacques Collombat, 1714–15); reproduced by kind permission of the Trustees of the Victoria and Albert Museum, London.

want to pause over for a moment (Fig. 2.6).[51] Unlike the portraits by
Vanmour[52] and 'Richardson', in which Montagu appears slender with
much of her breasts exposed, the engraving—based on figures in *Recueil
des cent estampes* (Fig. 2.7)—shows a solid, if not corpulent figure, well
covered by her garments and wearing an extremely elaborate head-dress
copied from a plate in Le Bruyn's *A Voyage to the Levant* (Fig. 2.8).[53] It
seems likely that this anonymous engraving was executed posthumously
and that it is part of the Montagu cult in the years immediately after her
death, a cult of which the unauthorized publication of her letters is the
clearest manifestation. It might, therefore, be taken as some measure of
the success of Montagu—and of allies like Astell—in colluding with her
portraitists in the production of her image. A most interesting feature of
this engraving—and one that is unusual in eighteenth-century female
portraiture—is the pose. Montagu is shown in this engraving in the classical
senatorial pose, one foot slightly forward, right hand outstretched and a
paper or book in her other hand, her eyes fixed upon a distant audience.
Identified in an accompanying inscription as 'The Female Traveller. In
the Turkish Dress', the image endows its subject with sight and with
speech and hence also with power. The verse at the foot reinforces these
connotations, constructing the subject as in command of knowledge:

> Let Men who glory in their better sense,
> Read, hear, and learn Humility from hence;
> No more let them Superior Wisdom boast,
> They can but equal M–nt–g–e at most.

By a curious but perhaps not accidental congruence, the reduction of the
name Montagu to M–nt–g–e produces a formula from which the name
Montaigne, a father of *belles-lettristes*, could equally be read.

We might argue, therefore, that at one level the Ottomanized portrait
of Montagu could, at one and the same time, serve *both* as a further
objectification of the female subject (woman as twice other—as female and
as oriental) *and* as the bearer of colonial power through knowledge, a sign

[51] There is a copy of this engraving in Princeton University Library and one mounted in *Portraits of English Poetesses*, ii, British Library.
[52] Kerslake, *Early Georgian Portraits*, no. 3924, *Lady Mary Wortley Montagu and her son, Edward accompanied by Turkish Servants*; Sotheby's, 13 July 1988 (32), single figure of Lady Mary Wortley Montagu in a landscape closely resembling this figure.
[53] See *Recueil des cent estampes*, pl. 3 and pl. 68; see Le Bruyn, *Voyage to the Levant*, pl. 35. Le Bruyn draws attention to the grandeur of dress that is particular to the women of Constantinople and describes how 'their *Tarpous*, or Head-dresses, are fasten'd to their Heads with a great many Handkerchiefs of various Colours, all wrought with Gold and Silver, and beset with all manner of precious stones, each according to her Ability' (39).

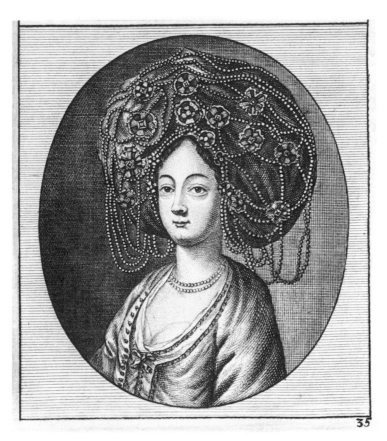

35

2.8 Anon., *Lady of Constantinople wearing a Tarpous*, engraving, plate 25 from
C. Le Bruyn, *A Voyage to the Levant: or Travels in the Principal Parts of Asia
Minor ... done into English by W.J.* (London: Jacob Tonson, 1702); reproduced
by kind permission of the Trustees of the Victoria and Albert Museum, London.

of national greatness whether or not accompanied by a black slave. At its most literal (at the level of the popular print), this articulation requires a set of masculine signifiers: the senatorial pose, the gestures of speech, the analogue with a French male philosopher.

I have earlier suggested a historical and psychic relationship between the damaged biological body of the female subject, Mary Wortley Montagu, and the fantasized, orientalized body as portrayed in the portrait attributed to Richardson. I have indicated that at an individual level the process of portrayal may be understood as reparation—that women possessed some degree of control over the images produced of them—but that at an ideological level portraiture is none the less yet a further mechanism for the appropriation of the female body. Accompanied by a black slave dressed in eighteenth-century European clothing, the body of Montagu clad in Turkish-style dress is invested in the 'Richardson' portrait as a sign of the colonial 'right' to appropriate foreign bodies and foreign culture. At the same time the body of woman is historically and metaphorically invested as nationhood gendered (and possessed). In colonial discourse the concept of nation is not only feminized but specifically sexualized, and woman in this discourse can function as a metaphor for the degeneration of the violated nation while simultaneously standing as a sign of the conqueror.[54]

What I am considering is, however, the process whereby woman as colonizer might seize this process of feminizing and, more precisely, sexualizing, to exploit the set of relationships between the individual body and notions of national identity. The appropriation of the discourse of colonial power by the female subject—in this case Montagu—does not, of course, rescue her from the power of that extended metaphor through which she represents the violated nation; we can still argue that the conclusion of the episode is a representation of a European female figure in Turkish-style clothing that is circulated in the West as an emblem of masculine power over female subjects and the superiority of West over East. My task—the implications of which are not confined to the subject of 'Montagu'—is none the less to challenge the reductiveness of this position. Linda Nochlin's statement that 'Woman's body has never "counted" in itself, only with what the male artist could fill it with, and that, it seems, has always been himself and his desires . . . it is a totally asymmetrical privilege; no such entry is provided for women artists'[55] does not allow any manner of organizing function for woman in the production and deploy-

[54] For a discussion of this question see A. Coombes and S. Edwards, 'Site Unseen: Photography in the Colonial Empire: Images of Subconscious Eroticism', *Art History*, 12, 4 (Dec. 1989), 512.

[55] S. Faunce and L. Nochlin, *Courbet Reconsidered* (New Haven, Conn., 1988), 32–3.

ment of her own image. It is the question of this function that I am concerned to investigate.

As this essay is concerned not only with the female subject in art but with the historical construction of femininity through art, I shall now look more closely at the question of Montagu's representation of Turkey as a site of pleasure. This issue was raised in the first part of this essay as one of general cultural valorization. Now I want to ask how did one who had, through the person of Flavia, victim of smallpox, rejected the mirror, negotiate the relationship between the actual and the idealized female body by holding up (for the first time) a mirror to Turkish womanhood? This relationship, as we have seen, was a matter of political and personal difficulty; portrayal as an act (as well as portraits as objects) were deeply implicated in its resolution.

Montagu is popularly understood to have corrected the widespread notions disseminated in guidebooks of the period, in which Turkish women were represented as abject slaves, by establishing the paradoxical concept that they enjoyed more liberty than Western women.[56] Certainly the fact that Ottoman women had rights over their own property and that divorce was available were attractive propositions and ones about which she wrote. The fact that the practice of veiling enabled Ottoman women to move around public spaces incognito was also seen to be advantageous. The notion that the regulations imposed by Islam on women are no more oppressive than the constraints of Western liberalism is, of course, very familiar today, and this is not the place to argue the relative merits of the case.

What we should recognize is the Western encounter with a culture in which portraiture had no place and, furthermore, in which the female face so valued in private had no currency in public. The loss of a husband's career prospects as a result of the destruction of his wife's face would be unimaginable in Montagu's Turkey, even though female beauty was highly prized by ruling males. Montagu, recounting the opportunities for freedom among Turkish women, reports that if caught out in infidelity they might suffer death at the hands of a husband. She tells how the body of such a woman was discovered not far from her house, bleeding from two knife-wounds, naked and wrapped in a coarse sheet:

She was not yet quite cold, and so suprizingly Beautifull that there were very few men in Pera that did not go to look upon her, but it was not possible for any body to know her, no woman's face being known. She was suppos'd to be brought in

[56] See e.g. Halsband, ' "Condemned to Petticoats" '.

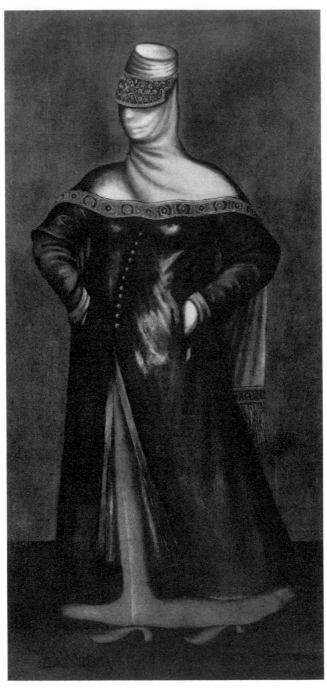

2.9 Anon. Austrian artist, *A Turkish Lady dressed for the Street*, *c*.1630–40, oil on canvas, $89\frac{1}{2} \times 45$ in.; private collection.

dead of night from the Constantinople side and laid there. Very little enquiry was made about the Murderer, and the corps privately bury'd without noise.[57]

In a culture where by this account it was impossible to identify a woman in public—no woman's face being known—the Western power structure that linked physical beauty to identity and thus valorized the individual through the representation of the body could be understood to have no purchase. At one level, of course, this means simply that we recognize portraits such as those we have been discussing as self-declared artifice like the Western masques and entertainments they resemble. But at another level the power of sight, which the female traveller uniquely wields (or so the narratives she and others constructed would have us believe), and which is a part of the orientalist discourse through which the West shaped and understood the East,[58] makes visible what is otherwise unseen. By virtue of her sex Montagu represents the unrepresentable not, as the ethnographic account proposes, in the interests of a truthful view of a hitherto unseen society, but in the form of a reconstruction of woman (herself) as object of her own pleasure. The killing picture and the reversed looking-glass of the European sick-room can be replaced by the fantasy other—also a woman and therefore also herself—of the bath or the harem.

The spectacle of Ottoman culture—of feminized Ottoman culture— enabled Montagu to be both viewer and viewed, to bridge the gap between self as object of another's pleasure and self as narcissistic, a gap that was a powerful ingredient of eighteenth-century social discourse and social function. At a personal level the veil, which Montagu found 'very easy and agreeable'[59] and in which Western artists had long portrayed Eastern women (Fig. 2.9), freed her to move around as she wished; it would also have obscured her ruined complexion and demoted her physical appearance, relieving her of the burden of acting as bearer of Western signs of status and making her distinguishable only from all men and undistinguishable from any woman. The actual veiling of herself—the adoption of Turkish dress—allowed Montagu freedom of access to the public spaces of Adrianople and Constantinople. More importantly, the symbolic obliteration of herself—the decision to visit the hot baths at Sophia incognito as well as the decision to engage with Ottoman culture

[57] Montagu to the Countess of——,May 1718, *Complete Letters*, i. 407–8.
[58] See e.g. Le Bruyn on Turkish women: 'The Women are very narrowly kept and Eyed, the One in their Service, and the Others in their Apartments. . . . The Gardeners and other Officers that chance to meet them in their Walks, are oblig'd immediately to turn on one side, and keep their Eyes fix'd upon the Ground, so that it may be said that not a Man has ever seen the Face of one of the *Sultanas* belonging to the *Seraglio* during her stay there.' *Voyage to the Levant*, 30–1.
[59] Montagu to Lady Bristol, 10 Apr. 1718, *Complete Letters*, i. 397.

at the level of practical experience—provided the site (as well as the sight) for the construction of the female body as object of narcissistic pleasure.

It is important in this respect to notice how carefully Montagu chose her dress: while going Turkish enabled her to act the *flâneur* in the streets of Constantinople, when visiting the baths at Sophia she wore European riding dress, and she wore Viennese court dress to visit the Grand Vizier's lady and the Kahya's lady in Adrianople. On both occasions, however, she travelled incognito in a Turkish coach.[60] Viennese court dress was, as she herself pointed out, much more magnificent than the English equivalent and must have connoted extraordinary power, given that the Austrians were on the point of war with the Ottomans. Riding habits were a version of the masculine suit worn by English women for riding, walking, and travelling, so Montagu entered the baths at Sophia not only as a European woman but as a masculinized European woman.[61] In both instances the dress served to establish the symbolic distance crucial to the narcissistic gaze.[62] She would be seeing woman like herself but different by culture, culture in this instance being articulated in terms of the body's dress and covering.

Montagu's account of the baths at Sophia is so well known as scarcely to need rehearsal. Yet it is worth quoting at length a passage that has been so often used to demonstrate historical truths in order to comment upon the way it is structured:

I was in my travelling Habit, which is a rideing dress, and certainly appear's very

[60] See Montagu to Lady——, 1 Apr. 1717 (for the account of the baths) and Montagu to Lady Mar, 18 Apr. 1717 (for the account of the visits to the Grand Vizier's and the Kahya's ladies); for a description of the extremely elaborate dress worn at the Viennese court see Montagu to Lady Mar, 14 Sept. 1716. *Complete Letters*, i. 312–15, 347–52, 265–9.

[61] W. Leeks ('Ingres Other-Wise', 31) points out that Montagu's position in the baths is voyeuristic because she refuses to take off her clothes, a position that is compounded by her status as Westerner and diplomat's wife. She argues that Montagu 'is playing a male role in relation to the women of the bath, with whom she does not identify. The power relation existing between her and the bathers is thus analogous in some ways to that of the male spectator and the female nude.' Leeks then goes on to acknowledge that the distance between Montagu and the bathers is broken down because she is also a spectacle that is looked upon, but Leeks does not pursue this line of enquiry because her interest is primarily with Montagu as a source for Ingres. Where I differ with Leeks is at the assertion that Montagu does not identify with the women of the bath and at the point where she reduces the common element between Montagu and the bathers to 'femaleness'. While acknowledging the ground-breaking aspect of Leeks's work, this form of essentialism is something I wish to question.

[62] This process is described by Lacan as follows: 'It is the intersection by which the single signifier functions here in the field of *Lust*, that is to say, in the field of primary narcissistic identification, that is to be found the essential mainspring of the effects of the ego ideal, of that being that he first saw appearing in the form of the parent holding him up before the mirror. By clinging to the reference-point of him who looks at him in a mirror, the subject sees appearing, not his ego ideal, but his ideal ego, that point at which he desires to gratify himself in himself.' J. Lacan, *The Four Fundamental Concepts of Psychoanalysis* (1973), ed. J-A. Miller, trans. A. Sheridan (Harmondsworth, 1977), 256–7.

extraordinary to them, yet there was not one of 'em that shew'd the least suprize or impertinent Curiosity, but receiv'd me with all the obliging civillity possible. I know no European Court where the Ladys would have behav'd them selves in so polite a manner to a stranger.

I beleive in the whole there were 200 Women and yet none of those disdainfull smiles or satyric whispers that never fail in our assemblys when any body appears that is not dress'd exactly in fashion. They repeated over and over to me, Uzelle, pek uzelle, which is nothing but, charming, very charming. The first sofas were cover'd with Cushions and rich Carpets, on which sat the Ladys, and on the 2nd their slaves behind 'em, but without any distinction of rank by their dress, all being in the state of nature, that is, in plain English, stark naked, without any Beauty or deffect conceal'd, yet there was not the least wanton smile or immodest Gesture amongst 'em. They Walk'd and mov'd with the same majestic Grace which Milton describes of our General Mother. There were many amongst them as exactly proportion'd as ever any Goddess was drawn by the pencil of Guido or Titian, and most of their skins shineingly white, only adorn'd by their Beautifull Hair divided into many tresses hanging on their shoulders, braided either with pearl or riband, perfectly representing the figures of the Graces. I was here convinc'd of the Truth of a Refflexion that I had often made, that if twas the fashion to go naked, the face would be hardly observ'd. I perceiv'd the Ladys with the finest skins and most delicate shapes had the greatest share of my admiration, tho their faces were sometimes less beautiful than those of their companions. To tell you the truth, I had the wickedness enough to wish secretly that Mr Gervase could have been there invisible. I fancy it would have very much improv'd his art to see so many fine Women naked in different postures, some in conversation, some working, others drinking Coffee or sherbet, and many negligently lying on their Cushions while their slaves (generally pritty girls of 17 or 18) were employ'd in braiding their hair in several pritty manners. In short, tis the Women's coffee house, where all the news of the Town is told, Scandal invented, etc. They generally take this Diversion once a week, and stay there at least 4 or 5 hours without geting cold but immediate coming out of the hot bath into the cool room, which was very suprizing to me. The Lady that seem'd the most considerable amongst them entreated me to sit by her and would fain have undress'd me for the bath. I excus'd myself with some difficulty, they being all so earnest in perswading me. I was at last forc'd to open my skirt and shew them my stays, which satisfy'd 'em very well, for I saw they beleiv'd I was so lock'd up in that machine that it was not in my power to open it, which contrivance they attributed to my Husband. I was charmed with their civillity and Beauty and should have been very glad to pass more time with them, but Mr W[ortley] resolving to persue his Journey the next morning early, I was in haste to see the ruins of Justinian's church, which did not afford me so agreable a prospect as I had left, being little more than a heap of stones.

Adieu, Madam. I am sure I have now entertained you with an Account of such

a sight as you never saw in your Life and what no book of travells could inform you of. 'Tis no less than Death for a Man to be found in one of these places.[63]

The framework for this account is that of the clothed European body and its signifying gestures; against this is constructed naked Eastern woman sexualized via a series of allusions that are all Western not Eastern. The passage from Milton is a *locus classicus* of female sexuality. While the reference to 'majestic grace' may refer to *Paradise Lost*, Book IV, line 290— 'With native Honour clad/in naked Majestie'—the reader would be led on to the celebrated passage a few lines later where Eve is described:

> She as a vail down to the slender waste
> Her unadorned golden tresses wore
> Dissheveld, but in wanton ringlets wav'd
> As the Vine curles her tendrils, which impli'd
> Subjection, but requir'd with gentle sway,
> And by her yielded, by him best receiv'd,
> Yielded with coy submission, modest pride,
> And sweet reluctant amorous delay.[64]

The women in the baths are like goddesses drawn by Guido Reni and Titian, that is, pagan goddesses such as Venus, depicted by artists renowned for the sensuousness of their handling.[65] The troublesome face is forgotten in the pleasure of the naked body and a situation in which 'the face would hardly be observed' is ruefully conjured as the writer admires the finest skins and most delicate shapes. The problem of the face suggests the name of the face-painter, Charles Jervas, an artist whose reputation Pope subsequently inflated in an epistle that specifically mentioned his portrait of Montagu.[66]

The slide from portraiture to the nude and back is an interesting one,

[63] Montagu to Lady——, 1 Apr. 1717, *Complete Letters*, i. 313–15.
[64] *Paradise Lost*, Bk. IV, ll. 304–11.
[65] For a discussion of the taste for Guido and Titian in the late 18th century, see F. Haskell, *Rediscoveries in Art: Some Aspects of Taste, Fashion and Collecting in England and France* (London, 1976), 27–8.
[66] Kerslake (*Early Georgian Portraits*, no. 3924), suggests that the portrait of Montagu (Lady Mary Pierrepont), painted before her marriage and showing her as a shepherdess (Bute Collection, Dumfries House), attributed to Kneller is likely to be by Jervas. This would date Montagu's acquaintance with Jervas well before her journey to Constantinople. Other portraits identified as Montagu in Turkish dress are said to be the work of Jervas or his studio (e.g. National Gallery of Ireland and Glynde Place, Sussex). It was to Kneller, however, that Montagu sat for a portrait in Turkish dress in 1720 commissioned by Pope (Bute Collection), engraved by Caroline Watson. Pope's *Epistle to Mr Jervas* was written *c.* 1715 and published in 1716; it specifically refers to Guido and Titian and at 60 the original referred to 'Wortley's eyes', but Pope changed this to 'Worsley's eyes' after he quarrelled with Montagu in 1729. *The Poems of Alexander Pope*, ed. J. Butt (London, 1963), 250n. Horace Walpole's sneering comments on Jervas as a painter of 'wretched daubings' (*Anecdotes of Painting in England (1762–1780)* 4 Vols. (1876), ii. 269–70) have been adopted by most biographers.

suggesting tacit investment in the sexual within the reading of portraits at the time. The name of Jervas seems here to be connected in a somewhat sniggering way with the representation of female sexuality; Montagu implies that studying the female nude might ensure that Jervas painted better portraits, but the implication is also that his name is somehow the appropriate one to invoke in this theatre of female flesh. Jervas was known personally to the writer and the sale of his studio contents included (among 2,128 pictures, prints, and drawings) an enormous number of engravings after allegorical old master paintings and one substantial lot described as 'Drawings. Nudities from the Life'.[67] Montagu represents the women in the baths at Sophia by invoking a portrait painter and, by implication, contemporary Western acts of portrayal that constructed femininity as sexual and as desirable.

Montagu's account terminates, after her explanation of the social function of the baths, with the revelation of what lies under her own skirt. At this point her Western body is found sealed in its clothing by patriarchal law; the interpretation of the stays is, of course, attributed by Montagu to the women bathers but the sense that she is implicated in this interpretation is compounded when we learn that this same patriarchal law imposes the itinerary and the schedule and demands, therefore, that she leave.

In her visit to the Kahya's lady, Montagu reverses the commonplace notion of an art that vies with nature and finds, rather, life that is more wonderful than art:

The Gravest writers have spoken with great warmth of some celebrated Pictures and Statues. The Workmanship of Heaven certainly excells all our weak Imitations, and I think has a much better claim to our Praise. For me, I am not asham'd to own I took more pleasure in looking on the beauteous Fatima than the finest piece of Sculpture could have given me. . . . Her fair Maids were rang'd below the Sofa to the number of 20, and put me in Mind of the pictures of the ancient Nymphs. I did not think all Nature could have furnished such a Scene of Beauty.[68]

When the maids begin to dance Montagu finds the spectacle sexually arousing, declaring:

Nothing could be more artful or more proper to raise certain Ideas, the Tunes so soft, the motions so Languishing, accompanying with pauses and dying Eyes, halfe

[67] *A Catalogue of the Most Valuable Collection of Pictures, Prints, and Drawings late of Charles Jarvis, deceased; Principal Painter to their Majesties King George I and II* (Mar. 1739–40); many of the 'nudities' were Jervas's copies after Raphael, Caracci, Berettoni, and others.

[68] Montagu to Lady Mar, 18 Apr. 1717, *Complete Letters*, i. 351. The fullest account of a harem is to be found in N. M. Penzer, *The Harem: An Account of the Institution as it existed in the Palace of the Turkish Sultans, with a History of the Grand Seraglio from its foundation to the Present Time* (London, 1936).

2.10 Caroline Watson after Sir Godfrey Kneller, *Lady Mary Wortley Montague*, 1720, stipple engraving, frontispiece to Lady Mary Wortley Montagu's *Works* (London: R. Phillips, 1803).

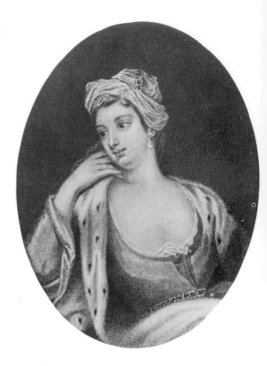

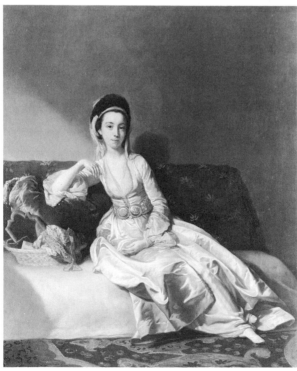

2.11 George Willison, *Nancy Parsons in Turkish dress*, c.1771, oil on copper, $22\frac{1}{2} \times 18\frac{3}{8}$ in.; reproduced by courtesy of the Yale Center for British Art (Paul Mellon Collection).

falling back and then recovering themselves in so artfull a Manner that I am possitive the coldest and most rigid Prude upon Earth could not have look'd upon them without thinking of something not to be spoke of.

In writing about dancing maids in this way, Montagu (like Daniel Defoe) is merely following earlier travel accounts which make great capital out of the erotic spectacle of Turkish dancing. Moreover, the sofa, which features in her account and which was to become an emblem of decadence in Cowper's *The Task* (1783), where the healthy outdoor life is offered in contrast, was already a stock item in orientalist writing. None the less, it is appropriate here to go beyond these explanations and to hypothesize a relationship between life and art that will enable us to understand the relational aspects of the definitions of femininity that Montagu was constructing and by which she was identified. Study of the individual subject as well as of social organization is needed if we are better to understand how gender works. The relations between the individual and social organization and between men and women are interconnected in ways that cannot be untangled *except* at the level of the psychic and the mythic.

In the presence of the Khaya's lady, Montagu finds life superior to art, and life assisted by art (dancing) offers extreme forms of pleasure of a kind that cannot be re-presented and can only be alluded to. Thus the controlling relationship between femininity, sexuality, and the art of image-making (which determined Montagu's viewing of the baths at Sophia) is here broken down and she is able to grasp the pleasure in looking and make it complete. For there is no intrusion here of patriarchal law and Montagu terminates the visit (and the account) only when she has enjoyed her fill of looking. The art of representation can henceforth be the individual's tool rather than her master, for Montagu has seized the power of sight (as well as the power of speech) in order to articulate her own pleasure. 'I took more pleasure', she affirms, in looking at the women of the harem than in the sight of 'the finest piece of sculpture'. The pagan goddess is overthrown not by Christianity but by the actuality of Islam, and the 'killing picture[s]' of European social systems of representation—now understood to be 'weak Imitations'—cease to be a threat.

III

In 1776, Reynolds reminded London audiences of one of the 'finest piece[s] of sculpture' with his image of the noble savage (Fig. 4.1): the Tahitian 'Omai', brought to London by Captain Cook, was portrayed in a toga-like garment and in a pose reminiscent of the Apollo Belvedere which served

more than once as an icon of masculinity in eighteenth-century portrait-ure.[69] By contrast, Montagu was a European portrayed in orientalized costume. And that costume—as Montagu's accounts of Ottoman femininity evince—carried connotations of sexual pleasure quite removed from the world of classical antiquity and the 'finest piece[s] of sculpture'. Those connotations are balanced by Montagu's pose, which in all the portraits of her lacks any suggestion of dancing and ranges from the permissibly langorous (as with the Kneller commissioned by Pope) to the sedate (as with 'Richardson' and Vanmour) (Figs. 2.10 and 2.12). The portraits of Montagu attributed to Vanmour construct a subject that is highly dis-tinctive; it bears neither the masque/fancy dress associations of works of a generation or so earlier, such as Van Dyck's *Teresia, Lady Shirley*,[70] nor the anecdotal quality of nineteenth-century orientalist painters like Gleyre in France and Thomas Allom in England. Moreover, the erotic associations of dress are counterbalanced by the statuesque pose. Compared with George Willison's portrait of Nancy Parsons in Turkish dress (Fig. 2.11) or with Liotard's portrait said to be Mary Gunning, Duchess of Coventry, both of which show women seated on sofas, the images of Montagu are extremely formal. Vanmour produced two portraits featuring Montagu, one a single figure and the other a group including the same figure in the company of her son and two servants.[71] In these portraits Montagu appears in possession of herself and at ease in her body-hugging Turkish garments. If this impression is the result of the persuasiveness of her writing then all the more reason to acknowledge the process of cultural appropriation and refinement that moves from word to image and back, operating to reconstruct and empower the damaged self as sexualized feminine body.

Woman's fertility was, Montagu pointed out, greatly valued in Ottoman society. She acquired considerable kudos by giving birth to her second child in Constantinople.[72] It is, therefore, entirely appropriate that Vanmour should reproduce Montagu with her son, the evidence of her own reproduction. The painting offers a strangely disconnected composition in which Montagu holds the hand of young Edward who is, like her, dressed in Turkish-style clothing. The lower part of the image is occupied by an expanse of tiled floor with a raised area covered with an elaborately patterned carpet. From the right an old man enters bearing a letter in one

[69] The Hon. Simon Howard, Castle Howard.

[70] 1622, National Trust, Petworth House.

[71] Sotheby's, 13 July 1988 (32), ex Wharncliffe Collection; Kerslake, *Early Georgian Portraits*, no. 3924. An account of Vanmour's work is to be found in R. Van Luttervelt, *De 'Turkse' Schilderijen van J. B. Vanmour en zijn School*, (Istanbul, 1958).

[72] Montagu to Anne Thistlethwayte, 4 Jan. 1718, *Complete Letters*, i. 371–2.

2.12 Attributed to Jean-Baptiste Vanmour, *Lady Mary Wortley Montague and her son*, c.1717–18, oil on canvas, 27 × 35½ in.; reproduced by kind permission of the National Portrait Gallery, London.

hand and holding a pipe in the other, while on the left a young woman is seated cross-legged on a sofa playing a *tehegour*. In the background there is a view of Constantinople. The painting is thus full of motifs of which Montagu writes and through which Turkey is constructed and processed for the West. We may take the letter that is being delivered as a sort of professional imprimatur—a reminder of Montagu's role as correspondent. None the less, the association would also have been with the Turkish love-letter, a topic particularly dear to English audiences and one about which Montagu wrote in response to enquiries from home in March 1718.[73] Both in Dutch seventeenth-century painting and in British nineteenth-century painting, the arrival of a letter is often a key to the unfolding of the narrative.[74] Here, however, the status of the letter that the attendant holds forth is indeterminate. The complicity of the subject in the production of an image of self that may be Turkish or may be English (may contain a love-letter or a business document) is, like the wearing of a riding habit into the women's baths at Sophia, capable of misrecognition. The power of knowing is denied the viewer. It is, therefore, the viewed that holds the balance of power, poised between East and West, between letter and music, business and pleasure. The female subject is thus constructed in a relationship of power to the viewer. The mirror is restored.

[73] Montagu to Lady——, 16 Mar. 1718, *Complete Letters*, i. 387–91. The Turkish love-letter was originally understood to be composed of flowers or other objects with symbolic significance but the idea seems to have rapidly extended to cover written correspondence. Jean-Etienne Liotard (1702–89) dealt with this theme and it reappears with great frequency in the 19th century. See e.g. David Wilkie, *The Turkish Letter Writer*, Aberdeen Art Gallery and Museum, and J. F. Lewis, *An Intercepted Correspondence*, private coll., Houston, Texas, both reproduced in Royal Academy of Arts, *The Orientalists*.

[74] See e.g. Vermer's *Woman Reading a Letter*, Rijksmuseum-Stichting, Amsterdam; Metsu's *The Letter Writer Surprised*, Wallace Collection, London; David Wilkie, *The Letter of Introduction*, National Gallery of Scotland, Edinburgh; George Elgar Hicks, *Woman's Mission: Companion to Manhood*, Tate Gallery, London.

3

ReWrighting Shaftesbury: The Air Pump and the Limits of Commercial Humanism

David Solkin

JOSEPH Wright of Derby's best-known painting, *An Experiment on a Bird in the Air Pump* (1768; Fig. 3.1), depicts a fashionable company in attendance at a lecture given by a natural philosopher, who is demonstrating the necessity of air to life by showing his audience (and us) a white bird struggling for breath in the partial vacuum that has been created within the glass receiver at the top of the pump. It is the climactic moment of the experiment, when the bird may die, or when the lecturer may restore it to health by opening the stopcock he grasps between the fingertips of his left hand. The suspense is heightened by the theatrical chiaroscuro, which highlights the various reactions of the spectators, ranging from the evident distress of the two young girls through to the calmer responses and apparent unconcern displayed by other members of the group.

This theme and its spectacular treatment add up to a kind of picture that defined Wright to his original audience as an artist who stood distinctly apart from eighteenth-century British norms—when an anonymous reviewer called him 'a very great and uncommon genius in a peculiar way',[1]

This paper derives from a lecture first delivered at the University of California at Los Angeles Center for 17th- and 18th-Century Studies (the William Andrews Clark Memorial Library) in February 1990, as part of a series of talks and workshops on Conceptions of Property, sponsored by the Clark Memorial Library and the National Endowment for the Humanities. Here I would like to express my appreciation to the two sponsoring bodies, and to Professors John Brewer and Susan Staves, for enabling me to test out my ideas in such a stimulating forum.

[1] 'A Lover of the Arts', *Gazetteer and New Daily Advertiser*, 23 May 1768, 4.

he must have been registering an opinion that was generally shared at the time. Though large-size depictions of such highly particularized figures were usually only to be found in examples of group portraiture,[2] the *Air Pump* presented its human actors as contemporary types, and not as specifiable individuals;[3] and while thematically it stood in clear relation to a tradition of conversation-piece imagery, no other English painter had ever created so monumental an image of an elegant social gathering, or one with such powerful visual impact. The representation of a dramatic narrative enacted by numerous figures on the scale of life was supposed to fall within the province of history painting, the most noble of the pictorial genres; yet according to academic theory the dignity of historical art conventionally depended on the presence of an heroic action described in the elevated language of classical idealism—on a type of style and subject-matter, in other words, that were pointedly absent from Wright's work. His novel combination of different features taken from a range of standard pictorial types has prompted most modern scholars to treat the *Air Pump* and Wright's other candlelight scenes from the 1760s as cultural oddities— to explain their production by referring to certain special factors that apply to him and him alone. Thus much has been made of Wright's provincial status (Wright 'of Derby'), of his links with an ostensibly enlightened midlands bourgeoisie, and of his sympathy with the nascent scientific, technological, and industrial revolutions, and so on.[4] While I would be reluctant to dismiss these issues out of hand, I believe that attempts to describe the *Air Pump* as a harbinger of great things to come have probably

[2] One important exception to this rule deserves to be mentioned here: the high-life genre scenes that figured as part of the series of supper-box paintings at Vauxhall Gardens, mainly designed by Francis Hayman and executed by him and his studio during the early 1740s. For an example of the sort of Vauxhall picture that might have been particularly useful to Wright, see the print after *Playing the Game at Quadrille* (designed by François Gravelot and painted by Hayman), in Brian Allen, *Francis Hayman* (New Haven, Conn., 1987), cat. no. 64, 135.

[3] Since as far as we know no one in the 18th century regarded Wright's candlelights as portraits, I am at a loss to understand why modern scholars from Nicolson onwards have wasted so much time and energy trying to identify the individuals on whom his figures may be based. I imagine that he did use some of his friends as models, but surely the key point is that he depicted them as knowable unknowns; in so doing, Wright allowed his viewers to consider his painted actors as surrogates for themselves, instead of regarding them as specific people whom they had simply never met.

[4] An extreme example of this tendency may be found in Albert Boime's *Art in an Age of Revolution 1750–1800—A Social History of Modern Art Volume I* (Chicago, 1987), 233–60, where the author goes so far as to claim that '*Wright would do for the Industrial Revolution what David did for the French Revolution*' (234). Boime's views take their point of departure from the pioneering work of modern Wright scholarship, Benedict Nicolson's *Joseph Wright of Derby—Painter of Light*, 2 vols. (London, 1968). In a forthcoming book, from which he has kindly allowed me to read a draft of the chapter on Wright, Stephen Daniels traces the origins of this 'progressive' interpretation back to the later 19th century.

3.1 Joseph Wright of Derby, *An Experiment on a Bird in the Air Pump*, 1768, oil on canvas, 72 × 96 in.; reproduced by courtesy of the Trustees of the National Gallery, London.

done more to obscure than to clarify the historical significance of Wright's achievement. I do not see him acting simply as the spokesman for a marginal cultural vanguard emerging north of the river Trent;[5] on the contrary, here I hope to show that his most complex candlelight[6] addressed the basic concerns of an ideological project which had for some time been of central importance to eighteenth-century British culture as a whole. Broadly speaking, we can perhaps best describe that project as encompassing a range of attempts to describe the forms of modern social life— what John Mullan has recently identified, in reference to the moral philosophers and writers of imaginative literature working in the middle part of the century, as a recurrent impulse to '*produce* society ... on the page'.[7] Though in Wright's case the medium was a painted canvas, he likewise took it upon himself to construct an image—part description, part projection, part critique—designed to instruct his audience about the character of their own world, using a scientific experiment as the parabolic means of achieving this larger moral end.[8]

To create a painting that sought to teach its viewers to know themselves was to embrace a philosophical agenda for the visual arts that had first been proposed in England at the beginning of the century, by Anthony Ashley Cooper, 3rd Earl of Shaftesbury. Taking his cue from Aristotle's *Poetics*, Shaftesbury asserted in his notes for an unpublished essay on the plastic arts that their highest duty was to promote 'knowledge of the species,

[5] Here I would emphatically agree with Daniels; see previous note.

[6] Of course, much of what I shall be saying about the *Air Pump* might also be applied to Wright's other candlelights of the 1760s, and especially to *A Philosopher giving that Lecture on the Orrery, in which a Lamp is put in place of the Sun* (exhibited Society of Artists, 1766; Derby Art Gallery), though the element of dramatic action featured in the *Air Pump* makes it a rather special case. The other major candlelights to which I refer (i.e. those depicting more than two figures) are Wright's *Three Persons Viewing the Gladiator by Candlelight* (Society of Artists, 1765; private coll.), and his *Academy by Lamplight* (Society of Artists, 1769; Yale Center for British Art, Paul Mellon Collection). Good colour reproductions, together with useful if rather unadventurous discussions of these and most other significant works by the artist, can now be easily found in Judy Egerton, *Wright of Derby*, Tate Gallery cat. (London, 1990).

[7] John Mullan, *Sentiment and Sociability: The Language of Feeling in the Eighteenth Century* (Oxford, 1988), 25.

[8] Of course, I would not claim to be the first scholar to identify the *Air Pump* as a 'moral' picture. The same assertion has been made by Egerton in the Tate Gallery catalogue (*Wright of Derby*, 61), and by William Schupbach (whose research provided Egerton with much of her information) in 'A Select Iconography of Animal Experiment', *Vivisection in Historical Perspective*, ed. Nicolaas A. Rupke (London, 1987), 340–7. While I have drawn upon both of these sources, which broadly confirmed the views I had previously held, the basic thrust of my argument differs fundamentally from theirs, as I hope will become apparent. A more provocative discussion of the *Air Pump*—with which I agree in part, though it bears less specifically on my own concerns—can be found in Ronald Paulson, *Emblem and Expression: Meaning in English Art of the Eighteenth Century* (Cambridge, Mass., 1975), 184–98.

of our own species, of *ourselves*';[9] he followed much the same line in his famous treatise on the *Judgment of Hercules*, which was first published in English in 1713. Here, of course, Shaftesbury constructed a definition of historical art that could not be applied to a picture like the *Air Pump*: but by the 1760s his aesthetic theories had been substantially rewritten by subsequent writers, to the point where they could now begin to accommodate forms of moral painting that would not have fulfilled the criteria the 3rd Earl had prescribed.

Among the various reworkings of Shaftesbury that appeared in the decades around the middle of the century, one in particular speaks with quite remarkable directness to the formal and thematic characteristics of Wright's scientific scenes. George Turnbull's *Treatise on Ancient Painting*, which appeared in 1740, has recently been described as a 'summary' of Shaftesburian aesthetics,[10] and no doubt it is so in many basic respects. But on a number of important issues Turnbull expressed opinions opposed to those of his principal model; and for us his positive evaluation of scientific practice constitutes an especially relevant case in point.

In his analysis of the highest purposes of art, Turnbull took as his starting-point Shaftesbury's contention that painting should contribute to the ethical instruction of mankind by giving concrete form to abstract notions of morality. Both writers, in other words, argued for a close alliance between the visual arts and moral philosophy. But in a significant departure from Shaftesburian dogma, which had no time for the inductive and empiricist premises of modern experimental science, the *Treatise* insists that attempts to separate natural (that is, Newtonian) philosophy from its moral counterpart are fundamentally flawed, and even pernicious. According to Turnbull, both aspects of philosophy should 'be managed and carried on in the same way of Experiment; and in the one case as well as in the other, nothing ought to be admitted as fact, till it is clearly found to be such from unexceptionable Experience and Observation'. Turnbull firmly believed, moreover, that 'Conclusions derived from moral Powers and Affections, considered apart from sensitive ones, cannot make *Human Morality*, if Man really is a moral Being, intimately related to and connected

[9] Anthony Ashley Cooper, 3rd Earl of Shaftesbury, 'Plastics: An Epistolary Excursion in the Original Progress and Power of Designatory Art', in *Second Characters or the Language of Forms*, ed. Benjamin Rand (Cambridge, 1914), 93.

[10] John Barrell, *The Political Theory of Painting from Reynolds to Hazlitt: 'The Body of the Public'* (New Haven, Conn., 1986), 11, 18–20, and *passim*. I see more differences between Shaftesbury and Turnbull than Barrell seems prepared to acknowledge, though I would not dispute the fundamental similarities that he points out.

with the Laws of the sensible World'.[11] Drawing on the basic premises of Lockean epistemology, Turnbull defines painting as a form of cultural expression that can marshal the conjoined resources of moral and natural philosophy for the advancement of human understanding. No doubt certain pictures are primarily moral, and others primarily natural; but even works that fall into the second category, such as landscape paintings, are bound to promote an awareness of 'the moral Ends or final Causes of Effects'[12] that are manifest in the physical world.

In short, Pictures which represent visible Beauties, or the Effects of Nature in the visible World, by the different Modification of Light and Colours, in Consequence of the [Newtonian] laws which relate to Light, are Samples of what these Laws do or may produce. And therefore they are proper Samples and Experiments to help and assist us in the Study of those Laws, as any Samples or Experiments in the Study of the Laws of Gravity, Elasticity, or of any other Quality in the natural World. They are then Samples or Experiments in natural Philosophy.[13]

On the other hand, 'Good moral Paintings' have to adhere to natural truths, if they are to serve 'as proper Samples in moral Philosophy, [which] ought therefore to be used in teaching it, for the same Reason that Experiments are made use of in teaching natural Philosophy'.[14] Such works provide lessons in human nature, whilst the former deal with the nature of the universe; but ultimately their respective purposes, like those of the different aspects of philosophy to which each is linked, form an inseparable whole— to teach men about themselves, the perceptible world, and the divinity responsible for all of creation.

The introduction of an empiricist component into the framework of Shaftesburian aesthetics forced Turnbull into the paradoxical position of subverting some of the most basic arguments of a discourse that he professedly admired. In modifying the 3rd Earl's views on philosophy— siding now with the moderns against the ancients[15]—he could not help but abandon his predecessor's strict definition of proper pictorial form. Instead

[11] George Turnbull, *A Treatise on Ancient Painting* (London, 1740), p. x.

[12] Ibid., 132.

[13] Ibid., 146.

[14] Ibid., 148.

[15] For an important discussion of Shaftesbury's hostility to minuteness of pictorial detail in relation to the contemporary debates between the ancients and moderns in scientific discourse, see Harry Mount, 'The Reception of Dutch Genre Painting in England, 1695–1829', unpub. Ph.D. thesis, Cambridge, 1991, 109–42. Mount also briefly notes (143–4) the different position adopted by Turnbull, and suggests that he may have been influenced by the English translation of Leonardo's *A Treatise on Painting*, which had been published in London in 1721. The idea of Joseph Wright self-consciously modelling his approach on Leonardo's example is an intriguing one, and not at all beyond the realm of possibility. I am grateful to Mount for permission to cite his research.

of insisting that the highest truths can only be communicated in the idealizing language of classical art, the *Treatise on Ancient Painting* grants an importance to the representation of particular appearances that Shaftesbury himself would have rejected out of hand. Both writers were agreed that 'Every Imitation ought to be performed with such Intelligence of human Nature, which is ever substantially the same, that it may be universally instructive and moving'. 'But', Turnbull proceeds to remark, 'every Imitation being particular, or representative of a certain Action; the Action painted ought to be told with such a strict regard to the Accidental *Costume*, that the Subject and Scene must be easily distinguished by those who are versed in History.'[16] The idea that historical actors should be shown in correct historical costumes goes hand in hand with a belief in the precise rendering of detail as one (if not the only) standard of natural truth. To support his position Turnbull cites a statement by Socrates, to the effect that 'A Picture must be a true Imitation, a true Likeness; not only the Carnation must appear red, but even the Stuffs, Silks, and other Ornaments in the Draperies. Without Truth no Imitation can please.' And if a work of art gives pleasure in this manner, it can do so without endangering its 'virtuous Effect' on the beholder—provided, of course, that the painter makes 'a fine and judicious Choice of Nature', and chooses a subject capable of 'exciting in our Minds great and noble Ideas of the moral kind'.[17]

Yet even as he qualifies certain fundamental assumptions of Shaftesbury's aesthetic enterprise, Turnbull refrains from directly challenging the conventional hierarchy of styles and genres. For him, as for the author of the *Hercules*, the sort of imagery that can best serve the purpose of inculcating virtue remains historical art in the grand style. In addition to the lost masterpieces of classical antiquity, Turnbull recommends the Raphael Cartoons and Poussin's works as models for the most noble form of painterly practice. Presumably he would have been aware of the recent appearance in Britain of quite a different type of moral picture, which William Hogarth had been producing for the better part of a decade; but the *Treatise* offers no approval for representations of improper conduct, nor any explicit sanction for the depiction of contemporary scenes. However, Turnbull nowhere rules out the possibility of creating a modern-life *exemplum virtutis*—and despite its rather unpromising title (which does little justice to the range of its concerns), his *Treatise* could easily have been read as offering implicit support for just such an artistic project.

[16] Turnbull, *Treatise*, 78–9.
[17] Ibid., 81.

Whether Joseph Wright ever read or was inspired by Turnbull is probably incapable of proof, though it cannot be denied that their different endeavours occupied a considerable area of common ground. One imagines that a painter trained in the 'particular' art of portraiture, and who enjoyed extensive contacts with his local scientific community, might have responded with considerable enthusiasm to the only art-theoretical text available to him that promoted an alliance between painting and natural philosophy, and legitimized the representation of 'accidental' forms. But speculations of this sort, however tantalizing they might be, are really rather beside the point. I have looked at Turnbull primarily for the purpose of establishing some of the basic parameters of relevant mid-eighteenth-century thinking about morality and the visual arts, so that when we begin to speak of the *Air Pump* as fulfilling a moral purpose, we can do so in historically specific terms. Obviously Wright sought to provide his viewers with something more than the straightforward representation of a scientific demonstration—and it would be entirely in keeping with the spirit of his grandest scientific candlelight if we were to regard it as 'sample or experiment in natural philosophy', not only by virtue of what it describes, but on account of its formal language as well. When Wright dramatizes the effect of light on colour, he does so in part to assist our understanding of Newtonian laws; and when he portrays every object in meticulous detail, one point is to enable us to emulate the audience within the picture, who achieve an awareness of natural truth through close empirical observation. At the same time, the depiction of human actors acting in and upon nature at a moment of high drama, of life and death, takes the *Air Pump* into the province of moral philosophy. If the supreme purpose of such philosophy lies in the promotion of self-knowledge, then this is a purpose that Wright appears to have embraced in a much more literal sense than either Shaftesbury or Turnbull had had in mind: instead of describing some exemplary hero from the classical or Christian past, he showed his viewers people they could recognize as belonging to their own world. Wright's ambitions could hardly be better encapsulated than by the following passage from Turnbull's book: 'The Design of moral Pictures is ... to shew us to ourselves; to reflect our image upon us, in order to attract our Attention the more closely to it, and to engage us in Conversation with ourselves, and an accurate consideration of our Make and Frame.'[18] Thus it is with Turnbull and Shaftesbury in mind that we must try and determine what the *Air Pump* 'reflected' on to its original viewers, how it engaged them in

[18] Ibid., 147.

a 'conversation' about themselves, and about the nature of the society in which they lived.

If this give and take had been in the nature of a direct and unmediated encounter, then the task I am proposing would be a relatively straightforward one. But one point requiring strong and immediate emphasis is that neither Wright nor his viewers would have been able to describe a social order, or even imagine its structure, outside an a priori conceptual framework. Here we must look back once again to Shaftesbury to see where and in what shape this framework emerged, and how it first came to play a part in the arena of aesthetic discourse. As John Barrell has so convincingly shown,[19] Shaftesbury's writings on art both drew upon and supported the basic precepts of a social and political theory—modern historians have called it civic humanism or classical republicanism[20]—that described an ideal polity according to a clearly defined set of terms that were challenged, revised, but never entirely abandoned as the eighteenth century went on. We know that those terms continued to carry paradigmatic force in formulations of art theory—for George Turnbull, to name but one obvious example, and in different ways for the early Reynolds. But I would go on to argue that Joseph Wright's ambitious attempts to 'produce' the forms of contemporary society likewise worked within, even as in some respects they worked against, a set of civic paradigms. Thus in order to uncover the discursive assumptions that informed the *Air Pump*'s conversation with its audience, we shall need first of all to construct another dialogue, in this case between Wright and Shaftesbury, and between the different representations that each produced of contemporary society.

To analyse this relationship in a manner that will enable us to highlight the specifically pictorial issues at stake, I have decided to compare the *Air Pump* with an earlier painting that was authored, if not actually executed, by Shaftesbury himself:[21] the portrait of the 3rd Earl and his younger

[19] See Barrell, *Political Theory*, esp. 1–68.

[20] Here the key work of modern historical scholarship remains J. G. A. Pocock, *The Machiavellian Moment: Florentine Political Thought and the Atlantic Republican Tradition* (Princeton, NJ, 1975), esp. chs. 13 and 14.

[21] In a letter written from Rome in May 1699, referring to a conversation that had taken place prior to his departure from London, Closterman told Shaftesbury (or Lord Ashley as he then was) how pleased he had been to hear of his Lordship's 'thoughts for a family picture', which the artist promised to paint as soon as he returned home. (The letter, now in the Public Record Office, London, is quoted in full in Edgar Wind, 'Shaftesbury as a Patron of Art', *Journal of the Warburg and Courtauld Institutes*, 2 (1938–9), 187–8.) Though we do not know what those thoughts were, they presumably referred to the double portrait, which is the only work that Closterman produced depicting more than one member of the Shaftesbury family. Given Shaftesbury's exceptionally profound interest in the visual arts, and in the construction of his own self-image—together with the highly unusual character of the picture in question—we can be virtually certain that he would have devised a specific agenda for Closterman

brother, Maurice Ashley-Cooper, which the Anglo-German artist John Closterman painted *c.* 1700–1 (Fig. 3.2).[22] I am not going to suggest that this directly influenced Wright (it is not an image that he could have known); instead I shall be considering Closterman's painting in the manner of a blueprint, a sort of ideological ground-plan, if you like, for the social edifice that the Derby artist was to construct in paint some seven decades later.

Closterman's full-length canvas portrays the two Shaftesbury brothers garbed in what was then considered Grecian fashion, conversing in a wooded grove containing a temple with Ionic columns. The Earl, on the right, appears to listen as Maurice expounds dramatically about the nature that surrounds them both. Its rugged, sylvan character corresponds quite closely to what Shaftesbury described as the 'most sacred' order of natural scenery, filled with 'pines, firs, and trunks of other aged trees ... those sacred recesses, where solitude and deep retreat, and the absence of gainful, lucratible, and busy mortals, make the sublime, pathetic and enchanting, raises the sweet melancholy, the revery, meditation. "Where no hand but that of time. No steel, no scythe, but that of Saturn's." '[23] In the broadest sense, then, Closterman's painting reworks the familiar Horatian topos of virtuous rural retirement, setting up an implicit contrast between the wholesomeness of a tranquil country life on the one hand, and the active and self-interested pursuits associated with city or court on the other. At the same time, moreover, the rustic setting also recalls the tracts of wood-

to follow. In January 1713, during the last months of his life, Shaftesbury wrote a series of three letters to the Neapolitan painter Paolo de Matteis, from whom he had earlier commissioned the *Judgment of Hercules*, asking him now to paint another picture, showing the Earl himself as a dying philosopher and student of the arts. From the correspondence it is clear that Shaftesbury wished his artist to work to an extremely detailed iconographic and compositional programme; furthermore, he described the project as one for 'une Espèce de Portraiture moderne caracterisée et rendüe Historique'—that is, for a type of modern portrait, in character and historical. I suspect that much the same notion, together with an equally specific list of demands, had emerged in his discussions with Closterman more than a decade earlier. In that instance, too, the 3rd Earl had set out to show how the wise direction of a man of taste could raise 'face-painting' to the level of high intellectual dignity traditionally associated with historical art. For the correspondence documenting the Matteis portrait commission (which was never carried out), see J. E. Sweetman, 'Shaftesbury's Last Commission', *Journal of the Warburg and Courtauld Institutes*, 19 (1956), 110–16.

[22] The picture is actually inscribed with the year 1702, but has been dated slightly earlier by Malcolm Rogers, whose conclusions are based on a combination of documentary and stylistic evidence. See Rogers, 'John and John Baptist Closterman: A Catalogue of their Works', *Walpole Society*, 49 (1983), 231–2, 258–9.

[23] Rogers (Ibid., 259), was the first to make the connection between Closterman's picture and this (undated) passage, which comes from Shaftesbury's unfinished '*Plastics*', 163. In the same note the Earl recalls a time when he and Closterman discussed the different species of landscape whilst in the woods around St Giles's House, the Shaftesbury family seat; it thus seems highly likely that the forest shown in the picture would have specifically reminded the sitters of their own landed property.

3.2 John Closterman, *Anthony Ashley Cooper, 3rd Earl of Shaftesbury, and his brother the Hon. Maurice Ashley-Cooper, c.*1700–1, oil on canvas, 95¾ × 64¼ in., reproduced by kind permission of the National Portrait Gallery, London.

land that covered much of Shaftesbury's Dorset estate—trees that then as now constituted an important part of its economic value. Yet I think we can fairly say that the picture mystifies the relationship between its two sitters and their paternal acreage. Land does not figure here as something owned, or as a resource to be exploited; rather, in its character of a classical retreat the forest signifies property as a moral and political phenomenon, as a piece of God's nature that has been entrusted to the Shaftesburys, and that supports them in their character of virtuous public men.

In common with other British political theorists of the period, Shaftesbury assumed that the character of any society, and of any individual as a social actor, rests on property as its material foundation. All his writings display an unswerving commitment to the most authoritative account of this relationship—the civic humanist account, that is—which specifically describes land as the only possible basis for a truly virtuous polity, as the only sort of property that could guarantee its possessor true freedom of action and thought. Apart from granting him the leisure to study the workings of society, and thence to achieve wisdom, the ownership of a substantial piece of 'real' estate also ensures that the landlord's concerns will coincide with the public interest at large. He alone can possess the 'public' or 'civic' virtues, those necessary for the exercise of heroism or statesmanship, and he is uniquely qualified to direct the nation's affairs. Landed property thus enables the creation of an ideal society, in the form of a moral hierarchy ruled by an élite of disinterested masculine citizens. It was Closterman's brief to characterize Shaftesbury and his brother as members of this genuine 'public', of that select group responsible for good government and social order.

Both iconographically and formally, Closterman's painting strives to represent its subjects as men of comprehensive vision, whose philosophical meditations range over the entire spectrum of things created by man as well as God. Their concern for spiritual matters is amplified by the Greek inscription on the temple, which identifies it as dedicated 'To the Pythian God', that is, to Apollo in his legendary and oracular connection with Delphi, the pre-eminent classical meeting-place of the natural and supernatural worlds. As the divinity charged with responsibility for all the civilized arts, Apollo's stewardship embraces philosophy, which Shaftesbury ranked as the highest form of human intellectual endeavour. 'It has not its name', he writes, ' . . . from the mere subtlety and nicety of the speculation, but by way of excellence, from its being superior to all other speculations, from its presiding over all other sciences and occupations, teaching the measure of each, and assigning the just value of everything in

life.'[24] Thus (moral) philosophy constitutes the field of study *par excellence* for the man of public virtue, the arena in which he develops and displays his capacity to rule. For Shaftesbury the citizen-philosopher has most to learn from the example of Socrates, who showed how to transcend self-meditation to contemplate the public good.[25] The 3rd Earl could have found no better example to support his Stoic assertion that 'real virtue and love of truth [are] ... independent of opinion and above the world'.[26]

In the arena of aesthetic judgement, the disinterested Shaftesburian virtuoso demonstrated his superior wisdom by confining his admiration to works which instantiated his own capacity to identify those higher, general truths which lay concealed from the view of lesser, particular men. The genuine man of taste thus rejected what Shaftesbury called the 'affectations' of most modern art in favour of the 'natural grace' that he found expressed in the works of Greek and Roman antiquity:[27] it is for this reason that Closterman's portrait champions its commitment as emphatically as possible to the idealizing language of the classical tradition. Although the brothers' faces are sufficiently individualized to permit us to distinguish one from the other, their postures closely mirror the forms of an antique sculptural model—also describing two brothers, in this case Castor and Pollux.[28] The Shaftesburys, then, quite literally embody the universal character of the nature which surrounds them, and which supplies the object of their divinely inspired enthusiasm. Under his patron's direction Closterman produced what might justly be described as an historical portrait *avant la lettre*, a picture that could not only claim to be worthy of serious aesthetic appreciation, but that in its philosophical theme and its vocabulary of central forms demonstrated the capacity of its sitters to rise above their own particular interests in pursuit of the general good.

Of course, the Closterman is 'historical' in another, more obvious sense, inasmuch as it incorporates a narrative dimension. While a momentary exchange between two brother-philosophers may not make for much of a story, or certainly not a terribly eventful one, its portrayal does activate

[24] Anthony Ashley Cooper, 3rd Earl of Shaftesbury, *Characteristics of Men, Manners, Opinions, Times* (1711), ed. John M. Robertson, 2 vols. in one (Indianapolis, 1964), i. 193.

[25] Lawrence Eliot Klein, 'The Rise of "Politeness" in England, 1660–1715', unpub. Ph.D. dissertation, Johns Hopkins University, Baltimore, 1983, 437.

[26] Shaftesbury, *Characteristics*, i. 171.

[27] Shaftesbury, '*Plastics*', 110, 152.

[28] Closterman's reference to the *Castor and Pollux* (which the artist would have seen in Rome; it is now in the Prado) was first pointed out by Alex Potts; see Rogers, 'Closterman', 259. For a discussion of the various interpretations of the subject-matter of this sculpture, and its importance in the history of European taste, see Francis Haskell and Nicholas Penny, *Taste and the Antique: The Lure of Classical Sculpture 1500–1900* (New Haven, Conn., 1981), 173–4 (the statue is reproduced on p. 175).

the figures, and in so doing enhances the public character of the image as a whole. Its enlarged significance would have been particularly obvious, I imagine, to viewers who gained admittance into Shaftesbury's portrait gallery, where the Closterman must have stood out quite dramatically from the more static likenesses around it. But beyond forging a link between portraiture and history painting, the artist's introduction of a conversational element also operates on the philosophical level, indicating the means whereby individuals join together to become active builders of the social realm. Shaftesbury added his voice to a chorus of earlier moralists and religious thinkers when he claimed that contemplating the beautiful order of the cosmos could teach men how to pattern their lives in accordance with God's will. The Earl added a new dimension to this doctrine, however, by stressing that an awareness of divine goodness prepares men psychologically for communal life. As Shaftesbury puts it, 'the admiration and love of order, harmony, and proportion, in whatever kind, is naturally improving to the temper, advantageous to social affection, and highly assistant to virtue, which is itself no other than the love of order and beauty in society'.[29]

Although Shaftesbury places the 'social' or 'natural affections'[30] beneath the level of virtue proper (that is, public virtue), he insists that 'A public spirit can only come from a social feeling or sense of partnership with human kind'.[31] Any leader who looks down upon the rest of mankind from a position of scornful superiority can only be an unnatural tyrant, for

If eating or drinking be natural, herding is so too. If any appetite or sense be natural, the sense of fellowship is the same. If there be anything of nature in that affection which is between the sexes, the affection is certainly as natural towards the consequent offspring; and so again between the offspring themselves, as kindred and companions, bred under the same discipline and economy. And thus a clan or tribe is gradually formed; a public is recognized.[32]

Herein, I think, lies the primary reason why Shaftesbury made the unusual decision to commission an emphatically interactive portrait of himself and his younger brother.[33] No doubt he and Maurice liked one another, and

[29] Shaftesbury, *Characteristics*, i. 279; for this point I am indebted to John Andrew Bernstein, *Shaftesbury, Rousseau, and Kant* (Rutherford, N. J., 1980), 28.

[30] Shaftesbury, *Characteristics*, i. 286.

[31] Ibid., i. 72.

[32] Ibid., i. 74.

[33] Shaftesbury also commissioned Closterman to paint two single portraits of himself and his brother, as types of the contemplative and active man respectively. For these two works see Rogers, 'Closterman', 231–2, 240, 259–60, cat. nos. 5 and 86, pls. 57 and 58.

we know they shared a common interest in Socratic philosophy;[34] but surely the crucial point was to represent the pair as men possessed of those 'natural affections' that originate in the private confines of the family sphere and ultimately lead 'to the good of the public'.[35] Closterman, in other words, has depicted his sitters experiencing the 'pleasures of sympathy',[36] which for Shaftesbury constituted the corner-stone of all human happiness. It was sympathy that Shaftesbury saw as the force in human nature that enabled the creation of a coherent and harmonious society; by 'society' he meant that 'company' of landed gentlemen, like himself and his brother, who came to agreement and mutual understanding by 'sharing contentment and delight'.[37] The 3rd Earl summed up this goal in one word: politeness.

To the term 'politeness' Shaftesbury and a host of other contemporary English moralists assigned an importance and a range of meanings that would have come as a great surprise to earlier writers on the same subject. Politeness had traditionally been a matter of proper social form, that careful management of appearances which adorned the speech and actions of the virtuous man; according to the general consensus, it was 'the art of pleasing in company', as Abel Boyer wrote in 1702.[38] By the early years of the century, however, this definition was already in the process of being radically amplified and transformed. The general tendency was to try and situate politeness within a moral framework, to find some way to forge the substance of virtue and its surface ornaments into an ideal of virtuous sociability. Shaftesbury sought to bridge this gap by arguing that philosophy arose out of politeness. 'To philosophise', he wrote,

... is but to carry good-breeding a step higher. For the accomplishment of breeding is, to learn whatever is decent in company, or beautiful in arts: and the sum of philosophy is, to learn what is just in society, and beautiful in nature, and the order of the world ... Both characters [the well-bred man and the philosopher]

[34] Both the 3rd Earl and Maurice were unusually fond of Xenophon, who had drawn upon the teachings of Socrates to trace a continuous path leading from family to friendship to polity, just as Shaftesbury did in the passage I have just quoted (see n. 32). On Shaftesbury's admiration for Xenophon, whom he dared to rank even above Plato in importance, see Klein, 'Rise of "Politeness"', 437. Just about all we know about Maurice Ashley-Cooper, apart from the date of his death (1726), is that he translated Xenophon's *Cyropedia* into English. Closterman's single portrait of Shaftesbury (see previous note) actually includes a book by Xenophon, whose ideas must also have provided an important source for the double image we have been discussing.

[35] Shaftesbury, *Characteristics*, i. 286.

[36] Ibid., i. 300.

[37] Ibid., i. 298. My discussion of Shaftesbury's views on sympathy owes a great deal to Mullan, *Sentiment and Sociability*, 28–9.

[38] Abel Boyer, *The English Theophrastus* (London, 1702), 106. This reference comes from Lawrence Klein, 'The Third Earl of Shaftesbury and the Progress of Politeness', *Eighteenth-Century Studies*, 18, 2 (Winter 1984–5), 190. This excellent article and Klein's Ph.D. thesis provided the primary bases for my discussion of Shaftesburian politeness.

aim at what is excellent, aspire to a just taste, and carry in view the model of what is beautiful and becoming.[39]

Closterman's portrait of Shaftesbury and Maurice Ashley-Cooper seeks to give this elision pictorial form. Here the two brothers figure as gentleman-philosophers, as men of good manners as well as good morals. The enthusiasm they display for the highest beauties of the cosmos is conveyed by bodies that manifest the excellent taste of the truly well-bred. Disposed in harmony with the woods behind them, and in accordance with the dictates of classical art, their postures conjure up the early eighteenth-century vocabulary of polite values: naturalness, ease, freedom, elegance, and refinement are just some of the more obvious examples that spring to mind.[40]

According to Shaftesbury, such qualities could best be modelled on the gentlemanly art of conversation; thus Closterman's double portrait effectively joins the manner of politeness to its quintessential matter. Here, as in so many of Shaftesbury's own writings, the conversational ideal is defined as an exchange of discourse among men of equal rank who address themselves to topics of mutual concern. Acting on their sympathy for one another, and out of respect for the rules of propriety and decorum, they place all selfish impulses to one side, and display that quality of dis-interestedness that not only guarantees their public spirit, but also sets them apart from their social inferiors. As the medium for perfecting taste, philosophy, and the social affections, polite conversation builds the very foundations of the commonwealth of virtue. It is that commonwealth in microcosm—the classical republican ideal of society as a 'mutual converse'[41] among masculine landowning citizens—that Closterman has portrayed.[42]

Equally to the point, perhaps, the double portrait also marks the inter-section of a dialogue between Shaftesbury and his fellow-citizens. Clo-sterman's task was simply to execute the designs of his virtuoso patron, to play the mechanical hand to the Earl's authorial mind. This was culture as created by and for the public man, both to demonstrate and to confirm the virtuous character that he possessed and shared with men of equivalent rank. But if these factors defined the conditions of cultural production and

[39] Shaftesbury, *Characteristics*, ii. 255.

[40] See Klein, 'Rise of "Politeness"', 43.

[41] Shaftesbury, *Characteristics*, i. 294.

[42] I am acutely aware that the Closterman double portrait raises a number of important questions that I cannot explore within the context of this paper; above all, it is not as 'pure' a statement of Shaftesbury's civic ideals as my treatment of it here might lead one to believe. A more comprehensive, and I hope a less reductive, account of this picture (and of Wright's *Air Pump* as well) will appear in my forthcoming book on painting and the public sphere in eighteenth-century England.

reception in an ideal Shaftesburian polity, it was an entirely different sort of world that produced Wright of Derby's *Air Pump*, and that his picture in turn re-produced.

The *Air Pump* was conceived by a professional artist operating independently of any patron;[43] Wright had established this brand of large-scale imagery, with its spectacular chiaroscuro, as his own particular speciality, one intended to attract maximum attention at an exhibition that attracted many thousands of viewers. Almost certainly, too, he designed the *Air Pump* with the reproductive print trade in mind. Under such circumstances the pressures to succeed demanded the sort of picture that would appeal to a much larger and socially more heterogeneous audience than Shaftesbury's public of landed gentlemen; though Wright evidently had ambitions of producing a serious moral painting, he also wanted to make something that would sell, that would be both accessible and popular, even if this entailed ignoring the hierarchical imperatives of academic theory. To Shaftesbury all such considerations would have been anathema, symptomatic of the deleterious effects of commerce on the visual arts, and on the fabric of society in general. In his efforts to preserve public virtue, economic activity—we recall his scornful reference to 'gainful, lucratible and busy mortals'—figured only negatively, as the force that posed the greatest threat to a healthy and coherent social order. Commerce tended to promote private desires at the expense of public needs, to encourage the spread of avarice, and to stoke the flames of luxury, that pernicious agent of corruption responsible for the downfall of so many great civilizations. At the same time the rising power of the market-place brought about a corresponding decline in a nation's cultural achievements; if there were no true public, there could be no truly public art, but rather an art that expressed particular truths, and catered to private appetites and interests. Hence, according to Shaftesbury, a commercial society could only produce a corrupted form of painting—that of seventeenth-century Holland being an obvious case in point. Yet if for him the Dutch school exemplified all that was antithetical to a dignified art, Joseph Wright evidently saw no contradiction between seriousness of moral purpose and a Netherlandish style. The other major source for his candlelight scenes—the English

[43] It is quite possible that Dr Benjamin Bates—who had earlier purchased the *Gladiator*—bought the *Air Pump* prior to its going on exhibition. In the Society of Artists' exhibition catalogue, Wright's title is not accompanied by the asterisk that denotes works available for purchase—though for the sake of preserving an aura of professional dignity (and success), painters were frequently reluctant to signal that they were on the look-out for potential patrons. In any case, given the usual pattern of transactions in the 18th-century English art market, a large subject-picture like the *Air Pump* is far more likely to have been painted and then purchased, as opposed to being commissioned in advance of its production.

conversation-piece tradition—was if anything even more problematic, both ethically and aesthetically, in so far as it focused on the trappings of opulence, which were often charged with encouraging selfish passions and illegitimate desires. Furthermore, the *Air Pump* specifically belonged to that category of conversational imagery which featured contemporary types as opposed to specifiable portraits—the best-known earlier examples being Hogarth's modern moral subjects. Wright's viewers would have known that such high-life genre scenes typically described their human actors in situations of moral peril, tempted or trapped by those irrational fantasies of wealth and status engendered by the agency of commerce. And it is precisely the central theme of Hogarth's progresses—the character of social conditions and relations in a commercial world—that Wright's *Air Pump* asked its viewers to judge.

That act of judgement, however, could not take place in an ideological vacuum. As I have already suggested, it had to be shaped by a set of established criteria, which I would say were broadly identical to those that informed Wright's attempt to represent his society to itself. For him, as for other mid-eighteenth-century British artists and writers, the task of 'producing society' had still to be conducted within the conceptual parameters defined by Shaftesbury and other civic humanist thinkers, even though at the same time Wright had to acknowledge—as the *Air Pump* surely does—that the actual circumstances of life in contemporary Britain no longer corresponded to the civic ideal. How, then, does the *Air Pump* inflect the discursive agenda that we have identified as the motivating force behind the Shaftesbury double portrait? What has happened to philosophy, politeness, conversation, sympathy, once these various attributes of classical citizenship have been deprived of their original enabling material foundation?

Shaftesbury and Closterman had represented property in its civic sense, as the material that guarantees a citizen's autonomy: a solid and immovable part of the natural world that is subject neither to improvement nor to exchange. Wright's figures, on the other hand, inhabit a universe of circulating commodities, the fruits of wealth from an indeterminate source. Here we see property not as a share of the public stock that has fallen to an individual by dint of birth or fortune, and that in turn allows him to fulfil his political potential, but rather as things that have been purchased to satisfy personal desires, to enable a more pleasant life. Where Closterman includes a Delphic temple to conjure up the transcendent values of classical civilization, Wright shows a doorway ornamented in the most up-to-date pseudo-antique style; and rather than wearing the ostensibly timeless garb

of the ancients, his figures are comfortably dressed according to the fashion of the later 1760s. Instead of trees we can just make out the bottom edge of an ornately framed landscape painting, in the upper left-hand corner; in place of an irregular 'wilderness', the perfect geometry of a wood and metal cage, and a moonlit vista framed by the bars of a casement window. Of all the various items shown in the interior, one of the more costly is the air pump itself; if scientific instruments were meant to expand the boundaries of human knowledge, they also entered many eighteenth-century homes as part of a thriving trade in luxury goods. Most of the objects and articles of clothing that Wright depicts would have originated in various parts of Britain, the one major exception being the white cockatoo, a rare and expensive bird from the East Indies which seems to have been quite unknown in Europe prior to 1760.[44] The bird is not the only living creature that has come into Wright's interior from the world outside; the same is true for the majority of his figures. While the scene appears to take place in the home of the incomplete family unit formed by a father with his two daughters, most of the remaining company would seem to consist of friends or relations gathered for this particular occasion. An even larger network of personal connections, and in this case of a distinctly commercial sort, is suggested by the presence of an itinerant natural philosopher, one of those travelling salesmen who peddled knowledge together with the tools of his trade. The objects and activities contained within this candlelit space thus presuppose the existence of a complex network of production and exchange, involving a countless number of particular and interdependent interests, of manufacturers, consumers, and intermediaries.

The emphatic modernity of the scene that Wright has described also indicates that this is a world that is subject to change; his *Air Pump* acknowledges a history, in other words—and one might say a geography as well—which Closterman's portrait of the Shaftesburys effectively sought to deny. The classical citizen—here I am paraphrasing John Pocock—did not see himself as the mere product of historical forces, of a specific phase in the development of any individual nation, but as the personification of an ideal that transcended time and place.[45] As we have noted, Shaftesbury believed that this world of value could only be visualized in the central forms of classical art; by abandoning that tradition in favour of painting in such a 'peculiar way', and in so highly particularized a pictorial language, Wright located both his art and the figures he portrayed within the

[44] The species of Wright's bird has been identified, and some of the implications of his choice discussed, in Schupbach, 'Animal Experiment', 346.

[45] Pocock, *Machiavellian Moment*, 466.

specialized conditions of social life that distinguished their world from the past.

The way in which the *Air Pump* insists on the individually distinctive characteristics of the various people and objects it portrays underlines the effect of commerce on social personality, how the whole figure of the public man has split into an array of human fragments. Wright shows men of various ages, a young woman, children[46]—each of whom manifests a different and partial response to the crucial phase of the experiment, and to its broader moral implications. None of the atomized individuals described in the *Air Pump* possesses the full rationality that had defined the character of the autonomous citizen; the unified construction of the gentleman-philosopher has succumbed to the division of labour, which has produced a world where philosophers are not gentlemen, and gentlemen are just as obviously not philosophers. While they may all aspire to understanding the workings of nature, for them its overall shape remains a mystery, a darkened cosmos that can only be perceived in discrete bits, by means of scientific rituals designed to demonstrate certain specific natural laws. The truths they seek to learn are those established by 'unexceptionable Experience and Observation', as George Turnbull would have phrased it; from an experiment that by the 1760s had been performed repeatedly for more than a century, they expect confirmation of what is already known. The air pump offers them a particular instance of the operation of a general principle, a law of nature, which they are (like us) then prompted to consider (though not all of them may do so) in its moral and religious dimensions. Hence Wright's invocation of the central human dilemma, concerning the temporal passage through life and into death; hence, too, his depiction of both earthly and heavenly light (candle and moon), which ask to be seen in relation to one another, as well as to the supreme and invisible author of enlightenment (in both the physical and spiritual senses of that word). That scientific demonstrations were meant to stimulate some degree of moral understanding was a commonplace notion in eighteenth-century educational literature. As Charlotte Lennox put it in 1760, 'to the mind of clear and cool reflection [the] use [of studies in natural philosophy] is plain and evident; they lead by smooth and regular gradations to peace and happiness; they raise the thoughts to humanity and devotion, and, by a regular transition, convey our contemplation from the creature to its Creator'.[47]

[46] It has often been suggested, and no doubt appropriately, that Wright selected his figure-types to invoke the traditional topos of the Ages of Man; see e.g. Paulson, *Emblem and Expression*, 186.

[47] Lady Charlotte Lennox, *The Lady's Museum*, 2 vols. (London, 1760–1), i. 136.

From observing particular phenomena, therefore, those who indulged in scientific study as a form of fashionable amusement strove to gain an intimation of general truths; but such truths could only be glimpsed from beneath, as it were, from the viewpoint of individuals with limited interests and experiences, of born subjects rather than born rulers—Lennox was speaking to an audience of women. To them she recommended natural philosophy for one reason above all: as a means of directing the dangerous female passion of curiosity into a safe and rational channel.

The *Air Pump* appears to support the opinion, voiced in numerous contemporary discussions of female education, that women can only gain an understanding of natural laws if male partners or fathers are there to act as intermediaries (would the same conditions have applied to an appreciation of the fine arts?). Yet the very fact that both sexes are present underlines the distance Wright has travelled from Shaftesbury's insistence that philosophical knowledge can only follow as a natural consequence of that genuine good breeding which is confined to the community of public men. By the 1760s, now that scientific study had entered into the lives of a much larger constituency, this progression tended more often than not to be argued in reverse: a claim frequently voiced by the popular scientists of the period was that their products actually helped to make men and women well-bred. In the words of one of the most successful of these didactic entrepreneurs, 'Knowledge is now become a fashionable thing, and philosophy is the science à la mode; hence, to cultivate this study is only to be in taste, and politeness is the inseparable consequence.'[48] Under circumstances such as those described by Wright in his *Air Pump*, the discussion of philosophy could help inculcate the virtues of sociability— but it falls far short of producing or communicating the comprehensive wisdom of the classical citizen. Perhaps this is the most that one can expect of philosophy in a commercial society: that together with the other civilized arts, it can contribute to a process of refining the passions into manners.[49]

The *Air Pump* makes it clear that this is a process that works over time: while the distress shown by the two young girls may express a perfectly 'natural' sympathy for the bird—this is an issue that I shall return to later—their reactions transgress the rules of decorum to which all the older members of the group conform. Self-command comes about through the agency of education—or, perhaps one might more accurately say, thanks

[48] Benjamin Martin (1704/5–82), quoted in J. R. Millburn, *Benjamin Martin, Author, Instrument Maker, and 'Country Showman'* (Leyden, 1976), 44.

[49] For an extended discussion of this issue of refinement, see J. G. A. Pocock, *Virtue, Commerce, and History* (Cambridge, 1985), esp. ch. 6.

to social commerce, through the exchange of sentiments and opinions that defines the improving function of conversation. 'It was not from Books, that I learned the most instructive affecting Lessons,' spoke a fictive young woman in a mid-century pedagogic dialogue; rather, 'It was by conversing with the better Part of the World'.[50] There could have been no doubt in the minds of Joseph Wright's original viewers but that the *Air Pump* portrayed their world's 'better part'—people 'of quality', both materially and morally, gathered together for the laudable purpose of improving themselves and one another. Yet here conversation, like philosophy, lacks the public character that Shaftesbury had ascribed to the speech shared by masculine citizens; Wright's figures, unlike Closterman's, occupy an emphatically private space closed off from the world outside. The private character of the gathering around the air pump is underlined by the presence of the children, and also by the inclusion of a token female presence within a group dominated by adult men.

Contemporary moralists never tired of recommending the mixing of the sexes as a mutually beneficial conjunction. 'The Man not only protects and advises, but communicates Vigour, and Resolution to the Woman,' claimed an altogether typical writer on the subject. 'She, in her turn, softens, refines, and polishes him.'[51] One woman who appears to have done her job well is the unseen mother of Wright's two young girls, whose absence asks to be read, I believe, as a sign of her domestic virtue. In a conduct-book published in 1756, simply entitled *The Wife*, Eliza Haywood condemned the married woman who indulged in the 'madness' of natural philosophy:

it best becomes her to center her whole studies within the compass of her own walls,—to enquire no farther than into the humours and inclinations of her husband and children, to the end that she may know how to oblige those she finds in him, and rectify what is amiss in them, and not to extend her speculations beyond her family, and those things that are entrusted to her management.[52]

It is because the mother has met all these obligations that the table in the *Air Pump* is so brilliantly polished, the children so well presented and so deferential, and her husband such a paragon of paternal benevolence. Yet at the same time his behaviour points to a broader pattern of social amelioration. As John Millar was to state in 1771,

The improvements in the state of society, which are the effects of opulence and refinement, will ... dispose the father to behave with greater mildness and

[50] David Fordyce, *Dialogues concerning Education*, 2 vols. (London, 1745), ii. 144.
[51] David Fordyce, *The Elements of Moral Philosophy* (London, 1754), 157.
[52] 'Mira' (Eliza Haywood), *The Wife* (London, 1756), 201.

moderation in the exercise of his authority. As he lives in greater affluence and security, he is more at leisure to exert the social affections, and to cultivate those arts which tend to soften and humanize the temper ... Being less occupied with the care of his own preservation, he enters with more delicate sensibility into the feelings of others, and beholds their distresses and sufferings with greater sorrow and commiseration.[53]

While eighteenth-century British culture granted women an important role in the civilizing process, ultimately what made such improvement possible was the ease and opulence engendered by the rise of commerce.

David Hume, I think, may have best summarized this point of view in one of his moral *Essays* from the early 1750s. Defending the luxuries produced by commercial societies, he insists that

The more these refined arts advance, the more sociable men become ... They flock into cities; love to receive and communicate knowledge; to show their wit or breeding; their taste in conversation or living, in clothes or furniture ... Particular clubs and societies are every where formed: Both sexes meet in an easy and sociable manner; and the tempers of men, as well as their behaviour, refine apace. So that, besides the improvements which they receive from knowledge and the liberal arts, it is impossible but they must feel an increase of humanity, from the very habit of conversing together, and contributing to each other's pleasure and entertainment. Thus *industry, knowledge*, and *humanity*, are linked together, by an indissoluble chain, and are found, from experience as well as reason, to be peculiar to the more polished, and what are more commonly denominated, the more luxurious ages.[54]

The *Experiment on a Bird in the Air Pump* manifests Wright's commitment to the ideology of refinement as much by virtue of its smoothly polished surface texture as through his choice of subject-matter, which would seem to describe the same 'indissoluble chain' so highly praised by Hume. In his own way Wright, too, was trying to show that a commercial society could produce individuals (including artists) capable of sharing the citizen's disinterested sympathy for creatures beside himself. Yet if we look back to the Closterman double portrait, it becomes immediately obvious that Shaftesbury construed sympathy in a fundamentally different sense. Rooted in their fraternal origins, the fellow-feeling displayed by the 3rd Earl and his younger brother expands outwards to encompass the whole of creation; the natural affections, Shaftesbury had argued, build the foundations of public virtue. In the *Air Pump*, by contrast, sympathy works

[53] John Millar, *Observations concerning the Distinction of Ranks in Society* (London, 1771), 102–3.
[54] David Hume, 'Of Refinement in the Arts' (1752), in *Essays Moral, Political and Literary*, ed. Eugene F. Miller (Indianapolis, 1987), 271.

inwards, and within much narrower constraints. The two girls are much affected by the plight of the struggling bird, and the father by the anxiety of his children; the young woman looks with some affection towards her husband or lover. But neither this couple nor anyone else, apart from the father, manifests any evident concern for the afflicted children or the cockatoo. As personal relationships become more distant, sympathy gives way to other reactions: the curiosity about science shown by the two seated figures on the left, and the apparently complete self-absorption enacted by the older man. This pattern of responses would seem to suggest that in a refined and opulent society, the workings of sympathy tend to be confined to circumstances of especial closeness. Adam Smith had made much the same point some nine years earlier in his *Theory of Moral Sentiments*: 'Men', he claimed, 'though naturally sympathetic, feel so little for another, with whom they have no particular connexion, in comparison with what they feel for themselves.'[55] For Smith, as Jean-Christophe Agnew has remarked, 'fellow-feeling was, more than anything else, a mark of the immense distance that separated individual minds rather than a sign of their commonality',[56] as Shaftesbury had believed. The 'mutual converse' that was his virtuous commonwealth presupposed a fundamental congruence of interests among all members of the political republic. Social affection among citizens confirms the fact that they know themselves and one another in the identical character of public men; whereas in a world subject to the division of labour, it takes an act of imagination for particular individuals to identify—if indeed they do at all—with the passions experienced by others whose situation is quite different from their own.[57] Thus the sisters in the *Air Pump* enter into the sentiments of the bird by imagining what its feelings might be like; they respond as beholders to a dramatic spectacle of distress, just as we respond to the scene as a whole. From our privileged position in the audience, we can project ourselves into the position of Wright's various actors, up to and including the poor cockatoo. The highlighted emphasis on the family group draws our attention to this touching vignette—Wright positions the spectator, in other words, as a connoisseur of admirable but exceptional feelings,[58] though in

[55] Adam Smith, *The Theory of Moral Sentiments* (1759), ed. D. D. Raphael and A. L. Macfie (Oxford, 1976), II. ii. 3, 86.
[56] Jean-Christophe Agnew, *Worlds Apart: The Market and the Theater in Anglo-American Thought, 1550–1750* (Cambridge, 1986), 178.
[57] My discussion of the imagination as a vehicle for sympathetic feeling owes a good deal to Agnew, *Worlds Apart*, 178 and *passim*. Other useful treatments of this issue may be found in Mullan, *Sentiment and Sociability*, and in David Marshall, *The Figure of Sympathy: Shaftesbury, Defoe, Adam Smith, and George Eliot* (New York, 1986).
[58] Cf. Mullan, *Sentiment and Sociability*, 13–4.

so doing he also invites us to take pleasure from distress. This may make an important contribution to the education of human sentiments, as numerous eighteenth-century moralists would have had their readers believe.[59] Yet the scene that Wright has described cannot help but raise certain ethical doubts: how virtuous are the people whom the painter has portrayed? and how virtuous the world 'reflected' on his canvas?

The answers to these questions hinge around the feature that dominates Wright's pyramidal composition: the receiver containing the suffocating bird. We can, I think, be virtually certain that its treatment would have struck many eighteenth-century viewers as an unnecessary act of cruelty (or as morally problematic, at the very least); contemporary popular science texts frequently recommend the use of a bladder or a 'lungs-glass' instead of a live animal, so as to avoid causing unnecessary pain both to the creature itself and to the human spectator.[60] And if we are to identify the cockatoo as a household pet, as at least one critic justifiably assumed in 1768,[61] then the exploitation of its suffering for the entertainment of an intimate sociable gathering cannot help but strike us as more than a little paradoxical. Here sympathy, together with the pursuit of knowledge, would appear to operate in a manner inconsistent with the dictates of morality; Hume's 'chain' may not be quite so 'indissoluble' after all. The progression from industry through knowledge to humanity may indeed be peculiar to the most polished societies; but, judging by the *Air Pump*, such societies may be just as likely to tread a downward path, leading from commerce to luxury, and from self-interest to cruel indifference. Wright's philosopher plays a particularly problematic role in this regard: for in demonstrating his expertise for his own profit and for the benefit of his audience, he also assumes a power over life and death, a power that he cannot control with certainty, and that is not rightly his, but God's. There is danger here for all the

[59] For a good example of how popular science texts could promote the suffocation and electrocution of animals as a means of teaching children both to care for helpless creatures, and to appreciate the wisdom of God, see Benjamin Martin, *The Young Gentleman and Lady's Philosophy*, 2 vols. (London, 1755), i. 398–400, 311–12. The relevant passages from Martin are quoted in Schupbach, 'Animal Experiment', 342–5.

[60] This issue is discussed in Schupbach, 'Animal Experiment', 341–2, and in David Fraser, 'Joseph Wright of Derby and the Lunar Society', in Egerton, *Wright of Derby*, 19. Here Fraser also points out that Wright appears to have based the figure of the boy lowering or raising the cage on the man pointing upwards to a skeleton on the left-hand side of Hogarth's *The Reward of Cruelty* of 1751. The connection between Wright and Hogarth deserves further thought, as I shall suggest below.

[61] The anonymous author of *Critical Observations on the Pictures, which are now exhibiting at the Great Room, Spring-Garden, Charing-Cross, by the Society of Artists of Great Britain, 1768* (London, 1768), 15, singles out the 'child whimpering for her pigeon' in the *Air Pump* as a 'tender and ingenious' touch. The fact that the cage appears to form part of the permanent furnishings of the room indicates that the bird must be a family pet. Given the rarity of the cockatoo, it comes as no surprise to learn that at least one contemporary viewer mistook it for another species.

actors in the *Air Pump*, a point underlined by the overtly religious character of Wright's image as a whole: that in pursuing their various interests these individuals will miss the true purpose of the experiment, which is to make mankind aware of the supreme wisdom of the Divinity, and to encourage them to conduct themselves in accordance with His will, and in the knowledge that He holds their fate within His hands.[62] The fact that the bird may die at any moment underlines the transience of their earthly existence; and to drive this point home, Wright has described the murky shape of a decaying human skull in the jar that sits in the centre of the table, where it is ignored by all but the oldest member of the company (he who is closest to death). The conjunction of skull and candle—we can just make out the taper's form along the left-hand side of the jar—functions here, as it had long done in Netherlandish art, as a sign of the vanity of human pleasures.[63] Prominent among those pleasures are philosophy, sympathy, and polite conversation; in the circumstances of private opulence, the corner-stones of what once had been the Shaftesburian ideal polity have lost their ethical moorings, and have taken on the mutable character of mobile forms of property, of refinements that may improve, but that can just as easily corrupt.

The *Air Pump*, then, differs in certain fundamental ways from the sort of moral picture that Shaftesbury or Turnbull had recommended. Among works of art, Turnbull claimed, it is

those which excite our moral Affections, and call forth generous Sentiments, that yield us the highest and most satisfactory and lasting Entertainment ... if those Imitations, which call forth our Pity and Compassion into Exercise, and interest us in behalf of Virtue and Merit, are indeed the Representations that give us the highest Satisfaction, it must be confessed that we are qualified by Nature to receive high Pleasure from social Affections, and virtuous Exercises; and that our Frame and Constitution is social and virtuous, or deeply interested by Nature in behalf of Worth and Merit.[64]

Although the *Air Pump* fulfilled many aspects of this agenda for history painting, at the same time it played the admonitory role of a 'modern moral

[62] This might be the appropriate time to suggest that the actors in Wright's other large candlelights are also shown treading on morally dangerous ground—that by focusing so intently on the visible objects immediately in front of them, they may lose sight of larger, less tangible, but more important truths. In the *Air Pump*, however, where action is joined to contemplation, such dangers more overtly manifest their presence. Fraser makes something of a similar point, in reference to the general theme of the transience of life, which also plays a part in the *Orrery*, in his 'Lunar Society' essay, 20.

[63] William Schupbach was the first to point this out, and to note that skulls are never mentioned in contemporary descriptions as present at scientific lectures of the sort portrayed by Wright; see 'Animal Experiment', 346.

[64] Turnbull, *Treatise*, 141–2.

subject': it is Wright's own *Midnight Modern Conversation,* if you like.[65] Like Hogarth, though with a far greater degree of ambivalence, Wright withheld ethical sanction from the social order he had produced on canvas, and from the fashionable world he addressed. Clearly there was a great deal to be said for a society that attended lectures on natural philosophy, or visited exhibitions of the fine arts; the exchange of opinions and material objects no doubt helped to refine the passions and to nurture social affections, but further work would have to be done before the task of building a commercial humanism could be brought to a successful conclusion. Together with many other products of mid-eighteenth-century British culture, the *Experiment on a Bird in the Air Pump* describes a new ideology in the making, albeit not yet entirely certain of its ground—an ideology inscribed with difficulty on to an older structure of civic and Christian values, which made it impossible to celebrate modern property relations without a profound sense of ethical unease. Perhaps Wright's picture can also offer us a timely word of warning, before we join the chorus of acclamation for those market forces we see marching in apparent triumph across the globe today.

[65] This is not an entirely frivolous analogy. If Wright's large candlelights did remind their original viewers of any earlier depictions of nocturnal conviviality, then one could hardly think of a more likely candidate than the *Midnight Modern Conversation.* It may be just coincidence (though I am inclined to suspect otherwise) that Hogarth's work also features an outstretched hand (holding a glass) at the central apex of its composition, and a large bowl occupying a prominent position on the table—though the contrast between its contents and those of Wright's jar could hardly be more emphatic. There would also seem to be formal similarities between the poses of the two figures on the right-hand side of the *Modern Conversation,* and those of the grey-haired man and the older of the girls on the same side of the *Air Pump.* The possibility of Wright's borrowing pictorial ideas from Hogarth, and in so doing enhancing the semiotic richness of his work, has already been raised by David Fraser; see n. 60 above.

4

Curiously Marked: Tattooing, Masculinity, and Nationality in Eighteenth-Century British Perceptions of the South Pacific

Harriet Guest

I

In 1776, Joshua Reynolds exhibited his full-length portrait of Omai at the Royal Academy in London. Omai (or Mai) came from Raiatea, an island not far from Tahiti, and had arrived in England in 1774 on board one of the ships commanded by James Cook on his second circumnavigation of the globe (Fig. 4.1). His appearance fed and encouraged the 'great curiosity'[1] that had been stimulated by accounts of the Pacific islanders after Cook's first voyage to the southern hemisphere, and Reynolds's portrait, I think, images that curious interest. For it can be understood both to represent and to smooth over the internal ambivalences that European powers project into colonialist expansion in the South Pacific, and thus to indicate the complex intersection of conceptions of the domestic and exotic which I want to explore in this essay.

The Humanities Research Centre, Canberra, awarded me a visiting fellowship which enabled me to work on this essay there. I am also grateful for the comments of John Barrell, Felicity Nussbaum, and Nicholas Thomas, and of seminar groups at the Australian National University, and the universities of Sydney, Wellington, and Auckland.

[1] The title of the islander was Mai, but most 18th-century British accounts name him Omai, or Omiah. I have adopted this colonialist form because it is British representations of the islander that I intend to discuss, and because it is still more widely used. I quote from *The Early Diary of Frances Burney, 1768–1778*, ed. Annie Raine Ellis, 2 vols. (London, 1913), i. 337.

Reynolds's *Omai* seems to present an immediate contrast to contemporary portraits of European subjects. It is not a private or intimately sociable image, comparable to some of Reynolds's portraits of fashionable women, or men in repose. But nor is it a portrait which indicates any social or public command. Though, as Bernard Smith has pointed out, the Tahitian assumes the pose of the 'self-confident patrician',[2] that seems to indicate the incongruity between domestic conventions or manners and exotic subject, for the figure demonstrates patrician authority only in ambiguous command of the spectator's curious gaze. Omai seems to be figured here as an orientalized 'noble savage', cleansed of characteristics that might mark his origin or history, and effaced by being endowed with what a recent biographer considers to be the 'somewhat negroid features' of 'an African princeling'.[3] The generalization of the image seems to make of Omai a blank figure, available to that diversity of inscription that George Forster commented on in European assessments of his character. He wrote that: 'O-Mai has been considered either as remarkably stupid, or very intelligent, according to the different allowances which were made by those who judged of his abilities.'[4] The inscrutable glazed effacement, which dislocates the image of Omai from standards that might measure allowances, or legitimize judgement, may, however, be exceeded or punctured in Reynolds's representation. The figure may be marked by a specifically colonialist curiosity that perceives the islander in terms that resist generalization, or perhaps even representation. It may construct—through what is concealed as well as what is discovered to the spectator's gaze—a focus or standard for judgement that privileges the exoticism rather than the Orientalism of the image.[5]

Exoticism, I suggest, inscribes its object with an acultural illegibility, isolated from any coherence of origin. Exoticized subjects are characterized as sports, marked as singular tokens lacking any significance beyond that of a fragmentary and unrepresentative (perhaps unrepresentable) insularity. This is perhaps no more than a strand within that cluster of discourses that constitute Orientalism in this period. But it may be useful to tease out this thread, and to emphasize its difference from that Orientalism which

[2] Bernard Smith, *European Vision and the South Pacific* (New Haven, Conn., 1985), 80–1.
[3] E. H. McCormick, *Omai: Pacific Envoy* (Auckland, 1977), 174.
[4] *A Voyage round the World*, in *Georg Forsters Werke*, ed. Robert L. Kahn (Berlin, 1968), i. 15.
[5] O. H. K. Spate compares Reynolds's image to that of 'a youthful Oriental sage' in *The Pacific since Magellan, III: Paradise Found and Lost* (Canberra, 1988), 256. The notions of Orientalism and exoticism I discuss are clearly, if indirectly, indebted to Edward Said's work on the subject. I discussed some of the issues raised here in my essay, 'The Great Distinction: Figures of the Exotic in the Work of William Hodges', *Oxford Art Journal*, 12, 2 (1989).

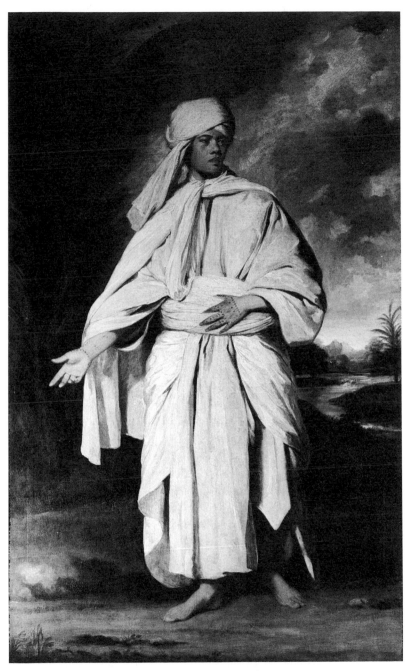

4.1 Sir Joshua Reynolds, *Omai*, 1775–6, oil on canvas, 236 × 146 in., Castle Howard,
Yorkshire; reproduced by permission of the Hon. Simon Howard.

assimilates its object to a generalized homogeneity, a wealth of inscrutable detail that it is the perquisite of the knowing European to articulate. For this thread of exoticism may help to unravel the peculiar texture of fascination and indifference that characterizes colonialist representations of the people of the South Pacific.

Joseph Banks had wished to bring an islander back with him as a souvenir of his trip to the South Pacific on Cook's first voyage. He noted in his journal that government could not be expected to take an interest in this project, but, he added; 'Thank heaven I have a sufficiency and I do not know why I may not keep him as a curiosity, as well as some of my neighbours do lions and tygers at a larger expense than he will probably ever put me to.' His notorious remarks on 'the amusement I shall have'[6] from this scheme indicate the private status of ethnological curiosity, and, in the allusion to private zoos, emphasize the extent to which that curiosity thrives on the isolation of its exotic object, on the colonializing displacement or dislocation of its object from any signs of the personal estate or cultural context that might produce legible or potent significance. Banks's curiosity seems to demand the unmediated access that John Rickman alluded to in his account of Cook's last voyage, where he lamented the inadequacy of 'the feeble pencil of a fribbling artist' to represent the islanders. A more gratifying object of study might have been provided, he suggested, by 'the importation of a native from every climate', to stock an academy with 'living pictures'.[7] The generalization of landscape, clothing, and physiognomy that makes an orientalized figure of Omai in Reynolds's portrait may be marked specifically by the colonialist curiosity animating Pacific expansion, which demands that its objects be presented stripped of context, and feeds on the wondrous exoticism which that nakedness enforces.[8]

The project of Pacific exploration is in some senses exceptional, and perhaps unrepresentative, in the history of European colonialism. A voyager commented, in an account of the South Pacific published in 1793, that the islanders' 'remote situation from European powers has deprived them of

[6] *The Endeavour Journal of Joseph Banks, 1768–1771*, ed. J. C. Beaglehole, 2 vols. (Sydney, 1962), i. 312–13.

[7] John Rickman, *Journal of Captain Cook's Last Voyage to the Pacific Ocean* (Amsterdam, 1967), 185.

[8] See Nicholas Thomas, *Entangled Objects: Exchange, Material Culture and Colonialism in the Pacific* (Cambridge, Mass., 1991), ch. 4. The clothing of Reynolds's figure bears some resemblance to that represented in pl. 3 of Sydney Parkinson, *A Journal of a Voyage to the South Seas* (London, 1984), as well as to conceptions of oriental and classical drapery. It may be the kind of clothing Horace Walpole alluded to in his comment that the plates from Cook's published voyages showed men and women 'dressed unbecomingly as if both sexes were ladies of the highest fashion' (quoted in Michael Alexander, *Omai: Noble Savage* (London, 1977), 108).

the culture of civilized life, as they neither serve to swell the ambitious views of conquest, nor the avarice of commerce. Here the sacred finger of Omnipotence has interposed, and rendered our vices the instruments of virtue.'[9] The writer alludes to the particular vices of Fletcher Christian and the *Bounty* mutineers, which he argues, might inadvertently work to civilize or enlighten the islanders. He imagines that the mutineers, isolated as a result of what he sees as their vicious rebellion, might establish proto-European communities in the Pacific. But what is I think significant, in this reflection on late eighteenth-century European expansion, is the suggestion that the underdetermined nature of European interest in the South Pacific produces or enables moral conflicts and inversions, a blurring that can only be deferred to the hand of Providence for its resolution. The project of expansion seems to disclose the moral and political ambivalences of the 'culture of civilized life'. The British repeatedly articulated their interest in the South Pacific in terms of the underdetermined and ambiguously transactive notion of curiosity—what Boswell identified as 'the enthusiasm of curiosity and adventure', experienced when 'one is carried away with the general grand and indistinct notion of A VOYAGE ROUND THE WORLD'.[10] The sense that this project is somehow set apart from the ambitious views of conquest, trade, and settlement by the whimsicality, licentiousness, or enlightened and scientific purity of curiosity seems to point to an internal and domestic ambivalence about the demarcation of vice from virtue—to an equivocation within the culture of civilized life that may be projected and exoticized in Reynolds's image.[11]

Omai was perceived by Cook to be 'dark, ugly', and therefore 'not a proper sample of the inhabitants of these happy isles, not having any advantage of birth, or acquired rank; nor being eminent in shape, figure, or complexion'.[12] Omai was not a proper sample or specimen because he was physically 'ugly', dark and obscure rather than patrician. He was the appropriate object of a feminized 'curiosity, levity and lewdness',[13] rather than of public or political recognition, and that exclusion from representative status may be figured in Reynolds's image in the prominent marking of his tattoos. The tattoos inscribe the generalized figure that

[9] George Hamilton, *Voyage of the H. M. S. 'Pandora'* (London, 1915), 127.

[10] James Boswell, *Life of Johnson*, ed. R. W. Chapman, rev. J. D. Fleeman (London, 1976), 722–3.

[11] On curiosity, see Spate, *The Pacific since Magellan*, 81, and my 'Great Distinction'. See also Daniel A. Baugh, 'Seapower and Science: The Motives for Pacific Exploration', in Derek Howse (ed.), *Background to Discovery: Pacific Exploration from Dampier to Cook* (Berkeley, Calif., 1990).

[12] *The Journals of Captain James Cook on his Voyages of Discovery: II: The Voyage of the Resolution and Adventure, 1772–1775*, ed. J. C. Beaglehole, 2nd of 3 vols. (Cambridge, 1969), 428, n. 2; James Cook, *A Voyage towards the South Pole, and Round the World*, 2 vols. (London, 1777), i. 169.

[13] John Forster, *Observations made during a Voyage round the World* (London, 1778), 247.

Reynolds portrays with an apparently incongruous ethnographic specificity, an authenticating 'air of truth',[14] inviting to the curious investigations of the natural philosopher, or collector of exotica. The dignity or 'benign authority' which recent critics have attributed to the figure's stance seems to be marked by those tattoos as the gesture of self-display appropriate to the private zoo or fairground exhibit, the exotic spectacle, rather than to the public position of the patrician. The reinscribed tattoos mark that conception of the Tahitian that was articulated in the *Gentleman's Magazine*, where a correspondent described Omai as 'a simple barbarian' whose transportation to 'a christian and civilized country' would 'debase him into a spectacle and a maccaroni, and ... invigorate the seeds of corrupted nature by a course of improved debauchery'. They stigmatize Omai as the authentic object of a curiosity that finds its gratification in the singular and exceptional specificities of corrupted or deformed nature.[15]

My discussion suggests, then, that the marking of Omai's hands in Reynolds's portrait indicates that the islander's gesture is appropriate to his exotic and unrepresentative status, for his tattoos are incompatible with any patrician authority his posture might seem to imply. It is as though they indelibly blacken and stain the transparent legibility of that classical stance. In this essay I want to explore the exoticism inscribed in tattoos, and in what were seen to be comparable marks of scarification and incision, in late eighteenth-century British perceptions of the islanders of the South Pacific. In writing on the South Pacific in the early nineteenth century, and in the late 1790s, tattoos were frequently represented as analogous to clothing, as a sort of textured surface that is integral to the body, but that also veils and conceals it, and lends it, perhaps, a kind of parodic social propriety. The earlier accounts from the 1770s and 1780s which I will be considering here remark in the ambiguously physical texture of the islanders' inscriptions—their movement, as it were, between the body's surfaces and irregularities, its uniforms and disguises—the intersections of discourses of civility and barbarity, of exoticism and nationality, and of gender difference, figured in anatomy or manners. In a sense, I think, many representations of tattooing in these decades mark in them signs of physical

[14] Joshua Reynolds, *Discourses on Art*, ed. Robert R. Wark (New Haven, Conn., 1975), 58, see also 199.

[15] McCormick, *Omai: Pacific Envoy*, 174, 138. The perception of Omai as a potential 'macaroni' clearly alludes to the reputation of Joseph Banks. Perhaps the most striking comparison with Reynolds's representation of Omai's posture of self-display is the engraving of 'A Merchant of Java', pl. 31 in Johan Nieuhof, *Voyages and Travels to the East Indies 1653–1670*, introd. by Anthony Reid (Singapore, 1988). Reid points out that this was 'one of the most influential accounts of the Malay World and South India in English' in the 18th century (p.v).

and moral differences that are both exoticized and internalized, retailored to form the new clothes of the emperor, or of imperial culture itself. For these representations indicate the problematic and shifting status of the marked man, of the redefinition of masculinity in these decades as marked, distinguished, identified in its cultural or physical, and national or ethnic differences. First, however, I want to consider the implications of Reynolds's theories of art for his portrait of Omai.

II

The sense in which the tattoos inscribe Reynolds's *Omai* with the ornamentation appropriate to the spectacle of barbarism, and indicate a debased and exoticized image of what might seem to be a portrayal of oriental dignity and public authority, can best be understood in the context of the Discourse that Joshua Reynolds delivered to the Royal Academy in December 1776. In this seventh Discourse, Reynolds accommodates the universalist ideals of his earlier arguments to a defence of the value of local prejudice, or 'national taste'. The argument moves from the valorization of a rationality that is comprehensive in its scope, to legitimate attachments of local sentiment that had appeared merely partial and valueless in that universalized context. It has recently been argued that this involves the attempt to harness together the incompatible discourses of civic humanism and of custom. It would be beyond the scope of this essay to work through the complex processes of that attempt, but I will need to pay some attention to them, for what interests me is their intersection with what might be identified as discourses of gender and exoticism. At what seems to me a critical moment in the transition from a civic to a customary or national discourse, in Reynolds's argument, he claims that the only customary 'fashions' which can be dismissed as valueless rather than 'innocent' are the corsets of English ladies, and the tattoos of Tahiti. The terms of the exclusion of these fashions in this text may indicate the significance of the reinscription of Omai's tattoos in the portrait Reynolds exhibited in the same year.[16]

Reynolds conducts his argument about the necessary recognition of

[16] Reynolds's portrait of Omai was exhibited at the Academy with a portrait of the same size of Georgiana, Duchess of Devonshire, in fashionable dress, which may illustrate the juxtaposition of unacceptable fashions in Reynolds's Discourse. See McCormick, *Omai: Pacific Envoy*, 168–9, 174. For a fuller reading of Reynolds's Discourse, see John Barrell, *The Political Theory of Painting from Reynolds to Hazlitt: The Body of the Public* (New Haven, Conn., 1986), 136–58, and his 'Sir Joshua Reynolds and the Englishness of English Art', in Homi K. Bhabha (ed.), *Nation and Narration* (London, 1990).

value in local custom largely in terms of an assessment of ornament as it is manifested in colour, and fashionable dress. In the opening stages of his discussion, the discourse of civic humanism seems to marginalize and impoverish ornament as transitory, superficial, and accidental—as a debased and sensual pleasure. Reynolds writes, for example, that colouring in painting 'can never be considered as of equal importance with the art of unfolding truths that are useful to mankind, and which make us better or wiser'. He implies that colouring is important only to 'those works which remind us of the poverty and meanness of our nature', rather than to 'what excites ideas of grandeur, or raises and dignifies humanity'. It impoverishes the universal man because, as Reynolds has explained, 'the help of meretricious ornaments, however elegant and graceful, captivates the sensuality ... of our taste'. An attention to the historical specificities of fashionable dress is similarly represented as a reminder of meanness. Reynolds suggests that it indicates the inadequacy of the individual to conform to the ideal uniformity and universality of man, and he argues that this failure could only be represented as natural or justifiable 'if the dress were part of the man'.[17]

The representation of ornament in the first half of the seventh Discourse, then, echoes the terms of Reynolds's Discourse of 1771, where he had suggested that the 'seducing qualities' of the ornamental style worked to 'debauch the young and inexperienced'. But when Reynolds returns to that image of seductive ornament, later in the seventh Discourse, he claims that it is not a matter of a debauching and prostituted sensuality, but of a more desirable and marriage-broking appeal, which, he writes, 'procures lovers and admirers to the more valuable excellencies of the art'. What seems to lend this new legitimacy to the feminized charms of ornament is the discourse of custom, in terms of which the sensual, local, and feminine are not dismissed as impoverished and peripheral accidents. Reynolds explains that:

Though we by no means ought to rank these [ornaments] with positive and substantial beauties, yet it must be allowed that a knowledge of both is essentially requisite towards forming a complete, whole, and perfect taste in them we find the characteristical mark of a national taste; as by throwing up a feather in the air, we know which way the wind blows, better than by a more heavy matter.

Ornaments are essential to the formation of a perfect and national taste founded in local custom, perhaps as marriage is essential to the legitimate reproduction of the national community, and the recognition of this, in

[17] Reynolds, *Discourses*, 130, 129, 128.

Reynolds's argument, seems to endow art itself with a kind of sensual or physical definition: from ornament, he claims, the arts 'receive their peculiar character and complexion'.[18] And, in contrast to the civic humanist ideal of universal man, the judicious spectator who is seduced by the legitimate ornaments of custom seems also to be incorporated in his membership in the national community of taste. It seems implicitly to be acknowledged that the spectator's customary dress is a part of his masculinity, or that his correct taste is sensual, and not only ideal, universal, transparently and chastely disembodied.

The ideal spectator seems to be embodied by the legitimation of the sensuality of his taste in Reynolds's argument, for this seems to authorize in his taste a kind of sensuous or physical response that had been absent from his chaste and disinterested judgement. But this 'embodiment' may take two different forms, which can best be distinguished in terms of the discourses of gender and exoticism. The first takes the form of what I will call the civilized man, and he bears a fairly close relation to the civic humanist ideal, for he seems, as it were, to recognize the value of custom, but to preserve his attachment to universal values. The seventh Discourse employs an extended analogy between the use of ornament in painting and fashions in dress, and this civilized man is represented in this context as revealing in sartorial elegance a taste and sagacity that might unproblematically extend to the 'highest labours of art'. Those highest labours, at this stage of the Discourse, do not seem to indicate that Reynolds is alluding to universal custom or taste, but rather that he appeals to a notion of culturally relative customs in dress or art. Reynolds goes on to argue that, in the encounter between a fashionable European and a Cherokee man, 'whoever of these two despises the other for his attention to the fashion of his country, which ever first feels himself provoked to laugh, is the barbarian'.[19] The fashions of these two men are perceived to be relative, arbitrary, and accidental because they depart from the ideal uniformity of nature and truth, but here, in the context of the discursive valorization of national differences, Reynolds seems to advocate a civilized pluralist tolerance, rather than the disembodied universality of the civic humanist ideal. The civilized man does not reject the sensual charms of ornament or the local colour of fashionable dress as distractions from the ideal transparency of universal truth. He seems, as it were, to invest himself in his own national identity, and to accept its relative absurdity. The highest labours of art

[18] Ibid., 67, 136, 135.
[19] Ibid., 137.

therefore seem to be compatible and continuous with fashionable elegance, and not opposed to the feminized sensuality that might imply.

It is at this stage in his argument that Reynolds alludes to tattoos and corsets, and, I suggest, introduces a spectator or subject who is more thoroughly and exclusively embodied in and coloured by his local or national identity, his 'second nature'. He writes that all 'fashions are very innocent The only circumstances against which indignation may reasonably be moved, is where the operation is painful or destructive of health, such as some of the practices at Otaheite, and the strait lacing of the English ladies.'[20] The Tahitian custom which was repeatedly associated with pain and the risk of infection was, of course, tattooing. The indignant response that this, and strait-lacing, should provoke in the spectator signals the transition from a civilized taste that accepts the essential but relative nature of national differences, to a customary and national taste that regards certain differences as the legitimate objects of local prejudice and disapprobation. In contrast to the civilized and worldly tolerance that Reynolds argued should be excited by the relative fashions of the European and the Cherokee, the indignation with which tattoos and stays are viewed seems to mark in the spectator a barbarian capacity to despise or ridicule difference, and he therefore seems more exclusively engrossed in his national character. The spectator's embodiment in those customs that are 'second nature' to him legitimates his indignant contempt. It seems to characterize him in terms of a barbarous fondness for sensual ornament, and an investment in local colour and dress, that causes his identity to converge and become imbricated with the exotic and feminine sensuality of English ladies and Tahitians; and the only significant difference between him, and these tattooed and corseted bodies, seems to be that their forms of adornment are not the 'characteristical mark of a national taste'. Their ornaments bite too deeply into the ornamental surface of the body, indicating a primal physicality incapable of generating cultural significance, rather than the local beauties that constitute the smooth and innocent form of customary second nature. Their markings thus seem to violate the status of custom as second nature in their unhealthy physicality, which, Reynolds suggests, is more properly the subject of the discourses of 'the professor of Anatomy'.[21]

The distinction between the sensual tastes of second nature, and the singular fashions appropriate to primitive bodies, is produced by the

[20] *Discourses*, 137.
[21] Ibid., 135, 138.

indignation which marks some ornaments as guilty and despicable—an indignation which seems to be legitimated and cleansed of barbarity by the community of national custom. Whereas the first fashionable spectator confirms his civility in his unimpassioned recognition of cultural relativity, the second implicitly appeals to notions of moral approval or disapprobation as constitutive of a community of values, tastes, and customs, which are authorized by their origin in 'the high and powerful advantages of rank, birth, and fortune'.[22] In the terms of the discourse of national custom that constitutes the second spectator, the differences between the bewigged European, the painted Cherokee, the corseted Englishwoman, and the tattooed Tahitian cannot be smoothed over by the recognition of the accidental and arbitrary relation each bears to the universal truth of nature. For the first pair innocently adopt the adornments of second nature, whereas the latter puncture that second nature to disclose an acultural and anatomical difference. The contrast between the two seems to depend on a distinction within the feminized terms in which ornament is articulated: a distinction between the feminizing and moral taste for ornament that produces and is articulated in national incorporation, and the immoral and exoticized femininity that marks or punctuates the gross physicality of bodies perceived to lack character or nationality.[23]

III

In Reynolds's portrait of Omai, I have suggested that it is this distinction that demarcates the spectacular exoticism of the Tahitian's stance from the patrician authority it might also seem to indicate. The tattoos ornament the figure with a peculiarly physical and acultural specificity. But in a sense I think it is their capacity to mark the fixity of the image in the register of pure and isolated spectacle that determines the nature of that physicality, and distinguishes it from the sensual definition implicit in customary second nature. The point can perhaps best be made by comparing Reynolds's image of Omai with a conversation piece by William Parry (Fig. 4.2). Joseph Banks seems to have commissioned these two paintings at about the same time, and both are thought to be based on Nathaniel Dance's sketch of the tattooed Tahitian. In Parry's painting, Banks is shown gesturing towards the unmarked—untattooed—hand of Omai, as if to point out that the

[22] Ibid., 137–8.
[23] On morality, custom, and the constitution of community in these decades see Adam Smith, *The Theory of Moral Sentiments* (1759), pt. I. ss. 1–2, and pt. V, and John Bender, *Imagining the Penitentiary: Fiction and the Architecture of Mind in Eighteenth-Century England* (Chicago, 1987), 218–28.

figure is here identified, not by the ambiguous ornaments of ethnographic particularity or national character, but through his presentation in the isolated vacancy appropriate to the spectacle of the exotic. The black background, which throws the figure of the Tahitian into relief, contrasts with the richly elaborate colours of the right-hand third of the canvas, where Daniel Solander sits. Solander had travelled with Banks on Cook's first voyage, and catalogued the collections of the British Museum in accordance with the Linnaean system, and it is presumably in his role as a natural philosopher that he is represented here, apparently poised to record and classify the curiosity that his patron Banks discovers to him. The figure of Omai is posed, perhaps again with ambiguously orientalized dignity, or perhaps as though he had been caught in transition, the turn of his body suggesting that his attention has been diverted from the other men, and redirected downwards, towards the artist and spectator. His face seems open to the spectator's curious gaze, and isolated in contrast to the apparently unselfconscious absorption of Banks and Solander, engaged in the mutually interesting tasks of observation and display. The warmth and detail of what looks like an oriental rug on the table at Solander's elbow, and the depth of the rural scene behind him, may indicate the displacement from the Tahitian, fixed against that flat blackness, of the ornaments that constitute national or ethnic identity. For the physical definition of the draped Tahitian figure seems emphasized by the naked and unmarked surface of the ornamental spectacle he presents.

The nakedness of Omai is perhaps most directly indicated by the contrast between his prominent display and the apparently modest figure of Banks. Banks's proprietorial gesture, and the tidiness and restraint of his dark suit, seem to indicate in him a masculinity that stands aloof from the colourful display of his protégées, and that distinguishes his patrician authority from their peripheral and dependent positions. Reading the painting in the context of Reynolds's seventh Discourse, it may seem as though the more luminous and colourful figures of the two protégées cast the sober-suited Banks in the position of the civilized spectator, invested in a national identity continuous with that of the universal connoisseur. It may seem as though, in particular, the Tahitian were the sign, the ornament, that indicated Banks's worldly tolerance and national difference—the grounding of his comparativist cosmopolitan taste in moral righteousness. Omai is the ornament he tolerates, does not ridicule, but in relation to which he establishes his own superior difference. The clarity of the contrast between patron and islander may to some extent depend on the erasure of Omai's tattoos, for that blankness seems to bring into focus, into relief, the

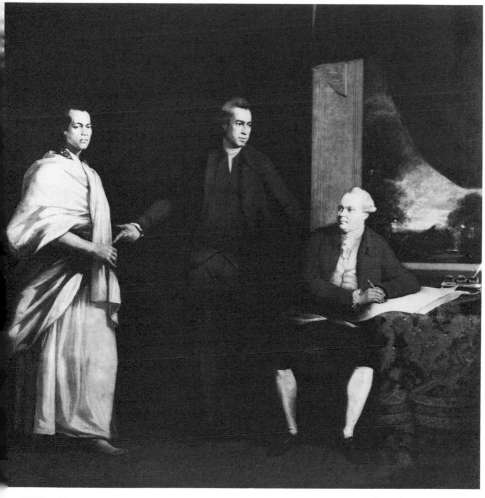

2 William Parry, *Omai, Joseph Banks and Dr Solander*, 1775–6, oil on canvas, $58\frac{3}{4} \times 58\frac{3}{4}$ in.;
reproduced by permission of the Hon. Clive and Mrs Gibson.

inscription of the whole figure of the Tahitian as exoticized spectacle. He is the feminized object of a philosophical curiosity that does not need to call attention to the marks of exoticization because it so clearly isolates him and indicates his deferential inferiority to the two Europeans.[24]

The contrast between this painting and Reynolds's image, then, focuses primarily on the difference between the terms in which they present the islander as curious spectacle. In Reynolds's portrait, I have suggested that the tattoos can be understood to indicate the curious and exotic status of the figure, and to disambiguate the implications of his representation in isolation. Whereas in Parry's conversation piece, it is the relations between the three men that produce the singular spectacle of the Tahitian's exoticism. I have suggested that these images of Omai can best be understood in terms of the gendered constructions of civilized and national taste in the theory of painting in the mid-1770s. Specifically, I think that they are marked by the instability of gender produced by the valorization of customary national identity. For that notion of national character, as Reynolds's Discourse indicates, appropriates to masculinity what had been articulated in the discourse of civic humanism as a feminizing, and perhaps barbarous, sensual taste for ornament. The figure of Omai might seem to be inscribed with a barbarous femininity that is thus uneasily proximate in its sensuality to that of the masculine spectator embodied in national taste. I suggested that in Reynolds's image the apparent oriental dignity of the islander is stigmatized as exotic, and thus excluded from this unsettling proximity, by the reinscription of the tattoos that punctuate the generalized dislocation of the figure. In Parry's painting, Omai is isolated as a naked spectacle of exotic curiosity. In both paintings the presentation of Omai as curious spectacle might be understood to prompt that fascinated distaste that excludes his physicality from the national and customary community of taste and moral prejudice. I want now to look briefly at two images of Joseph Banks which I think indicate the extent to which the representation of the islander as ornamental spectacle may blur or destabilize the definition of civilized masculinity.

The first of these two paintings is one of a pair of representations of the *Members of the Society of Dilettanti* (Fig. 4.3), which Reynolds completed

[24] Solander may be represented in the outmoded fashions appropriate to court dress, in contrast to Banks's more fashionably muted attire. The European dress which Reynolds's seventh Discourse presents as comparable in its customary whimsicality to that of a Cherokee man may also be that appropriate to the court, and it is therefore tempting to see in Parry's image a sort of allegorized emblem of the relations to fashion that Reynolds describes. George Keate's *Account of the Pelew Islands* (1788) represents the islanders as 'an *ornament* to human nature' (p. xiii), perhaps indicating that capacity to confirm European humanity that the composition of this image may attribute to Omai.

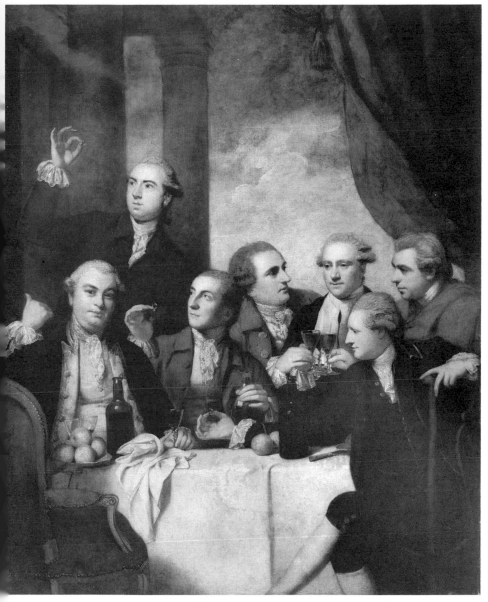

4.3 Sir Joshua Reynolds, *Members of the Society of Dilettanti*, 1779, oil on canvas, $77\frac{1}{2} \times 56$ in., Brooks's Club, London; reproduced by permission of the Society of Dilettanti.

in 1779, and which shows Banks seated on the extreme right; and the second is Benjamin West's portrait of 1771 (Fig. 4.4), painted soon after Banks's return from the South Pacific. In both, Banks is portrayed as a collector and connoisseur of curiosities. In Reynolds's painting the gentlemen are admiring a collection of antique gems while enjoying their claret. They demonstrate both the sensuality and the correctness of their taste here, as they do perhaps yet more obviously in the companion piece, where other members of the society admire antique vases and a lady's garter. But what this painting images most clearly is their conviviality, the bonds of social affection and affiliation evidenced in the co-ordinated gesticulations of their hands, and the common interest in curiosities that they point to. The gentlemen are the knowledgeable and judicious spectators of the tiny ornaments they hold between finger and thumb, and their shared fascination, as well as the complex sociality of their compositional relations one to another, seems to close them in an esoteric grouping that may shield them from the intrusions of curiosity. The elaborate network of relations between the men portrayed manifests their sociable and masculine equality in the—perhaps protective—bonds of their membership in an esoteric club.

West's portrait of Banks the world tourist is more immediately comparable to Reynolds's image of Omai, but here Banks's direct gaze seems to announce his ownership of the diverse artefacts that surround him, whereas Omai seems open to the spectator's curiosity because he looks diffidently away. The figure of Banks dominates the litter of curiosities, which indicate the comprehensive scope of his civilized survey, and contrast in their apparent disorder with his central and single illuminated form. But in the absence of those clear markers of common sociality—of fraternity—that Reynolds's image of the dilettanti celebrates, there is some peripheral ambiguity apparent in West's image of Banks. In the pantomime, *Omai, Or, A Trip Round the World*, which was presented on the London stage in the mid-1780s, the character based on the Tahitian was reported to have 'most whimsically and pantomimicaly dressed himself in a piece of the habit of each country he had met with',[25] perhaps as Banks does in this image. It is as though Banks at once celebrates and stares down the more frivolous aspects of his dilettantism, and of his reputation as a macaroni—'a kind of animal, neither male nor female, a thing of the neuter gender', as the *Oxford Magazine* had defined that term in 1770.[26] For the distinction

[25] McCormick, *Omai: Pacific Envoy*, 318 (quoting from W. Huse, 'A Noble Savage on the Stage', *Modern Philology*, 33 (1936), 303–16).
[26] Quoted from OED 'macaroni'.

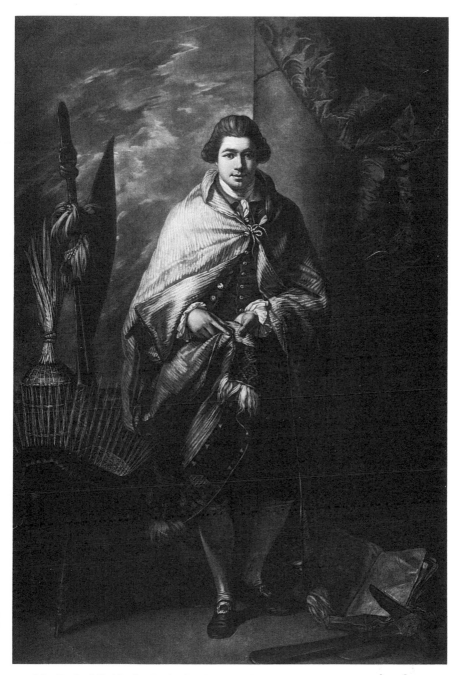

4.4 John Raphael Smith after Benjamin West, *Joseph Banks*, 1773, mezzotint, $22\frac{3}{8} \times 14\frac{7}{8}$ in.; reproduced by permission of the Trustees of the British Library, London. (I reproduce Smith's engraving after West in the interest of clarity of detail.)

between Banks and the spectacular array of curiosities arranged around
him seems porous and uncertain, perhaps as a result of the isolation in
which he is portrayed. In the group portrait of the Society of Dilettanti it
seems to be companionship, the mutual reciprocity of looks and gestures,
that confirms the manliness of their common interest in antique ornaments.
In Parry's conversation piece, it is the relation between the three figures
that emphasizes the masculine integrity of Banks, but represents the figure
of Omai as open to speculation. The ambiguity of gender in West's portrait
of Banks, which seems to represent the great collector as a curious spectacle
comparable to Reynolds's Omai, may be produced by the absence of a
visible and defining network of social relations. And national incorporation,
Reynolds's Discourse suggests, is manifested in social encounters between
men, in their recognition of the ornaments and fashions that constitute
relative customary identities, and in their shared disapprobation of tattooed
islanders and corseted women. Banks's exotic dress, in West's portrait, is
clearly not sanctioned by the example of those who possess 'the high and
powerful advantages of rank', or by local custom, and it therefore seems
to place his national and gendered identity in doubt. Banks's cosmopolitan
assimilation of the ornaments of different cultures may not establish his
civilized detachment, but may instead confuse or erode the demarcation of
his embodiment—his sensual involvement—in customary second nature,
from the unnaturally inscribed bodies that should arouse indignation.[27]

In the 'Thoughts on the Manners of Otaheite' that he wrote in 1773,
Banks indicated that a blurring of gender definition, analogous to that
which I have argued characterizes this portrait, was central to his conception
of the difference between civilization and barbarism. 'Us Europeans', he
argued, treat 'our women' with an attentive regard which produces in them
'beauty as well as those Elegant qualifications of the mind which blending
themselves in our manners make the Commerce between the Sexes so
much more deligh[t]ful to us than to the inhabitants of Africa or america'.
This thought alludes to the axiom of Enlightenment philosophy which
makes the treatment of women the index of civility—an axiom that implies,
of course, that masculine civilization varies in its degree of maturity or
progress, whereas femininity describes a universal constant. That impli-
cation is perhaps more nearly explicit in what Banks goes on to write about

[27] The blurring of Banks's civilized identity is also alluded to in Walpole's suggestion that the artist
on the first voyage might expect to be 'scalped by that wild man, Banks' (Alexander, *Omai: Noble
Savage*, 49). The ambiguity of gender in West's image may manifest the ambivalence with which
portraiture, in these decades, could conjure the presence of a clearly defined public to masculinize the
isolated figure it presents, but it may also be licensed by his youth.

tattooing. He writes that both the men and the women of Tahiti 'have a singular custom of inlaying under the skin certain figures in black', and he observes: 'I am inclind to think that as whiteness of skin is esteemed an Essential beauty these marks were originaly intended to make that whiteness appear to greater advantage by the Contrast Evidently in the same manner as the patches used by our European beauties.' The feminizing elision of the comparison between male and female Tahitians and European beauties works to endorse a homogenized and universal notion of feminine vanity untroubled by the cultural specificities of ornament that distinguish masculine fashions in Reynolds's Discourse. Banks's argument, in these thoughts, celebrates the feminized manners of 'Us Europeans' as indications of a high degree of masculine civilization, and it thus clearly distinguishes between the desirable achievement of feminization, and the natural femininity of those who are barbarized, and excluded from civilization, though their commerce may be necessary to its manners.[28]

The feminization that Banks's argument represents as necessary to the attainment of civility, appears, however, to be appropriate to a construction of masculinity articulated in terms of a different discourse from that which Reynolds expresses in advocating a sort of national indignation. In Banks's argument, civilized men assimilate feminized qualities of mind to their manners, but vain and sensual physicality are extruded from that notion of masculinity, and appropriated to natural and exoticized femininity. In Reynolds's Discourse, on the other hand, the sensuality of taste for ornament embodies masculinity in a distinctively national sensibility that excludes feminized exoticism as an immoral anatomical perversion—as a distinct kind of sensuality excluded from the moral sanction of the community. The difference between these discursive constructions, I want to suggest, is significant to the terms in which tattooed bodies are perceived in the Pacific by European voyagers, as well as to the images I have discussed.

IV

I want now to turn to written accounts and pictorial representations of the South Pacific in the late eighteenth century, and to consider them in the context of the constructions of national and civilized masculinity that I

[28] Banks, *Journals*, ii. 330, 332–3. On the relation between civility and civilization, see these terms in Johnson's *Dictionary*, and the discussion of their definition in Boswell's *Life*, 466, where Boswell argues that Johnson employs 'civility' in 'two senses' (i.e. to define a state of society and a condition of manners, which Boswell believes to be distinct).

have been discussing. But I want to begin by looking at some perceptions of anthropophagy which seem to me to provide a paradigm for the relations between domesticity and exoticism that inform those constructions. In 1773, ten men from the crew of the *Adventure* died at Grass Cove in the South Island of New Zealand. James Burney led the party which discovered their remains, and took these to be 'most horrid & undeniable proofs' that they had been cooked and eaten.[29] Perhaps the most lurid account of this incident was provided in one of the accounts published without the sanction of the Admiralty. Burney's party, according to this journal, 'found several of their people's baskets, and saw one of their dogs eating a piece of broiled flesh, which upon examining they suspected to be human, and having found in one of the baskets a hand, which they knew to be the left hand of Thomas Hill, by the letters T. H. being marked on it, they were no longer in suspence about the event'.[30] Burney wrote that what he had seen could 'never be mentioned or thought of, but with horror',[31] and his father observed that after his return to London he 'always spoke of it in a whisper, as if it was treason'.[32]

The moral distancing and disapprobation that mark Burney's notions of appropriate response, and that are promoted by the melodramatic fascination of the journalist's account, I have suggested, are an important constituent of European national identity, and produce a distinction between islanders and Europeans that is constructed primarily in terms of moral and physical differences. Earlier in 1773, Burney had written that he believed the New Zealanders to be 'in a state very little, if anything, superior to the Brute part of the Creation—being Cannibals, many of them Thieves & cursed lousy'.[33] The physical detail of the lice seems as capable of provoking the appropriate disapprobation, and perhaps of instantiating moral distance, as the practice of anthropophagy. The investment of

[29] J. Burney, *With Captain James Cook in the Antarctic and Pacific*, ed. Beverley Hooper (Canberra, 1975), 96.

[30] (?John Marra) *Journal of the Resolution's Voyage* (London, 1775), 94. In Burney's account, the European party initially identified what they found as dog's flesh, and Marra's implication that they could immediately distinguish it as human therefore seems to attribute a peculiarly refined degree of forensic percipience to the moralized sensibilities of its protagonists. The confusion with dog's flesh seems to be displaced into the suggestion (not mentioned in Burney's account) that the islanders' dogs were seen eating the flesh—an allegation that works to confirm the alien savagery of the islanders.

[31] Burney, *With Captain James Cook*, 97.

[32] The Journal of Charlotte Ann Burney, which reports Charles Burney's comments, also indicates that the discovery of the remains at Grass Cove was not universally regarded as convincing proof of cannibalism, or as an occasion for instinctive horror. Garrick commented, on hearing of James Burney's whispers: 'Why, what, they didn't eat em? . . . we are not sure . . . perhaps they potted 'em!' In *Frances Burney*, ii. 283.

[33] Burney, *With Captain James Cook*, 51.

customary and national significance in the appropriate responses of moral disapproval or horror is indicated in the various narrative elaborations on Burney's findings by voyagers who were not present. Among the recognizable remnants that Burney took back with him to the ship was a head, which because of its 'high forhead' was believed to be that of the captain's servant, 'he being a Negroe'.[34] But later narratives describing the events believed to have taken place at Grass Cove represent this man as having been the last to die, and emphasize that he 'must certainly have felt the most horrid sensations' at what he saw and anticipated, as though this horror confirmed his European, blanched, and sympathetic identity.[35]

The disapprobation that confirmed the common sensibilities of national and sociable identity is not, however, common to all of the voyagers' accounts, or, perhaps, the only response that seems available to Burney. Probably the most influential of the various reflections on the practice of anthropophagy that resulted from this voyage were those given in Cook's published account, which seem to be marked, on the one hand, by the sense of moral and physical distance apparent in Burney's comments, and, on the other, by the implication that the practice is in some respects analogous to treason as an articulation of a markedly political discourse. Cook wrote that the people of the South Island of New Zealand lived: 'dispersed in small parties, knowing no head but the chief of the family or tribe, whose authority may be very little'. He claimed that the social isolation and dislocation he perceived resulted in continual personal danger and warfare, and argued that 'were they more united under a settled form of government, they would have fewer enemies, consequently this custom would be less in use, and might in time be ... forgotten'.[36] The practice, I think, is constructed in terms which represent it as a violation of the ideal unity of the social and private body, as though cannibalism replicated social dispersal and dismemberment on the bodies of those killed in battle. It seems to indicate an almost anarchic state of social and private disarticulation and incoherence, and to be discursively constructed in terms which Europeans speak only in whispers, as though they were treasonable.

The second discourse or set of terms in which Cook articulates his thoughts on anthropophagy is, I have suggested, one which represents the practice in terms of the moral disapprobation that is a constituent of the community of national custom in Reynolds's Discourse. It is these terms,

[34] Furneaux's Narrative, in Cook's *Journals*, ii. 744.
[35] Anderson's Journal, in Cook's *Journals*, iii. 799. See Samwell's Journal, in Cook's *Journals*, iii. 998, and see also iii. 64, where it is suggested that the incident was caused by the servant's actions.
[36] See n. 11 above. Cook, *Voyage*, i. 127, 245.

I think, which inform Cook's comment that 'At present, they [the New Zealanders] have but little idea of treating others as themselves would *wish* to be treated, but treat them as they *expect* to be treated'. Human ingestion, he suggests, indicates a failure of sympathetic introjection, which he believes can best be remedied by 'connexion or commerce with strangers'. He explains that 'An intercourse with foreigners would reform their manners, and polish their savage minds'. That emphasis on savagery is, I think, a constitutive characteristic of this discourse, which enables the construction of the conditions in which the islanders are perceived to live in terms of the contrast between their 'inhuman and savage' practices and the sociable sympathies of European taste and morality.[37]

The first discourse, which I have suggested constructs anthropophagy as a manifestation of the absence of a unified state, and thus as accessible to change by settled and united government rather than through reform of manners, would seem in this context to inform Cook's perception of cannibalism as one of the 'ancient customs' which had been 'handed down ... from the earliest times'. It seems to be in the terms this discourse makes available that Cook concedes that the 'New Zealanders are certainly in some state of civilization', because they are obliging, and 'have some arts ... which they execute with great judgement and unwearied patience'.[38] This more humanistic and humanizing conception of the islanders' customs articulates, I think, the cultural relativism that is alluded to in Reynolds's account of the meeting between a Cherokee and a European man in its attribution of a civilizing significance to the ornamental arts. In terms reminiscent of Reynolds's perception of civility as something produced in relationships between men, it valorizes the perception of the New Zealanders as 'manly and mild', masculine but attenuated with that mildly obliging softness that Banks's account of the manners of civility suggested. The second discourse, on the other hand, seems appropriate to the construction of exclusive socialities of customary sentiment, in its emphasis on moral disapprobation and disgust as the responses prompted by the failure of sympathetic introjection.

V

These two different representations of anthropophagy, and of the conditions in which it might be either forgotten or rejected, can be seen to inform perceptions of tattooing, incision, or scarification as manifestations

[37] *Voyage*, i. 245–6. [38] Ibid., i. 245.

of 'ancient customs'. Representations of the islanders' tattoos in the sketch-books of the artists on Cook's voyages most usually show elaborate designs loosely framed by outlines that suggest isolated parts of the anatomy, disarticulated knees, thighs, and buttocks—or the profiles of lightly sket-ched faces, as in these drawings by Sydney Parkinson and Herman Spöring (Figs. 4.5 and 4.6). These two men were both employed to depict specimens of flora and fauna on the first voyage, and there seems to be little variation from the technique appropriate to botanical and zoological draughts-manship in these representations of tattoos as curiosities fixed for the perusal of the natural philosopher. Parkinson's more fully worked-up drawings of the New Zealanders are similarly disarticulated. The images that were engraved for the posthumous publication of his *Journal*, showing the faces of Maori men 'curiously tataowed, or mark'd, according to their manner', are precise maps of elaborate facial incisions which seem dislocated from the features they adorn, or fixed in transient and impassioned expressions that are represented as mask-like (Fig. 4.7)[39].

There is an incoherence in these drawings that may manifest the dis-location and discontinuity Cook attributed to the social formations of the New Zealanders, and that is, I think, apparent in voyagers' written reflect-ions on Maori tattoos. The surgeon on the first voyage, for example, wrote of incisions he found 'extreamly curious' on a man's forehead, looking 'as if a plate for example had been graved with numberless little flourishes confined within two arched lines, and empressed upon the part; and each little curve thus mark'd out, not by a simple line or superficial black mark but really indented in the Skin'.[40] The perception of elaborate facial incisions as analogous to engravings is not unique to this account, and it may have been implicit in Rickman's comments on the islanders as 'living pictures'. It may seem to imply that the islanders are beyond representation

[39] Parkinson, *Journal of a Voyage*, 91. Sydney Parkinson's brother attempted to reclaim drawings of islanders from Joseph Banks after the artist's death on the first voyage, arguing that his brother had been employed only to produce botanical drawings. He argued that Sydney Parkinson had produced images of people in his own time, and that they were therefore part of the family estate, and not of Banks's collection of memorabilia and curiosities. Banks, however, succeeded in claiming the drawings. Though Stanhope Parkinson was later confined in an asylum, the point he raised about the demarcation of ethnological and botanical or zoological curiosities indicates a significant instability in the discourse of scientific exploration and acquisition. For accounts of the tattooing practices of New Zealand, see Ko Te Riria and David Simmons, *Maori Tattoo* (Auckland, 1989), and Major General Horatio G. Robley, *Moko; or Maori Tattooing* (1896; Auckland, 1987). Robley's account includes drawings and discussions of pieces of tattooed skin from various parts of the anatomy, preserved in his own personal collection. For further discussion of some of these images and issues see Leonard Bell, *The Maori in European Art* (Wellington, 1980), and Margaret Jolly, 'Illnatured Comparisons: Racism and Relativism in European Representations of Ni-Vanuatu from Cook's Second Voyage', *History and Anthropology*, 5 (1990).

[40] Monkhouse's Journal, in Cook's *Journals*, i. 586.

4.5 Sydney Parkinson, 'Black
Stains in the Skin called Tattoo',
1769, pen and ink, *top left* $10\frac{3}{4} \times 7\frac{1}{4}$
in., *top right* $10\frac{3}{4} \times 7\frac{1}{4}$ in., *bottom left*
$11\frac{1}{4} \times 9$ in., *bottom right* $5\frac{7}{8} \times 4\frac{3}{4}$ in.,
British Library Add. MS 23920, f66
(a–d); reproduced by permission of
the Trustees of the British Library,
London.

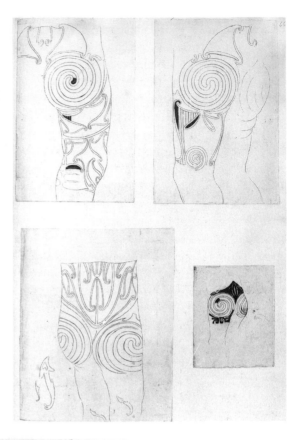

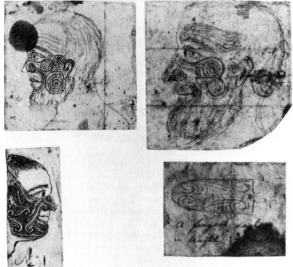

4.6 Herman Spöring, 'Black
Stains on the Skin called
Tattoo', 1769, pencil, *top left*
$4 \times 4\frac{1}{16}$ in., *top right* $4\frac{5}{8} \times 4\frac{3}{4}$ in.,
bottom left $4 \times 1\frac{3}{4}$ in., *bottom
right* $3 \times 3\frac{7}{8}$ in., British Library
Add. MS 23920, f67 (a–d);
reproduced by permission of
the Trustees of the British
Library, London.

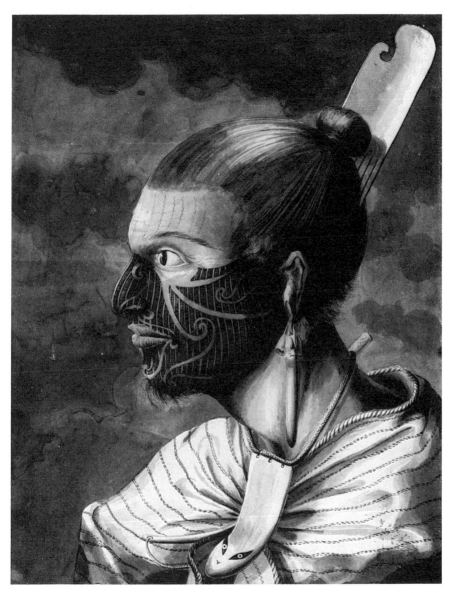

4.7 Sydney Parkinson, 'Portrait of a New Zeland Man', 1769, pen and ink and wash, $15\frac{1}{2} \times 11\frac{3}{4}$ in., British Library Add. MS 23920, f54 (a); reproduced by permission of the Trustees of the British Library, London.

in their exotic isolation, that they are, as it were, already the only possible image of themselves, already ethnologically specified to a degree that makes representation and cultural assimilation redundant. That exotic specificity, however, can be seen to be produced by the discourses of national custom that I have discussed. The precision with which the surgical anatomist or botanical draughtsman marks the islanders' image indicates his technical skill, and thus marks the knowledgeable and scrupulous accuracy of observation as a characteristic of the innocent and unclouded eye necessary to correct taste.

The representation of tattoos in some degree of isolation from the body they mark, in European texts, seems peculiarly interchangeable with the perception of them as 'really indented in the Skin'. It seems to substitute for the legible cultural significance of the body of second nature an inscribed and indented skin that is here not quite the object of distaste or disapprobation, but which is perceived to be appropriate to the taxonomies of surgical anatomy or botany. The dislocation and incoherence of these indentations seems to indicate here the excessively masculine or savage absence of convivial civility and sympathy—in contrast to, for example, the initials on the hand of Thomas Hill, which confirm the former coherence of his bodily identity and legible social place. Hill's tattoos seem to indicate a contrasting legibility in part, at least, because they had been inscribed in Tahiti, as accounts of the discovery of the hand emphasize. Their immediate decipherability points to the relative civilization of the Tahitians, and the approximation of their society to European notions of sympathetic sociability. The engraving of the discovery of the European's tattooed hand (Fig. 4.8), published in the unauthorized journal I quoted from earlier, represents the dissevered member as the focus for cohesive relations of what might be described as convivial horror among the European party. But the hand, poised as it were between barbarous incoherence and customary legibility, seems also to indicate the disarticulation and meaningless physicality attributed to the New Zealanders absent from the image, and to point up their 'inhuman and savage' guilt, their tasteless greed.[41]

Those drawings which represent incisions as integral to the expression of the face they adorn—for example, William Hodges's image of an 'Old Man of New Zeland' (Fig. 4.9)—seem in contrast to indicate a kind of sentimental appropriation which perceives in tattoos the marks of private

[41] On the ambiguous or transitional status attributed to Tahitian society, see my 'Great Distinction'. It seems remarkable that voyagers' accounts in these decades are silent about any analogy or similarity between Maori tattooing and the arts of carving and decoration that Cook saw as potentially civilizing. It is perhaps that analogy that is displaced, as it were, on to the image of the engraved plate.

4.8 Artist unknown, plate from John Marra, *Journal of the Resolution's Voyage* (London: John Newbury, 1775), $3\frac{1}{16} \times 6\frac{1}{3}$ in.; reproduced by permission of the National Library of Australia, Canberra.

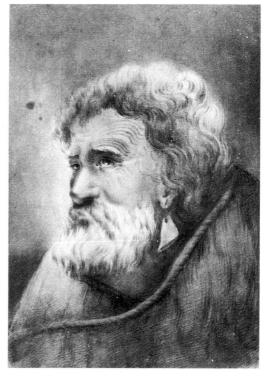

4.9 William Hodges, 'Old Maori man with a grey beard', 1773, chalk, $2\frac{1}{4} \times 14\frac{13}{16}$ in.; reproduced by permission of the National Library of Australia, Canberra.

character. The old man seems to be attributed the kind of dignity in resignation that marks the English rural poor in, for example, Gainsborough's images, and not the spectacular exoticism or ambiguously patrician authority that characterizes Reynolds's more formal and public representation of Omai. In Hodges's drawing, the inscription of the man's brow, in juxtaposition with his earring, may indicate the ornamentation appropriate to ancient customs whose cultural specificities are respected by the civilized spectator, who thus indicates his dispassionate and superior detachment. They mark the New Zealander as the sentimentalized object of a survey which gestures towards an ideally comprehensive universality in its capacity for humanizing and perhaps civilizing assimilation.

VI

These different figures of tattoos as marks of incoherence or of characteristic integrity may all, in a sense, manifest European perceptions of ornament as a sign of feminization. In Banks's 'Thoughts' on the tattoos of the Tahitians, as I have already noted, physical adornment was represented as feminizing in its universality, and European accounts of the tattooing operation in the late eighteenth century feminize those undergoing the process with varying degrees of explicitness. In the large oil paintings produced by the artists who travelled with Cook, it is exclusively feminine bodies that are inscribed with tattoos or scarifications. John Webber's *Portrait of Poedua* (Fig. 4.10) and William Hodges's *View taken in the Bay of Otaheite Peha* both clearly gender the representation of bodily ornament. Representations of the New Zealanders, in drawings and in written accounts, are much more ambiguous in their gender than these images of the 'softer' Tahitians, and there are no large oil paintings of tattooed male Maoris from this period. Perhaps their representation in the more private and readily textualized spaces of the drawing and engraved plate works to reinscribe their tattoos in a register of exotic production more immediately accessible to acultural feminization.

Hodges's and Webber's large paintings seem to allude to that construction of the relation between femininity and ornament that is apparent in Reynolds's Discourse, and which informs the observations of John Ledyard, who served as a corporal on Cook's last voyage. He wrote:

I observe that among all nations the Women ornament themselves more than the men: I observe too that the Woman wherever found is the same kind, civil, obliging, humane, tender being I do not think the Character of Woman so well ascertained in that Society which is highly civilized & polished as in the

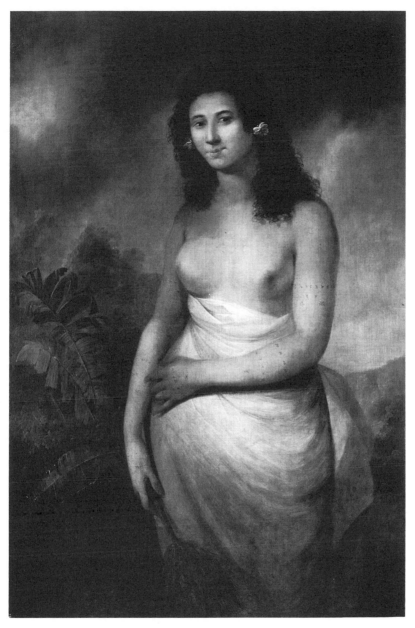

4.10 John Webber, *A Portrait of Poedua*, 1777, oil on canvas, 56 × 37 in.; reproduced by permission of the National Maritime Museum, London.

obscure and plain walks of Life . . . Climate & Education makes a greater difference in the Character of Men than Women.[42]

Ledyard's remarks, however, clearly indicate the extent to which the different constructions of what I have referred to as national or civilized masculinity are engaged in complex interaction with the conception of the gendering of ornament. The notion that women are more suited to the obscure and plain walks of life implies that they are somehow more natural than men, and are corrupted and deformed from that natural simplicity by civilization and polish. It implies that women are more markedly differentiated by their condition than are men, who therefore appear to be more universally accessible to civilization, and more capable of conforming to the ideals of civic humanism. It seems that women are too much the impressionable creatures of circumstance, and that they are therefore excluded from that moral community that forms a masculine identity continuous in both polished and plain life. The argument, on the other hand, that education and climate differentiate men, whereas women are everywhere the same, alludes to that construction of national and masculine character which excludes femininity because it is universal, unmarked, and as it were extranational. Women in this context appear to be either beneath or prior to national and customary second nature—somehow too essentially primitive to be fashioned into that cultural form. The appearance of continuity between these different gendered discourses seems to depend on the initial observation that women everywhere 'ornament themselves more than the men'—an observation that is contradicted most directly by accounts of New Zealand and the South Pacific. The observation seems, however, to lend a superficial plausibility to the following remarks, in which femininity is represented as excessive both in its universality and in its circumstantial difference, for this is here represented as a difference that is merely various, and ornamentally insignificant. It is represented, then, in terms of a civic humanist devaluation of ornament which here works to legitimate the more profound differences—of climate, education, and culture—necessary to national custom. This relatively sophisticated movement between the incompatible discourses which define masculinity in national or civilized terms seems plausibly to smooth over the incoherence of Ledyard's observations.

It is this incoherence that is I think manifested in European appropriations of tattooing in the eighteenth century. Joseph Banks, like John

[42] *John Ledyard's Journey through Russia and Siberia, 1787–1788: The Journal and Selected Letters*, ed. Stephen D. Watrous (Madison, Wis., 1966), 182–3.

Ledyard, Sydney Parkinson, and many of the other voyagers, was tattooed during his stay in Tahiti,[43] marking what has often been described as the inauguration of a nautical tradition—a tradition which might seem to punctuate the chaste detachment of civic humanist masculine definition, and to emphasize that feminizing attachment to ornament implicit in the definition of masculine national identity. The European voyagers seem to have perceived in the tattooing and scarification of the islanders they encountered the signs of the intersections of ethnicity, gender, age, and social station, which they thought were elaborated according to individual fancy. They thought, for example, that there might be a customary or ritual connection between a particular attainment—say, puberty—and the adornment of a particular part of the body. But they usually suggest that the designs that make up the tattoo are arbitrary and whimsical, dependent on what they saw as the vagaries of personal experience and choice. They conceived of tattoos as the markers of an esoteric diversity which could be imitated and appropriated, or assimilated, perhaps, in the context of that relativistic universalism that Hodges's image seems to indicate. John Elliott, who travelled on the second circumnavigation, recollects in his memoirs of Tahiti that he and his companions particularly admired the warriors of Bora Bora—men whom Cook thought troublesome and anarchic. Elliott writes that these men had 'particular marks tattooed on the Legs etc. We therefore called them the Knights of Bora Bora, and all our mess conceived the idea of having some mark put on ourselves, as connecting us together, as well as to commemorate our having been at Otaheite'. Elliott's messmates had a star tattooed on the left breast, and called themselves the 'Knights of Otaheite'. He notes that they intended to keep their badge secret, but 'we no sooner began to bathe, than it spread halfway through the ship'.[44] The tattoos Elliott describes seem to mark the appropriation of what are conceived of as signs of ethnic or national identity to a secret and exotic position that is excluded from customary or national definition. The notion of a brotherhood of knights seems to allude to that sentimental fondness for Gothic institutions which is important to, for example, Edmund Burke's conception of custom, but here those chivalric orders are identified with the esoteric orders of the men of Bora Bora, and they thus seem to stain the Europeans with a kind of exotic perversion of domestic and national identity. Several of the *Bounty* mutineers were distinguished by the badge Elliott describes, and one of them combined this star with

[43] See J. C. Beaglehole, 'The Young Banks', in Banks's *Journals*, i. 41 and n. 1.
[44] *Captain Cook's Second Voyage: The Journals of Lieutenants Elliott and Pickersgill*, ed. Christine Holmes (London, 1984), 20–1.

the tattooed mark of 'a Garter around his Left Leg with the Motto Honi Soit Qui Mal Y Pense'.[45] This is the appropriately parodic perversion of a custom, endorsed by 'the high and powerful advantages of rank', into insignia of national identity that coincide with the sign of the exoticization of the civilized body.

VII

In *The Structural Transformation of the Public Sphere*, Jürgen Habermas argues that the bourgeois publicity of rational communication between equals had initially to be instituted in privacy and secrecy because it threatened the relations of domination which were fundamental to courtly power. In these early stages, he writes, reason's 'sphere of publicity had still to rely on secrecy; its public, even as a public, remained internal'. Public exchange therefore went on in secret societies, in, for example, masonic lodges, which men were initiated into through rituals that established privacy and exclusiveness at the same time as affirming 'public' and fraternal equality between members. Habermas argues that

the practice of secret societies fell prey to its own ideology to the extent to which the public that put reason to use, and hence the bourgeois public sphere for which it acted as the pace maker, won out against state-controlled publicity. From publicist enclaves of civic concern with common affairs they developed into [what Manheim identified as] 'exclusive associations whose basis is a separation from the public sphere that in the mean time has arisen'.

Habermas's account constructs a relation between, on the one hand, a public, open, egalitarian society, and, on the other, a private, internal, and secret fraternity—an interdependence of the public and esoteric that informs societies such as those of the masonic lodges with 'a dialectical character'.[46] The masonic lodges are defensively hedged about with mysterious fraternization rituals which as it were mark off the societies they enclose from the contaminations of the courtly publicity ceremonies that are external to them. But as the public space they defend becomes itself the distinctive character of that external world, the masonic societies seem to be assimilated to the mystery and ritual that they had attempted protectively to externalize.

[45] *The Bligh Notebook, with a Draft List of the Bounty Mutineers*, ed. John Bach (Sydney, 1987), 214. James Morrisson, who bore the star and garter tattoo, remained on Tahiti for some time after the mutiny. Writing about his stay, he argues that every line of the tattoos is significant, dismissing the distinction between public significance and private whim that other voyagers' discussions allude to.

[46] Jürgen Habermas, *The Structural Transformation of the Public Sphere: An Inquiry into a Category of Bourgeois Society*, trans. Thomas Burger and Frederick Lawrence (London, 1989), 35.

A similar pattern of structural transformation may mark the processes of discursive interaction that I have been discussing. The discourse of civic humanism appropriates to masculinity an ideal universality unmarked by transitory or accidental vagaries, and excludes from that masculine ideal the various elaborations and sensual pleasures of ornamental femininity. The valorization of civility, I suggested, inflected that civic ideal with feminine elegance of manners, and refinement of sentiment. This softening of the definition of civilization introduced the possibility that its standards and ideals were relative, rather than universal, and it therefore implied that the civilized subject might extend a worldly tolerance to cultures perceived to be different, rather than necessarily opposed, and barbarously benighted. But this notion of the relativity of culture depended on the exclusion of feminized sensuality and vanity—of a gendered and devalued physicality that was universal in its lack of any cultural significance or legibility. Juxtaposed with civic humanism and the more ambivalent notion of civility, the discourse of custom which articulates the national community defines masculinity in terms which appear to appropriate to it a barbarous or feminine sensual taste for marks of ornament. In this context, the masculinity of the subject is defended by its discursive opposition to a construction of the feminine and exotic which is physically specific, but universal in its primitive debasement. To some extent, then, civility and custom seem to share a common antagonism to a feminine and exotic physicality that is excluded from the terms in which either discourse recognizes value or significance. What remain ambiguous, and therefore troubling, in status, are the different feminine qualities both of these discourses appropriate to themselves: the femininity of manners with which civility softens and relativizes the ideal masculinity of civic humanism, or the feminine and sensual love of ornament that manifests attachment to the local community of custom.

In Habermas's discussion of freemasonry there is an uneasy interchange between the fraternization ceremonies necessary to produce equality within secret societies, and the openness that characterizes the bourgeois public space of rational communication. That problematic interchange of inclusive and exclusive demarcation seems in the texts I have discussed to be shadowed or parodied by the inscribed and feminized anatomies of South Sea islanders, English ladies and sailors. They seem both to confirm and to blur the identity of civilization with the national community of custom, in their perversion of the secret ceremonies and insignia on which the opposition of the domestic and the exotic depends. Their ornamentation with the marks of fashionable whim or traditional custom seems to inscribe

in them the marginal limits, the painful line of transition, which confronts the domestic public with the spectacle of its own secret and exotic fragmentation, and excites its fascinated desire and repulsion.

5

The Origin of Painting and the Ends of Art: Wright of Derby's Corinthian Maid

ANN BERMINGHAM

The truth may be that we cannot form a clear
conception of anything unless we might also
have invented it. (VALÉRY)

I

LET us begin at the beginning. In a room lit by a single
lamp a young woman traces the shadow of a sleeping youth on a bare wall.
She is posed precariously; her left hand steadies her right as it tentatively
guides the sharp, pointed instrument along the line of his silhouette. He
sleeps heavily, a faithful grey hound at his feet; while she, overcome by his
presence, pauses to gaze rapturously at his face. The room is bare of
decoration; two large amphoras, a lamp hidden by a curtain, and a bench
make up its furnishings. Through an archway in a second room glows a
potter's fiery kiln.

Sometimes known as the 'Origin of Painting', Joseph Wright's *Corinthian
Maid* (Fig. 5.1) is one of many versions of the subject that were produced
in England and France during the second half of the eighteenth century.
While an exemplary iconographical account by Robert Rosenblum has
shed light on the extensive literary and artistic origins of the subject, the
reasons for its popularity in the eighteenth century and its possible cultural
significance remain shadowy.[1] By way of explanation, Rosenblum suggests

[1] See his 'The Origin of Painting: A Problem in the Iconography of Romantic Classicism', *Art
Bulletin*, 39 (Dec. 1957), 279–90; and George Levitine, 'Addenda to Robert Rosenblum's "The Origin

that the subject appealed to the period's romanticism, its 'lachrymal sensibilities', its historicizing tendencies, its delight in examples of feminine virtue, its taste for neo-classical linear style, its enjoyment of eroticism, its interest in physiognomy, its fascination with silhouette-making, and its relative tolerance of professional women artists.[2] While I have no wish to dispute the contents of this list, I would suggest that the list itself is a collection of effects not causes. The term linking most of its items (romanticism, sentimentalism, neo-classicism, and eroticism) is 'style', that is to say, what Rosenblum has dubbed 'romantic classicism'. Style is itself a symptom of cultural taste, however, and not an explanation for it. Moreover, it is incapable of accounting for those equally important items that cannot be directly attributed to its 'influence'—such as the role of women artists in the later half of the century. Rather than attempt to answer these questions in terms of period style, I wish to look at them within the more narrow historical context of late eighteenth-century British aesthetics. By focusing on Wright's painting I wish to explore the subject's connotations and reception, and suggest a social basis for its popularity. Briefly, it is my belief that the legend describes a particular relationship between image and object that was both popular and problematic; and for this reason, the Corinthian maid held a central yet ambivalent place in the institutionalization of the fine arts in Britain at the end of the century.

The subject derives from Pliny, who, in recounting the invention of painting, notes, 'all agree that painting began with the outlining of a man's shadow'.[3] Interestingly, however, Pliny never attributes this originary act to the Corinthian maid. Instead she appears in another context. Pliny mentions her in the story of Boutades, a potter of Sikyon, who with her help discovered how to model clay bas-reliefs. According to Pliny, 'She was in love with a youth, and when he was leaving the country she traced the outline of the shadow which his face cast on the wall by lamplight. Her father filled in the outline with clay and made a model; this he dried and baked with the rest of his pottery.'[4] In 1778 the poet William Hayley, a

of Painting: A Problem in the Iconography of Romantic Classicism" ', *Art Bulletin*, 40 (Dec. 1958), 329–31. More recently Hubert Damisch has discussed antique and Renaissance accounts of the story and their implications for the meaning and development of perspective painting. See his *L'Origine de la perspective* (Paris, 1987). The Corinthian maid is also discussed by Richard Shiff in his 'On Criticism Handling History', *History of the Human Sciences*, 2/1 (1989), 63–87.

[2] Ibid., 283–8.

[3] Pliny the Elder, *Pliny's Natural History*, trans. H. Rackham, 10 vols. (Cambridge, Mass., 1961), ix. 271.

[4] Ibid., ix. 371–3. In tracing the origin of the 'Origin of Painting', Robert Rosenblum discovered a second antique source, Athenagoras' *Apologetics*, which appeared in an English translation in 1714 (see Rosenblum, 'Origin of Painting', 281). In Athenagoras' account the father of the maid is a joiner by

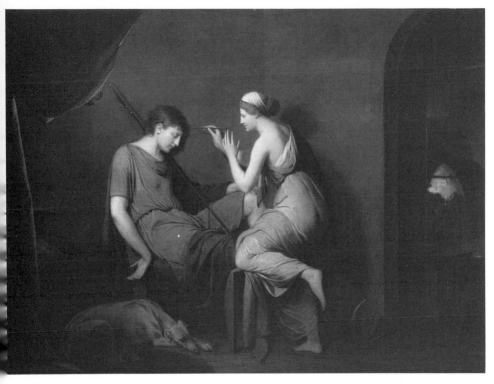

5.1 Joseph Wright of Derby, *The Corinthian Maid*, 1783–4, oil on canvas, $41\frac{7}{8} \times 51\frac{1}{2}$ in.;
reproduced by permission of the National Gallery of Art, Washington (Paul Mellon Collection).

friend of Wright's, embellished Pliny's tale in a poem entitled *An Essay on Painting*.[5] In the poem Hayley gives this account of the legend:

> Inspir'd by thee [LOVE], the soft Corinthian maid
> Her graceful lover's sleeping form portray'd:
> Her brooding heart his near departure knew,
> Yet long'd to keep his image in her view:
> Pleas'd she beheld the steady shadow fall,
> By the clear lamp upon the even wall:
> The line she trac'd with fond precision true,
> And, drawing, doated on the form she drew;
> Nor, as she glow'd with no forbidden fire,
> Conceal'd the simple picture from her sire:
> His kindred fancy, still to nature just,
> Copied her line, and form'd the mimic bust,
> Thus from thy power, inspiring LOVE, we trace
> The modell'd image, and the pencil'd face![6]

Significantly for Wright's painting, Hayley, unlike Pliny, locates the origin not only of clay modelling but also of drawing and painting in the maid's tracing.

The poem inspired Wright, who began planning his painting in 1778 as a commission for the potter Josiah Wedgwood, and who wrote to Hayley in 1784 when the work was nearly complete, 'I have painted my picture from your idea.'[7] Accordingly, the maid's relationship to pictorial representation is seen by Wright to be deeply intimate, born of desire provoked by the anticipated loss of the beloved. Withdrawn from the world, within the cloistered walls of her father's house, the maid's act of love—her tracing—in all its obvious inadequacy either to detain her lover or to fully render him, evokes its own powerlessness in the very act of opposing it. Lacking realism, her simple outline has no public status. Unlike mimetic

profession and models the features of her drawing in wax. Athenagoras adds an important detail to the story, which also appears in Wright's painting, in that he has the maid draw her lover's picture on the wall as he lies asleep.

[5] For a full account of Hayley's connection with Wright and his importance for *The Corinthian Maid*, see Judy Egerton, *Wright of Derby*, Tate Gallery cat. (London, 1990), 132–4, and Benedict Nicolson, *Joseph Wright of Derby: Painter of Light*, 2 vols. (London, 1968), i. 143–6.

[6] Quoted in Egerton, *Wright of Derby*, 133.

[7] Ibid., 134. Frank Cossa provides a complete account of the commission in 'Josiah Wedgwood: His Role as a Patron of Flaxman, Stubbs, and Wright of Derby' (Ph.D. dissertation, Rutgers University, New Brunswick, NJ, 1982), 224–47, as does Nicolson, *Joseph Wright of Derby*, 143–6.

art, it cannot deceive the eye in order to move or persuade the mind. As a trace it remains inaccessible to the imaginations and experiences of others. Its primitive literalness commemorates a private experience: the very spot where he lay his sleeping head; where the shadow fell; where she, breathless, traced its silhouette. It is not really a painting or drawing but, like a footprint, the sign of a lost presence. Like the shadow, it has no substance; it is an empty cipher, a project that can only be completed by the maid's own memory of her lover. The trace also erases her presence, for it lacks any of the signifying marks that would signal a shaping consciousness. Moreover, her selfhood is erased a second time by her father's effacement of her tracing with clay.[8] Thus in every way, the simple outline is the inescapable evidence of absence and lack and not, like Boutades' 'mimic bust', the illusionistic simulacrum of presence. Thus her father's invention seems less an inspired response to her inventive longing than a *horror vacui* provoked by the loss and emptiness that her outline memorializes.[9]

Instead of the Corinthian maid, Wright appears originally to have proposed the subject of 'The Alchymist' to Wedgwood. In a letter to his partner, Thomas Bentley, however, the potter revealed that he felt that 'Debutades daughter would be more apropos'.[10] Ever willing to please a patron, Wright agreed, and went so far as to suggest that he depict pottery and classical vases in Boutades's house that would resemble Wedgwood's ornamental works from Etruria. In mentioning this to Bentley, Wedgwood questioned the propriety of including examples of their 'fine things' in an image representing the 'infancy of the Potter's Art'.[11] Nothing of importance seems to have been done about the painting until 1782, when Wright

[8] In 'Freud and the Scene of Writing,' Derrida has observed that 'the trace is the erasure of selfhood, of one's own presence, and is constituted by the threat or anguish of its irremediable disappearance, of the disappearance of its disappearance' (*Writing and Difference* (Chicago, 1978), 230). His remarks seem particularly appropriate to our study of femininity and representation as encoded in *The Corinthian Maid*. Derrida has recently referred to the legend of the Corinthian maid in his catalogue for his exhibition at the Louvre, *Mémoires d'aveugle: L'Auto-portrait et autres ruines* (Paris, 1990), 48–57. For him the maid's tracing is both the origin of visual representation and a moment of blindness, for in order to make her tracing she must look at the wall and away from the motif. Thus within visual representation, within the origin of representation, within the moment of representation, there is blindness. Drawing is thus the trace or 'memory' of this blindness.

[9] On the relationship of Wright's imagery to signs of loss and mourning see Ronald Paulson, 'The Aesthetics of Mourning', in *Studies in Eighteenth-Century British Art and Aesthetics*, ed. Ralph Cohen (Berkeley, Calif., 1985), 148–81.

[10] *Letters of Josiah Wedgwood, 1771–1780*, ed. Katherine Eufemia Farrer, 3 vols. (Manchester, 1903–6), ii. 427. Wright did paint a painting called *The Alchemist in search of the Philosopher's Stone, Discovers Phosphorus*, which he took to Rome in 1773 and which returned with him to England in 1775. This image was mezzotinted by Pether in 1775. A second painting of the same title is signed and dated 1795. Nicolson believes that this second painting is a repainting of the 1773 original, and that the 1773 painting was the one offered to Wedgwood. (See Nicolson, *Joseph Wright of Derby*, 236, cat. no. 195.)

[11] *Letters of Josiah Wedgwood*, i. 428.

sent a sketch of it to Hayley for criticisms with the request that he forward
it on to Wedgwood. In April 1784 Wedgwood escorted some ladies to
Wright's studio to admire the nearly completed work, only to find them,
as he explained to the artist, affronted by the 'divisions of the [maid's]
posteriors appearing too plain through the drapery and its sticking so
close'.[12] Wright quickly assured Wedgwood that he would 'cast further
drapery upon the Corinthian Maid'.[13] Having finally satisfied his patron
and, presumably, feminine modesty, Wright notes in his account book for
4 July 1785 a receipt of £150 from Wedgwood for 'The Corinthian Maid'
and 'other pictures'.[14]

On the basis of Pliny's account and Wedgwood's patronage, Frank Cossa
has argued that the painting was understood by both the painter and the
potter to be about the origin of clay modelling and not about the origin of
painting.[15] While well taken, his point overlooks the fact that in the
eighteenth century images of the Corinthian maid were alternately entitled
'the origin of painting', and 'the origin of drawing'. This would suggest
that in addition to clay modelling, the pictorial arts of painting and drawing
were clearly understood also to derive from this source.[16] Indeed, Wright
acknowledged their shared nascency in a letter to Wedgwood explaining
his choice of drawing implement: 'as the lines she made were no doubt
scratched on the wall, for as it was said, it gave birth to designing, they
were I suppose unacquainted with drawing materials, it is natural to
imagine, She made use of some sharp pointed and hard instrument'.[17] The
letter suggests that Wright, like Hayley, saw both drawing and painting as
originating in the maid's scratched outlines. The tendency of this period,
evident in the titles of paintings of the Corinthian maid and in verbal
renditions like Hayley's poem, to rewrite Pliny and compress the origins
of the pictorial arts into a single seminal moment is significant. In addition
to simplifying what would otherwise be a series of different and possibly
contradictory histories, a single origin for the pictorial arts posited a primal
unity among them and imbued them with a logical and sequential formal
order. Such cultural rewriting provided a point of origin to which one
could return in order to trace the steps made by the visual arts from
their primitive beginnings to the present day. Moreover, in addition to

[12] Quoted in Nicolson, *Joseph Wright of Derby*, 146.
[13] Ibid., 146.
[14] Egerton, *Wright of Derby*, 132.
[15] Cossa, 'Josiah Wedgwood', 248–9.
[16] John Hamilton Mortimer's (*c.* 1771) version was titled 'The Origin of Drawing'; David Allan's
(1775) and Edward Francis Burney's (*c.* 1790) were titled 'The Origin of Painting'.
[17] Quoted in Cossa, 'Josiah Wedgwood', 242.

establishing a point of departure from which one could map a continuous history of art, it also provided a point of difference, that is, a past that could be contrasted with the present.[18]

It is as both a point of departure and a point of difference that the Corinthian maid will concern me. I would like to use the story, as depicted by Wright, to illuminate a range of aesthetic issues that emerged in the latter half of the eighteenth century in Britain having to do with the nature and purpose of the fine arts. Focusing on the commission of the painting by Wedgwood, I wish to look at its subject in connection with the period's cultural politics, that is, the relationship between the fine arts and other forms of artistic practice. To do this will mean examining the nature of the maid's invention, her primitive form of marking, and what were understood to be its generative powers and limitations. It will also mean coming to terms with the paradoxical nature of the image by positioning the work in terms of the gendered nature of artistic discourse, while subjecting this discourse to analysis. My working assumption will be that in the later eighteenth century the cultural hegemony of the fine arts and the place of women *vis-à-vis* artistic production and consumption were not separate issues but were deeply interwoven, and that images like *The Corinthian Maid* underscored this fact. In short, with the founding of the Royal Academy, the popularly understood role and purpose of the visual arts were recast. For this reason, the Corinthian maid occupied a central yet ambivalent place in the period's construction of painting. By examining the ends of art as they were reformulated at this time, I believe we come to understand the Corinthian maid as an enabling myth of their origin.

II

Two years before he commissioned Wright's painting, Wedgwood succeeded in creating a new material for making pottery which he called 'jasper'. From 1771 to 1777, when jasper was finally put into regular production, Wedgwood experimented extensively with different clays and chemicals to derive an evenly coloured earthenware bisque that could be polished like stone. Jasper followed his introduction of creamware in 1763 and black basalt in 1767. Like creamware, black basalt had been a great success not only because, as Wedgwood had predicted, it showed off a lady's bleached white hands to advantage, but because it catered to the growing popular taste for antique art. In particular, its imitations of

[18] On the question of beginnings and their uses see Edward W. Said, *Beginnings: Intention and Method* (New York, 1976).

Renaissance bronzes and of red-figure Greek vases from famous collections such as Sir William Hamilton's were highly esteemed and valued for their classical style.

By comparison the manufacture of jasper was not an immediate success. The experiments had been costly and time-consuming and the results were often unpredictable. The material was brittle and broke easily, the coloured grounds bled into the white reliefs, and the reliefs themselves often cracked or curled at the edges in firing or failed to adhere to the grounds altogether. As late as 1776 Wedgwood complained to Bentley, 'This Jasper is certainly the most delicately whimsical of any substance I ever engag'd with.'[19] And while he was determined to make jasper tablets he confessed, 'I apprehend we shall never make a Perfect one.'[20] Wedgwood fired over 10,000 pieces of jasper before achieving the effect he desired.[21] The losses were staggering. In May 1776 alone he reported a 75 per cent loss in firing jasper tablets.[22] Wedgwood had intended that jasper should be used primarily for bas-relief sculptural decoration in the form of plaques or tablets that could be set into furniture and architecture, or, less importantly, as small cameos and intaglios that could be used for seals and jewellery. In an early catalogue (1787) he described it as

Jasper—a white porcelain biscuit of exquisite beauty and delicacy, possessing the general properties of the basaltes, together with that of receiving colour through its whole surface, in a manner which no other body, ancient or modern, has been known to do. This renders it peculiarly fit for cameos, portraits, and all subjects in bas-relief; as the ground may be made of any colour throughout, without paint or enamel, and the raised figures of pure white.[23]

While tablets and smaller items in jasper were available from 1777 on, vases and other hollow-ware objects made of jasper were not exhibited to the public until 1782 and jasper tableware appeared a few years after that.

Through the production of jasper tablets Wedgwood and Bentley had hoped to capture the attention of architects and interior designers. Listed in the catalogue of 1779, jasper is described as suitable for application as 'Cabinet Pictures, or ornamenting Cabinets, Book-Cases, Writing-Tables

[19] Quoted in Robin Reilly, *Wedgwood*, 2 vols. (London, 1989), i. 531.
[20] Alison Kelly, *Decorative Wedgwood in Architecture and Furniture* (London, 1965), 59.
[21] Neil McKendrick, 'Josiah Wedgwood and the Commercialization of the Potteries', in Neil McKendrick, John Brewer, and J. H. Plumb, *The Birth of a Consumer Society: Commercialization of Eighteenth-Century England* (London, 1982), 105, n. 28.
[22] Reilly, *Wedgwood*, i. 531.
[23] Quoted in *Josiah Wedgwood: 'The Arts and Sciences United'*, Science Museum cat. (London, 1978), 14.

&c.'[24] In anticipation of architects, cabinet-makers, and decorators using the new material, Wedgwood chose colours for the jasper grounds that had been made fashionable for interiors by the architects Robert Adam and James Wyatt.[25] The decision to tap into the building and decorating boom of the late eighteenth century was, on the surface, a sound one. Architects like Adam and Wyatt were making large fortunes from building opulent houses and decorating them in the new neo-classical style. Yet, despite Wedgwood's acute market instincts and his close attention to the details of the fashion for neo-classical interior decoration, architects and decorators were slow to favour the jasper tablets.[26] In 1778 Wedgwood unsuccessfully attempted to win round the opinion of the architect and landscape gardener Lancelot 'Capability' Brown, who objected to the coloured ground of the tablets, insisting that they should have the colour of natural stone or be left white.[27] Retailing the encounter to Bentley, Wedgwood wrote:

Both Mr B. and Ld Gower objected to the blue ground, unless it could be made into Lapis Lazuli. I showed them a sea-green and some other colours, to which Mr Brown said they were pretty colours, & he should not object to them for the ground of a room, but they did not come up to his ideas for the ground of a tablet, nor would any other colour unless it were a copy of some natural & valuable stone. All other color'd grounds gave ideas of color'd paper, painting, compositions, casting, moulding &c. & if we could not make our color'd grounds imitate marble or natural stones, he advis'd us to make the whole white, as like to statuary marble as we could.[28]

Other architects were approached; Bentley recommended the tablets to Adam, and Wedgwood urged his partner to call on the architect James Wyatt and 'try if it is not possible to root up his prejudices & make him a friend of our jaspers. If we could by any means gain over two or three of the current architects the business would be done.'[29] Unfortunately, this was not to be. Writing to Bentley in 1779, after a report that certain

[24] Reilly, *Wedgwood*, i. 581.

[25] Ibid., i. 577. In the early 1770s Wedgwood had manufactured terracotta plaques for architectural decoration that could be painted over to look like wooden or plaster moulding. In 1777, at the time Wedgwood was experimenting with jasper, Mathew Boulton approached Wedgwood with the idea that they should collaborate. Boulton proposed that Wedgwood supply him with plaster plaques that Boulton could cast and then stamp in tin; these tin reliefs could then be painted and used for architectural decoration. Nothing came of this proposal.

[26] As Alison Kelly has shown, jasper was not completely ignored. However, as she acknowledges, it had to compete with a large selection of architectural ornaments produced at this time. See Kelly, *Decorative Wedgwood*, 69.

[27] Ibid., 582

[28] Quoted in ibid., 73

[29] Quoted in McKendrick, Brewer, and Plumb, *Birth of a Consumer Society*, 116.

architects had dissuaded Queen Charlotte from purchasing his plaques for chimney-pieces, he mused philosophically:

I am still perswaded the jasper tablets, & pictures must sell maugre all the good offices of our friends the architects ... *Fashion* is infinitely superior to *merit* in many respects; & it is plain from a thousand instances that if you have a favorite child you wish the public to fondle & take notice of, you have only to make choice of proper sponcers. If you are lucky in them no matter what the brat is, black, brown, or fair, its fortune is made. We were really unfortunate in the introduction of our jasper into public notice, that we should prevail upon the architects to be godfathers to our child. Instead of taking it by the hand, & giving it their benediction, they have cursed the poor infant by bell, book & candle, & it must have a hard struggle to support it self, & rise from under their maledictions.[30]

The following month he noted, 'If Sr Wm Chambers was as limited in his power over the *jasper tablets* as he is in the *Pearl White* [a new white pottery Wedgwood had developed] we should have nothing to fear from him in that respect.'[31] The only architect to use the tablets in this period was James Stuart, for the decoration of Mrs Montague's house in Portman Square, and Wedgwood wrote to Bentley congratulating him on his 'conversion of the Athenian.'[32] While the setback in marketing jasper was ultimately to prove only temporary, it lasted until after Bentley's death in 1780.[33]

For the first time Wedgwood's market instincts had seriously erred. Neil McKendrick, in his analysis of Wedgwood's commercial innovations, attributes the failure of the jasper plaques to their lack of aristocratic patronage.[34] While this is true, it is also true that Wedgwood was not creating useful items but objects that were more conspicuously 'art', or as he called them 'cabinet pictures'. Rather than sell direct to his usual well-to-do patrons or the larger middle-class public, Wedgwood was hoping to attain the notice and favour of middlemen, that is to say, artists who would contract for his works. While it is difficult to account for the architects' cool reception of the jasper tablets, there are some indications as to their reasons. Capability Brown's objection to the coloured grounds of the tablets suggests a reluctance to introduce into neo-classical buildings sculptural decoration that did not look like natural stone and that instead looked

[30] *Letters of Josiah Wedgwood*, ii. 493–4.
[31] Reilly, *Wedgwood*, i. 579.
[32] Ibid.
[33] Kelly, *Decorative Wedgwood*, 76–7.
[34] McKendrick, Brewer, and Plumb, *Birth of a Consumer Society*, 116.

conspicuously artificial and manufactured. Wedgwood admitted as much when he explained to Bentley:

I know they [jasper tablets] are much cheaper ... than marble & in every way better, but people will not compare things which they concieve to be made out of moulds, or perhaps stamped at a blow like the Birmingham articles, with carving in natural stones where they are certain no moulding casting or stamping can take place.[35]

Wedgwood's remark about Sir William Chambers holds a further clue as to why the tablets did not sell. Chambers was highly critical of the work of the Adam brothers. He disapproved of the linear quality of their designs and the thin and light proportions of their buildings, almost as much as he envied their success.[36] Since Wedgwood's jasper tablets were in the Adam style, they also merited his censure. At this time Chambers was architect to the King and Comptroller of the Board of Works, and his opinion carried some weight. Yet perhaps more telling is Wedgwood's mention of 'Pearl White' in regard to Chambers. Pearl white was used for tableware and was marketed as an 'innovation', as he stressed to Bentley, 'not an improvement' over the yellow-tinged creamware. Because it was used for tableware, the market for pearl white was primarily women and not men, and certainly not artists of Chambers's calibre. As Wedgwood's remark suggests, if jasper had been used first for tableware, Sir William Chambers's and the architects' influence over its fortunes might have been more curtailed. His insight is borne out by the fact that jasper became popular only in the early 1780s, that is to say, only after it was introduced into the production of hollow-ware items and marketed to the public in a more direct way. In other words, jasper appears to have become popular through its first appearance at the tea table and not on the chimney-piece.

Wedgwood is an excellent example of an early industrialist who recognized role of women as consumers and responded to it. 'It will be in our interest', he wrote to Bentley, 'to amuse, & divert, & please, and astonish, nay & even to ravish the Ladies.'[37] So as 'not to give offence to our delicate Ladies', female neo-classical figures were modestly draped in the manner he demanded of Wright's *Corinthian Maid* while heroes and gods were made to sprout fig leaves.[38] In addition, Wedgwood hired women like Elizabeth, Lady Templeton (1747–1823), Emma Crewe (c. 1787–1818),

[35] Kelly, *Decorative Wedgwood*, 72.

[36] Ibid., 76.

[37] Quoted in McKendrick, Brewer, and Plumb, *Birth of a Consumer Society*, 110.

[38] Quoted in ibid., 113. McKendrick has noted that, by contrast, for the aristocratic market Wedgwood was usually 'wholly faithful to the classical originals' (ibid.).

and Lady Diana Beauclerk (1734–1803) to devise designs that would appeal
to feminine taste, and subjects like Charlotte at the tomb of Werther paid
homage to feminine fidelity and *sensibilité*.[39] From Queen Charlotte and
the Empress of Russia, who bought creamware (and hence enabled Wedg-
wood to change its name to 'Queen's ware'), to the ladies who bleached
their hands and bought black basalt teapots, the feminine market was the
market Wedgwood had helped to create. By highlighting the role of a
woman in the originary process of tracing shadows, Wright's painting paid
tribute to Wedgwood's considerable female following. The sentimental
aspects of the story flattered a sensibility that the entrepreneur had so often
and successfully cultivated, and that appeared to extend even to the works
of art he himself privately consumed.[40]

The fortunes of the jasper tablets have, I think, some bearing on Wright's
painting. First, it is significant that Wedgwood turned down the subject
of the alchemist, preferring instead the Corinthian maid. Alchemy had
brought about the invention of porcelain in the West when in 1709 at
Meissen the alchemist Johann Fredrich Bottger discovered the process for
making a ceramic material that resembled Chinese porcelain. The King of
Poland and Elector of Saxony established the porcelain works at Meissen,
and this was to set the pattern throughout the Continent, culminating in
1756 with the founding of the royal factory in France at Sèvres. Throughout
the eighteenth century porcelain production was the lucrative pastime of
kings and princes. While porcelain was manufactured privately in England,
the lack of royal patronage and promotion meant that native porcelain
could not compete with the Continental ware. As Wedgwood never manu-
factured porcelain and had specifically created materials such as creamware
and jasper to compete with it, the subject of the alchemist may have seemed
an inappropriate one to him. By contrast, the story of the Corinthian maid
could be said to have spoken directly to the issues raised by the manufacture
of earthenware generally and to the jasper plaques in particular. The legend
locates the production of earthenware bas-relief in antiquity, and centres
its production on a moment that was coextensive with the invention of the
arts of drawing, painting, and design and that placed it on an equal

[39] Reilly, *Wedgwood*, i. 604–7.

[40] As regards Wedgwood's own taste in art, it should be noted that following the completion of *The Corinthian Maid*, Wedgwood commissioned Wright to do a companion painting for it. The choice of subject was *Penelope Unravelling her Web, by Lamp-Light* (J. Paul Getty Museum). Once again a woman is the subject of the painting, and once again love is the motive for her actions. In this case, however, she undoes her artistry, for to complete it would be to divide her from her husband and bind her to another. Louise Lippincott has suggested to me that *Penelope* refers to another of the midland industries, weaving, and that as *The Corinthian Maid* complements Wedgwood's innovations in pottery, *Penelope* refers to Joseph Arkwright's industrialization of textile manufacture.

footing with them. Rather than depending on the secret, occult practices of alchemy, it could be said to have an origin as open and straightforward as the maid's own unblushing love. The image had nationalist connotations for, unlike porcelain's royal and Continental origins and patronage, earthenware's humble beginnings were more democratically entrepreneurial and more attuned to the private commercial economy of Britain. Finally, the painting gave the craftsman a central role as an inventor and creative designer.

The choice of the subject of the Corinthian maid coincides with the beginnings of Wedgwood's attempts to market the jasper plaques. While the painting was surely not intended as an advertisement for the plaques, its subject highlighted the antique origins of their silhouette-like designs. These designs differed from the small medallions Wedgwood had made earlier in black basalt because the contrasting coloured grounds of the jasper tablets emphasized the flatness of the reliefs and their contours. By comparison the monochromatic black basalt bas-reliefs focused on the interior modelling of the design and made it appear to emerge in a more three-dimensional way from the ground. These medallions looked more like Renaissance bronzes than classical cameos. The jasper tablets thus represent a new phase in neo-classical taste, one more decidedly antique than Renaissance. The flat, silhouetted reliefs of the jasper tablets not only echoed the tracing of the Corinthian maid but also complemented the light and airy neo-classical interiors of men like Adam, Stuart, and Wyatt.

Moreover, like the maid's trace or Boutades' 'mimic bust', the tablets transcended mere craft. The distinction between craft and decoration became a matter of some importance for Wedgwood at this time. The most serious disagreement he had with Bentley was in attempting to devise what were to be their working definitions of 'utility' and 'ornament'. 'With respect to the difference between Usefull ware & Ornamental I do not find any inclination in myself to be over nice in drawing the line,' he wrote to Bentley in 1770. Yet after some reflection he continued, 'may not usefull ware be comprehended under this simple definition, of such vessels as are made use of at meals.'[41] In order to be considered 'ornamental', the tablets not only had to be non-utilitarian but they also had to take on some of the characteristics of art, most importantly an aura of uniqueness so as not to appear to be the objects of mass production 'stamped at a blow'. As McKendrick has pointed out, a large part of the popular cachet that Wedgwood products enjoyed had not only to do with their high quality

[41] *Letters of Josiah Wedgwood*, i. 373–5.

but with his positioning of them in the market as 'art'. To this end, Wedgwood kept his prices high, paid large commissions to the artists he employed like Flaxman and Stubbs, and was not averse to producing single objects for special clients.[42] He was a potter who was determined to stand above the rest by claiming a status for himself and his works that was superior to the merely commercial one of his competitors.

The legend of the Corinthian maid, with its emphasis on love as the source of creative inspiration, removed the tracing of designs and their casting in earthenware bas-relief from an origin in commercial production. Yet such a move was a mixed blessing, for while it raised the process above the level of commerce it could not raise it to the level of art. The sentimentalism of the story, with its emphasis on the private commemorative purpose and meaning of the tracing, precluded any notions of public significance or imaginative genius that would attend a work of art. The 'romantic classicism' of Wright's painting corresponds to a taste that Wedgwood had helped to create and that he now attempted to universalize through the production of the jasper tablets. Such a reading of the subject suggests that the reluctance of the architects to use the jasper tablets may in turn be attributed to their own growing pretensions to being 'artists' and a corresponding wariness on their part about supporting the manufacturer of 'Queen's ware' in what may have seemed to be a vulgarization and even feminization of the neo-classical taste.[43]

III

Somewhat paradoxically, I believe, it is precisely this anxiety with regard to the status of fine art and artists in Britain that accounts for the popularity of the Corinthian maid among artists in the later half of the eighteenth century. The subject appears to have been first painted by John Hamilton Mortimer. His painting is lost; however, an engraving of it published by Boydell in 1771 shows it to have been rather spartan in its neo-classical conception and design.[44] That same year Alexander Runciman painted the subject, depicting his figures close-up in a nocturnal garden setting. Like Wright, he too shows the maid's lover asleep, in this case his head resting

[42] McKendrick, Brewer, and Plumb, *Birth of a Consumer Society*, 104–8.

[43] It should be recalled that at this time Sir William Chambers was engaged in building Somerset House, the future home of the Royal Academy. He was devoted to professionalizing architecture and to this end became one of the founding members of the Academy. See John Summerson, *Architecture in Britain, 1530–1830* (Harmondsworth, 1969), 415–24.

[44] Reproduced in *John Hamilton Mortimer ARA, 1740–1779*, Tower Art Gallery cat. (Eastbourne, 1968), 32, fig. 47.

against a garden wall while she sketches his profile by moonlight.[45] Four years later David Allan painted an oval version depicting the maid *en déshabillé* on the lap of her lover, who is embracing her. [46] Both Runciman and Allan painted their works in Rome, and the sensuous and erotic overtones that one finds in them may be attributed to the influence of contemporary Italian painting. Like Mortimer's painting, Allan's was engraved, and it may have been through these engravings that Wedgwood— ever vigilant for antique subjects and designs for his own work—first encountered the story. The Corinthian maid also figures in James Barry's final mural *Elysium, or the Final Retribution* (1771–84) in the Great Room of the Society of Arts. There she appears with 'the shade of her lover' as one of the few women in the great pantheon.[47] In spite of Barry's rejection of the legend as 'fabulous', he nevertheless did a pen-and-ink sketch of the subject independent of the *Elysium* mural, which is now in the Ashmolean Museum.[48] It is also known that the subject occupied Angelica Kauffman.[49] In addition, Cossa has identified drawings of the Corinthian maid by Giovanni Battista Cipriani and George Romney, an engraving by Francesco Bartolozzi, and a watercolour drawing in a sketch-book attributed to Antonio Zucchi, all dating from the late 1770s.[50]

The coincidence of so many artists being preoccupied with the subject in the same decade is striking. By way of explaining its popularity, Cossa has suggested that the theme might have been discussed as decoration for the Society of Arts.[51] Early in 1774 it was proposed that the Society's Great Room should be decorated with eight historical subjects and two allegorical pictures, the former to be executed by Sir Joshua Reynolds, Benjamin West, Nathanial Dance, Kauffman, Cipriani, Mortimer, Barry, and Wright,

[45] Reproduced in Rosenblum, 'Origin of Painting', fig. 4.

[46] Reproduced in Egerton, *Wright of Derby*, 133, fig. 21, and Rosenblum, 'The Origin of Painting', fig. 6.

[47] See William L. Pressly, *The Life and Art of James Barry* (New Haven, Conn., 1981), cat. of paintings, no. 27, and p. 296, fig. 149.

[48] Pressly, *James Barry*, cat. of drawings, no. 20. See also Cossa, 'Josiah Wedgwood', 244, fig. 4.

[49] Joseph Grego, 'The Art of Artistic Advertisement in the Eighteenth Century', *Connoisseur*, 2 (1902), 93. Cossa attributes a drawing of the subject to Angelica Kauffman which is in fact by Felice Giani (1758–1823). It appears in *Angelika Kauffmann und ihr Zeitgenossen*, Vorarlberger Landesmuseum cat. (Bregenz, 1968), 68, fig. 245.

[50] See Cossa, 'Josiah Wedgwood', 244–7. The watercolour in the Huntington sketch-book is unlike the others in it, which have been attributed to Zucchi (see Carol Margot Osborne, 'A Late Eighteenth Century Sketchbook: An Attribution of Antonio Zucchi', MA thesis, University of California, River-side, 1975, 67–8). The watercolour is identical to a Bartolozzi stipple engraving in the British Museum (see A.de Vesme, *Francesco Bartolozzi, Catalogue des estampes* (Milan, 1928), no. 2223) and is catalogued as designed, engraved, pulled, and signed by Bartolozzi. A much later drawing by Edward Francis Burney of the Corinthian maid from about 1790 was discovered by Marcia Allentuck (see 'Edward Francis Burney and the "Corinthian Maid" ', *Burlington Magazine* 122 (1970) 537 and 539–40).

[51] Cossa, 'Josiah Wedgwood', 245.

the latter by Romney and Edward Penny.[52] Since it is known that at least six of these artists eventually produced images of the Corinthian maid, it is very likely that Cossa is correct and that the subject was discussed as a possible choice for the decoration. Falling somewhere between history and allegory, it could have appealed to artists preoccupied with either; her appearance in the last painting of Barry's cycle, *The Progress of Human Knowledge*, might therefore be the residue of an earlier iconographic scheme for the room.

With its emphasis on invention and design, the Corinthian maid would have been a natural subject for the Society of Arts, Manufactures, and Commerce. Founded in 1754 in order to promote improvements in the liberal arts, sciences, and manufacture, the Society held annual exhibitions of drawings, models, and designs and awarded premiums to the most outstanding submissions. The proposal for its founding was drawn up by William Shipley and read in part:

That whosoever shall make the most considerable progress in any branch of beneficial knowledge, or exhibit the most complete performance in any species of mechanic skill, whosoever shall contrive, improve, execute, or cause to be executed any scheme or project calculated for the honour, the embellishment, the interest, the comfort (or in time of danger, for the defence of this nation) may receive a reward suitable to the merit of his services.[53]

The emphasis placed by Shipley on progress, improvement, and invention of design could be complemented by the story of Boutades and his daughter. In so far as any notion of progress demands a myth of origin from which progress can be measured, the Corinthian maid not only suggested the antiquity of the alliance between art and manufacture but also their 'improvement'. The very primitiveness of the maid's scratched outline made a flattering contrast with the elegant way in which modern artists depicted it.

With its agenda to improve the fine and industrial arts in order to increase and maintain Britain's economic power, the Society admitted scientists, inventors, mechanics, and men of business, as well as professional artists. The heterogeneity of its membership was reflected in the exhibitions, where maps, watercolours, oil paintings, and mechanical

[52] Nicolson, *Joseph Wright of Derby*, 4.
[53] Quoted in D. G. C. Allan, *William Shipley: Founder of the Royal Society of Arts* (London, 1979), 43.

models all vied for attention.[54] The extreme diversity of the entries and the unevenness of their quality accounts for the professional artists' disgruntlement with the Society that led to the founding of the Royal Academy in 1769. It should be mentioned that the Society of Arts was not alone in this mixing of fine art with science, manufacture, and craft. Provincial societies such as the Society of Arts of Liverpool, founded by Wright in 1769, also followed this model. All of which makes the founding of the Royal Academy significant not just because of the opportunity it provided for professional artists to train and exhibit, but because it sought to redefine in a national way all that was understood in Britain by the terms 'artist' and 'art'.[55]

In the third paragraph of his first Discourse delivered on 2 January 1769 upon the opening of the Academy, Sir Joshua Reynolds makes explicit the fundamental philosophical difference dividing the old Society of Arts from the new Academy. Remarking that 'elegance and refinement' are the 'last effect of opulence and power', Reynolds continues;

An Institution like this has often been recommended upon considerations merely mercantile; and an Academy, founded upon such principles, can never effect even its own narrow purposes. If it has an origin no higher, no taste can ever be formed in manufactures; but if the higher Arts of Design flourish, these inferior ends will be answered at once.[56]

Making mercantile considerations incidental to the development of the 'higher arts of design' set the Academy on a higher path from the one trod by the Society of Arts. The artist was no longer on the same footing with the mechanic, inventor, scientist, and craftsman in that his work was not to enhance and maintain Britain's economic hegemony but to serve an abstract ideal of beauty. Commerce was now put at the service of art for its purpose was to create the culture of 'opulence and power' that enabled the arts to flourish.

The establishment of the Academy professionalized and gentrified certain forms of artistic practice by differentiating them from other forms of design and representation. The early *Discourses*, in particular, can be

[54] Artists fared no better in the exhibitions of the Incorporated Society of Artists. The Society's 1769 exhibition at Spring Gardens included 'An Old Man's head done with a hot Iron'; 'a vase of flowers in shell work', and a portrait of a lady 'composed of human hair'. As quoted from the Society's catalogue in William T. Whitley, *Artists and Their Friends in England, 1700–1799*, 2 vols. (New York, 1968), i. 229.

[55] On the importance of Reynolds and the Academy in defining the role of art in commercial society, see John Barrell, *The Political Theory of Painting from Reynolds to Hazlitt: 'The Body of the Public'* (New Haven, Conn., 1986), 69–162.

[56] Joshua Reynolds, *Discourses on Art*, ed. Robert Wark (New Haven, Conn., 1975), 13.

read as an attempt to wean English artists away from notions of art's commercial utility and to set a different course for artistic practice. In these addresses to the 'gentlemen' of the Academy, Reynolds's 'great style' emerges as the sacred quest of all artists, which can never be satisfied by expedient short cuts. It was a new beginning, one unencumbered by an artistic heritage for, as Reynolds noted, 'we shall have nothing to unlearn'.[57] The Academy and its schools would be the first to place their mark on the *tabula rasa* of British artistic culture. Having no visual culture of their own, the whole history of art was open to them from which to pick and choose in developing a national school. In the *Discourses* Reynolds unfolds a formalist history of art, a procession of past schools, styles, and geniuses who had contributed to the development of the arts, and who were to serve as models for Academy students. While consumerist, such a history excluded ideas of utility and denied any ideological meanings that could not be derived from ideal artistic form. By contrast, the Society of Arts saw the arts as the means to an economic end and as already occupying the site of popular cultural inscription. In practice, of course, the difference between these positions meant that professional artists could exhibit at the Academy safe from the embarrassment of having to share space with maps and industrial models. The line Reynolds implicitly drew between the fine arts and other forms of artistic practice was a difficult one for artists (including himself) not to cross. It was a boundary that had to be continually renegotiated as artists found themselves dependent for their livelihoods on the commerce in images, decoration, and design generated by commercial capitalism. Nevertheless, in the decade following the founding of the Academy, the institution of Reynolds's distinction was profoundly felt.

Placed in this no man's land between the fine and industrial arts in Britain, the Corinthian maid and her 'invention' could be seen to address the newly problematized relationship between them. Central to this issue is the sex of the maid, the fact of her femininity, and the gendered nature of artistic discourse of the time. Given the domination of artistic practice in the eighteenth century by men, it seems odd that a legend that attributed the invention of the fine arts of painting, drawing, and modelling to a woman should have found so many male admirers. To appreciate how this could be, we need to review what was understood to be the nature of the maid's invention and the distinction it underscored between genius and nature, and between invention and imitation. To understand these differences we must return to Wright's painting. Wright depicts the Corinthian

[57] Ibid., 16.

maid as holding a stylus, the 'sharp pointed and hard instrument' he described to Wedgwood. In ancient times the stylus was an instrument used for writing on wax tablets. The implication of this choice of tools is that writing preceded drawing. Put another way, one could say that the visual arts originate in the failure of writing to represent literally. Only the actual trace of her sleeping lover's silhouette will satisfy the maid's desire. Visual representation thus resists the arbitrary relationship between signifier and signified that characterizes the written sign and replaces this arbitrary relationship with one grounded in resemblance. For artists the relative transparency of the visual sign has always been problematic, for it threatens to confine their activities to the sphere of nature and imitation. In order to understand the difficulty this poses for art, one must understand something about the opposition in Western aesthetics between the terms 'genius' and 'nature'. In her analysis of the Western understanding of 'genius', Christine Battersby has pointed out that it has always been gendered as male and seen as the divine promptings within the male self to reproduce through art.[58] By contrast nature, gendered as female, through the processes of moulding and drawing makes sure that the copy is an exact reproduction of the original. 'Nature is involved in a manufacturing process not unlike minting coins.'[59] The distinction between 'creative ("productive") and pseudo-creative ("reproductive") imagination' she sees as integral to all Romantic theories of art.[60] Thus for an artist to be a genius he must struggle against nature and imitation, against the transparency of the visual sign of art.

In discussing the legend of the Corinthian maid and its meaning for Renaissance perspective painting, Hubert Damisch has made the point that for ancient authors like Pliny and Quintilian, tracing shadows was considered to be imitation and not truly invention, for in tracing 'nature was the artist'. Such slavish imitation of nature came second to invention.[61] The difference between invention and imitation was central to Reynolds's theories, and in the thirteenth Discourse he uses it to challenge Plato's idea of mimesis:

When such a man as Plato speaks of Painting as only an imitative art, and that

[58] Christine Battersby, *Gender and Genius: Towards a Feminist Aesthetics* (London, 1989), 63.

[59] Ibid., 63.

[60] Ibid., 100.

[61] From a lecture, 'The Origin of Painting', given at the University of California, Irvine, 23 Mar. 1989. On the importance of the original and the copy to late 19th-century French painting and art theory and to early modernism in general, see Richard Shiff, 'The Original, the Imitation, the Copy, and the Spontaneous Classic: Theory and Painting in Nineteenth-Century France', *Yale French Studies*, 66 (1984), 27–54.

our pleasure proceeds from observing and acknowledging the truth of imitation, I think he misleads us by a partial theory. It is in this poor, partial, and so far, false, view of art, that Cardinal Bembo has chosen to distinguish even Raffaelle himself, whom our enthusiasm honours with the name of Divine. The same sentiment is adopted by Pope in his Epitaph on Sir Godfrey Kneller; and he turns the panegyrick solely on imitation, as it is a sort of deception.[62]

To set matters straight he declares, not without a tinge of exasperation:

Painting is not only not to be considered as an imitation, operating by deception, but that it is, and ought to be, in many points of view, and strictly speaking, no imitation at all of external nature. Perhaps it ought to be as far removed from the vulgar idea of imitation, as the refined civilized state in which we live, is removed from a gross state of nature; and those who have not cultivated their imaginations, which the majority of mankind certainly have not, may be said, in regard to arts, to continue in this state of nature. Such men will always prefer imitation to that excellence which is addressed to another faculty that they do not possess; but these are not the persons to whom a Painter is to look, any more than a judge of morals and manners ought to refer controverted points upon those subjects to the opinions of people taken from the banks of the Ohio, or from New Holland.

To imitate nature is to remain in a state of nature. To Reynolds's mind such copying stifled real invention, which could only be born of practice informed by theory.[63] Painting, then, was to enforce an arbitrary relationship between signifier and signified; it was, in so far as it was able to manage this, to aspire to the condition of writing. Reynolds's remarks help to clarify the nature of the Corinthian maid's invention. Rather than inventing the *arts* of drawing, painting, and modelling, she invented a series of reproductive *media* or *technologies* which, when taken up by the proper hands, could be used to make fine art. The case is further clarified when we realize that the maid does not trace her lover's profile but rather the shadow cast by it. Her image is thus a copy of a copy, the trace of a trace, a doubly degraded phantasmal semblance. Within the dialectical oppositions of Western aesthetics, the Corinthian maid can be seen to illustrate the primitive, pseudo-creative, reproductive process of imitation that was the domain of nature, women, and the industrial arts, and that Reynolds and the Academy had repudiated. In short, the subject was emblematic of a not-too-distant past from which modern artists were now supposed to take their distance.

[62] Reynolds, *Discourses*, 232.
[63] In the second Discourse Reynolds warns the student against copying as a 'mechanical practice' and 'delusive kind of industry' that destroys 'those powers of invention and composition which ought particularly to be called out' (see Reynolds, *Discourses*, 29).

The nature of the maid's invention clarifies her depicted role as spectator and the bearer of the gaze. In discussing the cultural role of the female spectator of cinema, Mary Ann Doane has spoken of a 'certain naïveté assigned to women in relation to systems of signification—a tendency to deny the process of representation, to collapse the opposition between the sign (the image) and the real'.[64] The woman's spectatorship thus results in a 'purportedly excessive collusion with the cinematic imaginary'.[65] We may apply Doane's observation to the problematic status of the Corinthian maid, and say that for the woman artist, the producer of images, this supposed collapse of sign into referent signals a reluctance or inability to abstract a representation from nature. Like the figures in Plato's cave in the thrall of their own shadows, she is both consumer and producer of illusionistic simulacra. Even Boutades' 'mimic bust' is already a step closer to Reynolds's conception of art, for unlike his daughter's tracing it demands some conceptual ability to abstract form from nature. In all his *Discourses* Reynolds never once refers to the story of the Corinthian maid, and while praising Pliny for the information he provides about the works of ancient artists he nevertheless goes on to note that he is 'very frequently wrong when he speaks of them, which he does very often in the style of many of our modern Connoisseurs'.[66] Reynolds's remark suggests that the popular notion of art was closer to that of Pliny and Boutades than to his own. Thus, while providing a flattering antique pedigree for Wedgwood's jasper tablets, the subject of the Corinthian maid could well have signalled to the Academicians their own distance from such primitive if popular ideas and modes of artistic production.

IV

Given Reynolds's complaint about 'modern Connoisseurs', it is not surprising to find that the Corinthian maid appears to have been a favourite emblem for those engaged in the more popular entrepreneurial and mechanical sides of art. She makes an appearance on a number of trade cards of the period, such as one designed for the printseller John Jeffry or another for the miniature and enamel painter Richard Collins (Fig. 5.2).[67] As these advertisements suggest, the Corinthian maid could speak to the growing

[64] Mary Ann Doane, *The Desire to Desire: The Woman's Film of the 1940s* (Bloomington, Ind., 1987), 1.

[65] Ibid., 1.

[66] Reynolds, *Discourses*, 79.

[67] I am grateful to Marcia Pointon for finding the Richard Collins trade card in the British Museum, and to John Barrell for alerting me to its presence. John Jeffery's trade card is illustrated in Grego, 'The Art of Artistic Advertisement', 90.

popularization of art and of artistic practices such as drawing and painting among the middle classes. Unlike the market for fine arts, the market for amateur artists' materials and supplies was virtually ready-made, and the fortunes amassed by printsellers like Rudolph Ackermann in the early decades of the nineteenth century attest to this fact.[68] Amateur art practices were social in that their primary use was to signal one's politeness, taste, and social standing as much as—if not more than—one's proficiency with a particular medium. The desire to paint or draw signalled gentility, not genius, and for this reason was felt to be particularly beneficial in helping young women find husbands. By the early nineteenth century, the public that businessmen like Ackermann served was made up largely of women; it was a public that had been all but ignored by the Academy and shut out of its schools and exhibitions.[69] As a market it was characterized by a taste for personal and domestic ornament and a desire to satisfy this taste through consumer goods. It was the same market that Wedgwood had discovered and for whom he had designed his ware. Always with an eye for the main chance, Wedgwood appears to have foreseen the business possibilities presented by this developing art market, and provided unglazed vases, bowls, and other ceramic pieces ready for decoration. In the catalogue of 1781 are listed fifty-two lady's paintboxes in jasper, which in addition to providing colour cups and a small palette also contained a compass— presumably to enable the landscape painter to find her way home (Fig. 5.3).[70] Clearly the taste for popular, commercially produced art and art supplies that would serve a domestic and often decorative purpose ran counter to the aims and aspirations of the Royal Academy. Nevertheless, as an index of the growing vitality of this market, the number of amateur drawing and painting manuals printed in the last quarter of the eighteenth century more than doubled. While most of the manuals were directed to amateurs without regard for age or sex, several were addressed specifically to women.[71]

[68] For a discussion of Ackermann see John Ford, *Ackermann, 1783–1983: The Business of Art* (London, 1983), and Michael Clarke, *The Tempting Prospect: A Social History of English Watercolours* (London, 1981).

[69] For an exceptionally thorough account of this history of exclusion in the 19th century see Charlotte Yeldham, *Women Artists in Nineteenth-Century France and England: Their Art Education, Exhibition Opportunities and Membership in Exhibiting Societies and Academies, with an Assessment of the Subject Matter of their Work and Summary Biographies*, 2 vols. (New York, 1984).

[70] Kelly, *Decorative Wedgwood*, 118.

[71] In the 19th century the number of manuals addressed to women increased. The bibliography on drawing manuals is not extensive and includes: Peter Bicknell and Jane Munro, *Gilpin to Ruskin: Drawing Masters and their Manuals, 1800–1860*. Fitwilliam Museum cat. (Cambridge, 1988); Clarke *Tempting Prospect*; Joan Friedman, 'Every Lady her own Drawing Master', *Apollo*, 105 (Apr. 1977), 262–7; Francina Irwin, 'Lady Amateurs and their Master in Scott's Edinburgh', *Connoisseur*, 187 (Dec.

5.2 John Neagle, after Thomas Stothard, trade card for Richard Collins, enamel and miniature painter, no date, engraving, reproduced by permission of the Trustees of the British Museum, London (Banks Trade Card Collection).

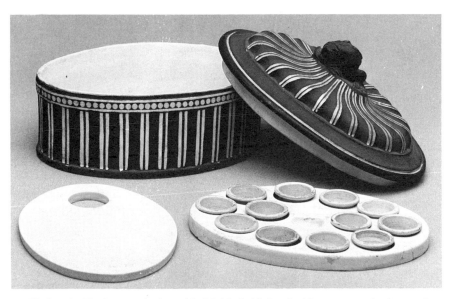

5.3 Black and white jasper paint box with dolphin finial, fitted with compass and palette and tray with twelve pots for colours; length 6½ in.; mark: Wedgwood S.; c.1781; reproduced by courtesy of the Wedgwood Museum Trustees, Barlaston, Stoke-on-Trent.

One such book, published in 1799, G. Brown's *New Treatise on Flower Painting or, Every Lady her own Drawing Master*, was popular enough to go through three editions before 1802 and to be plagiarized in 1816.[72] Brown directed his book to women in the belief that

The general taste for painting flowers that prevails, and the great progress that some ladies have made in painting, is a convincing proof, that taste or genius for painting is not confined to the other sex; on the contrary, I am inclined to think, that ladies would make much greater progress than men, were they first taught the proper rudiments.[73]

Lamenting the lack of a proper training and outlets for feminine artistic talent, Brown goes on:

Instead of being content with merely painting a flower, to decorate a flower-pot, or a border for a table, which many ladies are at a great deal of expense, and spend a great deal of time arriving at, how much more pleasure would it afford them to execute an exact representation of the most beautiful part of the vegetable creation.[74]

Looking to the future, Brown exclaims, 'so great is the barrenness of genius in painting among English artists, that I am sure there is every reason to hope that these times may produce some female artists, who will bear the palm from the other sex'.[75] While Brown's hope for a distinguished national school of women flower painters was not to be realized, his book echoes the tone of so many amateur drawing manuals published at this time in that it encourages the amateur in the belief that everyone (even women) can possess the 'taste' and 'genius' for painting. While Brown believed that genius could be served by thorough training in the 'rudiments' provided by the manual, 'taste in flower painting must be acquired by copying from nature'.[76] Nevertheless, this copying was not to be done directly—at least initially. His manual was set out like a colouring book with outline drawings of flowers on one page and coloured versions of the same on the opposite page (Figs. 5.4 and 5.5). These outline drawings were to be traced or copied and then coloured using the models and colour charts supplied. Although

1974), 230–7; John Krill, *English Artists Paper*. V. & A. (London, 1987); Kim Sloan, 'Drawing a Polite Recreation in Eighteenth-Century England', *Studies in Eighteenth Century Culture*, 2 (1982), 217–39; Ken Spelman, *The Artist's Companion: Three Centuries of Drawing Books and Manuals of Instruction*, booksellers' cat. (York, 1987); Ian Fleming-Williams in Martin Hardie, *Water-Colour Painting in Great Britain*, 3 vols. (London, 1968), iii. 212–81; Iolo Williams, *Early English Watercolours* (London, 1952).

[72] Brown's book was plagiarized by George Brookshaw, who even used Brown's remarkable title.

[73] G. Brown, *A New Treatise on Flower Painting or, Every Lady her own Drawing Master* (London, 1799), 1.

[74] Ibid., 3. [75] Ibid., 4. [76] Ibid., 8.

5.4 G. Brown, plate IX from *A New Treatise on Flower Painting or, Every Lady her own Drawing Master* (*c.*1799–1803), uncoloured soft-ground etching; reproduced by permission of the Yale Center for British Art (Abbey Collection).

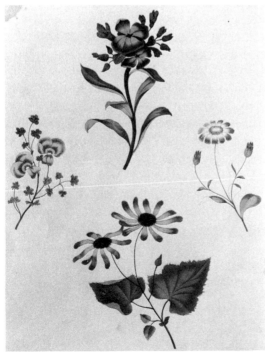

5.5 G. Brown, plate IX from *A New Treatise on Flower Painting or, Every Lady her own Drawing Master* (*c.*1799–1803), hand-coloured soft ground etching; reproduced by permission of the Yale Center for British Art (Abbey Collection).

he did not recommend 'an over exactness, when you copy from these flowers', and instead urged the amateur to attend to their 'general character', it is clear that his illustrations were intended to make up for the many drawing manuals' 'ill designed flowers' which women were used to copying. Thus before copying from nature the amateur was to copy from Brown; in both cases copying was the means whereby women were instructed. Brown's idea that genius is universal (in so far as it predisposes all ladies to flower painting), and only needs the proper training in copying to bring it out, distinguishes his aesthetic ideas, and those of many other manual writers, from the principles set forth by Reynolds in his *Discourses*. In contrast to the manual writers, Reynolds saw genius as innate and not to be acquired, and taste as something to be improved through the analytic formal study of past art and not through copying, to say nothing of the 'exact representation' of the 'vegetable creation'.

Unlike Reynolds, the writers and publishers of amateur manuals were willing to cast their net wide and grant everyone a modicum of aesthetic talent and judgement. In addition to teaching lady amateurs how to paint, booksellers and publishers also supplied them with fancy work to be decorated. Letter boxes, card-holders, fans, and fire-screens were moulded in papier mâché for women to paint, japan, 'mezzotint', *découpage*, and stencil. While Brown might lament ladies spending time decorating flower-pots or table borders, the extreme popularity of these modes of artistic practice suggests that others found such pastimes to be pleasurable and suitable feminine accomplishments.[77] An interesting example of the manuals that taught fancy work is B. F. Gandee's *The Artist or Young Ladies Instructor in Ornamental Painting, Drawing, &c consisting of Lessons in Grecian Painting, Japan Painting, Oriental Tinting, Mezzotinting, Transferring, Inlaying, and Manufacturing Ornamental Articles for Fancy Fairs*, published in 1835. Gandee's text is in the form of a series of conversations among Ellen, an artistic neophyte, her forbidding mother, and her artistically accomplished and clever cousin Charlotte. The book opens with Ellen recalling her past contributions to Lady Cooper's sale of fancy goods to benefit the infant school. 'I really feel ashamed', she tells her mother, 'when I recollect what mere trifles I sent, half a dozen pin cushions—three or four pen wipers—a few dozen paper flowers, and a card-board basket or two were all I contributed.' Resolving to do better, she promises, 'I am determined no exertion shall be wanting, on my part, to improve and make

[77] Illustrations of the interiors of Ackermann's Repository of the Arts and Fuller and Fuller's Temple of Fancy from the first decade of the 19th century show row upon row of these articles. See Krill, *English Artists Paper*, figs. 91 and 93, and pp. 95–101.

myself useful I am determined therefore to exert myself.'[78] Ellen is true to her word. Under the moral imperative to manufacture fancy goods for the charity sale, Ellen's home is transformed into something more like a small factory than a temple of the muses. With the benefit of Charlotte's instruction, she manages in three short months to master the 'arts' of 'grecian painting' (scratchboard), managing to produce eight examples in this technique in eight days, working at an average of four to five hours a day; 'japan painting' (gilding and varnishing a tracing), by which she decorates a new work-box as well as a 'quantity of tasteful articles' for the sale; 'transferring' (*découpage*), which involves cutting out images from prints, gluing them on to an object and coating it with twenty coats of varnish (a disagreeable process but one so simple Charlotte assures Ellen's mother that 'your own servant may be employed to do it'); 'oriental tinting' (stencilling with powdered colour), which Ellen uses to decorate two fire-screens for her mother, as well as four cardboard flower-stands, a pair of match cups, and 'numerous' card-racks, baskets, screens, portfolios, and blotting paper books for the sale. Along the way, Ellen also learns 'mezzotinting' (stencilling with black lead); 'inlaying' (tracing and painting on isinglass); and how to construct numerous paper articles such as screens, baskets, card-holders, etc., for future decoration.

Gandee's book provides good examples of the kind of decorative techniques employed by women amateurs in the late eighteenth and early nineteenth centuries. In every case, Ellen's handiwork depends on employing designs that were produced largely for fancy work, and that were supplied by stationers and booksellers. As with Brown's manual, the processes of tracing and copying efface the amateur's own 'style' through the reproduction of work already done elsewhere. Like the Corinthian maid, the woman amateur is not fully present in her work; in fact the signs of such presence—a prominent brush-stroke or a stray line—could be construed as faulty technique. Her subjectivity is eroded by the demands of tracing and copying, by the 'art' she produces/reproduces. While her work is reduced to being a copy, she herself verges on becoming nothing more than a machine for reproduction. Fancy work like flower painting was coded as 'feminine' and categorized as 'decorative' or 'ornamental'. Because it was intended to serve some modest domestic use it had no public standing, and because it was mass-produced and decorated with items that were also mass-produced it had no standing as 'fine art'. Ellen's status as

[78] B. F. Gandee, *The Artist or Young Ladies Instructor in Ornamental Painting, Drawing, &c consisting of Lessons in Grecian Painting, Japan Painting, Oriental Tinting, Mezzotinting, Transferring, Inlaying, and Manufacturing Ornamental Articles for Fancy Fairs* (London, 1835), 1.

a reproducer of the designs of others in her 'manufacture' of fancy goods points to a deep, almost unconscious connection between the domestic sphere of the lady amateur and the wider industrial sphere of commercial capitalism. Like the artisan, who in the industrial setting was increasingly relegated to executing the designs of the professional artist or designer, women amateurs became the vehicles for the transmission of the artistry of others. The techniques taught in Gandee's book were not new and can also be found in eighteenth-century manuals, such as the *Arts Companion, or a New Assistant for the Ingenious* (1749). The difference is that in the earlier period they would have been found in manuals addressed to both the craftsman and the amateur. With the industrialization of the craft and design industries in the nineteenth century, decorative techniques like *découpage* or japanning were gradually supplanted by more efficient processes. Nevertheless, they survived as feminine accomplishments. It is not an exaggeration to say that the aesthetic repertoire of the accomplished lady of the mid-nineteenth century was the repository of decorative techniques that had all but vanished from the industrial sphere. The pattern that emerges suggests that the denigration of craft in the late eighteenth and early nineteenth centuries by both industrial capitalism and the Academy facilitated its feminization, and that this feminization of craft ensured its marginalization as 'women's art'. Moreover, the growing tension in the nineteenth century between artists and designers, and between the Academy and design schools, is an indication of the increasingly problematic relationship of design, ornament, and craft to high culture, one that Wedgwood had encountered in his attempt to market his jasper tablets, and that is hinted at in the ambivalent image of the Corinthian maid.[79]

If Wright's *Corinthian Maid* can be said to have a contemporary meaning in the 1770s, it would be the relationship of women and certain forms of artistic production to the fine arts. The subject of the maid tracing her lover's shadow validated the notion of women's facility at imitation and lack of true creativity, and extended this bias to those arts that were merely mechanical or that, like Wedgwood's tablets, simply reproduced the art of others. It could support Reynolds's notion that copying nature was primitive and played no part in higher artistic cultures. The irony of Wedgwood choosing this subject at the time when he was attempting to make architects

[79] On the relationship of the Academy and professional artists to the areas of decoration and design see Stuart Macdonald, *The History and Philosophy of Art Education* (London, 1970). Throughout the 19th and early 20th centuries attempts were made by professional artists and critics as ideologically diverse as William Morris, Roger Fry, and Wyndham Lewis to bridge the gap between fine art and design. See Stella Tillyard, *The Impact of Modernism, 1900–1920: Early Modernism and the Arts and Crafts Movement in Edwardian England* (London, 1988).

'friends' of his jasper 'cabinet pictures' suggests, however, that not all cast the maid's invention in such an inferior light. If anything, the image is an ambiguous one, and points to a cultural ambivalence with regard to the place of the arts within a developing commercial and industrial culture. For Reynolds and the Academy, the image of the maid served as a point of difference from the recent past, and for men like Wedgwood and Bentley it was a point of continuity with it. For artists like Wright, who had been provincially trained and who were at home with men of science and manufacture, the Corinthian maid was a necessary fiction, one that embraced both the high and low ends of art in a myth of common origin. Levi Strauss has remarked that 'the principle underlying a classification can never be postulated in advance. It can only be discovered *a posteriori*.'[80] The retrospective gaze of the later eighteenth century back to the origin of the visual arts was just such an attempt to order them.

CODA

'From this day forward painting is dead': as all beginnings implicate their ends, the tracing of shadows must in some way foreshadow the end of painting. For this reason it is interesting to recall that one year after Wright finished *The Corinthian Maid*, Gilles–Louis Chretien invented the *physionotrace*, a process whereby an outline of a profile could be traced through a sight and by means of a pantograph transposed to a copper plate which was then etched. Chretien's invention allowed the artist to trace the interior details of the face, resulting in a complete portrait image that could be reproduced upwards of 300 times. The realism of the image and its reproducibility were seen as a scientific advance over the silhouette, which had been popularized in France in the 1760s.[81] An engraving by Jean Ouvrier from the 1770s after a painting by Johann Eleazar Schenau (1737–1806), entitled *L'Origine de la peinture, ou Les portraits à la mode*, depicts a young man tracing the silhouette of a young woman while children in imitation of the imitation trace the shadow of a cat and make shadow puppets (Fig. 5.6). Like the images of the Corinthian maid, Ouvrier's engraving suggests the domestication of art into simple, childlike practices. It also hints at the popular taste for exact likenesses, and an abiding idea of art as the literal trace of nature.

It was not, however, until the end of the century that the full implications

[80] Quoted in Said, *Beginnings*, 29.
[81] See Rosenblum, 'Origin of Painting', 287, and fig. 13.

of the Corinthian maid's invention were most fully realized. In 1799 Thomas Wedgwood, the son of Josiah, began with Humphry Davy a series of experiments with photosensitive silver nitrate on leather. Their photograms of leaves, insect wings, and paintings on glass were the first successful attempts ever to record natural images directly through photographic means. These experiments in tracing shadows with sunlight were written up and published by Davy in 1802 in *An Account of a Method of Copying Paintings upon Glass and of Making Profiles by the Agency of Light upon Nitrate of Silver.*[82] Thus in searching for the origin of painting, and finding it in the literal trace of nature, the eighteenth-century also simultaneously discovered, as nineteenth-century painter Delaroche would claim, the death of painting. The legend's popularity in the eighteenth century's revival of classicism did not coincidentally anticipate the dawn of a new relationship between image, object, and beholder that was photographic. Rather, it virtually established this relationship by setting the terms in advance whereby photography would be discovered, understood, and assimilated. A different origin would no doubt have had a different end; nevertheless it was this 'end' of painting that began the visual culture we have come to understand as our own.[83]

[82] Wedgwood and Davy's photograms were impermanent because they could not find a way to stop the developing process and so had to keep their images in darkness in order to preserve them. For a discussion of the importance, for modernist aesthetics, of the photograph as a 'transparent' image, see Richard Shiff, 'Phototropism (Figuring the Proper)', *Studies in the History of Art*, 20 (1989), 161–79.

[83] Since this book went to press, another trade card with an image of the Corinthian Maid has turned up. This was designed by Benjamin West and engraved by Francesco Bartolozzi for Thomas Sandby, Junr., drawing-master. It appears as plate xxvii in Ambrose Heal, *London Tradesmen's Cards of the XVIII Century: An Account of their Origin and Use* (London, 1925).

5.6 Jean Ouvrier, after Johann Eleazar Schenua, *L'Origine de la peinture, ou les portraits à la mode*, *c*.1770; private collection.

6

Gainsborough's
Diana and Actaeon

MICHAEL ROSENTHAL

I

GAINSBOROUGH painted the subject of *Diana and Actaeon* (Fig. 6.1) on to a canvas of $62\frac{1}{4} \times 74$ inches, in, it is thought, 1784–5.[1] This is the only mythological subject he ever attempted. He resisted painting the naked figure almost as consistently. The so-called *Musidora* in the Tate Gallery is connected in her pose to the nymph in the left foreground of *Diana and Actaeon*, and is the only comparable picture of which we know. Save for studies for *Diana and Actaeon*, no drawings by

This essay has seen many forms. It began as a research-in-progress paper read at the University of Warwick in October 1989. A revised and shortened version was delivered at the symposium 'Towards a Modern Art World', organized by the Paul Mellon Centre for Studies in British Art, and held at the Tate Gallery in December 1989, and one shorter still at the session on 'The Invention of Culture' at the Conference of the College Art Association in New York in February 1990. After this it was expanded for a history seminar at Clare College, Cambridge, in March 1990, and adjusted further before being read to the Graduate Seminar organized by the History of Art Department at University College, London, in May 1990. It has been extensively reworked since. For various observations on and criticisms of these many drafts, I owe great thanks to John Barrell, Ann Bermingham, Anthea Callen, Matthew Fattorini, Julian Gardner, Tom Gretton, Andrew Hemingway, Paul Hills, Simon Jary, Michael Kitson, Polly O' Hanlon, Sallie Richards, Sam Smiles, and Lisa Tickner. I am grateful to Christopher Lloyd, Keeper of the Queen's Pictures, to the Staff of the Print Room of the British Museum, and to Joy Pepe lately of the Yale Center for British Art for all the help they gave me.

[1] E. K. Waterhouse, *Gainsborough* (London, 1958), 123, no. 1012, calls it a 'very late unfinished work'. J. Hayes, *The Landscape Paintings of Thomas Gainsborough*, 2 vols. (London, 1982), ii. 535–9, no. 160, dates it *c*. 1785. A. Bermingham, *Landscape and Ideology: The English Rustic Tradition 1740–1860* (Berkeley, Calif., 1986), believes it was 'begun about 1784'. Arguments to be presented below will suggest 1784–6 as the most probable period for the painting of this canvas. Gainsborough pictured the Vale of Gargaphe as a world of pools and fountains and in the figure of Actaeon (an interloper from whom Diana and her nymphs must protect themselves) made a formal connection with the woodman in *The Market Cart* (London, National Gallery), in which, however, the figure bars all from access to his own private space.

Gainsborough of the naked figure appear to exist.[2] Since he was associated
most with portrait, landscape, and fancy pictures, and since he claimed to
find so little call for history painting in modern Britain, *Diana and Actaeon*
must invite us to ask why it was attempted, and what this tells not only of
Gainsborough's own practice in the 1780s, but also of more general issues
in British art at that time.

In part, *Diana and Actaeon* represents a deliberate expansion of the
artist's range, in the way of the *Hagar and Ishmael* done as a companion
to a *Cottage Door with Peasant Smoking*, or a large but too expensive
landscape with eleven figures proposed but never painted for Boydell's
Shakespeare Gallery in 1786.[3] Gainsborough's branching out can be inter-
preted as pointing to his real concern with problems related to what artists
should be doing, who they should be doing it for, and how their work
would be received, during the 1780s. Ann Bermingham has written that
the concern with voyeurism central to *Diana and Actaeon* is the 'main
theme' of various late pictures, and that its connection specifically with
Hogarth and his print, *Boys Peeping at Nature*, suggests that

painting is an investigative art, one that has nothing to do with conventions and
ready-made views of things but looks through the layers of cultural values and
conventions to the truth behind them. This independence turned Hogarth away
from the examples of the old masters and prevented Gainsborough from accepting
Reynolds's 'grand style'.

Bermingham goes on to point out that Gainsborough's *Mrs Douglas* (1784)
was, like Reynolds's *Mrs Siddons as the Tragic Muse* (1784), adapted
from the Sistine *Isaiah*; but where Reynolds had paraded the borrowing,
Gainsborough, working 'well within the code of art-historical cross-refer-
entiality advocated by academics like Reynolds ... managed to lighten and
personalize it'. And Gainsborough continued this pictorial dialogue in 1785
by showing Mrs Siddons not as an abstracted personification, but as she
appeared in her and his own world, presenting thus an alternative to the
kind of modern art advocated by Reynolds.[4]

This was consistent with views that Gainsborough had been expressing
for some time. Reynolds's fourth Discourse was published in 1772, and

[2] In J. Hayes, *The Drawings of Thomas Gainsborough*, 2 vols. (London, 1970), i. 297–308, the
recorded figure studies include none after the naked.

[3] *The Cottage Door* is at the University of California at Los Angeles (see Hayes, *Landscape Paintings*,
no. 185). *Hagar and Ishmael* is Hayes, no. 186. For Boydell's picture see W. T. Whitley, *Thomas
Gainsborough* (London, 1915), 269–70.

[4] Bermingham, *Landscape and Ideology*, 46–9. Reynolds's *Mrs Siddons* is in the Henry Huntington
Art Gallery, San Marino, Calif., and Gainsborough's in the National Gallery, London.

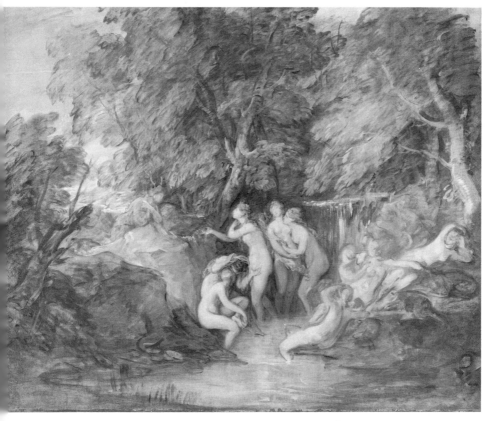

.1 Thomas Gainsborough, *Diana and Actaeon*, *c*.1784–6, oil on canvas, 62¼ × 74 in.; reproduced
y gracious permission of HM the Queen.

William Hoare of Bath sent Gainsborough a copy. While he confessed that it was 'amazingly clever', and 'could not be too much admired', he did feel that

betwixt Friends Sir Joshua either forgets, or does not chuse to see that his Instruction is all adapted to form the History Painter, which he must know there is no call for in this Country. The Ornamental style (as he calls it) seems form'd for Portraits. Therefore he had better come *down to Watteau* at once ... Every one knows that the grand style must consist in plainness and simplicity ... but Fresco would no more do for Portraits than an Organ would please ladies in the hands of Fischer.[5]

Diana and Actaeon figures within this debate. And as Gainsborough generally avoided historical subjects and had once called history pictures '*tragicomic*', it does so with no little irony.[6] This was a subject tailor-made for the 'grand style'. Diana and her nymphs offered artists the chance of painting beautiful females in a variety of poses. The subject had come to be associated with serious ideas such as paintings in the grand style were required to express: the randomness of fate, the notion that a complete knowledge of nature is self-defeating (meanings it still retained for Hogarth in 1751).[7] Gainsborough would have had access to this learned content through Hogarth. In addition, according to Ronald Paulson, he referred closely to Addison's translation of Ovid when he came to invent his scene, which is noteworthy in view of his liking to pretend an antipathy to literature.[8] Gainsborough's learning further extended to an extensive quotation and paraphrasing of motifs from suitable models painted by earlier artists. Here his practice was that of the artist who 'borrows an idea from an antient, or even from a modern artist, not his contemporary, and so accommodates it to his own work, that it makes a part of it, with no seam or join appearing', a practice that Reynolds advocated.[9]

There were plenty of precedents available. Gainsborough's teacher, Francis Hayman, had produced a *Diana and Actaeon* around the late 1760s. Amongst versions by old masters that Gainsborough might have seen was

 [5] M. Woodall (ed.), *The Letters of Thomas Gainsborough*, (London, 2nd edn. 1963), 96–7.
 [6] Ibid., 99.
 [7] M. Tanner, 'Chance and Coincidence in Titian's *Diana and Actaeon*', *Art Bulletin*, 56 (1974), 535–50. For Hogarth, see the discussion of his print *Boys Peeping at Nature* in Bermingham, *Landscape and Ideology*, 46–9, and also R. Paulson, *Hogarth: His Life, Art and Times*, 2 vols. (New Haven, Conn., 1971), i. 259–61, ii. 116–18, and S. Shesgreen, *Hogarth and the Times-of-the-Day Tradition* (Ithaca, NY, 1983).
 [8] R. Paulson, *Emblem and Expression: Meaning in English Art of the Eighteenth Century* (London, 1974), 224. W. Jackson, *The Four Ages* (London, 1798), 183, claims that Gainsborough was antipathetic to books.
 [9] R. Wark (ed.), *Sir Joshua Reynolds: Discourses on Art* (New Haven, Conn., 1975), 107.

a grisaille by Frans Floris owned by General Guise of Oxford, who also, according to Thomas Martyn, had a 'Diana in the bath converting Actaeon into a stag, with her nymphs about her ... by *Tintoretto*'. Martyn also noted a version by Carlo Marratta at Devonshire House, Piccadilly, and in the Long Room at Wilton were 'Giosep. de Sole. Three of Diana's Nymphs bathing. Actaeon looking at them. Girolino Peschi. Seven of Diana's Nymphs bathing. Sebastian Concha. Four of Diana's Nymphs bathing. Actaeon looking at them.' Martyn seems to have missed Sebastiano Ricci's large and lubricious canvas of Diana and her nymphs at Burlington House.[10] Although Northern European painters had attempted it, this was a subject within a dominantly Italian tradition of art. In the past Parmigianino had produced a version for the Rocca di Fontenelatto near Parma, Annibale Carracci had painted the story, and in the 1780s Titian's famous version was owned by the Duc d'Orléans. In 1764 William Woollett engraved a *Diana and Actaeon* by Filippo Lauri (Fig. 6.4), which was at that time owned by the Lord Bishop of Bristol.[11]

Gainsborough, then, lacked no opportunity of acquainting himself with earlier versions of his subject, either through prints or through original paintings. He presumably had access to Devonshire House, as he exhibited a portrait of the Duchess of Devonshire in the 1783 Royal Academy exhibition, and would have appreciated Marratta's being one of Reynolds's least favourite painters. He would have noticed those various pictures at Wilton, as well as recent commissions from Wilson and Reynolds, when he spent a week there in 1764.[12] To look to Italy both for his subject, and for ways of treating it, was as eccentric as his choosing this subject to paint at all. Gainsborough's art has normally been associated with that of the Low Countries, mainly with the paintings of Rubens, Van Dyck, Ruisdael, Wynants, and Watteau, or with the paintings of low life by Spanish artists such as Murillo. As Reynolds put it, in 1788:

Though he did not much attend to the works of the great historical painters of

[10] For Hayman see B. Allen, *Francis Hayman*, exhibition cat. (New Haven, Conn., 1987), 72–3. The Floris is in Christchurch College Picture Gallery, Oxford, no. 238, Guise Bequest, 1765. For the other paintings see T. Martyn, *The English Connoisseur*, 2 vols. (London, 1766), i. 141–50, ii. 49–67, 62, 187. For Gainsborough's portrait of the Duchess of Devonshire see Waterhouse, *Gainsborough*, no. 194.

[11] The Carracci is in the Royal Museum, Brussels.

[12] Woodall, *Letters*, 154–5. J. Kennedy, *A New Description of the Pictures, Statues, Bustos, Basso Relievos at Wilton House* (Salisbury, 1758), 101–4, and Anon., *Aedes Pembrochianae* (London, 1774), 88, tell us that the paintings were liable to be moved, and that the Peschi was thought to represent Callisto and Diana. By the time of the latter publication, the Concha was being described as 'Nymphs bathing and a Satyr peeping at them through the trees'. For Wilson and Reynolds see Sydney, 10th Earl of Pembroke, *A Catalogue of the Paintings & Drawings in The Collection at Wilton House* (London, 1968), 35–7, 29–30.

former ages, yet he was well aware, that the language of the art, the art of imitation, must be learned somewhere; and as he knew he could not learn it in an equal degree from his contemporaries, he very judiciously applied himself to the Flemish School, who are undoubtedly the greatest masters of one necessary branch of art.[13]

The customary antithesis between the painting of the Low Countries and that of Italy had been explained by Reynolds in the essays he wrote for the *Idler*, attacking Hogarth and his taste for an art based on material reality. Dutch art, wrote Reynolds, is based on 'literal truth and a minute exactness in the detail, as I may say, of Nature modified by accident'; the Italian 'attended only to the invariable, the great and general ideas which are fixed and inherent in universal nature'. Such opinions would recur throughout the *Discourses*, and were common currency. Thomas Martyn wrote *The English Connoisseur* (1766) as a guide to the best collections of pictures in Britain. In commending 'the taste which our illustrious countrymen in general have showed' for 'the greatness of design and composition in which the Italian masters are so well known to excell, before the gaudy Flemish colouring', he quotes Horace Walpole damning ' "the drudging mimicry of nature's most uncomely coarseness", upon which the Dutch so value themselves'.[14]

Gainsborough would have known and rejected all this. His art had been formed at Hogarth's St Martin's Lane Academy, and he probably relished the fact that versions of *Diana and Actaeon* or *Diana and her Nymphs* were on display at Wilton and at Burlington House, the two centres of that imported Italianate culture that Pembroke and Burlington had striven to promote, and Hogarth to oppose, earlier in the century. For Gainsborough was ironical enough a character to have turned to an Italianate subject in order to paint, as it were, a critique of Reynolds's academic theories. The character of that critique can be displayed through an analysis of his *Diana and Actaeon*.

As far as we know, nobody saw the picture during Gainsborough's lifetime: even intimates like Henry Bate were denied the opportunity of approving the extremely respectable subject of the painting, and the learned pictorial allusions it made. The composition develops through three surviving drawings (there may have been more). The first fixes the chiaroscuro and crowds the landscape with figures. In later ones (Figs. 6.2 and 6.3), Gainsborough distinguished his groups more clearly, and posed Diana and

[13] For Gainsborough and his sources see Hayes, *Landscape Paintings, passim*; Waterhouse, *Gainsborough, passim*. Reynolds is quoted from Wark, *Sir Joshua Reynolds*, 253.

[14] J. Reynolds, *Works*, ed. E. Malone, 2 vols. (London, 1797), i. 354, 353; Martyn, *English Connoisseur*, p. iii.

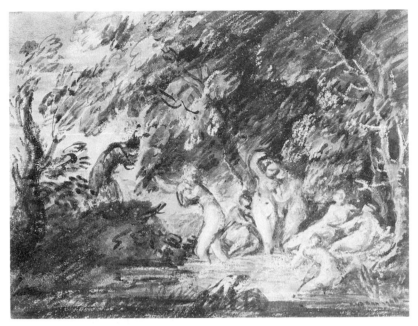

6.2 Thomas Gainsborough, study for *Diana and Actaeon* c.1784–5, grey and grey-black chalk and washes and white chalk on buff paper, $11 \times 14\frac{7}{8}$ in.; reproduced by permission of the Henry E. Huntington Library, San Marino, California.

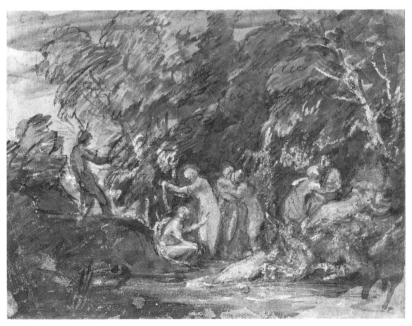

6.3 Thomas Gainsborough, study for *Diana and Actaeon*, c.1784–5, black chalk with grey, grey-black, and brown washes and body colour, $10\frac{3}{4} \times 14$ in.; reproduced by permission of the Cecil Higgins Art Gallery, Bedford.

Actaeon in a way familiar from book illustration, which had most recently been adapted by Hayman for his own version of the subject.[15] In the painting, though, he departed from the convention of representing Actaeon as standing. He dropped him behind a rise in the ground, and merged him colouristically into his surroundings. Woollett had toned the kneeling Actaeon into the landscape in his 1764 print after Filippo Lauri (Fig. 6.4) in a comparable way. Moreover, Lauri's rocks, woodland, and waterfall are arranged on a similar plan to Gainsborough's, and Gainsborough adapted the three women in Lauri's foreground, one reclining with her back to the spectator in front of two held in a partial embrace, in his right-hand group. Gainsborough initially disguised the borrowing by leaving out the waterfall, for this tellingly similar detail was painted wet over dry, that is, not until most of the picture was completed.[16] Gainsborough referred to other painters, too. The reclining figure in the foreground connects with Titian's Diana in his painting of this subject. The woman clutching her foot had served for Diana in Watteau's *Diana Resting* (then in England, of which a print was available), and, before that, in Louis de Boullogne the Younger's *Diana and her Companions Resting after the Hunt*. He structured the scene perspectively, and there is an academically proper principal light.[17]

Gainsborough took a fable from the academic canon, and to paint it adopted methods conforming to those advocated by Reynolds; and since, as far as we know, none of the figures was based on life studies, they were sanitized from any demeaning connection with 'common' nature. It is significant here that Reynolds's theory of painting was habitually long on form but correspondingly short on content. In that fourth Discourse about which Gainsborough had written to William Hoare, Reynolds had stated that, 'STRICTLY speaking ... no subject can be of universal, hardly can it be of general concern', although 'the great events of Greek and Roman fable and history' were at least 'popularly known', which was true for 'scripture history' as well.[18] He appeared far more certain about that 'just idea of beautiful forms', that 'grandeur of style', which, for Reynolds, was exemplified at its highest in the works of Michelangelo.[19] This artistic language was to be abstracted from an intimate and intellectual study of

[15] R. W. Lee, *Ut Pictura Poesis* (New York, 1957), fig. 20. The drawings are reproduced in Hayes, *Landscape Paintings*, entry to cat. 160.

[16] I am grateful to Anthea Callen for drawing my attention to this.

[17] The Titian is in the National Gallery of Scotland, Edinburgh. For Watteau see the entry to D. 66 by P. Grasselli and P. Rosenberg in *Watteau 1684–1721*, National Gallery of Art cat. (Washington, 1985), 134–5. See the entry to P. 28, 308–10, for Louis de Boullogne the Younger. His *Diana and her Companions Resting after the Hunt* is in the Musée de Beaux Arts, Tours.

[18] Wark, *Sir Joshua Reynolds*, 57–8.

[19] Ibid., 44, 275, and *passim*.

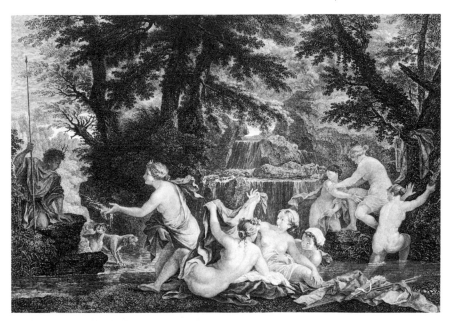

6.4 William Woollett after Filippo Lauri, *Diana and Actaeon*, 1764, engraving; reproduced by permission of the Trustees of the British Museum, London.

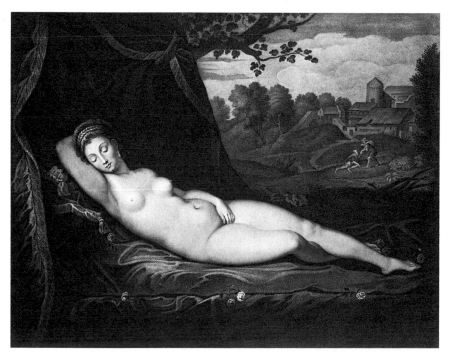

6.5 G. J. and J. G. Facius after Titian, *Venus*, 1781, mezzotint; reproduced by permission of the Trustees of the British Museum, London.

art and nature, and most appropriately articulated in representations of the naked figure. There was also, however, a tradition that it was not the mind but some other part of the male spectator that pictures of naked women elevated, and that to paint such subjects was morally improper.[20] Michelangelo himself had been strongly censured for filling the Sistine Chapel with nudes, and this attitude still persisted. In 1771 one critic found that the only objection to James Barry's *Adam and Eve* was 'an insufficiency of drapery', and in 1775 Barry took pains to counter this kind of censorious attitude. He argued that abstract beauty was necessarily represented through naked figures, and that it was mistaken to condemn such imagery as 'indecent and tending to lewdness' on the grounds that 'a great mind can raise great and virtuous ideas', and 'naked nature ... speaks a universal language which is understood and valued in all times and countries'.[21]

Learned it might have been, but Gainsborough's picture made it clear that, as far as he was concerned, this 'universal language' was less about intellectual abstractions than a sensual response of a kind that might be supposed to be common to many men. He directed attention to the women by painting them in a lighter tonality than much of the picture, and by having them block the area where the vanishing point would be. These are not the only means by which that invitation to voyeurism, central to the myth of Actaeon, is emphasized. Gainsborough also referred, in an academic way, to pictures likely to undermine any ideology that permitted academic art respectability because of its supposed appeal to the intellect. Before Watteau, Claude had used the figure of a seated woman clutching her foot for Diana, in his *Judgement of Paris*.[22] Here, the spectator is invited to join Paris in appraising the goddesses, and Gainsborough's quotation emphasized his subject's voyeurism. The reclining figure on the far right originated in the antique statue of Cleopatra (recently imitated by Cheere

[20] See Lee, *Ut Pictura Poesis*, 24, 33, 37–8; N. Llewellyn, 'Illustrating Ovid', in C. Martindale (ed.), *Ovid Renewed: Ovidian Influences in Literature and Art from the Middle Ages to the Twentieth Century* (Cambridge, 1988), 160–2; D. Freedberg, 'Johanus Molanus on Provocative Paintings', *Journal of the Warburg and Courtauld Institutes*, 34 (1971), 229–43; W. Studdert Kennedy, 'Titian: The Fitzwilliam Venus', *Burlington Magazine*, 100 (1958), 349–51; H. Zerner, 'L'Estampe érotique au temps de Titien', in *Tiziano e Venezia* (Vicenza, 1980), 85–90; C. Hope, 'Problems of Interpretation in Titian's Erotic Paintings', in *Tiziano e Venezia*, 111–24; D. Rosand, 'Ermeneutica Amorosa: Observations on the Interpretation of Titian's Venuses', in *Tiziano e Venezia*, 375–81.
The critic from the *Gazeteer* is quoted from *The Whitley Papers*, British Museum Print Room, i. 47. In 1764 it was written of William Thompson's *Jupiter and Leda* that 'few eyes could look upon it. It caused Chastity to blush and even Obscenity itself disowned it.' W. T. Whitley, *Artists and their Friends in England 1700–1799*, 2 vols. (repr. New York, 1968), i. 198.
[21] J. Barry, *An Inquiry into the Obstructions of the Acquisition of the Arts in England* (London, 1775), 152–6.
[22] This would have been known to Gainsborough through its appearance in Earlom's mezzotint engravings after Claude's *Liber Veritatis*, published by Boydell in 1777.

for the grotto at Stourhead) that Claude had used for the Echo whom Narcissus *neglects* to notice.[23] It is also connected to the pattern which originated in Giorgione's *Dresden Venus*, and had subsequently made frequent reappearances. Recent examples had included a *Venus* (Fig. 6.5), purportedly after Titian, which Boydell published in 1781 in mezzotint, a medium that emphasized its sensual appeal. Baron's (d. 1768) undated engraving after Titian's *Jupiter and Antiope* (Fig. 6.6) combined voyeurism and implicit violence in the motif of Jupiter as satyr disrobing an unwitting victim. In eighteenth-century Britain the pornographic aspect of much old master imagery was only too well appreciated—we need simply to recollect the popularity of Correggio—and the Renaissance iconography of Cupids as emblems of sexual arousal was vital enough for Reynolds to maintain it in his obscenely gesturing *Cupid as a Link Boy* (1774).[24]

Gainsborough also stripped the pretensions from *Diana and Actaeon* in the very way he painted the subject. In his fourteenth Discourse Reynolds called Gainsborough's style of 'odd scratches and marks' a 'chaos', an 'uncouth and shapeless appearance', which, 'by a kind of magick, at a certain distance assumes form' (and stressed Gainsborough's insistence that his works be inspected closely as well as prospected from afar). What Reynolds observed is also true of *Diana and Actaeon*. At a critical distance and beyond, the canvas communicates the illusion of a cool woodland pool and waterfall with figures. But then to move within that distance fragments this artifice, so that what the spectator sees is a variety of marks of paint on canvas. The spectator's movement makes and unmakes the scene, and means that it is impossible to judge whether or not the picture is finished.

While the landscape generally reads clearly, the figures are realized in varying degrees. The flesh of Diana and her companions has an opacity comparable to that in some of Gainsborough's contemporary portraits. In contrast the nearest woman partially exists as a brushed outline. The traces of red and blue recall the Venetian tradition, and reinforce the lack of colour in this scene, which the viewer is obliged to complete, perhaps even to colour, through active imaginative engagement. This process was more commonly thought proper to looking at sketches, and it contradicts Reynolds's maxim that

[23] K. Woodbridge, *Landscape and Antiquity* (Oxford, 1972), 2; O. Kurz, 'Huius Nympha Loci', *Journal of the Warburg and Courtauld Institutes*, 16 (1953), 171; F. Haskell and N. Penny, *Taste and the Antique* (New Haven, Conn., 1982), 184–7 and *passim*. Claude's *Narcissus and Echo* is in the National Gallery, London.

[24] N. Penny (ed.), *Reynolds*, Royal Academy, cat. (London, 1986), 33, 48, cat. no. 62. The painting is in the Albright-Knox Art Gallery, Buffalo, New York. For Cupids see n. 20 above.

We cannot recommend an indeterminate manner, or vague ideas of any kind, in a complete and finished picture ... leaving things to the imagination opposes a very fixed and indispensable rule in our art,—that everything shall be carefully expressed, as if the painter knew with correctness and precision, the exact form and character of whatever is introduced into the picture.[25]

But because each viewer is obliged to complete the forms of those parts that have been left so indistinct, each viewer may complete them differently. The invitation to look in this way closely matches what, in 1768, Sterne had written about reading: 'A true *feeler* always brings half the entertainment along with him. His own ideas are only call'd forth by what he reads, and the vibrations within, so entirely correspond with those excited, 'tis like reading *himself* and not the *book*.'[26] To see is to make, but not to possess. As fictions born out of art, the figures of Diana and the nymphs flout the academic convention that laid down that life-drawing from the model was the necessary preparation for such compositions as this. But the water denies access to their space, and any erotic stimulus they may provide is as fictional as they are. The spectator is isolated further by being denied any opportunity of identifying with Actaeon. His is a self-protectingly feminine pose, as if it is *he* who must cover his nakedness. And as if to defend himself from Diana's attack and the nymphs' gaze, he appears to become camouflaged, to disappear into the landscape. Lisa Tickner has defined this as 'an *anti*-history painting. It has no high moral tone.'[27] Gainsborough stressed this lack by making various jokes against his own learning, as he displayed it in this painting. *Diana and Actaeon* can accept contradictory readings, much as we are at liberty to think of it as either finished or unfinished.

II

Among other issues Lord Shaftesbury dealt, in his *Characteristicks*, with the concept of *ut pictura poesis*. He commended the history of Hercules as supplying various incidents which, because they could both indicate what had happened in the past, and intimate what was to come, compensated for the lack of a temporal dimension in painting. Hence the toddler Hercules could anticipate his future through freakish displays of strength and courage, just as Reynolds would paint him for the Empress of Russia in

[25] Wark, *Sir Joshua Reynolds*, 257–8, 264.

[26] Quoted by Paulson, *Emblem and Expression*, 230.

[27] Lisa Tickner, in a response to the College Art Association version of the paper. I am most grateful to Dr Tickner for sending me a copy of this. For Ovidian subjects and their appropriateness to bedrooms, see Llewellyn, 'Illustrating Ovid', 160–2.

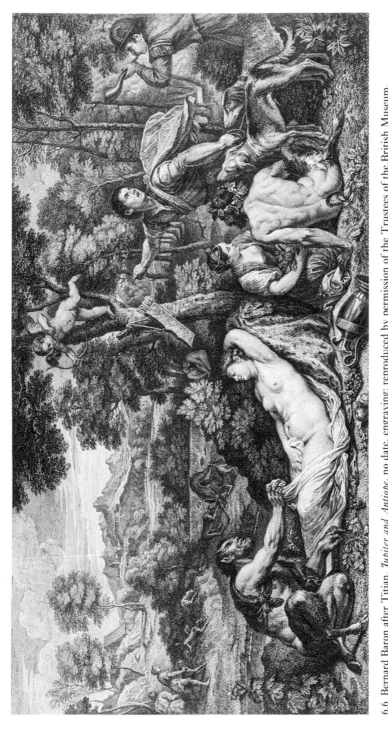

6.6 Bernard Baron after Titian, *Jupiter and Antiope*, no date, engraving; reproduced by permission of the Trustees of the British Museum, London.

1785.[28] In contrast, Shaftesbury demonstrated how some artists were lamentably careless about the unity of time and place by means of the example of the story of Diana and Actaeon. 'The Horns of Actaeon, which are the effects of a Charm, shou'd naturally wait the execution of that Act in which the Charm consists ... But in the usual Design ... the Horns are already *sprouted*, if not full grown; and the Goddess is seen watering the Sprouts.'[29] This is exactly what Gainsborough chooses to represent, and in doing so he is having a joke at the expense both of a mythological painting for which he saw no call, and of that Italianate artistic tradition in which he had so meticulously set his own *Diana and Actaeon*.

In 1771 Gainsborough had been engaged in an increasingly exasperated correspondence with the Earl of Dartmouth. Gainsborough was painting the Countess, and she wished to be clad in the generalized classical drapery Reynolds had invented. Gainsborough (anticipating here the different ways each painted Mrs Siddons) wanted her in a modern dress, to help the likeness and save it from being 'overset by a fictitious bundle of trumpery of the painter's own inventing'. Gainsborough made it quite clear that his objection was to what Reynolds had been promoting in the Royal Academy:

For my part (however your Lordship suspects my Genius for Lying) I have that regard for truth that I hold the finest invention as a mere slave in Comparison, and believe I shall remain an ignorant fellow to the end of my days because I never could have Patience to read Poetical impossibilities, the very food of a Painter; especially if he intends to be KNIGHTED in this land of Roast Beef, so well do serious people love froth.[30]

Since the story of Diana and Actaeon was just such a 'Poetical impossibility' as Gainsborough derided, it is hardly surprising if the iconography of his painting of it disintegrates into ambiguities.

In 1759 Dr Johnson wrote that he 'should grieve to see Reynolds transfer to heroes and to goddesses, to empty splendour and to airy fiction, that art which is now employed in diffusing friendship, in reviving tenderness, in quickening the affections of the absent, and continuing the presence of the dead'. His view in 1780 was that 'no one who now writes can use the pagan deities and mythology'.[31] Many, including, it appears, Gainsborough, would have said the same of painting. Writers had been doubting the

[28] The painting is now in the Hermitage, Leningrad.
[29] Anthony Ashley Cooper, 3rd Earl of Shaftesbury, Treatise III, *viz. A Notion of the Historical Draught or Tablature of the Judgement of Hercules* (London, 1713), 3.
[30] Woodall, *Letters*, 53. The letter dates from 18 Apr. 1771. Reynolds had been knighted in 1769 and in the third Discourse of 14 Dec. 1770, in which he had discussed the great style, had censured a 'neglect of separating modern fashions from the habits of nature' as leading to a 'ridiculous style'.
[31] S. Johnson, in the *Idler*, 45 (24 Feb. 1759). J. Boswell, *Life of Johnson* (Oxford, 1970), 1076.

contemporary relevance of pagan mythology since early in the century. Sean Shesgreen quotes Addison to this effect, and identifies Hogarth as amongst those who maintained this view. He reads *Strolling Actresses Dressing in a Barn* as a parody of *Diana and Actaeon*, the players dressed as classical deities, but *en déshabillé*, and lasciviously spied on through a hole in the barn roof.[32] In addition, in *Evening*, from *The Four Times of Day*, Hogarth had associated the fable with cuckoldry by representing it on the fan clutched by the adulterous wife of a hapless dyer. He made the linkage again in *The Countess's Morning Levée* in *Marriage à la Mode*, and this vulgar association, which must have gained wide currency through Hogarth's engravings, was made too in *The Lounger* of 15 September 1785, which Jack Lindsay quotes as describing a satirical painting in which a lady is Diana, her women friends, nymphs, and her cuckolded husband, Actaeon.[33] It may be appropriate here to point out that Grose's *Dictionary of the Vulgar Tongue* (1796) gives the verb 'to stag' as meaning 'to find, discover, observe', and in Gloucestershire 'stagging' is still used to indicate the process of eyeing up with lecherous intent.[34] And yet the nearest antecedent for Actaeon's unusual pose and gesture is that Italian Renaissance convention for representing Christ as He is baptized by John. A prototype is Annibale Carracci's picture in San Gregorio, Bologna, where Christ kneels in the landscape, with arms crossed.[35] On this analogy, Diana's baptism of Actaeon could represent that rite of initiation that ultimately results in his becoming at one with nature through his death, as suits the subject's traditional iconography (Gainsborough was, of course, a Baptist, and serious in his religion).[36]

Gainsborough's *Diana and Actaeon*, then, is a subtle, learned, and formally extremely complex work which exposes the pretensions of mythology and Italianate art by reducing them to public bar humour. The

[32] Shesgreen, *Hogarth*, 90–2.

[33] *Evening* and *Marriage à la Mode* were widely available as engravings. The latter paintings are in the National Gallery, London. J. Lindsay, *Thomas Gainsborough: His Life and Art* (London, 1981), 186. For Hogarth, see Shesgreen, *Hogarth*, 51. The painting of the story of Diana and Actaeon on the fan in *Evening* was itself probably a lewd pun, as in W. Congreve, *The Old Batchelor* (1695; London, 1781), 4: '*Bellmour* ... who would refuse to kiss a lap-dog if it were preliminary to the lips of his lady? *Sharper* Or omit playing with her fan?'. Also J. Thurston, *The Toilette. In Three Books* (London, 1730), iii. 39, 41: 'So plays the Fan, an Emblem of the Dame, / If Anger discompose, or Love inflame.'

[34] Gainsborough enjoyed crude puns. See e.g. Woodall, *Letters*, 93–5.

[35] For example, the altarpiece by Giovanni Bellini at Vicenza, the rendition by Perugino in the Sistine Chapel, or the version by Leonardo and Verrocchio in the Uffizi. I am indebted to Andrew Hemingway for this observation.

[36] For Gainsborough's concern with Christianity, see his letters to his sister, Mrs Gibbon, in Woodall, *Letters*, 77, and also 45, 126–7; this letter, probably of 1772, to Sir William Johnstone Pulteney, states: 'I generally view my works of a Sunday tho I never touch.'

ambivalence is total. If the figures lack surface particularization, this may be because the picture is unfinished, or it may be in order to generalize them as the grand style demanded. And if, as Reynolds would have it, Gainsborough's art represented common, material nature, communicating a 'powerful impression' of it, what would he say about pictures of naked women bathing in waterfall-fed pools like Wheatley's *Salmon Leap at Leixlip* (Fig. 6.7) of 1783?[37] Does it make a difference to the charge of the two pictures that the Wheatley represents the material world in such a way as to appear to raise no question about how it looks, and the other obliges each viewer to invent whatever 'nature' it is that *Diana and Actaeon* shows? Gainsborough's 'nature' is both generalized and particularized. He copies no forms one might see in common nature, and yet whatever nature he shows will be formed in the imaginations of private individuals, and there can be no guarantee that these formulations will tally. To gauge the significance of this we must look at the circumstances under which *Diana and Actaeon* was produced.

III

Gainsborough's relationship with the Royal Academy was usually detached and often uncomfortable. He quarrelled with it over the hanging of his pictures in 1773, which led to his not exhibiting again until 1777. From then on, Whitley states that a public rivalry between him and Reynolds was generally accepted to be one of the more interesting features of the contemporary art world, and there is evidence besides that cited in this essay that relationships between the two artists were distant, if not oppositional.[38] In the early 1780s, though, they began to build bridges. In 1782 Reynolds bought Gainsborough's *Girl with Pigs*, and that November the latter began Reynolds's portrait, although he never did finish it.[39] In 1784 Gainsborough had a final break with the Royal Academy when it refused to hang a series of his royal portraits low enough to be seen. That November Gainsborough wrote to the Earl of Sandwich, joking that, if he didn't like a portrait he was sending, 'your Lordship's cook-maid will hang it up as her own Portrait in the kitchen and get some sign-post gentleman to rub

[37] Wark, *Sir Joshua Reynolds*, 249. Gainsborough may have been having a joke at the expense of paintings like Wheatley's, which is a genre of picturesque scenes with naked women: given point in view of the way that Wheatley's 1774 *Harvest Wagon* (Castle Museum, Nottingham) is generally held to be a correction of Gainsborough's own version of the subject. A print after the *Leixlip* was published in 1785.
[38] Whitley, *Thomas Gainsborough*, 142–5. See also E. Fletcher (ed.), *Conversations of James Northcote R.A. with James Ward on Art and Artists* (London, 1901), 159–61.
[39] Woodall, *Letters*, 127–31. Whitley, *Thomas Gainsborough*, 193.

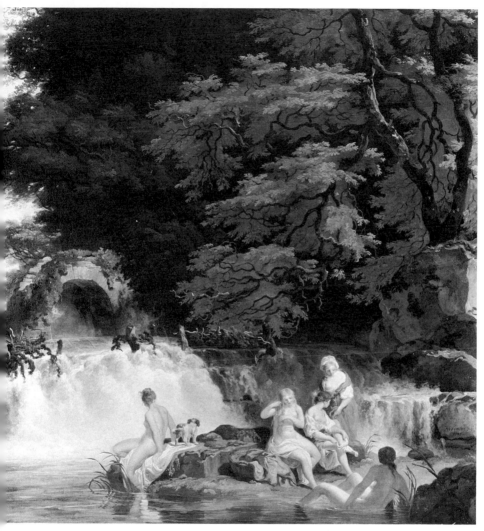

Francis Wheatley, *The Salmon Leap at Leixlip*, 1783, oil on canvas, $26\frac{5}{8} \times 25\frac{1}{2}$ in.; reproduced permission of the Yale Center for British Art (Paul Mellon Collection).

out the crown and sceptre and put her on a blue apron, and say it was painted by G—— who was very near being King's Painter only Reynolds's Friends stood in the way'.[40] The post of King's Painter had fallen vacant when Allan Ramsay died in August 1784, and Gainsborough, as the artist preferred by the royal family, clearly expected to succeed to it.

There was more than professional rivalry to the opposition between the two men. It was also, as Ann Bermingham has pointed out, ideological. Gainsborough's was a materialistic and investigative view of the function of painting, which was countered by Reynolds's generalizing aesthetic. From the 1720s Lord Burlington and his circle had promoted the classical and Italian in all things, opposed by Hogarth, for whom art was to be founded on the contemporary. Hogarth had eventually attracted the criticism of Reynolds. Gainsborough's own scepticism towards Reynolds's theories was rooted in his connection with Hogarth and the painters of the St Martin's Lane Academy. Gainsborough was taught to paint at St Martin's Lane by Hogarth's friend, Francis Hayman. His early style was dependent on seventeenth-century Dutch art, and committed to the representation of perceived realities. The example of Hogarth seems then, and always, to have had real significance. Without the association with Hogarth, founder of the Beef Steak Club and artist of *The Roast Beef of Old England & c.*, we should miss the irony of Gainsborough's 'froth' and 'Roast Beef' in that letter to the Earl of Dartmouth. Gainsborough's *John Plampin* (1753) is posed in the way of Hogarth's drunken Rake, or Hayman's sot in *The Wapping Landlady*, in apparently friendly satire of the sitter. Later on, *The Hon. Charles Wolfran Cornewall* was an essay in the mode of Hogarth's *Captain Coram* or *Thomas Herring*. Moreover, Gainsborough very seldom tried the grand style of male portrait pioneered by Reynolds.[41]

In Hogarth Gainsborough would also have found an archetype for the making of ironic and academically inappropriate pictorial cross-references. The composition of Scene One of *The Harlot's Progress* has been linked to the rather more elevated *Hercules between Vice and Virtue* produced by Paolo de Mattheis for the Earl of Shaftesbury. In a comparable way, Gainsborough paraphrased (among other models) one of the Quirinal Horsetamers, perhaps through the intermediary of Reynolds's *Captain Orme*, for his 1767 *Harvest Wagon*, a painting of low life and unclear

[40] Woodall, *Letters*, 133.
[41] The *Plampin* is in the National Gallery, London, the *Cornewall* in the National Gallery of Victoria, Melbourne, the *Coram* in the Foundling Hospital, London.

narrative.[42] And Hogarth, like Gainsborough, saw no call for history painting. He wrote of his invention of 'modern moral subjects', and of how the reception of the historical subjects with which he had decorated the staircase at St Bartholomew's Hospital led him to drop any ideas of attempting that genre in future. He published a print burlesquing the *Paul before Felix* he had painted for Lincoln's Inn. For Hogarth, the artist's main concern was to make a living, and Gainsborough damned 'Gentlemen' and wrote that they had 'but one part worth looking at, and that is their Purse'.[43]

We can understand the practices of many artists after *c.* 1750 in terms of an attempt to formulate a serious *modern* art, a project obstructed by the overwhelming demand for portraits. In the 1780s Gainsborough produced works which, to a degree, maintained the ethos of Hogarth's modern moral subjects, although they seem to have gone unnoticed as so doing. He painted these works, at least in part, according to that system laid down by Reynolds for the production of history painting, which, the *Discourses* assert, could alone express the greatness of the 'learned . . . polite, and . . . commercial nation' he perceived Britain to be.[44] As we have seen, artists were to acknowledge the traditions in which they were working through seamless borrowing from old masters. Gainsborough was prepared to do this, apparently to fit modern moral subjects into the canon, and endow them thus with a *gravitas* they might not immediately appear to warrant.

The *Shepherd Boys with Dogs Fighting* exhibited at the 1783 Royal Academy is about full-length portrait size, 88 × 66 inches. The imagery of violence and counter-violence originated in Hogarth's first two *Stages of Cruelty*; like Hogarth, Gainsborough uses animal behaviour as a metaphor for human, matching each boy with a dog by hair colouring and relative aggressiveness. In academic terms this is very much a 'low' subject, but it makes elevated references. Gainsborough had made a copy of Titian's *Vendramin Family*, and the scarlet stockings and emerald jerkin of the small boy with a dog to the right of that picture find a correspondence in the emerald and scarlet waistcoats worn by Gainsborough's boys.[45] Gillray's

[42] *Captain Orme* is in the National Gallery, London, *The Harvest Wagon* in the Barber Institute, University of Birmingham.

[43] For Hogarth, see J. Burke (ed.), *William Hogarth 'The Analysis of Beauty'* (Oxford, 1955), 216, and M. Kitson, 'Hogarth's "Apology for Painters"', *Walpole Society*, 41 (1966–8), 46–111, esp. 83, 91, 96, 98, 99, 100. For Gainsborough and 'Gentlemen' see Woodall, *Letters*, 101–2.

[44] Wark, *Sir Joshua Reynolds*, 13

[45] Waterhouse, *Gainsborough*, no. 1031. The *Shepherd Boys* is at Kenwood, the Iveagh Bequest, London. It was my intention to reproduce it, but unfortunately English Heritage would charge £46.80

Titianus Redivuus (1797), which had both rainbow and nymphs coloured red, green, and yellow, and a figure sporting a green and red frock, makes it clear that Gainsborough's colouring would have defined itself as Titianesque. In addition, Lisa Tickner has remarked on 'the artful invocation of a Renaissance slashed doublet in that ragged right sleeve'.[46] The association was strengthened by the figures being set into their landscape in the way of Titian's highly acclaimed *St. Peter Martyr*.

At that time Titian was praised for achieving a telling union between fable and landscape setting. His colouring, too, received unqualified praise. In 1783 Reynolds reckoned that antique pictures would have been coloured like Titian's, which would 'certainly eclipse whatever is brought into competition with it'. For Daniel Webb in 1760, Titian's colouring had come 'the nearest to nature and of course to perfection'.[47] By making these pictorial references, Gainsborough was able to link something of these qualities to his own picture, and the fact that he treated subjects from low life, or from daily experience, in this way suggests that for him it was the contemporary that formed the proper subject-matter for a morally serious modern art, an art intended to hang in houses, not in churches.

The youths, on a heroic scale, lack the coarse features often conventional in the representation of proletarian physiognomy; and the formal echo between boy and oak might allow him to take over something of that tree's associations with patriotic fortitude. Yet, instead of following the dictates of their common interest, by tending their flocks in a scene of Arcadian simplicity, the boys and dogs are fighting. Eighteenth-century poets saw civilization as constantly threatened by a typical human incapacity to sustain that moral *modus vivendi* that would alone thwart the reversion to savagery threatened in this image. In 1783 Britain was traumatized by the loss of the North American colonies, and it is conceivable that the shock then felt at the outcome of what many considered as a family dispute writ tragically large may inform this grand anti-pastoral.

Gainsborough was serious enough about the painting to joke about it in a letter to Sir William Chambers:

I sent my fighting dogs to divert you. I believe next exhibition I shall make the

(assuming a discount) as a reproduction fee. Titian's *St. Peter Martyr* was engraved by Martino Rota; his *Vendramin Family* is in the National Gallery, London.

 [46] Tickner, see n. 27.

 [47] See e.g. Count Algarotti, *An Essay on Painting* (Glasgow, 1764), 71, and Reynolds's response to this in Wark, *Sir Joshua Reynolds*, 199–200. For Titian's colouring in general see Algarotti, 49–50, and for Reynolds on Titian and the ancients see his annotation to William Mason's translation of Du Fresnoy's *De Arte Graphica* in Reynolds, *Works*, ii. 173, 204, 242. D. Webb, *An Enquiry into the Beauties of Painting*, 2nd edn. (London, 1761) 91.

boys fighting & the dogs looking on—you know my cunning way of avoiding great subjects in painting & of concealing my ignorance by a flash in the pan. If I can do this while I pick pockets in the portrait way two or three years longer I intend to turn into a cot & turn a serious fellow; but for the present I must affect a little madness.[48]

The picture itself suggests that there is every likelihood that 'great subjects' really did concern him. Discussion of what was a proper way to produce an elevated art for a modern society must have been inspired by James Barry's exhibition of his great cycle of pictures at the Society of Arts, which he opened to coincide with the opening of the Royal Academy exhibition.[49] Barry had proposed the commission himself, and worked for nothing; to make any money at all, he charged entry to view the pictures. Attendances were not good. Gainsborough chanced his luck by exhibiting his picture to potential buyers at the Royal Academy. The subjects chosen by each painter appear not to have been generally of concern.

Then came the events of 1784. The history of Gainsborough's final break with the Royal Academy is convoluted. The *Three Princesses*, which he withdrew along with his other exhibits, had been commissioned by the Prince Regent. To fail to hang a royal portrait so that it could be seen was an extraordinary thing for the Academy to do, and was possibly motivated by pique, for the Prince had failed to attend the Academy dinner after promising to do so if Reynolds, among others would vote for Charles James Fox in the Westminster election of 1784.[50] The history of this election may be related to the pre-history of *Diana and Actaeon* as well. It was around this time that Gainsborough painted the large *Lurchers Coursing a Fox*. Although this is usually linked to Snyders, the distinctive pose of the front dog matches that of the attacking hound in Titian's *Death of Actaeon*, then best known through Lisebetius's print (although Benjamin West caused a stir by rediscovering what most thought to be the original painting in 1785).[51] To work a mythology into a hunting piece fits an artist who thought history pictures '*tragicomic*' (you usually hunt foxes, not humans), and *Lurchers Coursing a Fox* may relate, too, to that Westminster election in which Gainsborough also voted for Fox. Contemporary prints bear titles such as *Fox in a Trap or the Constitution Preserved* and show Fox, like

[48] Woodall, *Letters*, 43.
[49] W. Pressly, *The Life and Works of James Barry* (New Haven, Conn., 1981), 89.
[50] Whitley, *Thomas Gainsborough*, 213–24; Woodall, *Letters*, 30–1.
[51] Hayes, *Landscape Paintings*, no. 159. I wished to reproduce the painting, but unfortunately English Heritage charge a £46.80 (assuming a discount) reproduction fee. For West, see Whitley, *Artists and their Friends*, ii. 31–4.

Actaeon, as a helpless victim, reminding us that in popular imagery the animal stood for the politician.

If Gainsborough had Actaeon in mind, then he may have been prompted to attempt illustrating the fable around 1784–5.[52] In 1783, as we have seen, Gainsborough was avoiding 'great subjects' but painted low-life ones so as to endow them with a comparable moral seriousness. He evidently thought that his progress had been enough to earn him the post of King's Painter in 1784, except that Reynolds's friends 'stood in the way'. There was the rift with the Academy. He may therefore have been prompted to attempt, in his own way, the grand style; to paint, in *Diana and Actaeon*, a subject of which Reynolds would approve, but in ways which would cast the gravest doubts on the feasibility of that style in late eighteenth-century Britain.

IV

In the early 1780s Gainsborough was expanding his range in various ways. Besides the aborted project for Boydell, or the late *Hagar and Ishmael*, he produced three formally complex and iconographically ambitious soft-ground etchings in 1780, and the extraordinary *The Mall, St James's Park*.[53] He wrote to Sir William Chambers of concealing ignorance and affecting madness, perhaps also to conceal an uncertainty about how the ambitious *Shepherd Boys with Dogs Fighting* might be received. Gainsborough responded to academic theory in painting rather than writing, and the *Shepherd Boys* might be a reaction to Reynolds's eleventh Discourse, delivered in December 1782. Reynolds (whom Gainsborough had recently been painting) dwelt on the excellencies of Titian's colouring, and on the landscape of *St. Peter Martyr*, and it was these that the *Shepherd Boys* acknowledged. This was not learning ostentatiously displayed, but a real demonstration of Titian's significance to modern art, reminiscent of Hogarth's attitude to the connoisseurs (remembered by Mrs Piozzi in the 1770s) that 'because I hate *them*, they think I hate *Titian*—and let them!'[54]

After the events of 1784, *Diana and Actaeon* may partly have been meant to expose the fallaciousness of academic theory, of the 'Poetical impossibilities' it demanded. Consequently the painting asks serious questions about what exactly the fine arts were supposed to do. Although most

[52] Ibid., ii. 31.

[53] For these prints see Hayes, *Landscape Paintings*, 125C, 128, and 128B, and *Gainsborough as Printmaker* (New Haven, Conn., 1971). I discuss them in an article currently under preparation. *The Mall* is in the Frick Collection, New York.

[54] Quoted by R. Paulson, *Hogarth*, ii. 292.

still claimed that the arts should flourish in a politically and commercially great nation, contemporary commentators communicate a sense that because what they understood to be a commercial society was developing at such bewildering speed, to define what kind of art it required was extremely problematic. Yet the tradition that it was through its culture that a nation of military, material, and imperial power demonstrated its virtues remained strong. The cliché that the qualities of society were manifest in the elevated character of its arts, letters, and music was expressed by many: Algarotti, Robert Strange, John Millar, Reynolds himself of course, and James Barry, who pronounced in 1775 that 'the scope and design [of poetry and painting] is to raise ideas in the mind of such great virtues and actions as are best calculated to move, to delight, and to instruct'.[55]

By then it was uncertain precisely who was going to be moved, delighted, and instructed, and by what means. Recent research has charted the consequences of the changes society was undergoing as the industrial and commercial sectors began to play an increasingly important role in the creation of wealth, and contemporaries manifested some anxiety as to how the structures of this changing society were to be perceived.[56] By 1767 one N. Forster was noticing how 'the several ranks of men slide into each other almost imperceptibly', and in 1796 Anthony Pasquin regretted that 'the VULGAR, who have no knowledge of propriety, should, from their numbers, their riches, and consequently their power, have the national patronage'.[57] As new ways of getting rich altered the constituency for the fine arts, Reynolds had to engage in shifts of position and intellectual manoeuvrings as, through the course of the *Discourses*, he attempted to state what painting might express the virtues of a nation of cultural and imperial power. In 1788 he was still unable to distinguish that English School that, in future histories of art, would be seen to compare with the Roman or Venetian, and for which he had been calling since 1768.[58]

[55] Algarotti, *Essay on Painting*, p. iv; R. Strange, *An Enquiry into the Rise and Establishment of the Royal Academy of Arts* (London, 1775), 60 and *passim*; J. Millar, *Observations concerning the Distinction of Ranks in Society* (London, 1771) pp. vii–viii; Barry, *Inquiry*, 168.

[56] See N. McKendrick, J. Brewer, and J. H. Plumb, *The Birth of a Consumer Society* (London, 1982); P. Matthias, *The Transformation of England* (London, 1975); P. Langford, *A Polite and Commercial People: England 1727–1783* (Oxford, 1989); H. Perkin, *Origins of Modern English Society* (London, 1969); J. Barrell, *English Literature in History 1730–1780: An Equal Wide Survey* (London, 1983), *The Political Theory of Painting from Reynolds to Hazlitt* (New Haven, Conn., 1986), and 'The Public Prospect and the Private View: The Politics of Taste in Eighteenth-Century Britain', in J. C. Eade (ed.), *Projecting the Landscape* (Canberra, 1986).

[57] McKendrick, Brewer, and Plumb, *The Birth of a Consumer Society*, 11. Barrell, *Political Theory*, 65.

[58] Wark, *Sir Joshua Reynolds*, 248. In the fourteenth Discourse, delivered 10 Dec. 1788, Reynolds's

Reynolds's lectures were articulated within the discourse of civic humanism, which was itself put under increasing strain as the eighteenth century progressed, and the traditional aristocratic social order was threatened by new money.[59] Stephen Copley has written that

In its 'traditional' form the discourse of civic humanism lacks a vocabulary to endorse the operations of trade and to account for the workings of a market economy in society: the former being regarded only as a source of social corruption, and the latter being seen to operate by standards far removed from any laudable criteria of civic virtue.[60]

Against the idea of a public compounded of men of landed wealth, wisdom, and disinterested views, guardians equally of the political and the cultural, was the reality of the rapid increase and growth of wealth gained through trade, commerce, and manufactures, and an increasing demand from a wider audience for the commodities of culture.

Well before Anthony Pasquin's lament that 'the VULGAR' should have 'the national patronage', others had been wondering if a commercial society could even support the arts. In 1755 Jean André Rouquet asked whether in England the arts and commerce were mutually compatible. Commerce made people rich but not polite. It gave them connections but no society. It brought them together without uniting them. Because it encouraged the habit of thinking in concrete particulars, it was inimical to the exercise of the imagination, vital to any art concerned with intellectual abstraction. Commerce fostered luxury, a further threat to the health of the fine arts, and Rouquet observed that while London boasted little of what he ranked as good public architecture, at least its shop-fronts were embellished in the very best of taste.[61] His fears for the arts in a commercial society were shared by John Brown, who in 1757 wrote how 'the Character and Manners of our Times ... on a fair Examination, will probably appear to be that of a "*vain, luxurious*, and *selfish* EFFEMINACY"' where vanity and luxury had banished morals or the arts from polite discourse as too weighty, and even Hogarth's pictures and writings had failed 'to keep alive the Taste of Nature or of Beauty'.[62] Lord Kames was equally gloomy. He felt that

'If ever this nation should produce genius sufficient to acquire to us the honourable distinction of an English School' suggests that its formation lay well in the future.

[59] S. Copley, *Literature and the Social Order in Eighteenth-Century England* (London, 1984), 10. There is an excellent account of civic humanism in the Introduction. Its application in aesthetic theory is extensively discussed in Barrell, *Political Theory*.

[60] Copley, *Literature*, 5.

[61] F. Rouquet, *L'État des arts en Angleterre* (Paris, 1755), 8, 10, 21–2. See also Barrell, *Political Theory*, 38–9, 145 ff., 184–5.

[62] J. Brown, *An Estimate of the Manners and Principles of the Times* (London, 1757), 29, 47.

'nothing tends more than voluptuousness to corrupt the whole internal frame, and to vitiate our taste . . . to extinguish all the sympathetic affections, and to bring on a beastly selfishness . . . benevolence and public spirit . . . are little felt, and less regarded; and if these be excluded there can be no place for the faint and delicate emotions of the fine arts.'[63]

Others, though, did make attempts to accommodate the civilizing function of the fine arts to contemporary circumstances. For Vicesimus Knox, writing in 1778, the public apparently no longer consisted of 'gentlemen' and the arts served a far wider portion of the population. The 'object of imitation' was now 'to touch the heart with sympathy, to raise the nobler passions, and to give a masculine pleasure . . . That general connection which subsists between all who partake of humanity causes a general concern in the interests of each individual.' The arts could still convey 'moral instruction', not through 'the deductions of reason, which can only be made by cultivated intellects', but 'by appealing to the senses, which are sometimes combined in great confection with the rudest minds'.[64] Although 'nobler passions' and 'masculine pleasure' were traditionally to be found and enjoyed only by men of the polite classes, Knox was apparently prepared to allow them to 'all who partake of humanity'. He was able, too, to allow that the luxury that wealth brought and many feared was not automatically debilitating, for 'the opulent have it in their power to be prudently luxurious, and to indulge in all the gratifications of profusion, without suffering all its consequences'. What was more, 'where progressive refinement continually introduces unnecessary wants . . . artificers of super-fluity become one of the most numerous bodies in the community. Should the demand for their manufactures cease, thousands would be immediately reduced to extreme want', and amongst those whose livelihoods were threatened by recession were, of course, painters.[65]

Such views were alien to those who were attempting to maintain the traditions of the civic theory of art. Reynolds was concerned to regard sensory appeal as one of paintings' lesser virtues, for it was 'not the eye, it is the mind, which the painter of genius desires to address'. The aim was to master the 'art of animating and dignifying . . . figures with intellectual grandeur, of imposing the appearance of philosophick wisdom, or heroic virtue'. These could 'only be acquired by him that enlarges the sphere of his understanding by a variety of knowledge, and warms his imagination

[63] Quoted by Barrell, *Political Theory*, 65.
[64] V. Knox, *Essays Moral and Literary* (London, 1778), 247, 261–2.
[65] Ibid., 228, 226.

with the best productions of ancient and modern poetry'.[66] Although
Reynolds obviously excluded many, particularly the 'rudest minds', whom
Knox would include in his public, one of the notable aspects of the
Discourses is that they actually have very little to say about the ideal
spectator of the elevated works of art they were concerned to inspire (or
about which subjects would best achieve these ends). In the first Discourse
we read of 'a general desire among our Nobility to be distinguished as
lovers and judges of the Arts', in the fifth, that 'our Exhibitions, while they
produce such admirable effects by nourishing emulation and calling out
genius, have also a mischievous tendency, by seducing the Painter to an
ambition of pleasing indiscriminately the mixed multitude of people who
resort to them'. It was mistaken, Reynolds insisted, to imagine that the
function of the fine arts in later eighteenth-century Britain was to serve a
market and that the exhibition was one of the artist's market-places.
Reynolds's ambitions had always been less worldly. In the first Discourse
he wrote of the Royal Academy that

An Institution like this has often been recommended upon considerations merely
mercantile, but an Academy, founded upon such principles, can never effect even
its own narrow purposes. If it has an origin no higher, no taste can ever be formed
in manufactures; but if the higher Arts of Design flourish, these inferior ends will
be answered of course.[67]

But alternatives to Reynolds's notions of art and the market were
variously articulated. An anonymous member of the Society of Arts argued
in a pamphlet of 1763 that the inception of exhibitions of painting in 1760
meant that artists could now counteract changes in systems of private
patronage and display their wares to potential buyers, those 'patrons of the
polite arts', under circumstances that would mean that 'their reputation is
not founded on the partial voice of private friendship, but on the merit of
public approbation', an unusually frank identification of 'public' with
'market'.[68] The artists' professional consolidation, first through the Free
Society of Artists, then the Incorporated Society of Artists, and eventually
through the founding of the Royal Academy, was a further response to the
perception of changing circumstances: increasingly, it would be through
exhibiting that painters met their customers—which is partly why someone
like Gainsborough was very touchy about the conditions under which his
works were shown.

[66] Wark, *Sir Joshua Reynolds*, 50, 51.
[67] Ibid., 14, 90, 13.
[68] *A Concise Account of the Rise, Progress, and Present State of the Society for the Encouragement of Arts, Manufactures, and Commerce* (London, 1763), 41–2.

The civic humanist tradition originating in Shaftesbury, and later con-
tinued by Bolingbroke, ran counter to the materialist philosophies first
expressed by Mandeville and later associated with Walpole. In the realm
of the aesthetic, these polarized views found their equivalent in the contrast
between Lord Burlington and Hogarth, or, later, Reynolds and Gainsbor-
ough. This involved, broadly speaking, setting an ideal of art concerned
with the world as it ought to be against an ideal of art based on the world
as it appeared. Hogarth permitted a capacity to appraise art to anyone who
could measure or discriminate objects in the real world.[69] Gainsborough,
too, was concerned with the material world, and, in common with Hogarth,
understood that he was painting for a market. His famous grouse to William
Jackson that 'I'm sick of Portraits and wish very much to take my Viol da
Gamba and walk to some sweet Village when I can paint Landskips and
enjoy the fag End of Life in quietness and ease' should be read against his
comment to Sir William Chambers that if he could 'pick pockets in the
portrait way two or three years longer I intend to turn into a cot & turn a
serious fellow'.[70] He could only be a 'serious fellow' once he was financially
secure. It was through portraits that he made his living. Landscapes, which
he painted for his own pleasure, had to take the chance of attracting a
buyer.

This was chancy enough because society itself was thought to be becom-
ing increasingly various, so that tastes were becoming various, too. For
Gainsborough, that paradigm of the public man, the 'gentleman', was a
'fictitious character', an enemy 'to a real artist', in the character of which
'many *a real Genius* is lost'.[71] His opinions would have been based on the
actual state of society in Bath, from where he was writing. Goldsmith noted
how this 'polite kingdom' was the resort of 'politeness, elegance and ease',
and Mark Girouard has observed how entry to its 'polite society' was
'available to anyone who wore the right clothes and could afford the
subscription of two and a half guineas which gave access to assembly rooms
and balls; as far as Bath was concerned, you were a gentleman or lady if
you dressed and behaved like one'.[72] London may have seemed less socially
deceptive; nevertheless, artists had to serve a market of mixed complexion,
as Reynolds himself demonstrated, with a pragmatism not apparent from
his writings, by painting portraits of courtesans as well as aristocrats.

[69] See e.g. W. Hogarth, *The Analysis of Beauty* (London, 1753), 81–2, or Kitson, 'Hogarth's
"Apology for Painters" ', 106.

[70] Woodall, *Letters*, 115

[71] Ibid., 101–2.

[72] M. Girouard, *The English Town* (London, 1990), 79.

Gainsborough's *Diana and Actaeon* invites many readings. There is no predictable way in which the imagination will complete or the intellect understand this picture. It seems to acknowledge and legitimize individual differences of response; it suggests that no cultural and therefore no social uniformity can be assumed in those who would be expected to take an interest in the fine arts, and that even perception is no simple issue, for provision must be made for people of different occupations, social groupings, education, and habits, noticing and valuing different aspects of the material world. Gainsborough's painting questions Reynolds's idea of nature as superior to its perceived material reality by forcing us to ask what 'material reality' is, and what Reynolds meant by the phrase 'common nature', the term by which he condemned paintings not in the 'grand style'. It underlines the fact that in late eighteenth-century Britain the shared understandings of a common culture, such as had arguably existed earlier among the landed aristocracy, were no longer to be relied on. What *Diana and Actaeon* has in common with contemporary works—those of Stubbs, Wright, West, Wheatley, Reynolds, and others—is its individuality. In early modern Britain painters had come to compete in a market. This may have joined them together in a common economic enterprise, but it could not guarantee any cultural or social unity.

7

Loutherbourg's Chemical Theatre: Coalbrookdale By Night

Stephen Daniels

Coalbrookdale by Night (Fig. 7.1) by Philippe Jacques de Loutherbourg was first exhibited at the Royal Academy in 1801. It was not offered for sale then and effectively disappeared from public knowledge until its acquisition by the Science Museum in 1952.[1] Since then it has frequently been used to illustrate writings on English industrialization, especially those directed at a popular audience. The painting shows a spectacular scene at an ironworks, predominantly an incandescent cloud of smoke and flames erupting into the night sky. More than most pictures of industrial sites, it seems to confirm the impression of English industrialization as a dramatic, earth-shaking event, an 'industrial revolution'. As such, it is eccentric to an industrial historiography that now declares that no such 'revolution' took place, that English industry developed sensibly in a piecemeal, gradual way.[2]

When *Coalbrookdale by Night* does appear in texts on English art history, it is usually as a freak.[3] In its style as well as its subject-matter, the painting does disrupt the conventionally rustic genealogies of English landscape art. In his own lifetime, Loutherbourg's colouring was seen to make his landscapes highly mineral: 'brass skies and golden hills,/ with marble

I wish to thank Christopher Baugh, Peter Bishop, David Fraser, John Gage, David De Haan, Ron Heisler, and Barrie Trinder for their help during the preparation of this essay.

[1] Kenwood, the Iveagh Bequest, Rüdiger Joppien, *Philippe Jacques de Loutherbourg, RA 1740–1812* cat. (London, 1973), no. 52.

[2] David Cannadine, 'The Present and the Past in the English Industrial Revolution 1880–1980', *Past and Present*, 103 (1984), 131–72.

[3] Leslie Parris, *Landscape in Britain c. 1750–1850*, Tate Gallery cat. (London, 1973), 67–8; Michael Rosenthal, *British Landscape Painting* (Oxford, 1982), 96.

bullocks in glass pastures grazing'.[4] *Coalbrookdale by Night* needed to make little concession to the organic world. Nor does it. The distant wooded hills look like solid rock and the writhing, skeletal tree on the left of the picture only serves to emphasize the acidity of the place.

Coalbrookdale by Night may not fit into temperate versions of English culture, but, I will argue, it presents a key image of its historical moment. It resonates with the rising tempo of spectacular patriotic display during hostilities with France. And it captures what E. P. Thompson called 'the climate of expectant frenzy' at the turn of the century when 'Napoleon [was seen] in the Book of Revelation ... the lost tribes of Israel were discovered in Birmingham and Wapping', and the British Empire was regarded as 'the peculiar possession of the Messiah, and his promised naval dominion'.[5] The grandeur of such visions was shadowed by a sense of imminent collapse of the present into the ruins of past empires. Moreover, the forces of corruption were seen to be satanic, in a worldly rehearsal for Armageddon.[6] If many rural pictures offered sturdy, earthy images of Britain, *Coalbrookdale by Night* shows how industry at this moment, specifically the iron industry, offered a more martial, less stable image of the nation. As I will show in the course of this essay, its constructive, almost precision-engineered, features are galvanized by apocalyptic currents.

While attending to the industrial features of *Coalbrookdale by Night*, I do not wish to align it to an alternative industrial genealogy of English art.[7] I will situate the painting in a variety of overlapping discourses and practices, including theatre design, technical drawing, political economy, tourism, alchemy, and freemasonry. By the end of the essay I hope to have demonstrated their interplay in Loutherbourg's picture. Showing this interplay in writing has not been easy. In order to avoid constant cross-cutting and recapitulation I have introduced some themes and topics more abruptly than I would wish. Also there is no sustained narrative order to the essay. The range of my research on this picture—from poking about in ruined furnaces to poring over occult texts—does not reduce to a simple story. The point of the essay is not just to show the complexity and power

[4] Peter Pindar, 'Lyrical Odes to the Royal Academicians for 1782', in D. Cook, *Art of England* (London, 1869), quoted on p. 332 of John Gage, 'Loutherbourg: Mystagogue of the Sublime', *History Today*, 13 (1963), 332–9.

[5] E. P. Thompson, *The Making of the English Working Class* (London, 1963), 382.

[6] Laurence Goldstein, *Ruins and Empire: The Evolution of a Theme in Augustan and Romantic Literature* (Pittsburgh, 1977), esp. 73–81. Anne Janowitz, *England's Ruins: Poetic Purpose and National Landscape* (Oxford, 1990), esp. 20–53.

[7] Like Monika Wagner, *Die Industrielandschaft in der Englischen Malerei* (Frankfurt, 1977).

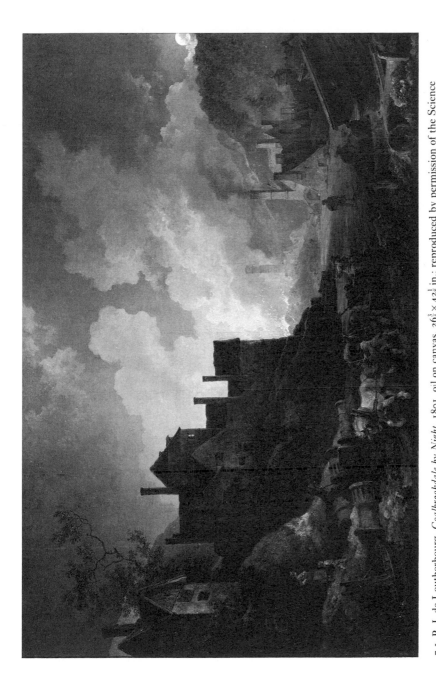

7.1 P. J. de Loutherbourg, *Coalbrookdale by Night*, 1801, oil on canvas, $26\frac{3}{4} \times 42\frac{1}{8}$ in.; reproduced by permission of the Science Museum, London.

of *Coalbrookdale by Night* but to contribute to a new historiography of the Enlightenment in England. This is breaking up the idea of a forward march from superstition to utility and instead mapping a broad and complex field of knowledge, some of which seems to us now respectably rational and useful, and some which seems unruly and arcane.[8]

<p style="text-align:center">I</p>

Loutherbourg's versatility is striking. He turned his hand not just to a variety of styles and subjects of painting but to a variety of other practices, from faith-healing to stage design. Indeed, he seems to have cultivated a reputation as a mercurial, mysterious figure.

After studying theology and mathematics at Strasbourg, Loutherbourg moved to Paris to start a precocious career as a painter, achieving election to the Académie in 1766 before the statutory age of 30. He produced works in various styles, from pastorals to tempestuous scenes of shipwreck and banditry. He moved to London in 1771 and continued his career as a painter, exhibiting regularly at the Royal Academy (he was elected in 1781) until his death in 1812. His sketching tours of British coastal and mountainous districts in the 1780s resulted in highly detailed documentary paintings of topography and working life. His later oils from the 1790s are more historical and allegorical and include a series of dramatic military and biblical scenes.[9]

Loutherbourg came to London not as a painter but as a stage designer. Garrick had been bringing to Drury Lane some of the illusionistic staging of the Paris Opera, and he imported Loutherbourg to develop it further. Loutherbourg quickly established a reputation for spectacular effects of light, movement, and sound. Many of his productions were given over largely to special effects. In 1781 he opened the Eidophusikon, a miniature theatre, almost a peep-show, showing scenes in movement with sunrises,

[8] Roy Porter, 'Science, Provincial Culture and Public Opinion in Enlightenment England', *British Journal for Eighteenth Century Studies*, 31 (1980), 20–46; Roy Porter, 'The Enlightenment in England', in Roy Porter and Mikulas Teich (eds.), *The Enlightenment in National Context* (Cambridge, 1981); Margaret Jacob, *The Radical Enlightenment: Pantheists, Freemasons and Republicans* (London, 1981); James Hillman. 'The Imagination of Air and the Collapse of Alchemy', *Eranos Yearbook*, 50 (1981), 273–333 (Frankfurt, 1982); Simon Schaffer, 'Natural Philosophy and Public Spectacle in the Eighteenth Century', *History of Science*, 21 (1983), 1–43; Clarke Garrett, 'Swedenborg and the Mystical Enlightenment in late Eighteenth-Century England', *Journal of the History of Ideas*, 45 (1984), 67–81.
[9] Joppien, *Loutherbourg*, Introd.; Gage, 'Mystagogue'.

moonrises, sunsets, thunderstorms, and conflagrations.[10] Like his other fiery paintings of the turn of the century, the *Great Fire of London* and the *Battle of the Nile*, (Fig. 7.2), *Coalbrookdale by Night* exhibits much of Loutherbourg's stagecraft: the wings and back-lighting, the counterpoint of fire and moonlight, the almost audible eruption of smoke and flames, the horse and cart in the foreground hurtling from the scene, one of the carters bawling to his companion above the din.

Loutherbourg's theatrical productions were not merely exhibitions of formal virtuosity. The stage in Georgian England was one of the main vehicles of patriotic display, and Loutherbourg's productions celebrated old heroes like King Alfred and new ones like Captain Cook.[11] He inserted newsworthy episodes into his productions: the King's visit to Spithead to review the fleet in his 1773 *Masque of Alfred*, and the arrival of captured French and Dutch ships in the 1782 run of the Eidophusikon.[12] Loutherbourg's directions for the 1779 production of Sheridan's *The Critic* included a scene of the destruction of the Spanish Armada: 'the fleets engage—the musick plays "Britons strike home"—Spanish fleet destroyed by fire ships, &c—English fleet advances—musick plays "Rule Britannia"—the procession of all the English rivers with their emblems, etc. begins with Handel's water musick.'[13]

In both its spectacular technique and its triumphal nationalism, Loutherbourg's stagecraft recalls Jacobean masques. And like these masques it is distinctly magical.[14] William Beckford gave Loutherbourg the title of 'mystagogue' for his special effects for the Christmas celebrations at Fonthill in 1781. Half a century later he was 'still warmed and irradiated by the recollections of that strange, necromantic light which Loutherbourg had thrown over what absolutely appeared a realm of Fairy, or rather perhaps, a Demon Temple deep within the earth, set apart for tremendous mysteries'.[15] Loutherbourg had always taken a deep interest in magic. When he

[10] There is now an extensive literature on Loutherbourg's stagecraft. I have found most useful Ralph G. Allen, 'The Stage Spectacles of Philip James de Loutherbourg' (unpublished Ph.D. dissertation, Yale University, 1960); Sybil Rosenfeld, 'The *Eidophusikon* Illustrated', *Theatre Notebook*, 182 (1963–4), 52–4; Rüdiger Joppien, 'Die Szenenbilder Philippe Jacques de Loutherbourgs Eine untersuchung zu ihrer Stellung zwischen Malerei und Theater' (unpublished Ph.D. dissertation, University of Cologne, 1972); Richard Altick, *The Shows of London* (Cambridge, Mass., 1978), 117–27; Christopher Baugh, 'Philippe James de Loutherbourg and the Early Pictorial Theatre: Some Aspects of its Cultural Context', in J. Redmond (ed.), *Themes in Drama*, ix (Cambridge, 1987), 99–127.

[11] Ralph G. Allen, 'De Loutherbourg and Captain Cook', *Theatre Research*, 4 (1962), 195–211.

[12] Altick, *Shows of London*, 120, 121.

[13] Allen, 'De Loutherbourg', 196.

[14] Frances Yates, *Theatre of the World* (London, 1969), 136–61, 169–85; Roy Strong, *Britannia Triumphans: Inigo Jones and Whitehall Palace* (London, 1980).

[15] H. A. N. Brockman, *The Caliph of Fonthill* (London, 1956), 36–8.

came to London he brought with him the pyrotechnicist G. B. Torré, who offered to instruct Garrick in the Cabbala and to materialize 'celestial manna'. In London he joined the circles of Swedenborgians and Behmenists and amassed a large library of occult texts. Here he met the notorious 'Count' Alessandro Cagliostro and followed him to Switzerland, preparing scenic designs for his Egyptian Rite of Freemasonry. After this partnership degenerated into violent quarrelling, Loutherbourg returned to London to create a wildly successful practice in mesmeric healing (the congestion outside and the presence of ticket-touts provoked riots). He then retired to the country to immerse himself in the Cabbala and biblical prophecies. When he took up his brush again around 1790 he produced works that are fiery, often apocalyptic.[16]

In his 1973 catalogue, intended to redress Loutherbourg's long neglect in England as a painter, Rüdiger Joppien barely conceals his exasperation with a subject who was 'promiscuous' with his talents, abandoning himself to magic, prophetic religion, and the flashier kinds of show business: 'Discipline seems not to have been Loutherbourg's strong point.'[17] Discipline, in this single-minded sense, seems not to have been the strong point of many painters at this time, including some Academicians. If subsequent art collectors and critics have neglected Loutherbourg, his versatility was esteemed, indeed marvelled at, in his own lifetime.[18]

Despite, or rather because of, his upbringing and career on the Continent, Loutherbourg was seen to identify characteristic British scenery that native painters had neglected and to invigorate ways of depicting the nation. In the catalogue of the posthumous sale of Loutherbourg's work (which included his large collection of occult texts as well as assorted paintings and drawings), Peter Coxe upheld Loutherbourg's patriotic vision:

He first led our rising artists to appreciate the romantic beauties of their native soil; for, after having explored the wild mountain scenery of North Wales, and the lofty and richly wooded regions of Cumberland and Westmorland, with their extensive lakes; he who had visited Italy, Switzerland, France and other parts of Europe, abounding in the picturesque and grand scenery of nature, declared that no English painter had occasion to traverse foreign regions in search of subjects, whilst our Island possessed such magnificent views as he had met with on his British tour. The truth of this ingenious foreigner's assertion was illustrated by the many correct views of these districts, so finely portrayed by his tasteful pencil,

[16] Gage, 'Mystagogue', 333–4; Joppien, *Loutherbourg*, Introd.; Morton Paley, *The Apocalyptic Sublime* (New Haven, Conn., 1986), 51–70.
[17] Joppien, *Loutherbourg*, Introd., n.p.
[18] Paley, *Apocalyptic Sublime*, 51–70.

7.2 P. J. de Loutherbourg, *The Battle of the Nile*, 1800, oil on canvas, $59\frac{7}{8} \times 84\frac{1}{4}$ in.; reproduced by permission of the Trustees of the Tate Gallery, London.

7.3 William Pickett, after P. J. de Loutherbourg, *Iron Works, Coalbrookdale*, hand-coloured aquatint, from Loutherbourg, *The Romantic and Picturesque Scenery of Wales* (London: no publisher credited, 1805).

which adorned the walls of the Royal Academy for years after his arrival in the Kingdom.

Loutherbourg, Coxe maintained, brought a 'new style of art into this country', more robustly empirical, combining 'deep and powerful insight into the details of things . . . with the clearest views for his general purpose'. He also reformed public taste with his dramatic theatre designs and peep-shows and his vignettes for the prophetic books in the Macklin Bible. 'The genius of DE LOUTHERBOURG was rather energetic than elegant,' Coxe concluded. And so 'this ingenious foreigner' was naturalized:

It is so many years since this highly respectable and much regarded artist made the choice of England for his residence, that his name and his works are so familiar to the whole of the artists that it is difficult to consider him with any feeling than as English extraction. Here he early practised his art; here his genius has been cherished; and here his venerable remains mix with the British soil.[19]

Written during the crisis of 1812, this memorial to Loutherbourg may well be defensive. As Morton Paley points out, Loutherbourg's precise national identity and allegiance seem as fluid as his art. The artist himself claimed various national ancestries, not just French and German as expected of a native of Alsace but also Polish, Lithuanian, and Swiss. In Paris Loutherbourg seems to have moved in radical masonic circles, but his later recorded remarks to Joseph Farington reveal a conservative strain. In 1803 he recommended a scorched-earth policy against an invading Napoleonic army and the following year was confident 'that the troubles in France will end in it being resolved into a limited Monarchy'.[20] Lou-therbourg's commitment to a magical form of freemasonry intended to unite all European lodges meant that any patriotic vision he entertained, not least a British one, would be inserted into a highly complex cultural field. Such is the case, I will argue, with *Coalbrookdale by Night*.

II

By the beginning of the nineteenth century Coalbrookdale referred not just to the small tributary of the Severn gorge, where the smelting of iron by coke was developed in the mid-eighteenth century by the Coalbrookdale Company, but to the whole area of the gorge, which the company helped

[19] Peter Coxe, *A Catalogue of all the Valuable drawings & c. . . . of James Philip de Loutherbourg Esq R.A.*, 18 June 1812, 4, 6, 3. Copy in Library of Victoria and Albert Museum.
[20] Paley, *Apocalyptic Sublime*, 70.

colonize and which was renowned as the largest, most concentrated, and most complex iron-making region in Britain.[21]

Coalbrookdale rose rapidly to national prominence. 'These works are supposed to be the greatest in the kingdom,' reported Arthur Young in 1776, 'the whole process is here gone through from digging the iron stone to making it into cannons, pipes, cylinders, etc etc.'[22] An 1801 *Description* of Coalbrookdale appended a list of over 150 products the Company produced, from every-day household objects to farming implements to large items of industrial plant.[23] The text accompanying a daytime view of Coalbrookdale (Fig. 7.3) in Loutherbourg's *Romantic and Picturesque Scenery of England and Wales* (1805), notes how the iron from this 'celebrated valley' circulated throughout the nation, connected by canal and river to the 'principal seaports ... beside most places of importance in the interior part of the Kingdom'.[24] The Seven Years War (1756–63) had first stimulated Coalbrookdale's iron industry, and the current war with France recharged it after years of recession. The Quakerism of Coalbrookdale's leading iron-masters made this a cause of some unease in local publicity. The 1801 *Description* was disinclined to connect Coalbrookdale's prosperity with 'the ravages of this unparalleled destructive war', although it did direct its readers to the cannon foundry 'where an immense number of those horrid instruments of destruction are cast, bor'd and finished. Perhaps it is the largest Manufactury of the kind in the Nation.'[25]

Coalbrookdale's publicists set out to astonish the visitor both with the data relating to the industrial process and with its dramatic effects. A typical passage from the 1801 *Description* runs:

We now pursue our course over the upper furnace Coalhearths, cross the Iron road, to a large Steam Engine of Boulton & Watts construction, which lifts the water from a reservoir about half a mile distance conducted to the bottom of the pit, 120 ft. deep, through a Cylindrical arch of bricks, constructed at a great expense. The Cylinder is 67 Inches Diameter, and that of the boyler 22 ft. the two working barrells or pumps are 26 inches Diam. each, & discharge 315 Gallons

[21] Barrie Trinder, *The Industrial Revolution in Shropshire* (London, 1981), *The Darbys of Coalbrookdale* (London, 1981), and *'The Most Extraordinary District in the World': Ironbridge and Coalbrookdale* (London, 1977). I have found this anthology of visitors' impressions of Coalbrookdale especially useful. Still useful is the section on 'Coalbrookdale and the Sublime' in Francis D. Klingender, *Art and the Industrial Revolution* (London, 1947), 71–83, and the edition ed. and rev. by Arthur Elton (London, 1968).

[22] Arthur Young, *Tours in England and Wales, Selected from the Annals of Agriculture* (London, 1932), 151.

[23] Barrie Trinder (ed.), *Coalbrookdale 1801: A Contemporary Description* (Ironbridge, 1979), 16–17.

[24] P. J. de Loutherbourg, *The Romantic and Picturesque Scenery of Wales* (London, 1805), n.p.

[25] Trinder, *Coalbrookdale 1801*, 15.

of water each stroke, and which is at the rate of 2235 Gallons Pr. Minute, &
perhaps one of the largest Engines ever erected ... When the Valve in the Boyler
is lifted, the Steam rushes out with such a noise and amazing impetuosity, as to
equal the loudest Thunder, and fill the mind of the spectator with wonder and
astonishment.[26]

The rugged grandeur of the Severn gorge and the fiery nature of
iron-making made Coalbrookdale a dramatic spectacle. Arthur Young
interspersed his information on the area's achievements with observations
on its scenic effects: 'the flames bursting from the furnaces with the
burning of coal and the smoak of the lime kilns, are altogether sublime.'[27]
Ironmasters organized Coalbrookdale as a spectacle, with scenic walks,
vantage-points, and times when the tapping of furnaces and casting could
be seen. A variety of views were on offer. The 1801 *Description* took the
visitor to the iron rotunda on the summit of Lincoln Hill, the limestone
cliff overlooking the Severn gorge. One side looked out to 'an enriched
view of beautiful and well cultivated fields, overhanging woods, bold
projecting rocks, the river Severn richly fraught with vessels, Reservoirs,
Works, Abbeys, Villas, Bridges, in short a superabundance of ev'rything
that can please or delight the eye'. The other looked down into 'a Quarry
about 150 feet deep and almost perpendicular, at the bottom of which are
several Limekilns and immense caverns supported by huge pillars, [which]
has all the appearance of the horrible'.[28] Those with a taste for the horrible
could be winched down mine-shafts, taken into tar tunnels, or ride, helter-
skelter, down inclined planes.

The single-span Iron Bridge across the Severn gorge was the centrepiece
of Coalbrookdale, the feature that focused the region's reputation.[29] The
Iron Bridge reorganized Coalbrookdale, not least scenically. Upon its
completion in 1780, the bridge's proprietors commissioned Michael Angelo
Rooker, a stage designer for London's Haymarket Theatre, to paint the
bridge and had the engraving dedicated to George III (Fig. 7.4). Rooker's
was to become the standard view of the Iron Bridge. Like the wings of a
stage, Lincoln Hill and Bethnall Edge rise steeply on the right and left
margins of the picture. The Iron Bridge frames the river, showing between
its arch a number of vessels on the water and a smoking smelter on the
bank.

When Loutherbourg painted *Coalbrookdale by Night*, the region was at

[26] *Coalbrookdale 1801*, 12–13.
[27] Young, *Tours*, 152.
[28] Trinder, *Coalbrookdale 1801*, 14.
[29] Stuart Smith, *A View from the Iron Bridge* (Ironbridge, 1979).

7.4 William Ellis, after Michael Angelo Rooker, *View of the Cast Iron Bridge near Coalbrook Dale*, *c*.1780, hand-coloured engraving; reproduced by permission of the Ironbridge Gorge Museum Trust.

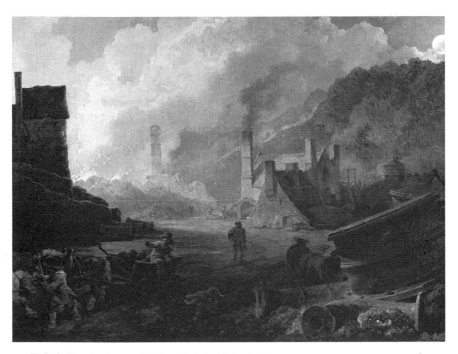

7.5 P. J. de Loutherbourg, *Coalbrookdale by Night*, detail.

the height of its renown. Not only was the physical landscape thoroughly worked over, often with the spectator in mind, but it had been continually represented in writings and pictures from a variety of ideological perspectives in a number of styles. Few places in Britain possessed such cultural density, few were refracted in so many ways. The very word 'Coalbrookdale' was sufficient to trigger a range of images and associations. In the rest of this essay I will show how Loutherbourg deploys these at one site.

It is tempting to extend the heritage metaphor of Coalbrookdale as a 'crucible' of the industrial revolution to the concentration of cultural elements in *Coalbrookdale by Night*. But this would be too functionalist a reading. It will become apparent in this essay that a more appropriate metaphor for the picture is the alchemical one of a 'chemical theatre', in which a whole range of transformations, esoteric and exoteric, are enacted and witnessed.[30]

<h1 style="text-align:center">III</h1>

The site of *Coalbrookdale by Night* is the Madely Wood or Bedlam Furnaces on the banks of the Severn. As the nearest furnaces to the Iron Bridge, they drew more attention from visitors than any others. They were first called Bedlam because they stood near a sixteenth-century house of that name, but the popularity of the name among visiting artists and writers was doubtless because of its reference to any place of turmoil.[31]

Built in the wartime boom years of 1757–8 at the base of an outcrop of coal and ironstone, the Bedlam Furnaces were incorporated in the Coalbrookdale Company in 1776. When the Company split in 1796, they were given over to one partner, William Reynolds. Reynolds was recognized as the most enterprising figure in Coalbrookdale, owning or controlling a network of works and installations including coal-mines, ironworks, chemical works, potteries, glassworks, wharves, warehouses, bridges, and canals.[32] The 1801 *Description* of Coalbrookdale hailed the 'noble ardour' of Reynolds's improvements, 'so truly characteristic of himself, as a liberal promoter of the different arts and sciences, in whose bosom merit in every

[30] On the metaphor in 16th-century English culture, see Charles Nicholl, *The Chemical Theatre* (London, 1980).
[31] For the history and working of the Bedlam Furnaces, I have drawn upon the following: Barrie Trinder, *Bedlam: A Guide to the Monumental Ruins of an Eighteenth-Century Ironworks*, (Ironbridge, 1984); Stuart B. Smith, 'New Light on the Bedlam Furnaces', *Historical Metallurgy*, 131 (1979), 21–30; Barrie Trinder, 'Problems of the Bedlam Furnaces (unpublished MS, Ironbridge Gorge Museum).
[32] Trinder, *Industrial Revolution in Shropshire*, 36–37, 43–4, 116–17, 138–9.

station always finds a place, and to whom the nation at large stands greatly indebted'.[33] More than any other ironmaster, Reynolds was esteemed as a speculative, even visionary scientist, transferring laboratory experiments on refining and casting to furnace and forge, trying out various applications for steam-power, collecting fossils from coal and ironstone to test geological theories, meeting with other like minds in those masonic gatherings that characterized the provincial culture of the Enlightenment. In ironstone, said Reynolds, 'lay coiled up a thousand conveniences of mankind: that in that ore lay concealed the steam-engines, the tramways, the popular and universal metal that in peace and war should keep pace with, and contribute to, the highest triumphs of the world'. The workmen he asked for specimens of ironstone and coal saw a less utilitarian side to his speculations. Some 'believed his aim to be to extract "goold" as they said, from the stone', reported an amused Victorian historian years later. 'Gambler Bough, of the sulphur pit, said he thought that the coal had been put there at the creation, and was intended to be used to burn up the world at the last day; and that he sometimes considered it a wrong thing to get, believing they ought to use wood.'[34]

Bedlam was a key site in Reynolds's industrial complex. He had just added a new furnace and spent much of his time superintending the works. The new furnace confirmed Bedlam as the most profitable ironworks in Coalbrookdale, making cast iron, the *Description* announced, 'of superior quality to any other in the Nation'.[35] Much of this was sent to Birmingham to be made into small wares, but there was a foundry on the site that made large castings like pipes and cylinders for steam-engines.

Loutherbourg portrays the industrial process at Bedlam with the precision tourists had come to expect. At the centre of the painting are the coke hearths (Fig. 7.5). Having just been opened (their clamps removed), they burst into flaming clouds of sulphurous smoke. Before them figures shovel and haul coke, with iron ore and limestone, into the charging house of the iron furnace, its chimney spouting black smoke. Castings from the foundry are scattered about the site. The cylinder and pipes in the right corner are parts of a steam-engine, those to the left are falanged like part of a water-wheel, those in the centre in front of the coke hearths look like cannon. Lumps of glassy slag, the by-product of smelting, cover the ground, seemingly a model for Loutherbourg's rendering of the distant hills. In the foreground a horse-drawn wagon on one of the plateways of

[33] Trinder, *Coalbrookdale 1801*, 15.
[34] John Randall, *History of Madely* (Madely, 1880), 81–101, quotation on 90.
[35] Ibid., 14.

7.6 P. J. de Loutherbourg, *Fire Engine Coalbrookdale*, 1786, pen and ink, $3\frac{1}{8} \times 4\frac{3}{4}$ in., Clore Gallery, Turner Bequest (CCLXXII–47); reproduced by permission of the Trustees of the Tate Gallery, London.

7.7 P. J. de Loutherbourg, *Iron Foundry, Madely Wood*, 1786, pen and ink, $3\frac{1}{8} \times 4\frac{3}{4}$ in., Clore Gallery, Turner Bequest (CCLXXII–48); reproduced by permission of the Trustees of the Tate Gallery, London.

7.8 P. J. de Loutherbourg, *Largest Fire Engine of Coalbrookdale*, 1786, pen and ink, $3\frac{1}{8} \times 4\frac{3}{4}$ in., Clore Gallery, Turner Bequest (CCLXXII–45); reproduced by permission of the Trustees of the Tate Gallery, London.

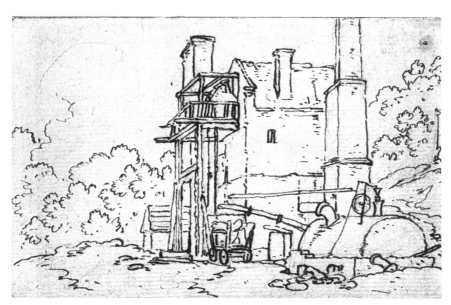

7.9 P. J. de Loutherbourg, *Large Fire Engine in Coalbrookdale*, 1786, pen and ink, $3\frac{1}{8} \times 4\frac{3}{4}$ in., Clore Gallery, Turner Bequest (CCLXXII–49); reproduced by permission of the Trustees of the Tate Gallery, London.

the site hurries away towards the Iron Bridge loaded with material, probably bars of pig-iron. Loutherbourg's daytime view shows Bedlam from the other side, downstream, the smoke and flames from the coking hearths silhouetting the engine-house that pumps water from the river. A figure on horseback rides towards the works, pulling a sledge laden with coal.

The foundry and engine-house are based upon Loutherbourg's pen-and-ink sketches of Bedlam and the Upper Works at Coalbrookdale (Figs. 7.6 and 7.7) made on his tour of the Severn valley and South Wales in the summer of 1786, a tour in which he made a number of sketches of ironworks at other sites. These are remarkable for their analysis of motion and circulation, in their delineation of sluices, chimneys, pipes, valves, ventilators, wheels, pulleys, wagons, and boats. The close-up sketch 'Fire Engine, Coalbrookdale' (Fig. 7.6), at Bedlam, shows details of water intake, steam pipe, float valve, and vertical rod, which can only be identified with the aid of technical drawings in contemporary encyclopaedias. The sketches of the other engine-house at the Upper Works (Figs. 7.8 and 7.9) are taken from more of a distance and are shown in a setting of water and trees. One provides a compositional format similar to the one Loutherbourg used in his daytime view.

The geography of the site in *Coalbrookdale by Night* follows closely a plan of Bedlam ironworks (Fig. 7.10) dated 1772, by George Perry, a local ironmaster and publicist for the area. An earlier, scenic perspective (Fig. 7.11), in which Perry had a major hand, drawing the technical details and providing the description, helps specify its iconography. Dated 1758, during the first surge in the iron industry, it is the earliest published view of Coalbrookdale and shows the pioneering Upper Works in the dale itself. On the right are smouldering coke hearths. Figures carry baskets of coke, ironstone, and limestone to the smoking furnaces on the left. While a two-horse cart in the middle distance, by the furnace pool, brings raw materials to the site, in the foreground a team of six horses, perhaps more, pulls a wagon loaded with a huge cylinder for a steam-engine, 'supposed to be Seventy Inches Diameter, Ten Feet Long and weighing about Six Tons' says the accompanying description, 'being the Real Dimensions of one lately cast in this Foundery'.[36] This is precisely the kind of cylinder shown in the right-hand corner of Loutherbourg's painting, which bears the artist's signature. If coking was the process that brought Coalbrookdale to national attention, castings for steam-engines were the product that established its reputation.

[36] Quoted in Trinder, '*The Most Extraordinary District*', 19.

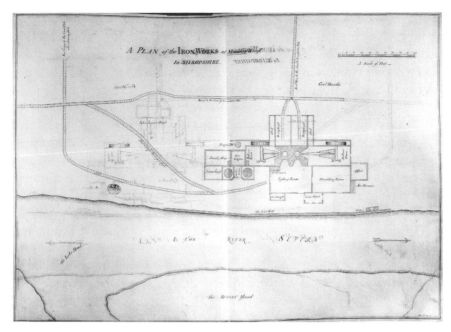

7.10 George Perry, *A Plan of the Iron Works at Madely Wood in Shropshire*, 1772, pen and ink, $26\frac{3}{8} \times 20\frac{1}{2}$ in., British Museum (King's Topography XXXVI 16–1); reproduced by permission of the Trustees of the British Museum, London.

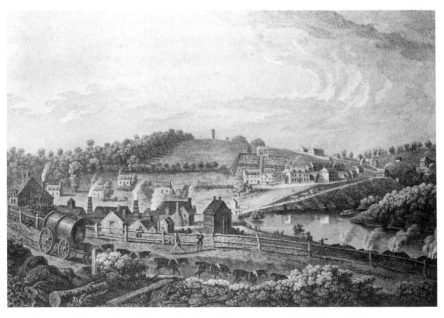

7.11 François Vivares, after Thomas Smith and George Perry, *The Upper Works at Coalbrookdale*, 1758, hand-coloured engraving, $15\frac{3}{8} \times 21\frac{5}{8}$ in.; reproduced by permission of the Ironbridge Gorge Museum Trust.

The perspective and description are an example of that genre of mid-eighteenth century prospect which displays the industriousness of a locality and, in an extending view, its contribution to the prosperity of region and nation.[37] Perry draws attention to the 'Perspective house' on the summit of the hill behind the ironworks, below which are ironmasters' houses and workers' cottages. 'The Face of the Country shews the happy effects of this flourishing Trade ... scenes of hurry and Business ... cheerfulness and contentment are not more visible in any other place ... a pleasing Proof this, that Arts and Manufactures contribute greatly to the Wealth and power of a nation, and that Industry and Commerce will soon improve and People the most uncultivated Situation.' Other 'delightful prospects' took in 'that fine fertile Country, Water'd by the Severn', enhancing that happy mixture of manufacture and agriculture that marked the reputation of this region. In the view of the Upper Works, a pleasure-boat on the furnace pool glides towards the scene of iron-making, and the kind of dramatic close-up taken by Loutherbourg: 'Pillars of Flame and smoke rising to vast height, large Reservoirs of Water, and a number of Engines in motion, never fail to raise the admiration of strangers, tho' it must be confess'd these things join'd to the murmuring of the Waterfalls, the noise of the Machines, and the roaring of the Furnaces, are apt to occasion a kind of Horror in those who happen to arrive in a dark Night.'[38]

In the later eighteenth century Coalbrookdale's smiling prospects were counterpointed by grimmer scenes. William Williams's *Afternoon View of Coalbrookdale* (Fig. 7.12), exhibited at the Royal Academy in 1778, shows tourists on Lincoln Hill, in sparkling clothes, looking out to the bright country, while below them Coalbrookdale is consumed in smoke and flames. The companion *Morning View* (Fig. 7.13) plunges down into the dale, following a coal wagon heading for the furnaces. Coalbrookdale is increasingly presented, often by night, as a cavernous, infernal region into which the spectator descends. By the turn of the century it was customary to liken it to hell or a setting for the Last Judgement. In 1801 Charles Dibdin published a nocturnal view (Fig. 7.14), under a full moon, of lateral mine-shafts by the Severn emitting a lurid light, and commented:

Coalbrookdale wants nothing but Cerberus to give you the idea of the heathen hell. The Severn may pass for the Styx, with the difference that Charon turned turnpike man, ushers you over the [Iron] bridge instead of rowing in his crazy

[37] On this genre see Stephen Daniels, 'The Implications of Industry: Turner and Leeds', *Turner Studies*, 61 (1986), 10–18, and 'Goodly Prospects: English Estate Portraiture 1670–1730', in Nicholas Alfrey and Stephen Daniels (eds.), *Mapping the Landscape* (Nottingham, 1990), 9–12.
[38] Quoted in Trinder, *'The Most Extraordinary District'*, 18, 19.

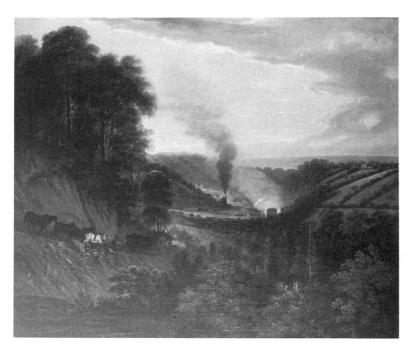

7.12 William Williams, *An Afternoon View of Coalbrookdale*, 1777, oil on canvas, $32\frac{1}{8} \times 49\frac{1}{4}$ in.; reproduced by permission of Rawleys House Museum, Shrewsbury.

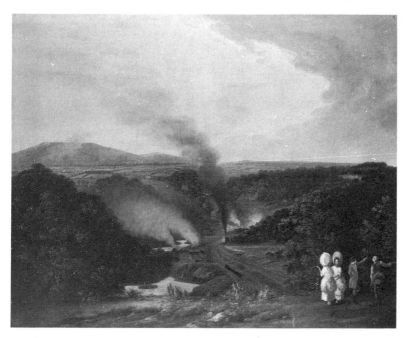

7.13 William Williams, *A Morning View of Coalbrookdale*, 1777, oil on canvas, $32\frac{1}{8} \times 49\frac{1}{4}$ in.; reproduced by permission of Rawleys House Museum, Shrewsbury.

boat; the men and women might easily be mistaken for devils and fairies, and the entrance to any one of these blazing caverns where they polish the cylinders, for Tartarus; and really, if an atheist who had never heard of Coalbrookdale, could be transported there in a dream, and left to awake at the mouth of one of those furnaces, surrounded on all sides by such a number of infernal objects, though he has been all his life the most profligate unbeliever that ever added blasphemy to incredulity, he would infallibly tremble at the last judgement that in imagination would appear to him.[39]

Loutherbourg had himself stoked up the taste for infernal scenes. The finale to the 1782 season of the Eidophusikon was the scene from *Paradise Lost* of the raising of the Palace of Pandemonium. The palace rose from a fiery lake surrounded by burning hills to the accompaniment of peals of thunder and bolts of lightning. It was 'bright as molten brass, seemingly composed of unconsuming and unquenchable fire'. Critics recognized the spectacle of smelting in its emergence. Coloured glasses made the scene change from 'a sulphurous blue, then to a lurid red, and then to a pale vivid light and ultimately to a mysterious combination of the glasses, such as a bright furnace exhibits in fusing various metals'.[40]

Loutherbourg's sketching tour of the Severn valley and South Wales was one of a number he made of provincial England in the 1780s that fasten on scenes of mineral processing. He worked up some of the sketches into exhibition pieces, which it is instructive to compare with *Coalbrookdale by Night. Labourers near a Lead Mine* (Fig. 7.15) was exhibited at the Royal Academy in 1783. The painting details the various stages of extracting and preparing lead ore, from winching the rocks from a pit, to washing in a vat to separate the ore, to loading and hauling by cart. In contrast to *Coalbrookdale by Night*, the momentum of the scene is relaxed. Work seems to have stopped momentarily. The cart is still, the horse grazes, the dog rests. A man sits, scratching his head. A woman leans, hand on hip, on her rake, observing a man and woman exchanging glances, perhaps engaged in a bit of dalliance. The woman in the left foreground of *Coalbrookdale by Night* strikes a similar pose, hand on hips. But she holds no implement of iron-making; she is not resting from an active role in the scene she surveys. The child by her side makes her into a motherly figure, and the timber-framed house behind amplifies her domesticity. A pile of castings separates her from a vigorously male world of work.

[39] Charles Dibdin, *Observations on a Tour through ... England* (1801–2), quoted in Trinder, '*The Most Extraordinary District*', 66.
[40] The description is by W. H. Pyne and quoted in Rosenfeld, 'The *Eidophusikon* Illustrated'. See also Altick, *The Shows of London*, 123.

7.14 Charles Dibdin, *Coalbrookdale*, 1801, engraving; reproduced by permission of the Ironbridge Gorge Museum Trust.

7.15 P. J. de Loutherbourg, *Labourers near a Lead Mine*, 1783, oil on canvas, $44\frac{1}{8} \times 55\frac{7}{8}$ in.; reproduced by permission of the Duke of Abercorn.

There are differences in the labour process between lead-mining and iron-making that inform these pictorial contrasts. If women worked in the extraction and preparation of iron ore, furnace and foundry work was the preserve of men. Perhaps a more telling contrast is the difference in polite mentality between the two periods. If it was affordable in the mid-1780s to see lead miners momentarily relaxing, by the turn of the century, in wartime, ironworkers were meant to be hard at it. But their energy was not easily contained in the polite imagination. Unlike farm labourers working hard for a pittance, ironworkers could command high wages. In periods of good trade, furnacemen, also miners, earned much more per week than their moral guardians among the clergy. This was a matter of some moral outrage, especially as the ironworkers' money was consumed in bonfires of good living, on good food and (understandably for furnacemen) abundant drink.[41] We might consider the strategic placing of that house in Loutherbourg's painting (which seems, from map evidence, to be an invention) in the light of the Archdeacon of Ludlow's observation of the workers at Madely in 1793: 'there is little attention paid by any of these people to have comforts, neatness of house or garden, or cleanliness of apparel; nothing indeed seems so difficult as telling whether high or low wages are best for the poor themselves.'[42]

Ironworkers were attracting a dual mythology of working both heroically and demonically in hellish conditions, of being both superhuman and subhuman. The highly patriotic essay on an 'Iron Foundry' in W. H. Pyne's *Microcosm* (1806), which illustrated ironworkers like blacksmiths manfully forging tools and making cannonballs, reports a more lurid side in the ironmasters' testimony 'that their workmen will labour at the mouth of an oven . . . during a spell of two hours, though he could not come within ten feet of it without being scorched'. He adds 'that of late those people had substituted raw spirits instead of beer for their drink, because the latter made them perspire so copiously, as in a little while to debilitate them. Such is the dreadful influence of despair, that we were told, a person, who was weary of existence, some years ago leapt into the largest of the fires, and of course was consumed in a moment.'[43]

[41] Trinder, *Industrial Revolution in Shropshire*, 205–7.

[42] Quoted in Trinder, '*The Most Extraordinary District*', 39. The Archdeacon, Joseph Plymley, was author of *A General View of the Agriculture of Shropshire*, first published in 1803. The manuscript from which I have quoted (British Museum Add. MSS 21018) is a detailed survey of social, economic, and religious life in Shropshire.

[43] W. H. Pyne, *Microcosm* (1806; repr. New York; 1971 in one vol.), 31.

IV

In his tours Loutherbourg followed in the steps of William Gilpin and, more than most followers or commentators, he realized the fire-power of William Gilpin's discourse of the Picturesque. Gilpin's famous set piece on Tintern Abbey is framed by the iron industry of the Wye. Indeed, industry is seen as a force to redeem the ruins. Upstream, Gilpin observes, 'little barks lay moored, taking in ore, and other commodities from the mountains. These vessels designed plainly for rougher water, than they at present encountered, shewed us, without any geographical knowledge, that we approached the sea.' 'Within half a mile [of Tintern Abbey] are carried on great iron works; which introduce noise and bustle into these regions of tranquillity.' This is not intrusive. 'The ground, about these works, appears from the river to consist of grand wood hills, sweeping, and intersecting with each other, in elegant lines. They are a continuation of the same kind of landscape, as that about *Tintern Abbey* and are fully equal to it.' But on closer inspection the ruins of the abbey now have loathsome associations. The wretched poor squatting there 'seem to have no employment, but begging: as if a place once devoted to indolence could never again become the source of industry'.[44]

If Loutherbourg's daytime view of Bedlam has ingredients of Gilpin's description of the Tintern iron-works—the riverside setting, the sweeping woody hills—his night-time view echoes Gilpin's description of the 'great forges of the Carron works' in Scotland. Gilpin itemizes the industrial process: the coking of coal, the driving of the bellows, the blast of air, the melting of the ironstone and limestone flux, the movement of the molten metal. It is the coke hearths that make the works 'exhibit a set of the most infernal ideas':

In one place, where coal is converted into coke by discharging it of sulphur, and the fire spread of course over a large surface; the volumes of smoke, the spiry flames, and the suffocating heat of the glimmering air, are wonderfully affecting. How vast the fire is, we may conceive when we are told it consumes a hundred tons of coal a day. At night its glare is inconceivably grand ... Among the horrid ideas of this place, it is not the least, that you see everywhere, black sooty figures wheeling about, in iron wheel-barrows molten metal, glowing hot.[45]

In his last book, on the 'Western Parts of England', published in 1798, Gilpin makes a sustained analysis of fire-power. This begins with the

[44] William Gilpin, *Observations on the River Wye and Several Parts of South Wales* (London, 1782), 31, 37, 35.
[45] William Gilpin, *Observations relative chiefly to Picturesque Beauty* (London, 1784), 77–8.

careening of a great ship in Plymouth Dock by night, 'the fire glimmering, sparkling or blazing [in] rolling volumes of smoke'. It moves on to other conflagrations by night which show 'action and passion distinctly represented; the hat waved, the agitated body, and the lips of the bawling mouth'. Bonfires were fine, burning houses better, and best were 'the operations to war', especially the 'burning of ships'. The 'noblest exhibitions', 'performed at night' and 'connected with great and prosperous events', were the burning of the Spanish batteries and battery ships during the Siege of Gibraltar of 1783, still renowned as the most spectacular episode of British sea power and a subject of theatrical displays.[46]

Just a year after this passage was published, the war against Napoleonic France provided a more dramatic spectacle, the blowing up of the French munitions ship during the Battle of the Nile. Within weeks this was the subject of an Eidophusikon-type exhibition.[47] Loutherbourg himself exhibited a painting (Fig. 7.2) of this episode at the Royal Academy in 1800, which shares the compositional structure of *Coalbrookdale by Night*. The exploding ship occupies the same position as the flaming coke hearths and performs the same function of illuminating the scene. A British man-of-war provides a wing-like frame like the buildings to the left of the hearths. British rescue boats hurry away from the conflagration, striking the same diagonal as the wagon. The correspondences are of course more than formal. It was cannon cast in British iron foundries that fired the broadside into the French ship. Both pictures are displays of British firepower.

V

The closest correspondence in painting for *Coalbrookdale by Night* is with the nocturnes of Joseph Wright, with their conjunction of blazing light, from flames or molten metal, and cool light from a full moon. There are evident exchanges between the work of Wright and Loutherbourg. Loutherbourg's first scenic pantomime, *The Wonders of Derbyshire*, took as its setting the region Wright has made famous. Among its scenes were Dovedale by moonlight, Matlock Tor, a lead mine, and the giant cavern 'Peaks Hole' showing rope-spinners working.[48] Wright's later paintings

[46] William Gilpin, *Observations on the Western Parts of England* (London, 1798), 206, 207, 208–9.
[47] John Gage, 'Turner and the Picturesque', *Burlington Magazine*, 107 (1965), 16–81, ref. on p. 23.
[48] Ralph G. Allen, 'The Wonders of Derbyshire: A Spectacular Eighteenth-Century Travelogue', *Theatre Survey*, 2 (1961), 54–66.

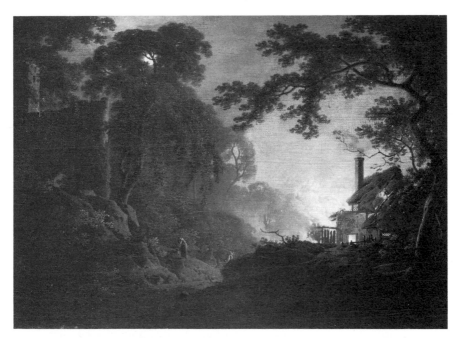

7.16 Joseph Wright, *A Cottage on Fire*, *c*.1790, oil on canvas, 25 × 30 in.; reproduced by permission of the Derby Museum and Art Gallery.

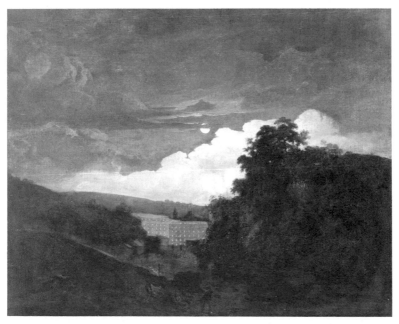

7.17 Joseph Wright, *Arkwright's Cotton Mills by Night*, *c*.1782–3, oil on canvas, $39\frac{1}{4} \times 49\frac{5}{8}$ in.; private collection.

also show evidence of the illusionistic stagecraft Loutherbourg developed.[49]

Coalbrookdale by Night combines the analytical precision of a painting like Wright's *Iron Forge by Night* (1773) which, as in a scientific section, breaks open the outside wall of the forge to display the sequence of power: the river's swift current drives the water-wheel which turns the drum which brings down the tilt-hammer on the glowing ingot positioned by the smith. Wright's later nocturnal landscapes, where fire threatens to consume a scene, are implicated too: the view of Gibraltar during the destruction of the Spanish batteries, the views of erupting volcanoes and firework displays, and especially the several versions of *A Cottage on Fire* (Fig. 7.16). Set in a steep gorge, framed by a blasted tree, fleed by terrified inhabitants, the cottages explode, as in Gilpin's description of 'the conflagrations of houses', 'bursts of fire from windows and doors . . . the force of fire on the different materials . . . more or less combustible'.[50]

The painting by Wright that most clearly corresponds to *Coalbrookdale by Night* in both subject and composition, is *Arkwright's Cotton Mills by Night* (*c.* 1783) (Fig. 7.17). Under a full moon, Arkwright's mills glow in the darkness of a steep, dark valley. They silhouette a figure in the foreground with a horse and cart, perhaps loaded with thread, crossing a bridge away from the site. The illumination of the mills comes not just from the candlelit interior, shining yellowish through the windows, but from some source outside which bathes the walls in rosy light. This may allude to the illumination of the mills during festive processions, which celebrated not only Arkwright but King and Country too.[51] At the time Arkwright's mills, the centre of a nation-wide cotton-spinning empire, were the most shining example of British enterprise, and sought out as such by visitors.[52] Defended by batteries of cannon and small arms against insurgents, they seemed a belligerent sight too. Working day and night, they reminded more than one commentator of the warships that symbolized the nation's might. 'These cotton-mills, seven stories high and fill'd with inhabitants, remind me of a first rate man of war', noted Viscount

[49] I am not implying that Wright merely followed Loutherbourg. Indeed, a reviewer of Loutherbourg's *Robinson Crusoe* (1781) thought it 'the first happy imitation of Mr Wright of Derby we ever saw in the theatre'. Quoted in Benedict Nicolson, 'Wright of Derby: Addenda and Corrigenda', *Burlington Magazine*, 130 (1988), 757, n. 39.

[50] Gilpin, *The Western Parts of England*, 208. All the paintings by Wright I mention are documented and reproduced in colour in Judy Egerton, *Wright of Derby*, Tate Gallery cat. (London, 1990).

[51] David Fraser, 'Fields of Radiance: The Scientific and Industrial Scenes of Joseph Wright', in Denis Cosgrove and Stephen Daniels (eds.), *The Iconography of Landscape* (Cambridge, 1988), 134–6. On patriotic illuminations see Linda Colley, 'The Apotheosis of George III: Loyalty, Royalty and the British Nation 1760–1820', *Past and Present*, 102 (1984), 95–129.

[52] Arkwright Society, *Arkwright and the Mills at Cromford* (Ripley, 1973); R. S. Fitton, *The Arkwrights: Spinners of Fortune* (Manchester, 1989), 29–35, 51–5, 80–3, 91–120.

Torrington in 1790, 'and when they are lighted up, on a dark night, look most luminously beautiful.'[53]

The style of *Arkwright's Cotton Mills by Night* owes much to illusionistic stagecraft, both of large-scale productions, and of peep-shows, which displayed, through back-lighting and perforated paper, night-time views of monuments like St Paul's, windows blazing under a full moon.[54] It is also configured by a geological diagram that brings it closer to the atmosphere of Wright's more explosive nocturnes of fireworks and volcanoes and to *Coalbrookdale by Night.*

VI

As David Fraser has shown, *Arkwright's Cotton Mills by Night* has parallels with the pioneering geological section of Matlock Tor drawn by Joseph Whitehurst, the keystone to his volcanic theory of the earth.[55] Wright shows the section in his portrait of Whitehurst (Fig. 7.18) with a smoking volcano on the horizon. Whitehurst maintained that 'subterraneous fire' was the primary agent shaping the earth. As water from the oceans seeps down fissures in the crust, so it is vaporized and the steam-power explodes the ocean bed, throwing strata (which have been deposited evenly on the ocean bed) into dramatic patterns. Whitehurst's section shows volcanic toadstone interleaved with limestone and, below the bed of the Derwent, a rubble-covered fissure reaching down, he presumed, into the sub-terraneous sea of fire. So Arkwright's mills glow like magma in a volcanic vent, their industrial power amplified by the primordial power of the earth.

Whitehurst's theory of 'subterraneous geography' was informed by detailed empirical observation, from mine-shafts and quarries in the Peak District and Coalbrookdale, and configured by engineering drawings, and images of blast furnaces. But it also had what seems to us now a more arcane dimension. The idea of a central fire goes back to medieval cosmology, where it supplies heat and flames to both hell and volcanoes. Whitehurst likened the process of vaporization to alchemical sublimation, and the interior of the earth to an alembic where 'there exists a central fire that heats the incoming water flowing downwards through subterranean passages from the oceans'.[56]

Correspondingly, Wright's scientific and industrial scenes are never

[53] *Torrington Diaries*, quoted in *Arkwright and the Mills*, 7.
[54] On peep-shows see Ralph Hyde, *Panoramania* (London, 1988), 115.
[55] Fraser, 'Fields of Radiance', 136.
[56] John Whitehurst, *An Inquiry into the Original State and Formation of the Earth* (London, 1778). On the idea of a central fire see Marjorie Hope Nicolson, *Mountain Gloom and Mountain Glory* (Ithaca, NY, 1959), 339.

narrowly empiricist or utilitarian. They present a Rosicrucian theatre of enlightenment in which the rituals of material and spiritual transformation are combined.[57] In his combination of chemical labour and ardent prayer, the figure of Wright's *Alchymist* (Fig. 7.19) recalls that in Khunrath's *Amphitheatre of Eternal Wisdom*. In their reworkings of the nativity, the ingot in place of the radiant byre, Wright's blacksmith scenes project the alchemical theology of the Behmenists.[58] The main institutional vehicle for this blend of exoteric and esoteric enlightenment was freemasonry.[59] But there was a wider market for its imagery. At the turn of the century, a transparency print was on sale in London showing a blacksmith's shop alongside the tomb of Rosicrucius, set in a vault 'where the sun never shone, but [which] was lighted by an inner sun'.[60]

By the later eighteenth century there had developed a distinctive genre of subterranean drama, mixing science and magic, in which it is difficult to distinguish serious speculation from kitsch wizardry. Wright planned and sketched a painting of John Sargent's *The Mine: A Dramatic Poem*, 1785,[61] a work with footnotes on Whitehurst's subterraneous geography as well as on the legend of Rosicrucius. The story concerns a Viennese nobleman who is falsely condemned to labour for life in a mercury mine (effectively a short sentence). When the condemned miners appear in their 'subterranean prison house', the stage is dark. It is then brilliantly lit for the 'spirits of the earth' (who release the hapless nobleman), performing their 'high alchemy', brewing various metals, ultimately spiritual gold,

> Thro' ponderous shades diffuse the golden rays
> And bid th'imperial Lord of Metals blaze.
> In earth's brute caverns we can make delight
> And gild with rapture the dark brow of night.[62]

The stagecraft of *The Mine* owes much to Loutherbourg's *Wonders of Derbyshire*, where a magician transforms a gloomy cave into a brilliant

[57] On Rosicrucianism see Frances A. Yates, *The Rosicrucian Enlightenment* (London, 1972), esp. 220–33; Marsha Keith Manatt Schuchard, 'Freemasonry, Secret Societies, and the Continuity of Occult Traditions in English Literature' (unpublished Ph. D. dissertation, University of Texas at Austin, 1975).

[58] I argued this in an unpublished paper, 'Joseph Wright and the Spectacle of Power', given as a lecture at the Tate Gallery in Feb. 1990 during the Wright of Derby exhibition. It is touched on in my review of the exhibition in *New Statesman and Society*, 23 Feb. 1990, 40–1.

[59] Yates, *Rosicrucian Enlightenment*, 206–19; Schuchard, 'Freemasonry', 166–229. Wright and many of his local patrons, including Whitehurst and members of the Lunar Society, were freemasons.

[60] Edward Orme, *An Essay on Transparent Prints* (London, 1807), 65. Orme lists it along with one of the *Burning of L'Orient* (in the Battle of the Nile) and *Illuminations for Peace*.

[61] Benedict Nicolson, *Joseph Wright of Derby* (London, 1968), 125.

[62] John Sargent, *The Mine: A Dramatic Poem* (London, 1785), 1, 8, 61.

7.18 Joseph Wright, *John Whitehurst F.R.S.*, *c.*1782–3, oil on canvas, $16\frac{1}{2} \times 28$ in.; private collection; detail.

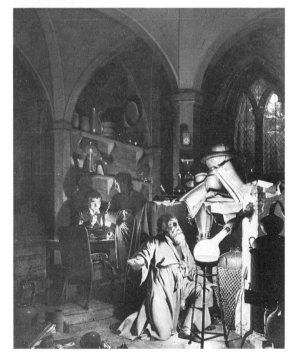

7.19 Joseph Wright, *The Alchymist in Search of the Philosopher's Stone, Discovers Phosphorus, and Prays for the Successful Conclusion of his Operation*, 1795, oil on canvas, $50 \times 40\frac{1}{8}$ in., reproduced by permission of the Derby Museum and Art Gallery.

palace and gardens. Such stagecraft was deployed in the caves of Derbyshire themselves. In 1795 a minister from Perthshire was dressed as a miner and taken through gloomy passages into a vast limestone cavern which his guides had lit with candles. One guide 'had ingeniously withdrawn himself on purpose to surprise us; he was standing on a pinnacle of the rock where I could not conceive it possible for a human being to stand; and therefore his appearance struck me at first with the idea of some supernatural being inhabiting a region of enchantment'.[63]

Loutherbourg's illustrations for Cagliostro's Egyptian Rite of Freemasonry were a sustained piece of subterranean theatre. The Rite had initiates descend into an underworld to be met by trials of air, fire, and water, in an infernal atmosphere of noise, steam, and smoke.[64] Loutherbourg's pictures of the various 'philosophical operations' of the Rite seem to have been designed to hang in the vestibule of the lodge for initiates to contemplate before their rite of passage. The picture (Fig. 7.20) of the key episode shows an apprentice slaying the figure of Mercury, the alchemical death necessary to resurrect the mercurial anima for the sublimation of the philosopher's stone. Above the figures is the mercurial heart, in the form of a flaming vessel, in which a temple emerges into form. This stands at the intersection of beams from the sun and moon, signifying the marriage of sulphur and mercury, the basic principle of alchemical transformation. In what seems to be the final scene (Fig. 7.21), an apprentice beholds in rapture a vision of the Temple of Zion.

What made alchemical imagery so compelling was its resonance in the biblical imagery of furnaces and refining fire, especially in the prophetic books. Loutherbourg projected his alchemical imagery into his apocalyptic illustrations for the six-volume Macklin Bible, completed in 1800 (if, by the last volume, the publishers felt obliged to provide an 'Explanation' for some of his more obscure symbolism). Loutherbourg's illustration (Fig. 7.22) to the verse in Isaiah 2 on the last days when 'the mountain of the LORD's house shall be established in the top of the mountains' reworks his imagery for the Egyptian Rite. The winged mercurial heart flies towards a shining Temple of Zion over seven volcanic hills inscribed with the signs of the planetary metals.[65]

[63] William MacRitchie, *Diary of a Tour through Great Britain in 1795* (London, 1897), 59–60. On tours of mines generally, see Esther Moir, *The Discovery of Britain* (London, 1964), 91–7.

[64] Henry Ridgely Evans, *Cagliostro and his Egyptian Rite of Freemasonry* (New York, 1933); Anthony Vidler, 'The Architecture of the Lodges: Rituals and Symbols of Freemasonry', in *The Writing of the Walls: Architectural Theory of the late Enlightenment* (Princeton, NJ, 1987), 83–102.

[65] Loutherbourg's alchemical preoccupations have yet to be adequately researched. John Gage touches on them in *Colour in Turner* (London, 1969), 136–42, 181. A work along the lines of Ronald

7.20 P. J. de Loutherbourg, *Tableau de la Loge des Compagnons*, date unknown, watercolour, 8 × 6 in.; reproduced by permission of Torre Abbey House, Torbay.

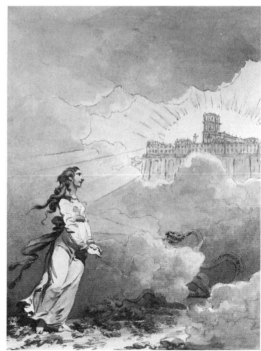

7.21 P. J. de Loutherbourg, *Tableau de la Loge des Compagnons*, date unknown, watercolour, 8 × 6 in.; reproduced by permission of Torre Abbey House, Torbay.

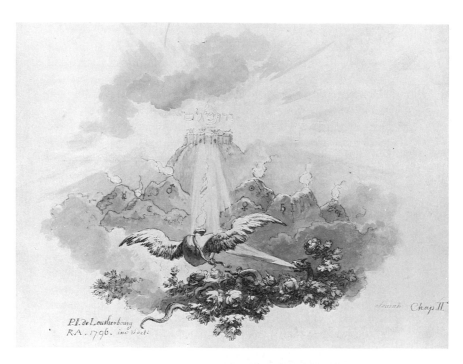

7.22 P. J. de Loutherbourg, *Headpiece to Isaiah Chap. II* (for Macklin Bible), 1796, pen and ink, $10\frac{1}{2} \times 8\frac{1}{2}$ in.; reproduced by permission of Bolton Public Library.

7.25 P. J. de Loutherbourg, *Coalbrookdale by Night*, detail.

7.24 P. J. de Loutherbourg, *A Philosopher in a Moonlit Churchyard*, detail.

7.23 P. J. de Loutherbourg, *A Philosopher in a Moonlit Churchyard*, 1790, oil on canvas, 34 × 27 in.; reproduced by permission of the Yale Center for British Art (Paul Mellon Collection).

VII

There are echoes of a number of Loutherbourg's apocalyptic subjects in *Coalbrookdale by Night*, from the flaming coal hearths, reminiscent of the refining fire of Isaiah in the Macklin Bible, to the scattered castings, like the broken columns illustrating the Book of Jeremiah, or the charging cart-horse cross-bred with the stallion from the painting *The Vision of the White Horse* (1798), taken from the Book of Revelations. I want to develop this aspect of the picture further with reference to the most influential prophetic voice in Coalbrookdale itself, that of the vicar of Madely parish, in which the Bedlam ironworks were sited, John Fletcher.

Born Jean Guillaume de la Fléchère, of a Swiss noble family, Fletcher was famous throughout Europe as the most powerful theologian of Methodism. (Wesley considered him his natural successor.) Fletcher's milleniarism and faith-healing made him a cult figure in Behmenist and Swedenborgian circles. During Fletcher's life and decades after his death in 1785, Madely was a place of pilgrimage.[66]

Fletcher considered Madely an ideal parish because its industrial world seemed prophetic of the world to come. 'I thank you for your view of the iron bridge', he wrote from Switzerland to a local correspondent in 1781. 'I hope the word and the faith that works by love will erect a more solid and durable bridge to unite those who travel together towards Zion.'[67] Fletcher's most famous work, *An Appeal to Matter of Fact and Common Sense* (1772), used the local scenes of sulphurous mines, forges, and furnaces as an image of the fallen world. The 'Sons of Vulcan' laboured in a 'confused noise of water falling, steam hissing, fire-engines working, wheels turning, files creaking, hammers beating, ore bursting, and bellows roaring ... while a continual irruption of flames, ascending from the mouths of their artificial volcanoes, dazzle their eyes with a horrible glare'.

> Our earth's the bedlam of the universe,
> Where reason (undiseas'd in Heaven) runs mad,
> And nurses folly's children as her own,
> Fond of the foulest ...

D. Gray's *Goethe the Alchemist* (Cambridge, 1952) would be useful if only because Loutherbourg seems to have emerged from a similar environment in Strasbourg. On alchemy and alchemical symbolism, I have found useful E. J. Holmyard, *Alchemy* (Harmondsworth, 1957) and C. A. Burland, *The Arts of the Alchemists* (London, 1967).

[66] Barrie Trinder, *John Fletcher: Vicar of Madely during the Industrial Revolution* (Ironbridge, n.d.) and *Industrial Revolution in Shropshire*, 157–63; Desirée Hirst, *Hidden Riches: Traditional Symbolism from the Renaissance to Blake* (London, 1964), 242, 263.

[67] Quoted in Trinder, *Industrial Revolution in Shropshire*, 112.

This is one of a number of quotations from Edward Young's *Night Thoughts* interspersed throughout Fletcher's *Appeal*, as it moves from infernal gloom to celestial glory:

> He rose! He rose! He broke the bars of death,
> Oh the burst gates, crush'd sting, demolish'd throne,
> Last gasp of vanquish'd death! Shout, earth and heav'n,
> This sum of good to man; whose nature, then,
> Took wing, and mounted with him from the tomb!
> Then, then, we rose; then first humanity
> Triumphant, passed the crystal gates of light.[68]

First published in 1742–5, *Night Thoughts* became widely read throughout Europe in the second half of the eighteenth century. It provided a storehouse of prophetic imagery, much with a strongly alchemical resonance. As Joppien has shown, Loutherbourg's *Philosopher in Moonlit Churchyard* (1790) (Fig. 7.23) illustrates the passage quoted above on the Resurrection. Among the ruins of Tintern Abbey, at night, under a full moon, a figure stands before an open tomb, striking the posture of the apprentice gazing at the Temple of Zion in the scene from the Egyptian Rite. This figure beholds a fresco of the Resurrection, the figure of Christ rising in a brilliant, fiery cloud. A dial on the wall above the fresco (Fig. 7.24) casts a shadow from the moon showing one o'clock. Joppien asserts this looks back to the passage in the second canto of *Night Thoughts* where the 'bell strikes one ... the knell of my departed hours'.[69] But it surely refers more resonately to Young's use of the shadow from a dial as the Writing on the Wall:

> That solar shadow, as it measures life,
> It life resembles too: life speeds away
> From point to point, though seeming to stand still ...
> Should not each dial strike us as we pass,
> Portentous, as the written wall, which struck,
> O'er midnight bowls, the proud Assyrian pale,
> Erewhile high-flush'd, with insolence, and wine?
> Like that, the dial speaks; and points to thee[70]

The dial, with its one o'clock shadow, reappears on the wall of the house at the left of *Coalbrookdale by Night* (Fig. 7.25). It is difficult to resist the inference that Loutherbourg, perhaps through a reading of Fletcher's

[68] John Fletcher, *Works*, 2 vols. (London, 1836), i. 4–162, quotations on 20, 31, 99.
[69] Rüdiger Joppien, 'A Visitor to a Ruined Churchyard: A Newly Discovered Painting by P. J. de Loutherbourg', *Burlington Magazine*, 118 (1976), 294–301, quotation on 298.
[70] Edward Young, *Night Thoughts* (Edinburgh, 1843), 'Night Second', ll. 421–3, 405–9.

Appeal, used the site of the Bedlam ironworks to allude to Young's passage on 'earth, the bedlam of the universe', particularly as it goes on to locate the line of Lucifer's descent with the trajectory of imperial corruption:

> O that the fiend had lodg'd on some broad orb
> Athwart his way; nor reach'd his present home,
> Then blacken'd earth with footsteps foul'd in hell,
> Nor wash'd in ocean, as from Rome he passed
> To Britain's isle; too, too conspicuous there![71]

VIII

Coalbrookdale by Night is at present exhibited in the Iron and Steel Gallery of the Science Museum. It is placed opposite a Bessemer converter in a sequence that stretches from a tableau in an Iron Age cave to a life-size model of a modern, glowing 300-ton ingot. Despite its overtures to the suave technology of the computer age, the restyled Science Museum is still structured on the heavy-metal heritage of industrial Britain, its great girders and engines, and its great heroes, Darby, Telford, and Brunel. And so *Coalbrookdale by Night* is consolidated.

In Coalbrookdale itself, in the open-air Ironbridge Gorge Museum, *Coalbrookdale by Night* is a frequent image on publicity material. The painting is also a source for excavation and restoration work on the remains of the Bedlam Furnaces. Here the painting is both part of the academic genre of industrial archaeology and part of the more populist theme-park packaging of the area. Both have been vigorously criticized by solemn social historians who are suspicious of any attempt to present industry as a landscape.[72]

I do not want to dismiss these interpretative frameworks, only their tendency to align *Coalbrookdale by Night* to highly specialized histories and so to limit the cultural resonance I have tried to amplify in this essay. For a change, and allowing such graven imagery, I would display *Coalbrookdale by Night* in a remote Ulster chapel, during a sermon that envisioned the break-up of Britain in the flames of hell.

[71] Ibid., 293, 'Night Ninth', ll. 1823–7.
[72] Bob West, 'The Making of the English Working Past: A Critical View of the Ironbridge Gorge Museum', in Robert Lumley (ed.), *The Museum Time Machine*, (London, 1988), 36–62.

8

J. M. W. Turner at Petworth: Agricultural Improvement and the Politics of Landscape

ALUN HOWKINS

I

TURNER lived in a period when the English landscape was undergoing a profound visual transformation, the result of enclosure and of the improved agriculture of the late eighteenth and early nineteenth centuries. Few of Turner's contemporaries could have been more aware of the scale of these changes in the English landscape than he was, for few had travelled as widely: by 1830 he had sketched or painted in virtually every county of England. In the late 1820s he sought to represent, indeed celebrate, aspects of this visual transformation in some of his best-known paintings, the four landscapes painted for George Wyndham, 3rd Earl of Egremont, at his seat in Petworth, Sussex. Turner's relationship with Egremont was a long one, stretching back to 1805, and in 1808 he bought his first 'estate painting', a view of the Forest of Bere, a part of the Wyndham estates in Hampshire.[1] From 1809 Turner had a study reserved for his exclusive use at Petworth, and in 1810 he painted Petworth House as well as other estate paintings for great Sussex landowners. In the same

This essay began as a lecture at the Tate Gallery which was delivered in May 1987. Since then it has benefited from the advice of several people but especially John Barrell and Stephen Daniels.

[1] *The Forest of Bere*, c. 1807, bought by Egremont in 1808. It is suggested that the figures in this picture who are working at various forest trades may have been added at Egremont's request: see Martin Butlin and Evelyn Joll, *The Paintings of J. M. W. Turner*, 2 vols. (New Haven, Conn., rev. edn. 1984), ii (text), 59.

year he painted Cockermouth Castle, another Egremont property and a former possession of the Earls of Northumberland, from whom Egremont derived a slightly spurious claim to ancestry.[2]

The 'Petworth Landscapes', which Turner painted in the late 1820s, are different from his earlier work for Egremont in that they form a coherent group.[3] They are a series of oil sketches and finished paintings which all appear to relate to a single commission for the 3rd Earl, who at one level may have seen them simply as part of his portfolio of investments, for he quite frequently took a purely commercial attitude to the arts, as his relationship with Haydon shows.[4] The paintings are also, however, representations of Egremont's investments, and therefore of his wealth and power, for all but one—the exception is *A Ship Aground*—are paintings of places in which he had a direct financial stake. Four are of the park he had inherited, one of the largest private parks in southern England: these are *Petworth Park; Tillington Church in the Distance*, which may have been a sketch for *The Lake, Petworth: Sunset, Fighting Bucks*, and *The Lake, Petworth; Sunset*, apparently a sketch for *The Lake, Petworth: Sunset, a Stag Drinking*. There are also three pictures—two sketches and a finished painting—of Chichester Canal, a project inspired and financed by Egremont; while the subject of two further works—the sketch and painting of the Chain Pier at Brighton—though it will not concern us here, was also a product, in part, of Egremont's financial speculation.[5] All these images of Egremont's investments are landscapes in the sense that they are images of the coast or countryside 'composed into formal patterns'. These patterns were not arbitrary, rather they were 'a complex of associations and meanings, and more important, ... a composition, in which each object bore a specific and analysable relationship to the others'.[6] To look at these

[2] *Petworth, Sussex, the Seat of the Earl of Egremont: Dewy Morn.* See also *Rosehill Park, Sussex, c.* 1810, painted for Sir John Fuller, MP for East Sussex.

[3] The ten paintings relating to this commission are discussed as the 'Petworth Landscapes, *c.* 1828–30' in Butlin and Joll, *Paintings*, ii. 164–9. They are (with the numbers assigned to them by Butlin and Joll): *Evening Landscape, probably Chichester Canal, c.* 1825–8 (282), and *Chichester Canal, c.* 1828 (285), both at the Tate Gallery, London, and both try-outs or sketches for *Chichester Canal, c.* 1829, Petworth House (290); *Petworth Park: Tillington Church in the Distance, c.* 1828, Tate Gallery (283), an alternative version of *The Lake, Petworth: Sunset, Fighting Bucks, c.* 1829, Petworth House (288); *The Lake, Petworth; Sunset, c.* 1828, Tate Gallery (284), a sketch for *The Lake, Petworth: Sunset, a Stag Drinking, c.* 1829, Petworth House (289); *The Chain Pier, Brighton, c.* 1828, Tate Gallery (286), a first version of *Brighton from the Sea, c.* 1829, Petworth House (291); and *A Ship Aground, c.* 1828, Tate Gallery (287).

[4] Hon. H. A. Wyndham, *A Family History 1688–1837: The Wyndhams of Somerset, Sussex and Wiltshire* (Oxford, 1950), 319–21. My thanks to Stephen Daniels for his comments here.

[5] These involvements are outlined below, but see also discussions in John Gage, *Collected Correspondence of J. M. W. Turner* (Oxford 1980), 250, and Butlin and Joll, *Paintings*, ii. 164–9.

[6] John Barrell, *The Idea of Landscape and the Sense of Place, 1730–1840* (Cambridge, 1972), 3–5.

paintings in this way is to turn the key to important aspects of their meaning.

In this essay, I shall be concentrating on three of these paintings: *Chichester Canal* and *The Lake* *Fighting Bucks*, both at Petworth, and *Petworth Park; Tillington Church*, which originally hung at Petworth but is now in the Tate.[7] First, *Chichester Canal* (Fig. 8.1). It is sunset and we are placed on the eastern bank of the canal, or possibly on a boat or at the lock at Sidlesham, looking towards the distant spire of Chichester Cathedral. A warm glow fills the whole painting and a deep calm is conveyed by the smoothness of the water and the unhurried ease of the boat in the left foreground. This stillness is emphasized by the scurrying and perhaps the calling of the moorhens in the right foreground. Even the leaves are still. The eye is drawn to the centre of the picture, to the ship, sails furled and apparently either still or moving very slowly. To us, the ship may seem to belong within the apparently natural landscape of trees and riverside pasture; but to contemporaries, the ship—a three-masted coastal or ocean-going vessel—would have seemed oddly out of place in this inland landscape. But that, they would have quickly realized, is the point of the picture; for it is not a natural landscape at all but a highly improved one. The painting endorses this improvement by celebrating it in the classic manner of the sea-port paintings of Van de Velde or Claude; the same point is made by Rosenthal in relation to Constable's paintings of canal scenes, and we shall return to it later.

The Chichester Canal was also Egremont's project. Like many in the early stages of industrialization, Egremont saw in canals, and making rivers navigable, a relatively easy way of opening markets to produce, and bringing raw materials and necessities into hitherto remote areas. By 1791 Egremont had made the Rother navigable from the Arun at Arundel to Midhurst, thus opening up his estates to commercial exploitation. By the time Arthur Young carried out his survey for the Board of Agriculture, published in 1813, the system had been extended to include links nearly to Chichester.[8] Ultimately it was to link London to the sea. William Marshall wrote in 1798 of Egremont's 'patriotism and benevolence' which (like the canals he had sponsored) 'flow in every direction, [and] have made the Rother ... navigable ... to Midhurst'.[9]

The other two pictures I want to consider are more complex. In *Petworth*

[7] See below, p. 243 and n. 38.
[8] Revd Arthur Young, *General View of the Agriculture of the County of Sussex* (1813; repr. Exeter, 1970), 421–2.
[9] William Marshall, *The Rural Economy of the Southern Counties*, 2 vols. (London, 1798), ii. 153.

8.1 J. M. W. Turner, *Chichester Canal*, 1829, oil on canvas, 25 × 52 in.; reproduced by permission of the Tate Gallery and the National Trust (Lord Egremont Collection), Petworth House, Sussex.

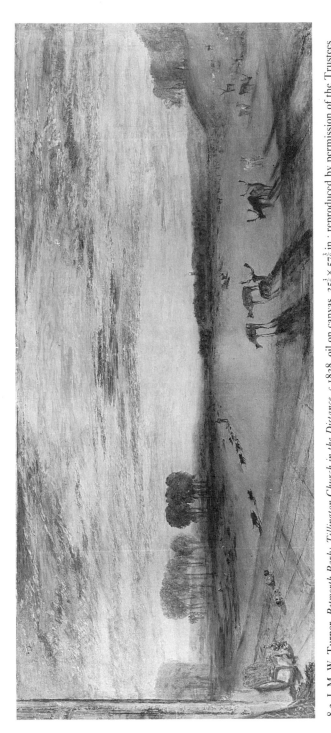

8.2 J. M. W. Turner, *Petworth Park: Tillington Church in the Distance*, c.1828, oil on canvas, $25\frac{3}{8} \times 57\frac{3}{8}$ in.; reproduced by permission of the Trustees of the Tate Gallery, London.

Park; Tillington Church (Fig. 8.2), the eye is drawn deep into the landscape, towards the church with its curious tower, built by Egremont, in 1807, according to Pevsner as 'an eyecatcher for Petworth'. 'The effect', Pevsner continues, 'does not work now, but it did in the early nineteenth century, as the Turner landscapes at Petworth show.'[10] Here Richard Wilson's famous remark about Claude—'you may walk in [his] pictures and count the miles'—clearly applies to Turner. Space is all: here is the power of the landed estate. What Marshall wrote of Petworth in 1798 is almost literally reproduced here, down to the rejection of the petty conception of beauty for the ideal of the grand.

The views from Petworth Park—which equally commands the Weald, the district under notice [that is, the low Weald], the rugged front of the wild, broken Hills of Sussex and Surrey, lengthening to a very great extent,—though they are seldom beautiful are frequently grand; well according with the magnificence of the house, and with the extensive domains that attach to it[11]

In Turner's version the whole is somehow toned down, and we have what Rosenthal and Cosgrove have called the 'Georgic' landscape. This is explained by Cosgrove as the Virgilian notion of a 'society of individual farmers who intervene in nature, making it respond more clearly to the rhythms and needs of human life but nevertheless relating to husbandmen rather than exploiters'.[12] Hence the chair in the foreground of *Petworth Park; Tillington Church*, which is there not only as coulisse, but also to soften the power of the park by making it smaller and almost domestic. In the painting all things and eyes are drawn to the sun, but between us and the sun stands Egremont. Egremont is returning to the terrace, and perhaps to his book and drink, and his dogs rush to greet him, irresistibly, magnetically drawn to him, as to the sun. Haydon's diary, in a remarkable passage, makes precisely this comparison but takes it further, making Egremont not 'Le Roi Soleil' but warm and very English: 'Such is Lord Egremont, literally like the Sun. The very flies at Petworth seem to know there is room for their existence ... The dogs, the horses, the cows, the deer & pigs, the Peasantry & the Servants, the guests & the family, the children & the Parents, all alike share his bounty and opulence & luxuries.'[13]

The third picture I shall be considering, *The Lake, ... Fighting Bucks*, is essentially the same view from a slightly different position. We have

[10] Ian Nairn and Nicholas Pevsner, *The Buildings of England: Sussex* (Harmondsworth, 1965), 351.
[11] Marshall, *Rural Economy*, 169.
[12] Denis E. Cosgrove, *Social Formation and Symbolic Landscape* (London, 1984), 67.
[13] Willard Bissell Pope (ed.), *The Diary of Benjamin Robert Haydon*, 5 vols. (Cambridge, Mass., 1960–3), iii. 167.

moved away from the house towards the horizon. The immediate effect is to make the whole scene smaller, or 'cosier'. The vista is closed down by the trees to left and right and the wooded hill on the horizon. Tillington Church is there, but little more than a shadow which scarcely draws the eye to the horizon. Instead we stay in the foreground and middle distance, where we confront almost literally all human and animal life. To the left a cricket match is in progress, a marquee is erected, and a large crowd is gathered to celebrate what contemporaries would almost certainly have called 'bucolic sports'. The middle foreground is dominated by Petworth's famous deer, including the fighting bucks of the title. To the right are more deer, and streaming down the hill beyond them Petworth's equally famous but much less romantic herd of Southdown sheep and prize pigs.

The Lake Fighting Bucks is still a landscape in the grand manner, and indeed that is how it, like all the Petworth pictures, is usually judged. Yet the attention spent on what ought to be only 'figures' adding to the structure of the picture has gone much further than is conventional or perhaps even desirable, given the genre. No single group of people or animals has taken over the picture in the way they do in other pictures, especially those of Morland, nor are they simply or mainly a part of the landscape. They have, to quote John Barrell from a different context, 'a crucial importance in determining the subject, and so the "meaning" of such landscapes, and the value they had for those who looked at them'.[14]

II

During Turner's lifetime, as we have already seen, England's agriculture and rural landscape underwent basic changes. This is not the place to argue at length whether or not we can talk of an agricultural revolution in the late eighteenth and early nineteenth centuries, but to stress that the English countryside was transformed by parliamentary enclosure at its height between 1780 and 1820; by industrialization, with its insistent demands for the production of cereals and roots to feed a growing non-agricultural population; and, perhaps most important of all, by a growth in the 'business' aspects of farming and rural management. As a simple but essentially correct summary puts it:

By the end of the eighteenth century, England had come to possess an agriculture which was self conciously innovative, progressive, and attuned to the needs of the growing market in food commodities ... Output and productivity had increased

[14] Barrell, *The Dark Side of the Landscape: the Rural Poor in English Painting 1730–1840* (Cambridge, 1980), 17.

dramatically and had enabled the expanding, commercialized farming sector to supply the burgeoning urban market . . . Improving landlords and their aggressively commercial tenants prospered.[15]

The south of England experienced this prosperity unevenly. There was certainly good wheat country, and by the middle years of the Napoleonic Wars even parts of the infertile High Weald were under plough in an attempt to cash in on the apparently ever-increasing prices. This land, to the north and east of Petworth, was 'nothing but the poorest barren soil',[16] according to the Revd Arthur Young, the agricultural reformer, but it was not so much nature as man that was at fault. The optimism of eighteenth-century farming had created the belief, no matter how ill founded, that any land was capable of improvement given hard work and the rational application of the right techniques. The barren land of the Weald could be worth 'five times as much' with proper thought, said Young.[17] But some farmers, with their stubborn belief in old ways, stood firmly against such change. As Marshall lamented of the Weald in the 1790s, 'there are few districts of this Island at this day, in which a larger portion of ill placed prejudice still remains than in the north western parts of Sussex'.[18]

By 1813 this backward mob was, in the Revd Arthur Young's more optimistic view, in retreat before the new and powerful ranks of agrarian capital: 'the increasing attention,' he wrote, 'observable in the better cultivation of the country, affords an agreeable spectacle, not only of rational amusement and satisfaction, but is also eminently useful in a national light'.[19] Foremost amongst those responsible for this change, in Sussex at least, was the 3rd Earl of Egremont: 'In this class, it is impossible for the Author not to mention the Earl of Egremont. To do justice to the exertions of this distinguished nobleman, is far above the reach of my humble capacity; suffice to say, that his lordships estates are conducted upon a great scale, the highest state of improvement.'[20]

Egremont is best known today as a patron of the arts, and perhaps pre-eminently as a patron of Turner, yet to contemporaries, especially in his native county, it was as an agriculturalist of the most advanced and improving school that he was famous.

[15] Howard Newby, *Country Life: A Social History of Rural England* (London, 1987), 27.
[16] Young, *General View*, 8.
[17] Ibid., 27.
[18] Marshall, *Rural Economy*, 171.
[19] Young, *General View*, 17.
[20] Ibid. See also Martin Butler, Mollie Luther, and Ian Warrell, *Turner at Petworth: Painter and Patron* (London, 1989), Ch. 1 and app. 1. This book appeared after much of the work was done for this essay.

George O'Brien Wyndham was born in 1751, the son of Sir Charles Wyndham, 2nd Earl of Egremont, a powerful county Whig. He inherited his lands and title in 1763 aged 12. As well as Petworth he came into a substantial estate in the north derived from the Percy family, from whom the Wyndhams were loosely descended. George Wyndham's father, the 2nd Earl, had taken little interest in his estates in an agricultural sense, being more concerned with his political career, and his northern estates— too out of the way to be often visited by a London politician—suffered badly from his neglect and absenteeism.[21] But if he cared little for the agricultural side of his estates, his pride and position led him to make major changes in their visual aspects. It was the 2nd Earl who created the park at Petworth.[22] A park was not only, or even mainly, a thing of beauty: it was the representation of power—in this case the new-found and public power of the Whig oligarchy of which Wyndham was a member. These landscapes 'represent the victory of a new concept of landownership, best identified by that favourite eighteenth-century word, *property*'.[23] As Stone says, 'prestige was now best displayed by a visible demonstration of the new aesthetic of the picturesque, as illustrated in the grounds'.[24] These great parks represented power and grandeur by their open display of conspicuous consumption. Blenheim, Caversham, and many others saw productive land transformed into deer parks, and into unproductive vistas in the manner of Claude for pleasure and show. Deer, the most wasteful of almost all beasts, were long-established symbols of power. Until the sixteenth century all deer belonged to the monarch, and the killing and keeping of them remained a closely guarded and prestigious right until well into the nineteenth century.

The park, however, represented more than power: it represented order. Order in its careful structures, in its balance and its planned planting; order in its protective walls and fencing; order in its keepers, and above all in the draconian legislation of the period after the 1720s, designed specifically to protect these 'new' enclosures.[25] According to Lancelot 'Capability' Brown, the landscapes he designed were dependent 'intirely upon principle ... a good plan, good execution and perfect knowledge of the country'.[26]

[21] *DNB*, compact ed., 2 vols. (Oxford, 1975), ii. 1158.

[22] On the park at Petworth see Dorothy Stroud, 'The Gardens and Park', in *Apollo* (Petworth special number), 105 (1977), 334 ff.

[23] Cosgrove, *Social Formation*, 99.

[24] Lawrence Stone and Jeanne Fawtier Stone, *An Open Élite? England 1540–1880* (Oxford, 1984), 336.

[25] E. P. Thompson, *Whigs and Hunters: The Origins of the Black Act* (London, 1975), ch. 1, *passim*.

[26] Dorothy Stroud, *Capability Brown* (London, 1975), 157.

Almost, one thinks, like the political schemes of his great Whig patrons.

It was this Whig patronage that led the 2nd Earl of Egremont to Capability Brown in 1751, the year after he had inherited his title. In the next fourteen years the Earl spent the not inconsiderable sum of £5,600 on his grounds, with Brown transforming the early eighteenth-century gardens of Petworth, which Jeremiah Milles in 1743 had found small 'and not in good taste', into a magnificent display of country power.[27] The gradual extension of the estates in Sussex and the rise in the political fortunes of Egremont are reflected in the park. It becomes, seen in this way, the symbol of the Whig domination of the politics of England in the years after the 1720s. Here Egremont's 'inordinate pride'[28] found its visual expression in vistas of lake and woodland stretching to the skyline. William Cobbett, who usually knew better, was impressed when he visited Petworth in 1822: 'The Park is very fine, and consists of a parcel of those hills and dells which nature formed here, when she was in one of her most sportive moods ... From an elevated part of it, you see all round the country to the distance of many miles ... It is upon the whole a most magnificent seat.'[29]

By 1822, however, this attitude was old-fashioned. The very ordered nature and the magnificence of the eighteenth century were exactly what later generations were to see as waste. The increased demand for foodstuffs, especially during the last quarter of the eighteenth century, provided a vital impetus for a section of the aristocracy and gentry to turn their attention to agricultural improvement. Land became more and more an economic asset of vital importance. Acreage under crops, yield per acre, rents, breeding stock—all became subjects of gentlemanly concern and correspondence. It was not simply a matter of profit (although that was important enough) but of patriotism. Increased agricultural production alone guaranteed England's stability and continued growth. From as early as the 1720s, many noblemen had taken up the 'patriotic cause of improvement', as William Marshall put it in 1798.[30] Coke and Townsend in Norfolk and Bedford in Buckinghamshire spent vast sums on scientific experiment and enclosure, making their estates more profitable and increasing, in their view and in the view of their supporters, the common good. The final seal of patriotic approval was given by the agreement of the King to head the new Board of Agriculture in 1793.

A delicate balance between agricultural and aesthetic uses of land had

[27] Stroud, 'Gardens and Park', 336–8.
[28] *DNB*, ii. 1158.
[29] William Cobbett, *Rural Rides* 1830; repr. (Harmondsworth, 1967), 119.
[30] Marshall, *Rural Economy*, 195.

existed since at least the sixteenth century, but now things began to change, especially in the south and east. Although at the most basic level increased productivity meant increased profits, a new balance had to be struck between the *representation* of power and status via land and the *reality* of economic power in the form of higher rents and increased prices. The appearance of landscape itself was changed by this changing relationship between symbolic and actual power, and so were the ways in which landscape was represented.

The 3rd Earl of Egremont came to maturity through these years, and his life represented, as surely as did his father's, the changes of his era. To the 2nd Earl, Petworth was an ornament, a costly jewel, whose value, as a demonstration of wealth and power, was its very uselessness. To the 3rd Earl—hereafter 'Egremont' refers to him—the estate, which he nurtured and made profitable, was very different. He spent a fairly short time in London upon reaching his majority. He flirted with politics, and, though he seems to have been well thought of as a potential politician, he lacked his father's arrogance and open political ambition. In 1782 he withdrew from politics when the King used his power to elevate Pitt. Throughout his life Egremont continued to attend the House of Lords on occasion, and when, in the 1820s and 1830s, he believed the status quo to be seriously threatened, first by Catholic emancipation and then by parliamentary reform, he attended assiduously, always voting against change. Nevertheless, his real place was and remained that of a great country gentleman.[31] It is clear that by the 1780s he had decided to live at Petworth and devote his considerable wealth and power to improving the agriculture of the estate and of Sussex. At the end of the decade signs had already appeared of this interest. It was characteristic of his brand of authoritarian paternalism that he built a new prison at the same time as he provided running water to all the streets of the town.

In August 1793 his status as an improving landlord and agriculturalist was recognized by his appointment, at its foundation, to the Board of Agriculture. By that date he appears to have taken over Petworth Fair and turned it into an annual cattle show. After 1795 he presented an annual prize of a silver cup for the finest bull shown at the fair and fifteen guineas for the best heifer. In 1797 he moved well out of his area when he established a society at Lewes for 'rewarding industry among the labouring poor, and distributing prizes to the best ploughmen'.[32] By the time Marshall

[31] Wyndham, *A Family History*, 234–44 and chs. 17–18.
[32] William Marshall, *The Review and Abstracts of the County Reports to the Board of Agriculture*, 5 vols. (1818; repr. Exeter, 1971), v: *Southern and Peninsular*, 466.

and Young published their surveys of the agriculture of Sussex, Egremont had become an exemplar of agricultural improvement. Indeed, Young's 1813 report is dominated by Egremont and his fellow (but East Sussex) peer Lord Sheffield, to such an extent that when Marshall brought together and reviewed all the reports published by the Board of Agriculture he was forced, despite his own admiration for Egremont, to cast doubt on Young's reliance on these two men.[33] But Egremont continued to be seen as a spur to Sussex agriculture, and as an example of how a landlord ought to behave Young's judgement on Egremont was firmly endorsed by Marshall:

The thought of one man having been instrumental in the improvement of his country, and still exerting himself in the same career, must be a constant fund of gratification to every benevolent mind; and that long may he live to enjoy the fruits of his labour in the service of country is the wish of every man in the county.[34]

In even more exaggerated vein, Horsfield, the antiquarian and historian of Sussex and also a client of Egremont's, quotes in his *History, Antiquities and Topography of Sussex* (1835) an anonymous poem on Egremont:

> Heedless of pomp, to art and science dear,
> Lord of the soil, see EGREMONT appear[35]

III

I want now to return to the paintings. A problem with many of Turner's works, to the historian at least, is the lack of precise detail about the circumstances in which they were produced, a lack caused by Turner's apparent disinclination to write. According to both Gage[36] and Joll,[37] the commission that is the subject of this essay, was for a group of paintings to hang in the Grinling Gibbons Room, then a dining-room, at Petworth. It is now thought that they were commissioned in 1827, probably as a result of a chance meeting between Egremont and Turner at a sale in July of that year, where the relationship, which seems to have been broken off in 1815, was renewed. By August 1828, according to Creevey's diary, two of the pictures, *Petworth Park; Tillington Church* and (probably) *The Lake*,

[33] *The Review and Abstracts of the County Reports to the Board of Agriculture*, 455.

[34] Young, *General View*, 426–7; quoted in Marshall, *Review and Abstracts*, v. 464.

[35] Thomas Walker Horsfield, *The History, Antiquities and Topography of Sussex* (Lewes, 1835), ii. 179.

[36] Gage, *Correspondence*, 250.

[37] Evelyn Joll, 'Painter and Patron: Turner and the Third Earl of Egremont', *Apollo*, 105 (1977), 378.

Petworth, Sunset (both now in the Tate), had been hung at Petworth.[38] Eventually, these were replaced by *The Lake, . . . Fighting Bucks* and *The Lake, Petworth: Sunset, a Stag Drinking*, and two other pictures, the final versions of *Chichester Canal* and *Brighton from the Sea* (the Chain Pier), were added. The four paintings were hung in Gibbons's panels beneath four earlier family portraits, which deliberately made a link to the imagined feudal past from a very real capitalist present.[39]

This also points to the crucial linking theme of the paintings, that they were all paintings of 'family' property. This point is crucial to what I feel is both Turner's and Egremont's project. What John Gage says of the two pictures of the park that I have been discussing is true, in a sense, of all the 'Petworth Landscapes': they 'were a celebration of Egremont's policy of improvement'[40]—and the point is given a special importance if we unpack the meanings within the pictures of the park. Petworth, as we have seen, was designed and completed by Capability Brown. It symbolized the ambition, the pride, the power of a relatively new 'Whig' grandee. Its designer was linked to him by politics and patronage, its design was based on one of his own paintings, Claude's *Jacob and Laban*—nature mimicking art at the behest of a great lord. Turner's paintings of Petworth Park seem to take the process a stage further: they are art imitating nature imitating art. The result, however, is very different from Claude's painting: where Claude seems to offer us a twilight scene, just before dawn or at dusk, Turner gives us the garish yellow light of a summer sunset; where Claude's foreground is enclosed and overhung by prominent trees, Turner's foregrounds are open and without any vertical motifs at all, so that their elongated format seems stretched even further by their unrelenting horizontality.

More importantly, and interestingly for the argument here, the Petworth that Turner painted is very different from the park that Brown had envisaged. In the improved agricultural world of the early nineteenth century, the proud 2nd Earl's Whig park was a problem. In the 1770s, as it was coming to fruition, the Duchess of Northumberland wrote: 'Chestnuts, Oaks and Beeches of stupendous size and surpass all that I have seen in my life . . . the Parks are quite in character . . . the Stag Park quite in the forest stile exhibits a pleasing wilderness.'[41] Arthur Young was less

[38] Butlin and Joll, *Paintings*, ii. 165.

[39] National Trust, *Petworth House* (London, 1982), 21. See also Butlin, Luther, and Warrell, *Turner at Petworth*, 116 and fig. 115.

[40] Gage, *Correspondence*, 250.

[41] National Trust, *Petworth House*, 34.

complimentary. He dealt with the stag park in his chapter headed 'Wastes'. After agreeing that 'it was an entire forest scene', he went on to describe it as 'overspread with bushes, furze, some timber, and rubbish; of no kind of use, if we except a few miserable ragged young stock which it annually reared; and would not have lett for more than 4s. or at most 5s. per acre'.[42] Even the deer were a problem. Both Marshall and Young found it difficult to say a good word for them or to find them a place in an improved world. But it was not only profit that mattered. From the 1790s a new generation of gardeners and theorists of gardening such as Uvedale Price and Payne Knight developed a critique of Brown's 'open landscape'. They argued not only that it was wasteful, but that its very conspicuous consumption separated men from one another and created social distance by upsetting the 'natural' order which saw the estate, the church, and the village in close physical harmony.[43]

As a result of these kinds of changes in economic and aesthetic attitudes and with an eye to profits, Egremont began in the 1790s, with Young's aid, to turn Brown's park into productive land. Young can take up the story:

The greatest improvement that I know undertaken in this county has been effected on the Stag Park at Petworth, some years ago, by the Earl of Egremont ... The undertaking of converting between 7 and 800 acres of land, was an exertion to be expected only from an animated and enlightened improver. It was begun about sixteen or seventeen years ago; the timber sold, the underwood grubbed, and burned into charcoal upon the spot; and every part of the park has been since drained ... the whole of it enclosed and divided into proper fields, and planted regularly with white thorn, all of which has been trained in the neatest manner.[44]

One can almost hear John Clare's bitter jibe 'little parcels little minds to please'. What mattered to Young, however, was that all this 'waste' was now worth 20s. or 30s. per acre instead of 5s. or 6s.[45] Arthur Young felt, at this stage of his career anyway, no such qualms about these changes. Against Clare's 'peasant' vision he set the improver:

It is impossible not to feel great respect, in contemplating the energy of an individual of the highest rank and fortune, animated with such ideas, and expending his income in so meritorious a manner, forming navigations, rewarding industry in the lower classes, improving breeds of livestock ... introducing improvements

[42] Young, *General View*, 188.

[43] Stephen Daniels, seminar at University of Sussex, Feb. 1987.

[44] Young, *General View*, 188–9.

[45] Ibid., 189; John Clare, 'The Mores', in Eric Robinson (ed.), *Selected Poems and Prose of John Clare* (London, 1967), 170.

... all of them in so many and various shapes contributing their assistance to national prosperity.[46]

In a similar way, as we have already suggested, *Chichester Canal* is a celebration of the improved landscape. As already noted, Rosenthal has argued for a precisely similar interpretation of Constable's paintings of canals, and Turner himself painted canals and improved river navigations on several occasions.[47] It has been argued that this painting is a 'mistake' in that the Earl had already withdrawn his funds from the canal in 1826, before Turner began painting, and that he had intended a different Turner (possibly *A Ship Aground*) to hang in its place.[48] This would seem most unlikely. The four paintings done for the dining-room, and their hanging in pendant with family portraits, suggest in the Earl a desire to record and celebrate. An anonymous *Ship Aground* would not have fulfilled this function. More likely is the other suggestion by Joll, that Egremont 'planned' the pictures some time before they were actually painted.[49]

Whatever the case, and although the Earl had withdrawn his money from the canal project by 1827, his name was still linked with it and with a range of canals throughout Sussex. Again both Young and Marshall praise Egremont at length for his endeavour. 'The advantages which England has derived from extending its inland navigation, have been prodigious; and to agriculture it has been no less beneficial than to manufacture and commerce,' begins Arthur Young's account.[50] Again value, profit, and social good all come from agricultural improvement. Prices are increased for the farmer by the ease of movement of goods, the landowner's rents are raised, and the new urban workers are fed. Even the rural poor benefit since Egremont only employs local labourers who 'have none of that turbulence and riot with which foreign workmen are inspired'. In addition, wages are better and the men are trained. 'They are now a set of men who have been so long accustomed to the employment, as to be ready to engage themselves in any work of the sort.'[51] Improvement, then, is the ultimate blessing, bringing wealth and social harmony to all classes.

These ideas are expressed clearly in the fine landscape *The Lake, ... Fighting Bucks* (Fig. 8.3). What marks this painting out from the others is its foreground. Although it has 'classic' landscape features, even elements

[46] Young, *General View*, 426.
[47] My thanks to Stephen Daniels for pointing this out.
[48] Butlin and Joll, *Paintings*, ii. 168.
[49] Ibid.
[50] Young, *General View*, 419.
[51] Ibid., 424.

of what Graham Reynolds calls Turner's 'elevated landscape painting of historical and mythological subjects', and which many regard as his finest— even his 'unique'—achievement,[52] it is transformed by the crowding of men and animals in the foreground. In doing this Turner was initially deliberately echoing earlier representations of Petworth, especially a painting by Thomas Phillips of 1798 which still hangs there. This is a fairly conventional view of the park from much the same viewpoint as that of Turner's more famous rendition. However, it does include both animal and human figures, creating 'a landscape portrait using each detail singly and collectively to represent the interests of his patron'.[53]

In Turner's project, though, the scene is transformed. There is no coulisse but an open space of grass, filled with the domestic inhabitants, human and animal, of Egremont's domain, vying with the sublimity of the picture's total structure for command of its ultimate meaning. There is a tension here between the almost violent sunset and the harmonious unity of men and animals in the foreground. The scheme is domesticated, closed by what is happening. There is actually a precise echo of Uvedale Price's criticism of Brown's landscapes: the open landscape of Whig power is transformed by activity into the tighter, closed, paternal landscape of Price, and more importantly of Egremont.

I want to look more closely at this picture in the light of what I have said about the changes in agriculture on Egremont's estates. Moving across the picture from right to left we have five groups; deer; sheep and pigs; more deer, including the fighting bucks; black sheep and possibly pigs, and people. It seems likely that none of these groups was originally in the painting but that they were added at Egremont's request.[54] It would then have been the patron who intervened to domesticate the landscape, although Turner, as I will suggest below, was probably happy to concur.

What, then, was the noble lord asking Turner for? At the most basic level, he wanted a panorama, showing his possessions but also his improvements and his social position. Egremont believed that improved agricultural production was achieved through the application of 'scientific agriculture', selective stock breeding, and the improvement of the old 'wastes' and unenclosed landscape. This is represented in the picture by the mixture of animals. Streaming down from the north in the right of the picture, formerly the 'wilderness', comes Egremont's famous herd of South Down

[52] Graham Reynolds, *Turner* (London, 1969), 208.
[53] Butlin, Luther, and Warrell, *Turner at Petworth*, 115. There are several other engravings of Petworth of a similar nature from the late 18th and early 19th centuries.
[54] Butlin and Joll, *Paintings*, ii. 167.

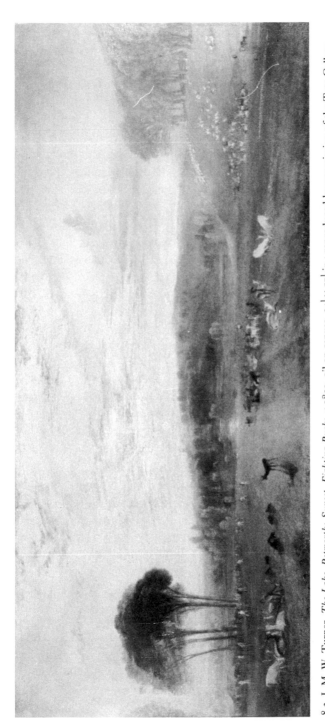

8.3 J. M. W. Turner, *The Lake, Petworth: Sunset, Fighting Bucks*, *c.*1829, oil on canvas, $24\frac{1}{2} \times 57\frac{1}{2}$ in.; reproduced by permission of the Tate Gallery and the National Trust (Lord Egremont Collection), Petworth House, Sussex.

and black sheep. 'It is thoroughly well stocked', wrote Young of the improved stag park, 'with flocks and fattening sheep of the South Down and Spanish breed, Leicester and Romney: the whole of it is a garden.'[55]

Just as, for Young, the vastness of the park is domesticated to a garden, so in the picture the park is reduced in scale by the presence of this domesticated throng. This is emphasized by the group of animals in the foreground. Here we see both 'savage nature' in the form of the bucks fighting and domestic agriculture in the shape of the sheep and pigs. Here is the source of a second area of tension. Sheep and deer crop in the same way, and in sixteenth- and seventeenth-century agricultural practice they were literally enemies, in that forest law usually forbade the keeping of the humble sheep alongside the regal stag. Worse still, in that animated flood on the right-hand side of the picture there may even be pigs, for we know that Egremont allowed them to graze in the park, much to the delight of Marshall. 'Lord Egremont has tried a great variety of hogs, and made many experiments, to determine the most profitable food ... they are killed after summer grazing in the park ... and altho the *pigs* had no corn given to them, they might pick up the crums which fell from the mangers of the deer.'[56] The pig, although a delight to Marshall's improving mind, was in the hierarchy of quadrupeds the lowest. It was dirty and 'mean', and lived on waste; above all it was the 'cottager's animal'. In all respects, then, the pig was the opposite of the stag, lacking even the sheep's redeeming virtues of ancient lineage and pleasant appearance.[57] Yet the result of this tension is harmony, carefully achieved and delicately balanced. Egremont retains his park and his deer as the symbols of his old aristocratic power, modified, however, by the introduction of a prize breed of livestock, the symbols of a newer power.

If the animals in the picture point to agricultural improvement and the great changes in the Petworth landscape, the people in the left foreground make a point about social improvement, Egremont's other great project. This crowded landscape proclaims the coming together, under the benevolent eye of Egremont, of all his estate. Every year at a cricket match the park was open to all his people in one of the great rituals of paternalism. Cricket was in itself 'special', being identified, even in the early nineteenth century, as the game of both the gentry and the 'honest poor', a game in which opposing teams of these different fractions might even play one

[55] Young, *General View*, 189.
[56] Marshall, *Review and Abstracts*, v. 506.
[57] Peter Stallybrass and Allon White, *The Politics and Poetics of Transgression* (London, 1986), ch. 1.

another. In May 1834 6,000 people were present, according to Charles Greville, to walk, play cricket, eat, and bob to the Lord. As our anonymous Sussex muse of 1835 wrote,

> He, while surrounding tongues his worth proclaim
> Shall turn aside, and 'blush to find it fame'.
> But future times, with concious pride shall tell,
> Of him whose honor'd course deserved so well;
> While all around in every deed may see
> The sterling stamp of true *Nobility*.[58]

The improvements Egremont made to Petworth town were part of the same project, yet they were only a slight part of his work. A contemporary wrote that he spent £20,000 a year on charitable purposes.[59] He built schools in Petworth, improved estate dwellings, was known to be a 'good' landlord, and set up an emigration society, which was much admired as a solution to the 'over-population' of rural districts. Yet we should be cautious. Charity was not disinterested; it was certainly not radicalism; and it served a precise purpose: to reward the honest and thrifty with work and with carefully controlled 'gifts', and to punish the 'indigent' and those who refused to fit in by the refusal of those gifts. Thus the gift structured and reinforced the social order and the ties of dependency within it. In a time of increasing crisis in the rural areas of southern England, and in Sussex especially, Egremont's charity secured him a loyal workforce. 'Gratitude', writes David Roberts, 'played a psychological role in promoting that deferential posture so indispensable to the working of agriculture and the ordering of village society.'[60]

When Cobbett looked at Egremont he saw a good landlord of the old style who cared for his tenants, but what Cobbett saw as a 'natural' relationship was in fact a carefully achieved balance. In the winter of 1830–1, when much of Sussex was racked by the outbreak of rick-burning and machine-breaking known as the Swing Rising, Egremont escaped almost untouched.[61] Cricket matches, running water in the street, and regular employment created an at least half-genuine respect. Similarly, when the New Poor Law was introduced in 1834 with its harsh regime, Egremont, through his appointees, made it virtually unworkable on his estates. The workhouse that separated husband from wife and parent from child could

[58] Horsfield, *History*, 179.
[59] *DNB* ii. 1160.
[60] David Roberts, *Paternalism in Early Victorian England* (London, 1979), 116.
[61] Eric Hobsbawn and George Rudé, *Captain Swing* (London, 1969), shows clearly that the disturbances of 1830–1 hardly touched the Petworth estate.

have no place in the harmonious world of Petworth. In return the poor were duly 'grateful'.[62] As Haydon wrote in his diary, 'the very Convicts love him, for they all say, "If he is to preside, ah, if Lord Egremont is there, we shall be sure to get off!" The Townspeople seem to adore him!'[63]

Yet there was another side, and one that Young and Marshall, less versed in the hypocrisies of a later age, clearly saw. 'The great utility', wrote Young,

which results to the community at large, from holding out rewards to the poor and industrious among the lower ranks, and from discouraging, as much as possible, every propensity to idleness, long since induced his lordship to distribute to the sober and industrious bounties in clothes, which are intended to serve for the encouragement of active industry, at the same time that they might operate as a check and discouragement of the idle, by cutting of all hopes of such being recommended as objects of charity.[64]

Charity on the Petworth estate went only to those in possession of a certificate signed by 'two respectable persons', and many were excluded. Egremont built a school but also a gaol; he opened his park to great feasts, at which he 'delight[ed] to reign in the dispensation of happiness', but paid wages 3s. a week lower than those in the non-deferential and scattered small farms of East Sussex.[65] This was the other side of improvement, which is not celebrated in the great pictures in Petworth House.

I have tried to argue that Turner's landscapes of Petworth both reflect and conceal changes in English rural society in the years in which he painted, by representing an ideal and harmonized social order and celebrating agricultural improvement. In a sense this was Egremont's wish, but I think it was also Turner's. In his fine article on Turner and Leeds, Stephen Daniels makes a convincing case for Turner celebrating industrialization in 1816, and celebrating it as a patriot. In Daniels's account Turner saw British manufacture as a vital weapon in the war with France: 'the manufacturers of Leeds . . . had overcome the Continental blockade.'[66] But agriculture was even more important in overcoming the Continental blockade than was industry. In part at least, Egremont's agricultural improvement was directed by his perception that English agriculture had a patriotic duty to produce more food to feed a growing population.

[62] *PP 1837*, Select Committee on the Poor Law Amendment Act. See e.g. the evidence of Edward Butt, 20 March 1837.
[63] *Diary of Benjamin Robert Haydon*, iii. 170.
[64] Young, *General View*, 445–6.
[65] Roberts, *Paternalism*, 17–18.
[66] Stephen Daniels, 'The Implications of Industry: Turner and Leeds', *Turner Studies*, 61, 16.

'Everything is now conceded at Petworth to grazing and ploughing,' wrote the *Sporting Magazine* in 1795.[67] In 1801 Egremont wrote of the need for agricultural protection and control if 'England and Ireland were to be encouraged and enabled to feed themselves' and thus to prevent the nation being constantly at the mercy of Continental enemies.[68]

It is not difficult to see that if Turner saw the manufacturers of Leeds as Daniels suggests he did, he almost certainly saw Egremont in a similar way. Indeed, in a poem on Bridport Turner specifically links the fortunes of agriculture to patriotism:

> Plant but the ground with seed instead of gold
> Urge all our barren tracts with agricultural skill,
> And Britain, Britain, British canvas fill;
> Alone and unsupported prove her strength
> By her own mean to meet the direful length
> Of Continental hatred called blockade.[69]

The great agriculturalists like Egremont were in their own eyes, as well as possibly in Turner's, instrumental in this process. Indeed, our Sussex poet thought so when he wrote of Egremont,

> Firm in attachment to his native land,
> No foreign feeling guides his fostering hand.[70]

How better, then, could Turner thank his patron, acknowledge his own patriotism, and celebrate the harmony and prosperity that came from Egremont's paternalism, than to paint a sequence of great pictures, above all a sequence that celebrated and described Egremont's self-perception of greatness.

[67] Quoted in Wyndham, *Family History*, 246.
[68] Ibid., 331.
[69] Quoted in Daniels, 'Implications of Industry', 15.
[70] Horsfield, *History*, 179.

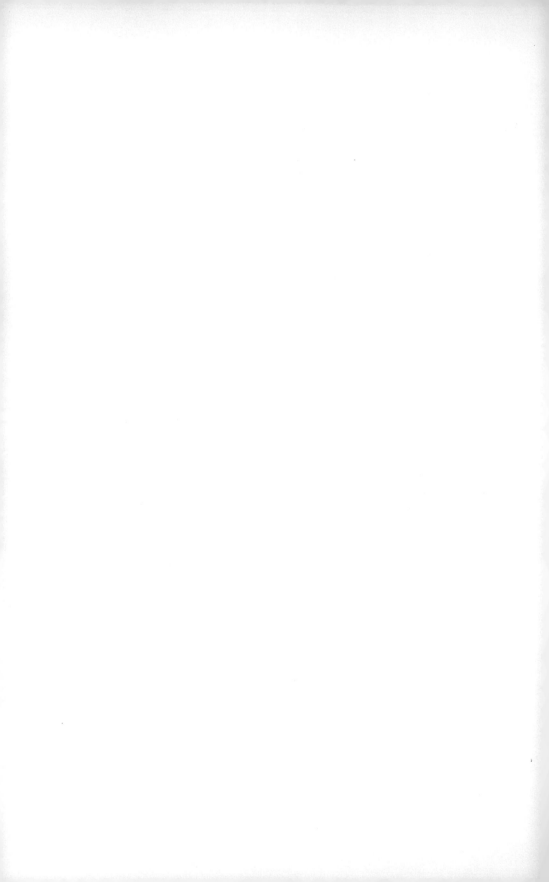

9

Benjamin Robert Haydon:
The Curtius of the
Khyber Pass

JOHN BARRELL

I

AT the end of November 1839 Benjamin Robert Haydon was trying to decide what subject to paint next: 'perhaps Marcus Curtius or the Duke—or a Crucifixion—I don't know what'.[1] This indecision says a good deal about the meaning for Haydon of the painting which is the subject of this essay. He was in fact just finishing a painting of the Duke of Wellington, a grand historical portrait of the Duke revisiting the field of Waterloo, standing beside his horse, and 'musing' on the victory that had established his position as a hero and a patriot without rival in Britain.[2]

I am grateful to Marcia Pointon, Jacqueline Rose, and Sam Smiles, who read this essay in draft and commented on it most helpfully.

[1] *The Diary of Benjamin Robert Haydon*, ed. Willard Bissell Pope, 5 vols. (Cambridge, Mass., 1960–3), iv. 597. Pope (*Diary*, v. 595) believes that Haydon first conceived the idea of painting Marcus Curtius's leap into the gulf in August 1836, when he records that he awoke from a dream with 'a terrific conception of Quintus Curtius' and that next day he rubbed in the subject (*Diary*, iv. 374–5). I see no reason to believe that Haydon here confused the legendary hero Marcus Curtius with the fully historical Quintus Curtius, or Quintus Curtius Rufus, author of *The History of Alexander*, the account of the invasion of Asia by Alexander the Great, one of Haydon's great heroes and the subject of two of his paintings. The dream (discussed below, pp. 281 and n. 84), which involves swimming naked with the Duke of Wellington, a storm, and a sublime wave which threatens the safety of Haydon and his wife Mary, has no resemblance to anything in the legend of Marcus Curtius, but could have reminded Haydon of any number of adventures in Quintus Curtius's *History*: see *The History of Alexander*, trans. John Yardley, ed. Waldemar Heckel (Harmondsworth, 1984), 26, 33, 56–8, 69, 72, 205–7, 220–1, 233–5.

[2] *Wellington Musing on the Field of Waterloo, or A Hero and a Horse which Carried him in his Greatest Battle, Imagined to be on the Field Again Twenty Years After* was first exhibited in 1842 at the British Institution, and is now in St George's Hall, Liverpool.

He had attempted to paint a Crucifixion in 1823, but had abandoned the work when he was imprisoned for debt. The ambition to return to the subject stayed with him until his death—it will be 'my last & greatest work', he wrote in 1843[3]—but the huge painting he had in his imagination was never realized. In a sense, however, *Curtius leaping into the Gulph*, eventually painted in 1842 and exhibited at the British Institution in February of the following year, *was* his Crucifixion, just as it was another version of the Iron Duke. The painting depicts a moment of crisis in the history of the city of Rome, when according to Livy a prodigious chasm of immeasurable depth appeared in the Forum. Soothsayers were consulted, who announced that, if the Roman Republic was to endure, the citizens must decide what constituted their chief strength, and offer it to the gods as a sacrifice. The most valuable possession of the Republic, argued Marcus Curtius, was the arms and valour of its citizens; and so saying he mounted his horse and plunged fully armed into the gulf.[4] Like the Duke of Wellington, Marcus Curtius was the supreme military hero and patriot; like Christ, he made the supreme sacrifice, so that others might live.

The painting Haydon made of this subject (Fig. 9.1) takes up so much space in the Royal Albert Memorial Museum at Exeter that at the time of writing the museum authorities have felt obliged to realize the death it represents, and have buried it alive: at the time of writing, the Curtius is concealed by a false wall hung with other paintings. Nevertheless, at $10\frac{1}{2} \times 7\frac{1}{2}$ ft., it is not an enormous work by Haydon's own standards. It covers only slightly more than half the area of canvas he had employed in *The Judgment of Solomon* (1814); it takes up hardly more than a quarter the square footage of *Christ's Entry into Jerusalem* (1814–20) or *The Raising of Lazarus* (1820–3).[5] As Haydon himself pointed out, however, the painting gives an extraordinary impression of size—'it looks gigantic'[6]—

[3] Willard Bissell Pope (ed.), *Invisible Friends. The Correspondence of Elizabeth Barrett Barrett and Benjamin Robert Haydon 1842–1845* (Cambridge, Mass., 1972), 143. For the progress of Haydon's attempt to paint the Crucifixion, see Eric George, *The Life and Death of Benjamin Robert Haydon Historical Painter 1786–1846*, 2nd edn. with additions by Dorothy George (Oxford, 1967), 144–7, 172–3. The detailed history of the work can be tracked through the index to the *Diary*.

[4] Livy, *The Annals of the Roman People*, vii. 6; *Diary*, v. 225.

[5] *The Judgment of Solomon*, 154 × 130 inches (385 × 325 cm), was first exhibited at the Water-Colour Society in 1814; it was rediscovered in 1960 (George, *Life and Death*, 385), and in 1963, according to Pope (*Diary*, v. 588), it was owned by the picture restorer Jack Gold, of Richmond, Surrey. *Christ's Entry into Jerusalem*, 228 × 192 inches (570 × 480 cm), was first exhibited at the Egyptian Hall in 1820, and in 1967, according to George (387), was at the Athenaeum of Ohio, St Gregory's Seminary, Cincinnati. *The Raising of Lazarus*, 168 × 249 inches (420 × 623 cm), was first exhibited at the Egyptian Hall in 1823 and is now in the Tate Gallery.

[6] *Invisible Friends*, 39.

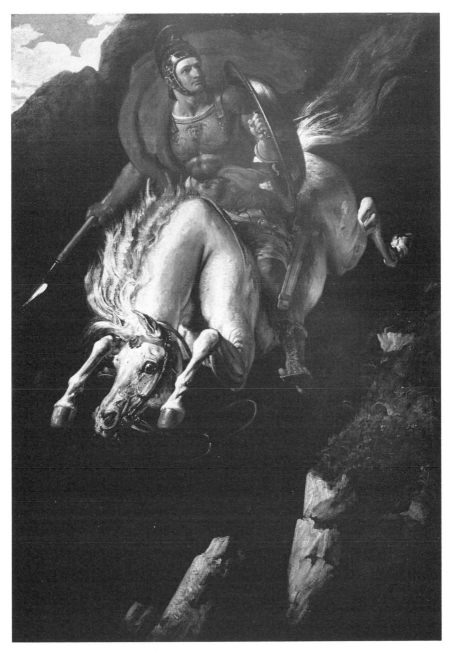

9.1 Benjamin Robert Haydon, *Marcus Curtius leaping into the Gulph*, 1843, oil on canvas, 120 × 84 in.; reproduced by permission of the Royal Albert Memorial Museum, Exeter.

partly because it seems to threaten our safety. The poet Elizabeth Barrett Barrett (later to be Elizabeth Barrett Browning), who was a correspondent of Haydon's, reported to him the opinion of her cousin John Kenyon: 'you almost tremble while you look at it lest you should be overwhelmed bodily by man & horse.'[7] The horse and rider are charging almost at the spectator, who is positioned below ground level, within the immeasurable gulf itself, with no secure place to stand. We seem obliged, or at any rate invited, to experience something of the vertiginous terror felt by the horse, if not by the impassive rider.

The effect of great size is produced also by the format of the picture, and by its strange emptiness—the result of what Haydon described as 'the mode and manner of selecting the essential from the superfluous' which gave the work its unusual 'air of size'.[8] The canvas is filled, certainly, but it is filled by much less—in terms of figures and setting—than we expect of a work so large. *The Duke of Wellington musing on the Field of Waterloo* (Fig. 9.2) is slightly larger than *Curtius*, and is a similar attempt to pass off a single-figure subject as a history, as a narrative painting. But the landscape format allows room for the monuments and farmhouses of Waterloo to appear on either side of the life-size figures of Wellington and his horse. The low horizon allows a generous measure of emblematic sunset to appear in the sky. By contrast, the upright painting of Curtius is (as the *Spectator* put it) 'a big picture of a hero, full of brute energy and display';[9] it is almost filled by the life-size horse and rider, who appear, moreover, against the vast empty blackness of the chasm; there is room only for the briefest indications of the foreground and background, and a couple of square feet of sky.

The painting was too extraordinary to be ignored, and almost every reviewer who wrote up the British Institution in 1843 seems to have regarded it, for better or worse, as the event of the exhibition. Though it remained unsold at his death, *Curtius* was the last of Haydon's paintings to achieve any significant degree of critical approval, and some reviewers were thoroughly enthusiastic.[10] The *Illustrated London News* called it 'a

[7] Ibid., 29.

[8] Ibid., 39.

[9] *Spectator*, 11 Feb. 1843.

[10] For Haydon's attempts to sell *Curtius*, and the history of the painting after his death, see Michael Pidgley, *The Tragi-Comical History of B. R. Haydon's* Marcus Curtius Leaping into the Gulf: *A bicentenary Tribute to Benjamin Robert Haydon (1786–1846)* (Exeter, 1986), 10–11, 2–3. I am very greatly indebted to Pidgley's excellent pamphlet, which among other things identifies and reproduces other representations of the Curtius subject in the 19th century and earlier. To his list I can add a small engraving of 1825 (Fig. 9.3), perhaps the closest analogue of Haydon's painting, which appeared in John Robinson's *Ancient History; exhibiting the Rise, Progress, Revolutions, Decline, and Fall, of the*

9.2 Benjamin Robert Haydon,
*Wellington Musing on the Field of
Waterloo, or A Hero and a Horse
which Carried him in his Greatest
Battle, Imagined to be on the Field
Again Twenty Years After*, first
exhibited 1842, oil on canvas,
$103\frac{1}{2} \times 127\frac{1}{2}$ in.; reproduced by
permission of the Walker Art
Gallery, Liverpool.

9.3 Artist unknown, after
Benjamin Robert Haydon, *Marcus
Curtius leaping into the Gulph*,
wood-engraving, *Illustrated
London News*, 8 April 1843.

noble picture', and published a large wood engraving of it (Fig. 9.4). The *Morning Chronicle* considered it 'one of the best pictures Mr Haydon has painted for some time past . . . This is decidedly the finest work on a large scale in the exhibition.' The *Britannia* was the most favourable: the painting was 'not only the best work which this artist has exhibited during many years, but one which would do honour to any school of historic art'. Only the *Observer* ('an enormous abortion—a big monstrosity') could see nothing to praise in the painting. Perhaps the most common opinion was that *Curtius* was a failure but a noble one, remarkable for its ambition and originality. 'It is undoubtedly a failure, but it is the failure of a giant' (*Morning Post*). 'A vigorous composition, rather too heavy, but still manifesting much original power' (*Bell's New Weekly Messenger*). 'Full of power and vigour as the picture is, it is an undoubted failure.' But 'it is beyond the reach of any living English master. To fail thus, one must be a giant in art' (*Court Journal*).

Of the three most prestigious periodicals, however, in which exhibitions of modern painting were reviewed, the *Art-Union*, the *Athenaeum*, and the *Spectator*, the last two produced a much harsher version of this opinion.[11] 'There is hardly a visitor to the gallery, who will not smile at the huge *Curtius*,' wrote the *Athenaeum*. 'Yet there is genius in the picture.' 'HAYDON's *Curtius* is a bold design, vigorously executed,' pronounced the *Spectator*, 'but utterly deficient in dignity and elevated sentiment.' For these two critics, the painting was not simply a sublime failure: it was a work which, in attempting the sublime, had made itself (and its author) ridiculous. What was especially at stake for both was the expression of Curtius. According to the *Athenaeum*, 'the man wears on his brow the true look of opera heroism'. The *Spectator* went rather further:

The hero, who has just taken the fatal plunge into the abyss that yawns beneath, looks round with the assured self-complacency of an expert rider, performing a bold feat of horsemanship. Not a trace of the bold character and lofty purpose of the patriotic Roman is visible in this florid, chubby-cheeked physiognomy . . . substitute a red coat and a black cap for the armour and helmet, and call it 'The

States and Nations of Antiquity for the Use of Schools, A New Edition, with Engravings (London, 1825), opposite p. 300. I have found the following reviews of *Curtius leaping into the Gulph*, all published in 1843: *Morning Chronicle*, 6 Feb. (the review also appears in the *Evening Chronicle* of this date); *Morning Post*, 6 Feb.; *Britannia*, 11 Feb.; *Spectator*, 11 Feb.; *Bell's New Weekly Messenger*, 12 Feb. (the review also appears in the *Planet* of this date); *Observer*, 12 Feb.; *Court Journal*, 18 Feb.; *Athenaeum*, 25 Feb.; *Art-Union*, 1 Mar.; *Illustrated London News*, 8 Apr. All references to these publications are to the editions of these dates unless otherwise stated.

[11] For a discussion of the reviews of Curtius in these three publications, and in the *Illustrated London News*, see Pidgley, *Tragi-Comical History*, 6–9.

9.4 Artist unknown, *Curtius leaping into the Gulph*, from John Robinson, *Ancient History* (London (for Geo. B. Whittaker), 1825); see n. 10, p. 256.

9.5 Artist unknown, after Benjamin Robert Haydon, *The Curse*, wood-engraving, *Pictorial Times*, 3 February 1844.

Desperate Leap', and the picture might captivate some fox-hunting gentleman—though he would perhaps object to the neck of the horse as exaggerated, and to the animal altogether as being somewhat wooden.

The *Art-Union*, too, which offered a generally very favourable account of the picture, and which seems (as we shall see) to have been willing to adopt what may have been Haydon's own account of the appropriateness of the hero's expression, still permitted itself to suggest that 'the model has not been a good one, the countenance not being sufficiently heroic to correspond with previous impressions'.

These are the objections of writers thoroughly involved in the art-world, men in the know, and men who know, in particular, that Haydon had used his own head as the model for Curtius. 'The sly malice of the Critics is exquisite,' wrote Haydon to Elizabeth Barrett. 'They pretended not to know it is myself, call it chubby cheeked, & a want of the heroic, & all sorts of things to reach me as if ignorant.'[12] To his sister he had written, when beginning the picture, that he would paint his own head for Curtius, and that this would be 'fair', for he had never done such a thing before.[13] To Elizabeth Barrett, however, he acknowledged that he had previously used his own head for his Solomon, for his *Assassination of Dentatus* (1808), and for his *Alexander Taming Bucephalus* (1826–7). 'You must be convinced I am the *quintessence of Vanity*,' he writes, of this habit of painting the great heroes of history in his own image. But at least for the *Curtius*, he explains, he had no real alternative: as a model for the self-sacrificing Roman 'my head is the best I ever saw'.[14]

It seems likely, however, that Haydon had done a good deal to prompt the three prestigious periodicals to make their 'impertinent' and 'scurrilous' attacks on Curtius's expression and physiognomy.[15] The longest and most favourable review, in the *Britannia*, bears all the marks of having been written after a conference with Haydon, and to give expression to his own account of the painting—an account he must have offered to as many reviewers as were willing to listen. This is the part that concerns the figure of Curtius himself:

The expression given to Curtius is novel in its application to this subject, but, in our opinion, perfectly just. In his countenance we discern no signs of desperate effort, no indication of preternatural resolution wound up to a terrible purpose,

[12] *Invisible Friends*, 46.
[13] Frederic Wordsworth Haydon (ed.), *Benjamin Robert Haydon: Correspondence and Table-Talk*, 2 vols. (London, 1876), i. 429.
[14] *Invisible Friends*, 46.
[15] Ibid., 39.

no struggle between the lingering instinct of nature and the anticipation of immortal glory. All this is past. The hero sits his horse calmly and collectedly, his face turned back for a moment to the world he is leaving behind, and his whole demeanour attesting that he embraces death like a bride, nor shrinks from the final moment. Mr Haydon, we believe, considers himself to have been, in some degree, a martyr to the cause of historic painting, having devoted himself to that pursuit during a series of years when the state of public patronage was as dark and uninviting as the Gulph of Curtius. We are informed that the face he has given his hero bears a strong resemblance to his own. Whether any symbolical meaning is intended we do not know, but we may be permitted to hope that the artist is not too late for the better era which we trust is dawning on high art, and that he, and all else whose aspirations lead them to that distinguished vocation, may be destined to achieving the renown without incurring the sacrifice.

The *Art-Union*, despite its wry comment on the inappropriateness of the model, borrowed some of this, whether from the *Britannia* or from Haydon himself, for its own review of the painting. 'The absence of all alarm' from Curtius's face 'is a triumph', for 'Curtius should assuredly not be seen, at the moment he is precipitating himself into the gulf, bracing up his nerves for the terrible exploit—all *that* is past. His face exhibits the calm determination of one who has resolved on self-immolation as the price of immortal glory.'

There was indeed a 'symbolical meaning' in the painting; whatever else it may have been, it was a painting about Haydon himself, about his own heroism. For critics and artists in the early 1840s who could still take seriously Haydon's ambitions, for himself and for 'High Art', this meaning may not have been in conflict with the established, iconographical meaning of the subject, a story of sublime and heroic patriotism. The number of those sympathetic to Haydon's ambitions and ideals, however, was fast dwindling; and even he seems to have felt that the painting risked tumbling down the easy descent from the sublime to the ridiculous. This essay is an attempt to trace out the symbolical meaning hinted at by the *Britannia*; it also suggests that the painting came to acquire an additional but related set of meanings for Haydon, meanings also perhaps disclosed by the *Britannia*, in the eager account it offers of Curtius as sexual hero, who 'embraces death like a bride, nor shrinks from the final moment'. 'Identity', Stuart Hall has written, 'is formed at the unstable point where the "unspeakable" stories of subjectivity meet the narratives of history, of a culture.'[16] *Curtius*, I shall be arguing, is a painting which attempts to

[16] Stuart Hall, 'Minimal Selves', in Lisa Appignanesi (ed.), *ICA Documents 6: The Real Me: Post-Modernism and the Question of Identity* (London, 1987), 44.

represent an artistic career in crisis as a heroic martyrdom. But it also discloses a much more anxious identity than that of hero or martyr, one generated out of the fear of artistic humiliation, the public history of an imperialist war, and a personal history of sexual fantasy and insecurity. It would be hard to imagine a more 'unstable point' than the gulf into which Curtius is falling; at this uneasy conjunction, the site of a trio of shameful defeats—artistic, military, and sexual—*Curtius leaping into the Gulph* invites itself to be read as a painting about the death of painting, at least of High Art in the tradition of Joshua Reynolds, James Barry, and Benjamin West.

II

In early and mid-nineteenth-century Britain, to invoke Curtius was to invoke a civic spirit of courage, altruism, and self-sacrifice of a kind, it was often claimed, that could hardly be looked for in modern societies, commercial and increasingly democratic. The point is made for example by Thomas De Quincey, in a characteristically Tory essay on the English defenders of the 1830 revolution in France. In particular, De Quincey was concerned to ridicule those who represented the Parisian 'mob' as patriotic and disinterested. 'Disinterestedness', he writes,

is not reconcilable, upon any extensive scale, with human nature in its present condition of infirmity. Sublime acts of self-devotion have arisen but rarely, at intervals, in a course of many centuries ... How monstrous then to call upon us for an act of credulity so sweeping as this assumption, not of one Athenian Codrus, or one Roman Curtius, but of ten thousand Parisian Codri and Curtii from the dark recesses of St Antoine! Less than forty years ago, from that frightful quarter of Paris, came forth those myriads of murderous levellers, who wallowed in the blood of illustrious victims. One generation is passed, and it is audaciously pretended ... that from those very same abodes of gloomy wretchedness, the very same gloomy dens of guilt, ignorance and abject pauperism, martyrs by thousands, and self-devoting heroes, upon the high Roman plan ... have issued upon the simple excitement of apprehensive patriotism.[17]

[17] 'France and England', *Blackwood's Edinburgh Magazine*, 28 (Oct. 1830), 704–5. For the attribution of this essay, and 'Hints for the Hustings', discussed below, to De Quincey, see William E. A. Axon, 'The Canon of De Quincey's Writings with reference to some of his Unidentified Articles', *Transactions of the Royal Society of Literature*, 2nd series, 32 (1914), 1–46. According to the review in the *Art-Union*, 'the grand story of the Roman sacrifice is familiar to every reader—from childhood to old age'. Pidgley points out that John Martin, one of the most popular painters in Britain, had published a small steel engraving of the subject in the 1829 edition of the *Forget Me Not*, which was published in an edition of 10,000. Two years later he had exhibited a water-colour of the subject; and in 1837 he produced a large mezzotint of the 1829 version. The most pleasantly figurative reference to Curtius in

To De Quincey, Curtius, the hero who gives his life to save the republic, can hardly be imagined at any period of history, let alone in the 'present condition' of human nature. To Haydon, Curtius is an example of civic virtue all the more necessary for being unimaginable in a nation such as Britain, a 'trading Nation', as Haydon described it.[18] Two days before he set up the canvas on which *Curtius* was to be painted, he was lamenting that 'There is no desire in the English for "High Art". Fresco being immovable, is no *property*, and the Commercial feeling connected with the Aristocratical renders them insensible to any feeling for any characters higher than themselves.'[19]

To grasp the 'symbolical meaning' of the painting, we have to grasp that Haydon's thinking about art still found expression—and by 1843 he was virtually alone in this—in a discourse which represented the attempt to rescue the reputation of the British School of painting as a task not so very different from rescuing Britain itself. Haydon's whole concept of High Art—of heroic history painting—was based on the conviction that a state which has lost a sense of the civic and patriotic values inherent in High Art is a state which has lost everything worth having. When he is writing within the terms of this civic discourse, he makes no distinction between what endangers the state and what puts at risk the survival and eventual triumph of High Art. Political crises are of importance to him primarily in that they distract attention from questions of culture. 'These times are serious indeed,' he writes in 1835. 'Never were political feelings deeper, more determined, or more threatening. Literature & Art will be sacrificed.'[20] Or take this opening paragraph of a letter to the Prime Minister, Viscount Melbourne, written in 1839, at the height of British anxieties about French imperial ambitions in the eastern Mediterranean:

The affairs of the East may be getting serious, and France may be creeping into her former preponderance, which may and will require another war to reduce and divide; but consider what the state of Europe will be if the President of the Royal Academy is permitted to rule unchecked and unmolested; if the purest despotism in Europe be not reduced to constitutional law.[21]

There may be a touch of irony here, at his own expense, but if so the effect

the period that I have come across is W. H. Russell's *My Diary in India, in the Year 1858–9*, 2 vols. (London, 1860), i. 191–2. Speaking of the deep 'gulf' between the British and the 'natives' in up-country India, he says, 'Still there is no Curtius' spirit among us to leap into the chasm.'

[18] *Diary*, iv. 382.
[19] *Diary*, v. 124.
[20] *Diary*, iv. 268.
[21] *Correspondence and Table-Talk*, i. 412.

is to confirm that Haydon was generally in the habit of seeing a crisis for art where others saw a crisis for the state.

Haydon's own political allegiances were to a large extent determined by an overriding concern for the future of High Art and the British School of painting. He was not without political convictions on large issues: in 1832 he was a firm supporter of the Reform Act, for example; he became an equally firm opponent of an extension of the franchise; he was a chauvinist who believed that British foreign policy should always be motivated by a determination to give the French a bloody nose.[22] But so thoroughly were all these issues hooked up for him with a patriotic concern for the health of British painting, that he could give his allegiance to one party or another largely according to what position he expected it to take on the issue of public patronage for history painting. 'Whatever party passes state encouragement,' he wrote in 1837, 'to that party I anchor for Life.'[23] 'The real truth', he wrote two years later, was that 'I court all Parties to get one [or] other to do *something*, for the Art'.[24] At the end of the 1830s he came to regret his support for reform, and to be disgusted at the foreign and imperial policy of the Whigs, and at about the same time he finally despaired of their policy towards the arts.[25] His heart, if not his vote, was for a few years with the Tories, but he began to be disenchanted by Tory economic policy in 1842, at about the same time as he became suspicious that he was being excluded, partly by Peel's influence, from the plans to decorate the new Houses of Parliament with paintings in fresco.[26]

By the early 1840s, Haydon was in the habit of seeing his whole career thus far (he was 56 when *Curtius* was painted) as a long and lonely crusade to deliver the British School from the hands of the portrait-painters of the Academy and their barbarian customers, an aristocracy which he adored and revered, but which was hopelessly ignorant about art. He saw every reverse he suffered in this campaign as the result of a conspiracy to silence him, to punish him, to deprive him of patronage. On the last day of 1841, for example, he catalogued the reasons why of all artists in Britain he had

[22] For Haydon's support for the Reform Act of 1832, see esp. his letters to *The Times* under the signature 'Radical Junior' on 20 Oct. and 19 Nov. 1831. Haydon claimed to have written three letters ('these glorious letters, the best thing I ever wrote', *Diary*, iv. 27); the third may be the letter signed 'Radical' of 27 Mar. 1832. For his anxieties about the momentum towards universal franchise, see *Diary*, iv. 83, and for his regret at having participated in the reform movement, see e.g. *Diary*, iv. 556; for his attitude to the French, see e.g. *Diary*, iv. 352, 446, 498, 547–8, 658–9, and George, *Life and Death*, 10–11.

[23] *Diary*, iv. 444.

[24] *Diary*, iv. 556.

[25] For an intriguingly candid discussion by Haydon of his disenchantment in 1839 with the Melbourne Ministry and the Whigs, see *Diary*, iv. 555–8.

[26] *Diary*, v. 149–57, 173.

'the least chance of any' to participate in the decoration of the Houses of Parliament. They include the quite unusual diligence with which he studied drawing; the 'indisputable evidences of Genius' in his major paintings; the fact that (as he claimed) he had educated most of those in the next generation of artists who had any pretensions to be regarded as history painters;[27] the fact that he had 'been imprisoned 4 times for persevering to improve the people & advance the Taste'—or rather for debts incurred in trying to make a living at 'High Art'; the fact that it was he who first proposed the decoration of the House of Lords; the persistence with which over twenty-five years he had presented each successive Prime Minister with plans for the future of art and design in Britain; the frequency of his petitions to Parliament in the same cause; and, finally, the fact that

I have lost all my property; been refused the honors of my Country; had my talents denied, my character defamed, my property dissipated, my health injured, my mind distracted, for my invincible devotion to the great object now to be carried, & therefore I cannot be, ought not to be, & have not any right to hope to be rewarded by having a share of its emoluments, its honor, or its glory.[28]

It is, I want to suggest, in the context of such protestations as these, and in the context in which these protestations are made, that the 'symbolical meaning' of *Curtius* is to be understood. Indeed, the painting can itself be read as just such a protestation.

Though *Curtius* was conceived before, it was not begun until after the Royal Commission was announced. The Commission, in order to determine who should participate in the decoration of the Houses of Parliament by paintings in fresco, established a competition, which required artists to submit one or two cartoons for frescos by the early summer of 1843.[29] Haydon submitted two cartoons, of which the first, *The Curse* (Fig. 9.5), a representation of Adam, Eve, and the serpent after the Fall, was almost certainly a carefully disguised satirical allegory at the expense of the Royal Academy.[30] *The Curse* was completed in the summer of 1842, and then

[27] Including Charles Eastlake, who had just been appointed Secretary of the Royal Commission inquiring into the decoration of the new Houses of Parliament.

[28] *Diary*, v. 108–9.

[29] For the 'Cartoon Contest', see George, *Life and Death*, 263–77; F. Knight Hunt (ed.), *The Book of Art: Cartoons, Frescoes, Sculpture, and Decorative Art, as applied to the New Houses of Parliament* (London, 1846); Clarke Olney, *Benjamin Robert Haydon, Historical Painter* (Athens, Ga., 1952), 237–41; see also Haydon's review of the exhibition (under the name 'Henry Ardor') in the *Civil Engineer and Architect's Journal*, Aug. 1843, 275–7.

[30] My evidence for the claim that *The Curse*, whatever else it is, would have been thought of by Haydon as a satirical allegory directed at the Royal Academy, is based on the congruence between the title of the cartoon and the elaborate image of the snake, coiled and still erect, on the one hand, with Haydon's habit of referring to the Academy as 'the Curse', and as a snake, or Hydra, on the other. In

Curtius was painted, and finally Haydon's second cartoon. Throughout this period, Haydon's diaries show him protecting himself against the possibility of failure in the 'Cartoon Contest' by anticipating it as a certainty; and protesting his pre-eminent right to participate in the decoration of Westminster, on the grounds of his lifelong devotion to 'High Art'.[31] In the early summer of 1842, Haydon's premonitions of failure intensified, when he was not invited to give evidence before the Royal Commission.[32] *Curtius* was painted in the aftermath of this rebuff, as a statement about Haydon's patriotic devotion to his art, and as a premonition that he would fail in the contest. If he did fail, he would be Curtius indeed:

November 1841, contemplating the Academy's likely response to the proposal that the new Houses of Parliament should be decorated in fresco, Haydon wrote: 'The Academy, like a coiled snake, lies crouched, with its glaring eyes watching the first symptom of life of High Art as its helpless Victim lies beneath its Boa coils. The first move, the first heave of its lovely bosom, the first faint gleam of its long closed silken lashed Eyes, will be death. The Monster will rear up its crested and feckled head, & darting its fangs in its white throat, convulse it for a moment, & benumb it again for a Century. Then it will hiss & roll & glitter in its gilded slime, till it coils again over its lovely victim, and crouches down its guilty head, to guard & watch. O, the Curse of Constituted Imbecilities in Art' (*Diary*, v. 96–7). In January 1842, shortly before he began the cartoon, Haydon wrote about the Academy to his ex-pupil Seymour Kirkup in these terms: 'the great overwhelming Curse of English Art is still erect, and nourished by its own intrigues. All the good done, all the benefits obtained for the English people has been disputed, thwarted, harassed, intrigued against by the portrait-painting Hydra!' (*Correspondence and Table-Talk*, ii. 179). In July 1843, a few days after he heard that he had failed to gain a premium in the Cartoon Contest, he wrote: 'the Academy lies crouched & ready, Eyes fixed, fangs poisoned, that at the very first symptom of life in the beautiful form of History, dart will go the fangs into its throat' (*Diary*, v. 299). In the diary there are some drawings of the snake that would eventually appear in the cartoon (*Diary*, v. 205), in two of which it is 'crested' as well as 'coiled'—it has a crown-like crest which I think may have signified that the snake, the Curse, was a 'Royal' Academy. 'If the Academy was reduced by the Queen taking her name from it ... then we should soon see how long it will hold up its head,' he wrote in January 1842, five days before writing the letter to Kirkup (*Diary*, v. 120). In the cartoon, the snake appears without a crest, but still erect, still with its head up: God's curse ('upon thy belly shalt thou go') has not yet taken effect, or he has not yet got round to cursing the serpent. Without some such explanation—the curse as the Academy itself, as well as God's curse on Adam, Eve, and the serpent—the title of the cartoon (as was noted by the *Pictorial Times*, 3 Feb. 1844) is 'unexpected and inappropriate'. If there is any cursing going on, it seems to be taking place in the foreground, between Adam and the serpent—the head of Adam, I take it, was probably modelled on Haydon's own, though *Bell's New Weekly Messenger* (9 July 1843) suggests that 'Byron's portrait has sat for Adam'. Christ seems to be blessing Adam, rather than cursing him. In a review of the first volume of Haydon's *Lectures* in January 1845, the *Art-Union* writes: 'Mr Haydon has always presented himself a foreground figure in his sketches of the levelling of academies.' *The Curse* is an image, precisely, of the 'levelling' of an as yet unlevelled snake; a cartoon is (arguably) a sketch; and it may well be that the *Art-Union* is making oblique reference to what I have suggested is the subtext of the work.

It is not fanciful to see such allegorical meanings in the art of the time. At the British Institution of 1843, where *Curtius* was exhibited, James Inskipp, who had recently failed to qualify as ARA, presented a painting called *The Fern-Cutters* in which the initials RA were painted on a donkey. 'A happy stroke of wit', thought *Bell's New Weekly Messenger* (12 Feb. 1843); the joke backfired, however: according to the *English Chronicle and Whitehall Evening Post* (7 Feb.), some 'jocular academicians' interpreted the initials to mean 'Rejected Associate'.

[31] See esp. *Diary*, v. 110–11 and v. 289 ('I have made up my mind to a reverse').
[32] *Diary*, v. 159–60, 153, 156–7; *Correspondence and Table-Talk*, ii. 188.

he would have sacrificed his life so that others could produce the public works of High Art which he had first envisaged. The point is made clearly enough by the review in the *Britannia*: 'we may be permitted to hope that the artist is not too late for the better era which we trust is dawning on high art, and that he . . . may be destined to achieving the renown without incurring the sacrifice.'

The two parts of this doubly 'symbolical meaning'—protestation and premonition—are held together by a play on words which derives from the story of Curtius as told by Livy, and which returns continually in Haydon's account of his own life, and in the reviewers' accounts of *Curtius leaping into the Gulph*. Livy nowhere quite describes the actual leap. The hero looks at the temples in the Forum; he then stretches out his hands, first to the heavens, then to the yawning chasm and the gods below, and finally . . . *se devovisse*, 'he devoted himself'. In Latin, the verb *se devovere* means 'to devote oneself to death', 'to make a sacrifice of oneself'. According to the *OED*, this pagan meaning has naturalized itself in English only with a pejorative sense: 'to devote' may mean 'to give over or consign to the powers of evil or to destruction', as well as (more usually) 'to consecrate' or 'to give up, addict, apply [oneself] zealously or exclusively'. The dictionary finds no overtones of literal self-sacrifice in 'self-devoted' or 'self-devotion'. It is clear, however—and clear from the *OED*'s own examples for 'self-devoted',[33] as well as from the passage quoted above from De Quincey—that in the eighteenth and early nineteenth centuries the derivatives of *se devovere* were used to describe the literal sacrifice of one's life in a civic or patriotic cause, as well as to describe the zealous and exclusive commitment to a particular pursuit—such as High Art.

We have already encountered one protestation by Haydon of his 'invincible devotion' to a scheme for establishing the public patronage of High Art in the decoration of the Houses of Parliament. In his writings of the early 1840s, the language of devotion, in both its senses, is everywhere linked with that of sacrifice, of martyrdom, even of his own 'crucifixion'. In a lecture first published in 1844 but written some years earlier, he argues that High Art will be established in Britain only by 'successive martyrdoms', and warns of the sufferings to be endured by 'any noble-minded boy . . .

[33] The *OED* examples include quotations from Addison, Wordsworth, Lady Morgan, and Scott. The relevant passage from Addison's *Cato* (IV iv) speaks of the death of 'the self-devoted Decii' in terms of '*Roman* virtue'; the example from Wordsworth's 'Laodamia' (I. 48) comes from a passage in which the speaker offers himself as a 'sacrifice' in 'a generous cause'; the passage from Lady Morgan's *France 1817* speaks of 'self-devoted patriotism'; in ch. 4 of Scott's *Count Robert of Paris*, a group of 'bold and self-devoted men' give their lives that others may escape.

who is resolved to devote himself' to history painting.[34] 'You know the fate of all reformers,' he writes to his ex-pupil Seymour Kirkup in December 1841, 'they are cursed and crucified.'[35] In the aftermath of the failure of the Royal Commission to invite him to give evidence, in June 1842, he wrote a long letter to Kirkup, cataloguing his services to High Art, and speaking of his 'devotion' and 'sacrifice'.[36] The catalogue of his struggles and sacrifices for art drawn up at the end of 1841 ends with his own epitaph;[37] and eighteen months later, after the failure of his cartoons, he published an anonymous obituary of himself, thinly disguised as 'Henry Ardor', who died 'in the midst of a desperate struggle to make Sovereign, Legislature and People do their duty to the higher walks of design'.[38]

The controversy about the appropriateness of Curtius's expression is also, I believe, a controversy about the appropriateness of Haydon's desire to represent himself, and his devotion to High Art, by the image of patriotic self-devotion—of literal self-sacrifice, of suicide after the high Roman fashion. That this question was present to Haydon himself is suggested by the first reaction to the painting recorded in his diary. 'A Lady' called on Haydon in his painting room on the very day that he 'did the head of Curtius from myself'. She 'did not see the likeness, & said it was a head of *self-devotion*!' 'Hem,' adds Haydon, enigmatically enough, but the play on words, or the uneasy relation of literal and metaphorical, may be present even here, as the lady fails to recognize the devoted artist in the face of Curtius, but registers clearly enough the expression of a hero devoting himself to death.[39] When the painting was exhibited, the *Morning Post*, attempting to find words to acknowledge the grandeur of a painting it nevertheless regarded as a failure, spoke of Curtius in terms of 'the devotion exhibited by the self-renouncing sacrifice'. According to the *Spectator*, however, 'the vainglorious expression' on the face of Curtius/Haydon

[34] Benjamin Robert Haydon, *Lectures on Painting and Design*, 2 vols. (London, 1844 and 1846), i. 104.

[35] *Correspondence and Table-Talk*, ii. 175.

[36] Ibid., ii. 188, and see *Lectures*, ii. 221. In 1841, following a rumour that he would be excluded from any future scheme regarding the Houses of Parliament, he writes in his diary, 'I have sacrificed always myself for the art and this *here* is my reward' (*Diary*, v. 67). While painting *Curtius* in October 1842 he writes to Eastlake, the secretary of the Royal Commission, that he has 'sacrificed everything' to 'the Art of my country and the elevation of the taste of its people' (*Correspondence and Table-Talk*, i. 430–1). 'The first Victim in all Revolutions is he who caused them,' he writes at the end of 1842, in the same journal entry that records the completion of *Curtius* (*Diary*, v. 236); and when he fails to be rewarded in the Cartoon Contest, he notes that he 'must be sacrificed as a successful Rebel' against the art establishment (*Diary*, v. 311).

[37] *Diary*, v. 110–11.

[38] *Civil Engineer*, Aug. 1843, 275.

[39] *Diary*, v. 216.

'dissipates any idea of its owner being animated by sublime self-devotion'. Once the secret is out, and Curtius is recognized as Haydon himself, the play on words can work so as to question not only the appropriateness of the expression, but the truth or value of Haydon's own self-image as one who has, in the words of the *Britannia*, 'devoted himself' to history painting in the grand manner. The *Athenaeum*, it will be recalled, though it admired the contrast in the painting between 'animal terror and human devotedness', still found the expression of Curtius/Haydon absurdly theatrical, 'the look of true opera heroism'.

The *Curtius*, and the degree of Haydon's self-identification with it, inevitably raises the question of its relation to Haydon's own suicide in 1846. The suicide was expected by no one, but as we track through Haydon's writings of the preceding ten years or so, it is easy to see it as continually foreshadowed in them. Several times he writes about the suicide of Castlereagh, and of others who died—as Haydon was eventually to do—by cutting their throats.[40] In the 1830s Haydon frequently represented the risks he took and the dangers he faced in his career in terms of a hazardous journey, heroically undertaken, across a landscape as precipitous as the gulf in *Curtius*. He writes of himself as taking a wild philobatic pleasure in risks thus represented: 'when on a precipice, where nothing but God's protection can save me, then I delight in Religious hope.'[41] In an earlier, unpublished version of the life of Henry Ardor, he contrasted him with David Wilkie, whom he christened 'Caution':

When Caution came to one of those precipices which intersected the great road, Ardour was always for taking a run and clearing it by a leap, while Caution preferred descending by the foot path, crawling at the bottom & mounting safely on the other side. Ardour as might be expected sometimes broke his shins & sometimes his head & sometimes he leaped over all & stood huzzaing, but he often saw Caution steadily fagging away ... *Ardour's* great pleasure was danger, while Caution's was safety. The consequence was that Caution got into the court of his Sovereign while Ardour got into his Prison.[42]

[40] For Castlereagh, see *Diary*, iv. 316, 319, and *Lectures*, i. 58; for Romilly, see *Lectures*, i. 59; for Colonel John Gurwood, see *Diary*, v. 503 and iv. 376. Haydon did not intend to cut his throat; he did so only after an attempt to shoot himself in the head had failed.

[41] *Diary*, iv. 468. I have borrowed the term 'philobatic' from Michael Balint's *Thrills and Regressions* (1959; repr. London, 1987). The detail of Balint's argument cannot be gone into here; the book distinguishes between two character-types, 'philobats' and 'ocnophils'. See n. 42.

[42] *Invisible Friends*, 188–9. In the later version of the story of Ardor and Caution, in the *Civil Engineer*, Caution is no longer Wilkie but Eastlake. The relevance of Balint's distinction (see previous note) will be apparent from a comparison of this quotation with these lines from Balint: 'In the event of fear and anxiety, the reaction of the ocnophil is to get as near as possible to his object, to squat or sit down, go on all fours, lean forwards, or even press his whole body to the protecting object All this is markedly present in any of the so-called giddy situations, like looking down from excessive

The day before he killed himself, according to his son Frank, 'he said he had dwelt with pleasure on the idea of throwing himself off the Monument and dashing his head to pieces'.[43]

In fact, Haydon had an embarrassment of reasons for taking his life: the wreck of his ambitions, a tumour of the brain, the oppression of unbearably hot weather, the prospect of imprisonment, yet again, for debt, and a continual anxiety about how to provide for his wife and daughter—he seems to have calculated, rightly as it turned out, that his death would release a tide of public sympathy sufficient to ensure the financial security of his family.[44] In another sense, however, the suicide was surely one final attempt at self-representation—at representing his devotion to art in the image of self-devotion, of literal self-sacrifice. The suicide depicted in *Curtius* is in some sense a wager, or the stake in an attempt to blackmail the Academy, the Government, the Royal Commission, the art press. 'I have set my life upon a cast, and I will bear the hazard of the die,' he warned the audience at one of his lectures, in what may well have sounded like the true spirit of opera heroism.[45] Three months before he killed himself, Haydon copied into his diary some words by Canning, written before the fall of Napoleon, about the likely end of the man with whom for much of his life Haydon had identified himself: 'All is still but folly: his final destruction can neither be averted or delayed, and his unreasonable mummeries will but serve to take away all dignity from the Catastrophe of the Drama; *and render his fall* at once *terrible & ridiculous.*'[46] The emphasis is Haydon's. In the *Curtius*, in lecture after lecture, in letter after letter to the press and to politicians, he had insisted that he had staked, had devoted, no less than his life to High Art. If the sublime claim and the sublime fall were not to look ridiculous, he had no option but to show how thoroughly, how literally, he had meant what he said.

III

In 1844, with the hope of participating in the decoration of the Houses of Parliament all but gone, Haydon envisages himself dying for art as a soldier, like Curtius, and like Macbeth, fully armed: 'I will stick to it and die with

heights into depths and precipices The reaction of the philobat is what is generally called the heroic one: turning towards the approaching danger ... standing upright on his own' (*Thrills and Regressions*, 37–8).

[43] *Correspondence and Table-Talk*, i. 236.
[44] *Diary*, v. 555–62. For a full account of Haydon's last days and suicide, see Alethea Hayter, *A Sultry Month: Scenes of London Literary Life in 1846* (London, 1965).
[45] *Lectures*, ii. 130.
[46] *Diary*, v. 527.

"harness on my back." '[47] It was crucial to his self-identification as Curtius that the Roman hero was a soldier, or a citizen-in-arms. Curtius and Napoleon were only two in a long line of military and naval heroes with whom Haydon was accustomed to compare himself—Alexander, Caesar, Columbus, Wellington; there is no evidence that he compared himself so insistently with other painters. 'A Grand Picture', he wrote, while painting *Curtius*, 'should look [as] if foreground, middleground, Back ground, heads, hands, bodies, limbs, men, women, & children had all rattled out of the end of a brush like Perkin's steam gun.'[48] In a lecture on Beauty, published in 1846, he had some fun with his audience about the vagueness of the term, citing a dispatch from the Afghan war about a detachment of Grenadiers, who captured a fort 'in *beautiful style, bayonetting all within it!*' (Haydon's emphasis). The year before, however, he had written in his diary: 'The Bayonet is the weapon of the British soldier, let the brush be the weapon of the British Painter, the brush, the whole brush, & nothing but the Brush.'[49] So thoroughly had art become hooked up with aggression that the act of painting itself was fantasized as a process of shooting, stabbing, and even dismembering the enemy: that at least seems to be the implication of the disjoined body-parts to be rattled out of the steam-gun.

Painting, for Haydon, was war carried on by other means. Generally, the war was against the French—whether the 'brick-dust' of the school of David, or the 'costume school' of Delaroche.[50] If hatred of the French was as much a corner-stone of his politics as was devotion to the success of the British School in High Art, this was because the two motives were quite inseparable. In the middle 1830s he was as firm in his hatred of the French as he had been in 1815, and 'perfectly convinced that the Foreign policy of England ought to be based on the principle that France is a natural enemy, open or concealed, in peace or war';[51] his hatred and conviction were strengthened still further as in the late 1830s fears grew in Britain about the imperial ambitions of the French. The advent of Prince Albert, however, and the anxiety, which none felt more keenly than Haydon, that

[47] *Correspondence and Table-Talk*, ii. 215.

[48] *Diary*, v. 223. The steam-gun invented by Jacob Perkins in 1824 is invoked again, somewhat anachronistically, at *Diary*, v. 453: 'I want to paint a Picture as if out of Perkins' Steam Gun, as Rubens & Tintoretto did & I will if I live.'

[49] *Lectures*, ii. 262; the dispatch was published in the supplement of 9 Jan. 1841 to the *London Gazette* of the previous day. It is among eight pages of dispatches sent or forwarded by Sir Willoughby Cotton to the Secretary of the Government of India. It was reprinted in the *United Services Magazine*, Feb. 1841, 276–7, and Haydon, who later contributed to that journal, could have come across it there. For the brush as bayonet, see *Diary*, v. 475.

[50] For David's 'brick-dust' see *Lectures*, i. 261 (and see ii. 155, 157) and *Diary*, v. 79. For Delaroche, see the *Civil Engineer*, Aug. 1843, 276, and *Diary*, v. 295.

[51] *Diary*, iv. 446. See also iv. 352, 547–8, 658–9; George, *Life and Death*, 10–11.

Cornelius and his followers would be called in to execute the frescos in the Houses of Parliament, distracted him for a while from his Francophobia. 'Call in the Germans?' he expostulated, in a lecture of the early 1840s. Never! In tones borrowed from Harry at Agincourt he pleaded:

At least keep *this* ground sacred and holy ... with all its historical recollections, which imagination will call up at the very mention of its name; *at least* let *this* portion of London be unbruised by foreign hoof. No man surely who has a drop of English blood in his veins, or British bottom in his nature, ever can, or ever will, patiently endure the decoration by any other than *British* hands, of a spot, hallowed by the tread of the Black Prince, or his illustrious father.[52]

Foreign *hoof?* Haydon's propaganda campaign of the early 1840s against the cloven-footed artists of Germany found expression in lectures, in his diary, in letters to the press.[53] It became, inevitably, a kind of military campaign as well. In a letter sent to the *United Services Magazine* early in 1844, the argument that British painters were entirely adequate to the task of decorating the Houses of Parliament in fresco has mutated into an insistence that Wellington at Waterloo had needed no foreign aid to defeat the French: the British Army had no more need of Blücher in 1815 than the British School had need of Cornelius now.[54]

Curtius leaping into the Gulph, however, was also involved in a more immediate relation between painting and warfare. In 1838, in an effort to warn off the Russians from making further advances into Central Asia and to extend the commercial interests of the East India Company, a British expeditionary force, the 'Army of the Indus', marched through the Bolan Pass into Afghanistan: this was the beginning of the First Afghan War. The force soon achieved its immediate objectives: the capture of Ghazni, the occupation of Kabul, the deposition of the Emir, Dost Muhammad, and his replacement by an unpopular puppet, who could not rule without a continued British presence in the country. By 1840 a Company force of British nationals and sepoys was encamped outside Kabul, complete with cricket equipment, officers' wives, and a large number of camp-followers. In November of the following year there occurred what the British insisted

[52] Benjamin Robert Haydon, *Thoughts on the Relative Value of Fresco and Oil Painting, as applied to the Architectural Decorations of the Houses of Parliament; read at the Friday Evening Meeting at the Royal Institution, Albemarle St, March 4, 1842* (London, 1842), 36–7. I quote from this emphatic version of the lecture, rather than from the unitalicized version that appeared in *Lectures*, ii. 194–6.

[53] For Haydon's Germanophobia, see *Diary*, v. 80–1, 118, 140, 144, 148, 154–5, 166, 195, 197–8, 203–4, 214, 216–23, etc.; Haydon's first letter in reply to Dr Merz's strictures on British art (the '*Kunst Blatt* Critique'), in the *Spectator*, 11 Nov. 1842, repr. in the *Art-Union*, Dec. 1842; another letter to the *Art-Union*, Feb. 1843; the life of Ardor in the *Civil Engineer*, Aug. 1843, 275; his lecture on fresco painting, *Lectures*, ii. 153–99; and numerous other places.

[54] *United Services Magazine*, Feb. 1844, pt. 1, 279–81; see also *Invisible Friends*, 52–3.

on terming an 'insurrection'. A number of the leaders of the British
expedition were killed, and eventually the British had no alternative but
to abandon Kabul and attempt the difficult march, in the middle of winter,
through the Khurd Kabul and the Jagdalak Passes, to join up with another
British force at Jalalabad, which was itself hard pressed. The result was a
disaster for the British: a few were captured or taken as hostages, but
thousands died on the march, which ended with the destruction of the last
remnant near Gandamak in January 1842. Only one man reached Jalalabad.
In the spring of that year, a relief column entered Afghanistan via the
Khyber Pass, hitherto thought impassable by an army. The garrison at
Jalalabad was relieved; the prisoners and hostages were found and rescued,
and by a series of appalling atrocities in Kabul and elsewhere the 'stain
that had been cast on the military honour of Great Britain' was 'wiped
away'.[55]

Haydon followed the progress of the war with great interest. In late
1840, when the war was thought to be more or less over, he read Henry
Havelock's *Narrative of the War in Affghanistan*; he followed the progress
of the war in the dispatches published in the *London Gazette*; in early 1843,
when *Curtius* was at the British Institution, he read Vincent Eyre's best-
selling and angry account of the conduct of affairs at Kabul and of the
retreat: Eyre had survived by being taken prisoner.[56] When the news of
the 'insurrection' reached London, Haydon wrote in his diary, 'The Queen
is elevated beyond belief. The insurrection in Affaganistan is her
corrector.'[57] The diary makes it clear, on this page and elsewhere, just why
Queen Victoria's elevation needed 'correcting' by such a setback: her sins,
recorded minutely in the diary, were all sins against art. They were mainly
sins of simple ignorance and bad taste,[58] but, more unforgivably, she had
expressed her disappointment with Wilkie's portrait of her, with the direct
result, so Haydon believed, that Wilkie had left for the Holy Land, in
search of authentic imagery for paintings of biblical subjects, and had died
on the trip. The very next entry in the diary, after the one just quoted,
records that Wilkie 'was killed like Racine by the frown of a Sovereign!'[59]

[55] See the speech of Lord Auckland in the House of Lords, 20 Feb. 1843, in reply to the Duke of
Wellington's motion for a vote of thanks to Lord Ellenborough and the officers and men who in 1842
had avenged the disasters of earlier that year.

[56] Henry Havelock, *Narrative of the War in Affghanistan. In 1838–39*, 2 vols. (London, 1840)—see
Diary, v. 4. For the *London Gazette*, see above, n. 49. Vincent Eyre, *The Military Operations at Cabul,
which ended in the Retreat and Destruction of the British Army, January 1842. With a Journal of
Imprisonment in Affghanistan* (London, 1842)—see *Invisible Friends*, 47.

[57] *Diary*, v. 130.

[58] *Diary*, v. 9, 40, 127–8.

[59] *Diary*, v. 130; see also v. 30.

No less seriously, Victoria's marriage to Albert had opened the door for Germans to steal commissions that were the birthright of British artists.[60] Worst of all, she had taken unnecessary offence at an unintended act of impoliteness by Haydon himself: in inviting her to attend an exhibition and raffle of his *Xenophon and the Ten Thousand* in 1836, he had enclosed some tickets, as if to imply she would not be admitted without them. It was as a direct result of this, so Haydon believed, that he had been rebuffed, on Victoria's accession, when he applied (humiliatingly, for a man of his pride and independence) for the post of historical painter to the Queen.[61]

For the reason, no doubt, that Haydon saw the disasters in Afghanistan as intended to teach Victoria a lesson, as well as because of his general habit of figuring the art of painting as the art of warfare, the events of the war became involved in his imagination with his career as a painter, and with *Curtius* in particular, which was being painted as Britain awaited news of the fate of the prisoners and hostages. In November 1842 he records the news of the recapture and destruction of Kabul (and the Treaty of Nanking, following the equally unjustifiable Opium War in China) in terms that typically dwell on the implications of the victory for the British School of painting:

The news yesterday was so glorious from Cabul & China, I have not been so excited since Waterloo. 3 Cheers for dear old England. Huzza! huzza! huzza! May I never live to see her flag degraded!—her Empire lessened! her *Jack Tars* beaten—her soldiers defeated, or her Monarchical Government in the hands of Radicals and Doctrinaires. May I live to see her Art able to compeat with the grandest Art of Ancient & Modern Time. Grant these things, O God. Amen, with all my soul. Amen.[62]

A week later, he began to change the background to *Curtius*. Originally, it seems, the horse and rider were imagined as if seen from ground level, against a background of sky; now the sky was changed to rocks, and the view became one from *within* the chasm. On 1 December, he records that he 'sketched rocks from Affaganistan—Sketches for Curtius—great use';[63] almost certainly he was copying the rock formations in the superb volume of lithographs *Sketches in Affghanistan*, published in the summer of 1842

[60] For Haydon's strictures on Albert, see e.g. *Diary*, v. 162, 288–9; *Correspondence and Table-Talk*, ii. 201.

[61] *Diary*, iv. 345–6, 441; *Correspondence and Table-Talk*, ii. 202; George, *Life and Death*, 235. The whereabouts of *Xenophon and the Ten Thousand*, first exhibited at the Egyptian Hall in 1832, is unknown.

[62] *Diary*, v. 226.

[63] *Diary*, v. 228.

(Figs. 9.6 and 9.7).[64] These were lithographs by Louis and Charles Haghe, after original drawings by James Atkinson, who had accompanied the second wave of British troops through the Bolan Pass in 1838. The gulf in the Roman Forum was becoming a pass in Afghanistan.

If this suggests that an optimistic meaning—of patriotic pride and triumphant heroism—was attaching itself to the painting, this changed dramatically the following month. On 9 January *The Times* reported the effective end of the First Afghan War, in the return of all the British troops through 'the hostile defiles of the Khyber'. The Khyber, nearly thirty miles long and full of places of potential ambush, was the most feared pass in Afghanistan; for this reason, no doubt, a tradition soon established itself that the retreat from Kabul had come to grief there, rather than in the Khurd Kabul Pass, at Jagdalak and Gandamak.[65] As we have seen, it was

[64] James Atkinson, *Sketches in Affghanistan* (London, 1842). The lithographed sketches that contain representations of the rocky passes of Afghanistan are the title-page vignette, 'Beloochees in the Bolan Pass', no. 5, 'Entrance to the Bolan Pass from Dadur', no. 6, 'The Wild Pass of Siri-Kajoor'; no. 7, 'The Opening into the Narrow Pass above the Siri Bolan'; no. 9, 'Entrance to the Kojak Pass from Parush'; no. 10, 'The Troops Emerging from the Narrow Part of the Defile in the Koojah Pass'. Any of these could have suggested to Haydon the rock formations depicted in *Curtius*. Atkinson's sketches were lithographed by Louis and Charles Haghe, and Haydon may well have been a particular admirer of Louis Haghe's work, for he was a subscriber to the five volumes of lithographs by him after David Roberts, issued as *The Holy Land, Syria, Idumea, Egypt, and Nubia*; the subscription list appears in vol. i (London, 1842). There are two other possible sources of images of the rocks of Afghanistan of which I am aware. The first is Rupert Kirk's anonymously published *Views of the Defiles and Mountain Passes in Affghanistan* (London, n.d.: the catalogue of the India Office Library suggests 1841). This is a volume containing three lithographs by C. Bigot after original drawings by Kirk; they are the merest military topographical notations, and not likely to have been much help to Haydon. A second possible source is the panorama of Kabul which was exhibited at Robert Burford's Panorama, Leicester Square, London, from 21 May 1842 to 6 June 1843 (see Scott Wilcox, 'The Panorama and Related Exhibitions in London', M. Litt. thesis, University of Edinburgh, 1976, 260). Haydon was interested enough in Burford's panoramas to record visits to two of them, in 1834 and 1837 (*Diary*, iv. 245, 403); the published key, however, to the Kabul panorama suggests no similarity between the (very few) rocks in the foreground of the panorama and the formations painted by Haydon. Sam Smiles has found advertisements in local newspapers for 'Cook's Panorama of the War in Afghanistan' exhibiting in Exeter and Plymouth in 1843, but there seems to be no evidence that it was brought to London. My thanks to Ralph Hyde and Sam Smiles for alerting me to these panoramas and for supplying information about them.

[65] The Khyber Pass was surveyed by Lieutenants John Wood and R. Leech in the mid-1830s. Their description of the pass and the route to Kabul appeared in *Reports and Papers, Political, Geographical, and Commercial, Submitted to Government, by Sir Alexander Burnes . . . Lieutenant Leech . . . Doctor Lord . . . and Lieutenant Wood . . . Employed on Missions in the Years 1835–36–37, in Scinde, Affghanisthan, and Adjacent Countries* (Calcutta, 1839). Wood and Leech were not overawed by the pass, but it retained its awesome reputation. For expressions of contemporary fear of the Khyber Pass, see e.g. the anonymous *Narrative of the Recent War in Affghanistan, its Origin, Progress, and Prospects* (London, 1842), 53: 'The defile of the Khyber pass, one of the most formidable and impenetrable in Asia . . . has hitherto been reckoned impassable for an army when the inhabitants had determined to oppose them.' Charles Nash (ed.), *History of the War in Affghanistan, from its Commencement to its Close* (London, 1843), 116, explains that the Bolan Pass rather than the Khyber was chosen as the route of the first invasion of Afghanistan, because 'at that time, great apprehension was entertained of the difficulties which beset that line of march, especially of the terrible Khyber Pass and the robber tribes which infest it'. For the tradition, to be found even in scholarly publications, that the massacre at

believed that no army could get through the pass until, in 1842, in an action that received vast publicity in Britain, it was 'forced', so the phrase was, by the relief column under General Pollock. According to *The Times*, the final return of the British troops through the pass was less successful than it should have been. The division led by Pollock got through without much difficulty, but 'the second, commanded by General McCaskill, was not equally fortunate'. On the following day, Haydon exclaims, in an entry in his diary, 'What is "High Art" in England but a long Kyber Pass? with the misery of a passage in, but not a passage out. 39 years have I struggled to raise my Country's tastes, & 32 have I been utterly without employment.'[66] The remark seems to echo, not only the *Times* report, but a much-quoted prediction by the Duke of Wellington, to the effect that it would be easier for the Army of the Indus to invade Afghanistan than to extricate itself from the situation the invasion would create.[67] Haydon quoted this remark himself, in March 1843, when he completed his second cartoon for the forthcoming Cartoon Contest: 'Now the Cartoons are done come the difficulties, as the Duke said of Cabul.'[68] If the 'symbolical meaning' of *Curtius*, hinted at by the *Britannia*, was a double meaning—the painting as a claim to pre-eminence and a premonition of failure—the meaning briefly projected on to the work by the events in Afghanistan was no less two-edged: Curtius triumphantly forcing the Khyber; Curtius falling to his death in the pass. Haydon the patriot victorious in the patriotic pursuit of High Art; Haydon unable to extricate himself from a struggle he could not hope to win.

IV

In a lecture first published in 1846, but first delivered in early March 1842, while Britain was anxiously awaiting the final outcome of what the newspapers were already describing as 'the disasters in Affghanistan', Haydon spoke of the obstacles to the imminent re-establishment in Britain of High Art. The fifth and greatest reason, he claimed, was

what the Duke calls, in his despatches, the croakers, who have no belief in their

Gandamak occurred in the Khyber Pass, see e.g. Atkinson, *Sketches in Affghanistan*, description of pl. 21; *DNB*, articles on Sir William Macnaghten and General George Pollock; *Haydn's Dictionary of Dates* (16th edn., London, 1878), article on 'Afghanistan'.

[66] *Diary*, v. 239. Other mentions of Afghanistan in Haydon's *Diary* will be found at iv. 535–6; v. 137, 370.
[67] See Patrick Macrory, *Signal Catastrophe: The Story of the Disastrous Retreat from Kabul, 1842* (London, 1966), 81.
[68] *Diary*, v. 253.

9.6 Louis and Charles Haghe, after James Atkinson, 'Entrance to the Bolan Pass from Dadur', plate 5 from Atkinson's *Sketches in Affghanistan* (London: Henry Graves and William Allen, 1842).

9.7 Louis and Charles Haghe, after James Atkinson, 'Entrance into the Kojak Pass from Parush', plate 9 from Atkinson's *Sketches in Affghanistan* (London: Henry Graves and William Allen, 1842).

own talents, or the talents of any others; and we have the procrastinators, who say, had we not better wait until there is a rail-road in the Bolan pass, till the corn-law league be abolished, till the revenue be in surplus, and till there be no longer a single complaint from people, chartists, radicals, abolitionists, electors, dissenters, agriculturists, manufacturers, constituencies, or corporations? When this milennium of happiness comes to pass, then will be the time for historical painting.[69]

The invasion of Afghanistan through the Bolan Pass was spearheaded by the Bengal Division of the Army of the Indus, under the command of Sir Willoughby Cotton, whose accurate understanding of the political situation of the country, and of the dangers of attempting to maintain a line of communication through the Bolan, quickly earned him a reputation for extreme caution. As Haydon may possibly have known, Sir William Hay Macnaghten, the gung-ho civilian who effectively controlled the conduct of the military operations around Kabul, and who died in the 'insurrection' of 1841, had regarded Cotton as 'a sad croaker'.[70] A 'croaker', according to the *OED*, is 'one who speaks dismally or despondingly, one who forebodes or prophesies evil'. Such people, according to Haydon, were delaying the triumph of British art in the Palace of Westminster, and of British arms in the passes of Afghanistan.

As we shall see, Sir Willoughby Cotton played a crucial role in Haydon's own fantasy life, as one actor in a narrative which, along with the impending Cartoon Contest, and the First Afghan War, is among the determinants of the meaning for Haydon of *Curtius leaping into the Gulph*. In the aftermath of the 1832 Reform Act, Haydon was rewarded for his faithfulness to the Whig cause with a commission to paint *The Reform Banquet*, one of those vast nineteenth-century commemorative pictures which cram together as many portraits as possible of important persons.[71] This commission required Haydon to meet and sketch everyone thought to have made an important contribution to the cause of reform, and he soon became—or so he thought—on intimate terms with the most fashionable Whigs in London. In early 1833, he met and became infatuated with Mrs Caroline Norton, the poet and novelist, who was unhappily married to a civil servant and was soon to be accused by him, and triumphantly acquitted, of criminal

[69] *Lectures*, ii. 192–3. In a review of Haydon's *Lectures* (first vol.) in Jan. 1845, the *Art-Union* had associated itself with Haydon's attack on what it called 'the croaking about "the sun of British Art being set"'.
[70] See John William Kaye, *History of the War in Afghanistan*, 3 vols. (London, 1874), i. 431–2; J. A. Norris, *The First Afghan War 1838–1842* (Cambridge, 1967), 263.
[71] *The Reform Banquet* was exhibited in the Great Room, 26 St James's Street, London. According to Pope (*Diary*, v. 593), it was at Howick, Alnwick, Northumberland, in 1963.

conversation with the Whig Prime Minister, Viscount Melbourne.[72] By the summer of 1833 Haydon was convinced that Mrs Norton reciprocated his feelings; he made a declaration of love, and was rejected.[73] His infatuation continued, however, into the next year, when Mrs Norton agreed to sit as *Cassandra*, in a painting so composed as to represent Cassandra/Norton as an interloper in the family of Agamemnon/Haydon.[74] He continued to meet Mrs Norton occasionally in 1835, and even to paint her; but eventually, in 1836, he ceased to pursue her, not only because she still refused his advances, but because Haydon's jealous fear that he had been rejected in favour of Melbourne was not allayed when the trial for criminal conversation collapsed for lack of evidence.

The affair, though it never quite became one, caused Haydon (and his wife) a very great deal of anxiety, which lasted for years afterwards. In March 1843, when *Curtius* was at the British Institution, and more than seven years after he had been on terms of any intimacy with Mrs Norton, he could not stop himself from embarrassing Elizabeth Barrett, whom he had never met and could hardly claim to know, by pouring out the whole story, or a version of it highly favourable to himself, in two excited letters.[75] It is the diary, however, that most clearly reveals the strategies by which he coped with the various anxieties occasioned by his infatuation. He dealt with his guilt at being unfaithful, if only in thought, to his wife Mary, mainly by persuading her to agree that his infatuation was no more than she deserved: before they married, Mary had caused Haydon great pain by flirting with Sir Willoughby Cotton: Haydon's own flirtation was intended, he told himself, 'to shew my love I could pique her'.[76] After the trial of Mrs Norton, Haydon developed a new account of his infatuation. He had indeed been briefly attracted to Mrs Norton, whose indecent advances, however, he had managed to repel, because of the superior attractions and virtue of Mary.[77] 'Our Love', he wrote, 'is quite a tale. I saved *her*, and she saved *me* from Caroline.' The nature of the reciprocity was changed: it was no longer a case of each piquing the other, but of

[72] For an account of the relationship of Melbourne and Caroline Norton, see Philip Ziegler, *Melbourne: A Biography of William Lamb, 2nd Viscount Melbourne* (London, 226–43).

[73] *Diary*, iv. 119–21.

[74] *Cassandra Predicting the Murder of Agamemnon* was treated by Pope as lost in 1963. There is a murky sepia photograph of it, with an accession stamp of 1909, in the file of prints after Haydon in the Department of Prints and Drawings at the British Museum. The painting is said to be at Shute House, Axminster, the seat of Sir Edmund de la Pole, Bart. It shows Cassandra, large and imposing at the centre of the picture; two children, Electra and Orestes, are running away from her in terror.

[75] *Invisible Friends*, 40–1, 45–6.

[76] *Diary*, iv. 190, 418.

[77] *Diary*, iv. 442.

each rescuing the other from seducers and home-breakers, Cotton and Caroline.[78] From 1836 onwards, Mrs Norton appears in Haydon's diary and letters as an unprincipled and promiscuous whore, whose attempt to entice Haydon from his wife had been blasted by one virtuous beam from Mary's beautiful eye.[79]

Caroline Norton, as Haydon himself acknowledges, was an unlikely and an uncharacteristic object-choice for Haydon. It may be this, as well as the continual promptings of guilt, that causes Haydon to invoke Mary in comparison with Caroline on almost every occasion that they meet. Mary is a Miranda, he writes, and Miranda is his ideal of womanhood, 'who melts, *always*. Mrs Norton would melt, but like Vesuvius.'[80] The future champion of the rights of separated and divorced women was imagined as the type of masculine woman: she is compared, not only with Cassandra, but with the Sybils of Michelangelo, with 'a priestess of Delphos', with Mrs Siddons, with Sappho, and with Minerva as distinguished from Venus; she is imagined as a sculpture, as a 'marble beauty', even as Memnon, the Egyptian god whose huge and enigmatic head (in fact it is the head of Rameses II) was now to be seen in the British Museum.[81]

It seems likely that this infatuation for a woman Haydon regarded as so unlike his ideal of femininity, so masculine, is linked to an insecurity about his own sexual orientation. So at least it seems fair to conclude from his accounts of his first meeting with Disraeli, which took place in the first days of his acquaintance with Mrs Norton. Disraeli had just returned from a tour of Egypt, and according to Haydon 'seemed tinged with a disposition to palliate its famous vices'. Haydon clearly suspected him of having indulged in sodomy while in the East.[82] The thought returned a few days later, when he engaged Mrs Norton's husband in conversation about the case of the MP Charles Baring Wall, then awaiting trial on the depressingly familiar charge of attempting to commit an unnatural offence on the person of a policeman. 'It happened', writes Haydon,

that very night D'Israeli was going on in that extraordinary manner at Mrs

[78] *Diary*, iv. 379.

[79] *Diary*, iv. 516; v. 54, 76, 284; *Invisible Friends*, 45–6.

[80] *Diary*, iv. 56, 100.

[81] For Caroline Norton as Cassandra, see *Diary*, iv. 51, 64; as a Sybil, v. 56, 97, 101; as a Delphic priestess, iv. 51; as Mrs Siddons, iv. 110; as Sappho, iv. 191, 201; as Minerva, iv. 103, 105; as Greek sculpture, iv. 47; as a 'marble beauty', iv. 49; as having a Greek mouth, cut by an Egyptian sculptor, iv. 111; as a Greek bust cut by an Egyptian sculptor, and as Memnon, iv. 264. For a fascinating account of Mrs Norton's attempts to represent herself, see Mary Poovey, 'Covered but not Bound: Caroline Norton and the 1857 Matrimonial Causes Act', in *Uneven Developments: The Ideological Work of Gender in Mid-Victorian England* (Chicago, 1988), 51–88.

[82] *Diary*, iv. 50–1.

Norton's. I think no man would go on in that odd manner, wear green velvet trowsers & ruffles, without having odd feelings. He ought to be kicked. I hate the look of the fellow It must be insanity. The touch of a man is poison to one's feelings. When I have a model I hate even to touch his wrist; I always put myself in that attitude, & let him imitate.[83]

In one way or another, his infatuation with Mrs Norton seems to call up an insecurity about his gender identity and sexual orientation. A dream recorded in 1836, which seems to refer to the threat posed by Norton to his relationship with Mary, begins with a strange incident in which Haydon strips himself naked in front of his hero the Duke of Wellington.[84] The more he suspected Melbourne of succeeding where he had failed, the more he began to console himself by suggesting that Melbourne, and his whole administration, were idle, effeminate moral cowards,[85] and by indulging in fantasies about his own powerful masculinity. He repeatedly imagines having sex with Mrs Norton, her sister Lady Seymour, and his wife Mary, all at the same time—'I'd satisfy 'em all, the Darlings, if they were mine!'—and he recalls a time, when he was younger, when he had had four mistresses on his hands at once.[86]

In this context, it seems likely that the invasion of Afghanistan—an invasion approved by a Prime Minister who was Haydon's imagined rival for the favours of Mrs Norton, and led by a soldier who had been a rival for Mary's favours[87]—was one site for the expression of insecurities which had elsewhere found expression in the macho military fantasies in terms of which Haydon was in the habit of figuring his own very peaceable profession. This relates in turn to one aspect of what I want to suggest is

[83] *Diary*, iv. 58.

[84] 'I dreamt I was with the Duke of Wellington near the Sea. I stripped': *Diary*, iv. 374 (see above, n. 1). See also *Diary*, iv. 589, where Haydon, invited to Walmer Castle to make sketches of Wellington for *Wellington Musing on the Field of Waterloo*, writes of going to church with the Duke: 'However high his destiny above my own, now we were at least equal before our Creator. Here we were stripped of extrinsic distinctions.' My suggestion that the dream recorded at iv. 374, of the 'sublime' wave that threatens to engulf Haydon and his wife, may have been interpreted by Haydon as a figure for the threat posed by Norton to his masculinity and to his marriage, is based partly on an idea for a picture recorded in the diary at iv. 523, which seems to be a repetition of the material of the dream: 'the Almighty looking out of the Cloud & terrifying the Aegyptians, the sea drowning them, & the Israelites escaping in the background'. Norton was associated by Haydon with Egypt (see above, n. 81); Mary Haydon was Jewish.

[85] See e.g. *Diary*, iv. 196, 246, 260–1.

[86] *Diary*, iv. 109, 111; see also iv. 112, 232.

[87] In the aftermath of the retreat from Kabul, Haydon sided with many Tories in blaming the disasters on Melbourne and his appointee in India, Lord Auckland, and in believing that 'the Affaganistan Massacre' was 'a judgement of the Almighty for unjust invasion' (*Diary*, v. 144). I do not intend to suggest that Cotton was Commander-in-Chief of the Army of the Indus in the invasion of Afghanistan; only that he commanded the first column to enter the country.

the overwrought and thoroughly overdetermined representation of masculinity in *Curtius leaping into the Gulph*.

The civic discourse in painting, which attributed a special importance and value to such sternly republican subjects as the self-devotion of Curtius, was the powerful expression (as I have argued at length elsewhere[88]) of masculine fantasy. History painting as defined by the discourse of civic humanism was devoted to teaching the masculine virtues of independence and self-restraint, and the refusal of pleasure in the service of the state: like the character in *Dr Strangelove* played (appropriately enough) by Sterling Hayden, the hero of history painting must preserve his vital bodily fluids for the struggle against enemies within and without. In its sternest, most republican manifestation, the civic discourse could conceive of no place for women among those that history painting addressed: they had no use for the hard masculine lessons it taught, and were best thought of either in the form of Minerva, the quasi-male personification of masculine virtue, or of Venus, the image of all that the civic hero must put out of his mind, if he is to achieve the reputation and glory he seeks. One of the rewards of masculine renunciation and chastity, however, is that the civic hero, by the careful retention of his vital juices, becomes all the more potent, or more *potentially* potent, so to speak. It is with this in mind, it seems, that Haydon backed up his claim to be able to satisfy three women at once: 'I have never been *debauched*, never exhausted my Nature—by *preying on Garbage*—or forced Nature beyond her power—I am in better vigor & better now than I was at 18. I hope my children will never read this. B. R. Haydon.[89]

The story of Curtius is a *locus classicus* of civic self-denial and masculine renunciation, and so, in a sense, is Haydon's *Curtius*. Elizabeth Barrett certainly recognized its obsession with a certain version of masculinity, and certainly found it oppressive. At an early stage in their correspondence, Haydon attempted to engage her in an epistolary argument about the relative merits of his hero, Wellington, and hers, Napoleon. She was expected to prepare for this by reading through the twelve volumes of Wellington's collected *Dispatches*. For some reason she declined,[90] and would not participate in the discussion. 'Mr Haydon,' she wrote,

you are Marcus Curtius . . . to say nothing at all of your being Solomon; & therefore it is scarcely fair, I beg you to consider, that I, who am Elizabeth Barrett a woman

[88] See my essay 'The Dangerous Goddess', in *The Birth of Pandora and the Division of Knowledge* (London, 1992), 63–87.

[89] *Diary*, iv. 192; see also iv. 232.

[90] *Invisible Friends*, 69.

& unwise, should be exposed to the full fire, drums & trumpets, of your military tactics. And so, if you please, we wont fight like Napoleon & Wellington *about* Napoleon & Wellington, we will leave them to posterity. Certainly you deserve to be opposed to a general of the Empire—you clash your arguments with such iron eloquence. You deserve twice over to be Curtius.[91]

Elizabeth Barrett here connects Haydon's self-identification with Curtius with his worship of Wellington. All three men, by virtue of being men, engross all wisdom and all knowledge of military affairs—so what would be the point of a woman arguing against them? Haydon *is* Wellington, for he has the iron eloquence of the Iron Duke; he is Curtius, twice over; and to be Curtius is primarily, pre-eminently, to be a real *man*.[92]

In another letter to Elizabeth Barrett, Haydon told her that his *Curtius* was being criticized 'as if sitting too *low* in the Horse—mere trash'.[93] Though there is little in the published reviews of the painting to suggest that Curtius's seat had become the widespread topic of discussion that Haydon suggests it was, he returned to the point in his diary,[94] and in a letter to the *Illustrated London News*, on each occasion producing a pair of drawings to prove the absurdity of the charge (Fig. 9.8).[95] Whatever so preoccupied Haydon in the relation of horse and rider, there was no problem with the anatomy of the horse, as Haydon's drawings clearly demonstrate. There was an issue of some kind, though, with Curtius's seat. In an early sketch for the picture (Fig. 9.9), Curtius is shown leaning well back, as if he has just successfully cleared a five-bar gate. In the painting, Curtius is tilted forward, so that the angle between his body and the foreshortened neck and head of the horse becomes more nearly acute. It may have been this that so engaged Haydon, in his attempts to justify the effect; for it is this that invites the painting to be read as the image of a wildly potent hero, triumphant, certainly 'unshrinking', and following his own enormous phallus to death or glory.

[91] Ibid., 88.

[92] Elizabeth Barrett later adds Macaulay—the Macaulay of *The Lays of Ancient Rome*—to Curtius and Haydon in her list of Wellington-types, characterized by a preoccupation with military affairs and iron eloquence: 'You admire him I hope. You ought to do so, because he is a genius militant, after your kind—with a strong metallic ring in him ... No man can write a battle like Macaulay. If your Duke, who can fight one pretty well, were to try the writing of one, how cold & tame & cowardly it would seem in comparison to Macaulay's!' (*Invisible Friends*, 153).

[93] *Invisible Friends*, 46.

[94] *Diary*, v. 253.

[95] *Illustrated London News*, 18 Mar. 1843.

V

If the history of art were better organized, *Curtius leaping into the Gulph*, an image (among other things) of the death of the civic painter-as-hero, would be the last British history painting conceived within the terms of the civic discourse. It was not literally the last: Haydon himself, certainly the last British painter to articulate or even to understand that discourse, went on to paint a series of works—*Alexander's Combat with the Lion*, *The Banishment of Aristides*, *Nero Playing on the Lyre*—in which the spirit of ancient virtue is still just breathing.[96] But in various ways *Curtius* seems to announce the end. To begin with, there is the attempt to soldier on as a painter in the civic mode by superimposing the war in Afghanistan, its disasters and its brutal victories, on to a story of republican self-sacrifice. The military adventures of the East India Company in Afghanistan and China in the years round 1840 made it elaborately clear that an exploitative commercial empire could not be disguised as a civic republic, and that victories won in wars of imperial expansion were not the same thing as victories won against the tyrants and barbarians who threaten the safety of a city-state.

But the painting speaks equally clearly of the anachronism involved in the pictorial representation of masculinity in the form of heroic self-devotion. It is not that self-devotion was no longer called for: the rhetoric of imperialism was itself a rhetoric of service, of self-sacrifice, and in Macaulay's *Lays of Ancient Rome*, for example, exactly contemporary with Haydon's *Curtius*, the relevance of the self-sacrificial values of republican Rome to imperial Britain is unmistakably implied. It was not, however, for reasons explored in other essays in this book, a rhetoric that painting, or the audience for painting, now largely the urban middle class, had much use for. The painting of the mid-nineteenth century must have appeared to Haydon as alarmingly feminine or effeminate, and even the history painters among his younger contemporaries must have been embarrassed by the exaggerated manliness that drives Haydon's work, the gestural,

[96] *Alexander's Combat with the Lion*, exhibited at the Pantheon, is now lost, according to Pope (*Diary*, v. 596). For *The Banishment of Aristides* and *Nero Playing the Lyre*, both exhibited at the Egyptian Hall in 1846, see George, *Life and Death*, 388. The first picture, begun as soon as the *Curtius* was finished, appears also to have had some significant connection in Haydon's mind with the First Afghan War, or with British interests in Central Asia. In the *Diary*, v. 303, 18 Aug. 1843, he writes, 'Composed Alexander, & thought of introducing Lysimachus. Williams says it happened at Bokhara! (Bazaria).' The exclamation mark suggests that Haydon has been struck by a coincidence: it may be that he saw a connection with Sir Alexander Burnes, known as 'Bokhara Burnes', the author of *Travels into Bokhara together with a Narrative of a Voyage on the Indus*, 3 vols. (London, 1834). Burnes was killed in the 'insurrection' at Kabul in late 1841.

9.8 Benjamin Robert Haydon, letter to the *Illustrated London News*, 18 March 1843.

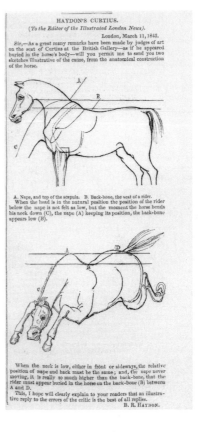

HAYDON'S CURTIUS.

(To the Editor of the Illustrated London News).

London, March 11, 1843.

Sir,—As a great many remarks have been made by judges of art on the seat of Curtius at the British Gallery—as if he appeared buried in the horse's body—will you permit me to send you two sketches illustrative of the cause, from the anatomical construction of the horse.

A. Nape, and top of the scapula. B. Back-bone, the seat of a rider.
When the head is in the natural position the position of the rider below the nape is not felt as low, but the moment the horse bends his neck down (C), the nape (A) keeping its position, the back-bone appears low (B).

When the neck is low, either in front or sideways, the relative position of nape and back must be the same; and, the nape never moving, it is really so much higher than the back-bone, that the rider must appear buried in the horse on the back-bone (B) between A and D.

This, I hope will clearly explain to your readers that an illustrative reply to the errors of the critic is the best of all replies.

B. R. HAYDON.

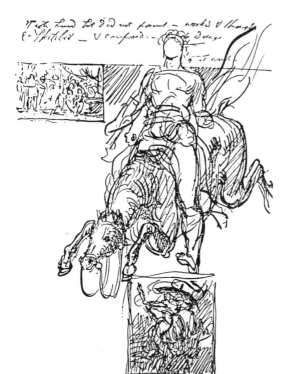

9.9 Benjamin Robert Haydon, sketch for *Marcus Curtius leaping into the Gulph*, October 1842, pen and ink; from *The Diary of Benjamin Robert Haydon*, ed. W. B. Pope, Cambridge, Mass., 1963).

rhetorical show of public virtue, the almost exclusive insistence on narratives of active heroism.

Finally, as De Quincey's essay suggests, the heroism of civic self-devotion looks almost absurdly out of place, if not on the North-west Frontier, then certainly in mid-nineteenth century Europe, where the 'city' conjured up images not of the city-state, but of 'abodes of gloomy wretchedness, ... dens of guilt, ignorance and abject pauperism'. The new 'practical' language of moral and municipal improvement, in which a concern for the public good was beginning to find expression, would look for heroism in the urban missionary and the sanitary engineer,[97] and could attribute no value at all to a kind of heroism which, though it claimed to be disinterested, appeared in fact to be entirely absorbed by the selfish hope of fame. That the *Curtius* was a complete anachronism in the new world of Victorian Britain is a point made best of all by *Punch*, which in the spring of 1843 illustrated a parody of Macaulay's *Lays* with a parody of Haydon's painting (Fig. 9.10). A reluctant Curtius, in full Roman gear, has been shoved and prodded into the gulf; a makeshift fence, a warning sign, an oil-lamp, all indicate that the yawning chasm is no more than a hole in a modern city street; the only threat to man or beast is a newly installed water main.[98]

In an essay of 1840, De Quincey writes of 'the fierce Jacobinism which growls for ever in the lower strata of our ... domestic population'. He describes the experience of a parliamentary investigation into the very poorest districts of London, which aimed at finding 'some practical means for applying a general system of drainage to such districts'. The 'senators', however, soon 'paused from their researches into sewers and drains, in order to gaze at the appalling spectacle of hopeless degradation', at 'beings whose means of livelihood are ... a mystery, and who die like rats in holes, never illumined by Christian truth or Christian charity'.

Yet even these wrecks of humanity, when they come abroad into public haunts for the purpose of buying gin, do not (as might be expected) fasten their impre-

[97] For such notions of heroism see Norman Vance, *The Sinews of the Spirit: The Ideal of Christian Manliness in Victorian Literature and Religious Thought* (Cambridge, 1985), esp. 2 (quoting Elizabeth Barrett Browning, *Aurora Leigh* (1856), bk. V, 152: 'all men [are] possible heroes'); 28 (Wilberforce and Howard); 33 (Lord Shaftesbury); 66 (Nightingale, Livingstone).

[98] *Punch*, 6 May 1843; this and other caricatures of Haydon's *Curtius* are reproduced by Michael Pidgley, who points out (*Tragi-Comical History*, 11) that six months after the cartoon appeared (on 3 Nov. 1843), Haydon spent an evening with some of the *Punch* artists, including William Kidd and Kenny Meadows (*Invisible Friends*, 155). He wrote of the evening in his diary (*Diary*, v. 324): 'Kidd was a perfect Lear's fool—& was unmerciful on young Simpson with a beard from Munich. He said, "Haydon, who was that fellow who jumped into the gulph on Boustephalous!" Poor Kidd's Classics are capital!'

9.10 Artist unknown, caricature of Haydon's *Curtius, Punch*, 6 May 1843.

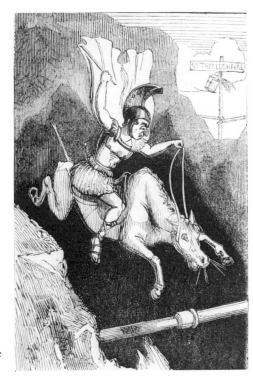

9.11 Henry Bernard Chalon, plate 6, 'Terror', from *Passions of the Horse*, a series of six lithographs, 1827; reproduced by kind permission of Jeffery Bates Antiques, Boroughbridge. The foreground horse appears to be the model on which Haydon based the horse in *Curtius leaping into the Gulph*.

cations on those who stand nearest to themselves in the social machinery; it is not landlords, it is not parish-officers, it is not the police, whom they denounce. No: it is the Government ... whom they hold responsible for their own misery And in this delusion they are confirmed by many of their betters; especially by those who have recently written upon Chartism.[99]

De Quincey's reactionary fury reminds us of two things in particular: that the civic discourse never recovered its legitimacy in Britain after its appropriation in the 1790s by Jacobinism; and that if a version of it was alive anywhere in the Britain of the 1840s, it was to be looked for in the language of the People's Charter—where it survived, however, as a language of independence, freedom, equality, not of military heroism or the glory of self-immolation.

A civic art needs to be able to imagine, at least, that those it addresses are potentially citizens, animated by a pure disinterestedness and devotion to the public good. In his moments of greatest despair in the 1840s, Haydon would sometimes invoke the 'People' as the only hope for High Art, as the only constituency where his message was understood.[100] It was essential to this appeal to the People, however, that it was an appeal to 'public opinion', to the wishes of the People as represented by Haydon himself. Despite his earlier support of the Reform Act, he had no desire that the People, or more of them, should be in a position to represent their own wishes to Parliament. This contradiction can be understood only in terms of his devotion to High Art: Haydon could never really conceive of a civic art except as addressed to an aristocratic and public-spirited ruling class; and the clearest message in all his writings is that no amount of flattery would persuade the polished plutocrats of the British ruling class to treat Haydon as Pericles had treated Phidias, or to take seriously the connection between the political health of the nation and the quality of its visual art.

The difficulty for Haydon of imagining an appropriately civic audience for history painting, except in an aristocracy reformed out of all recognition, and a people abstracted from all concrete identity, became greater than ever before when his disenchantment with the Whigs was followed by a similar loss of faith in the Tories. The difficulty is no doubt related to what is, perhaps, the most striking feature of all in the *Curtius*: that it is a painting of heroic self-sacrifice in which, as the excellent review in the *Morning Post* points out, there is no single sign of the society for whose

[99] Thomas De Quincey, 'Hints for the Hustings', *Blackwood's Edinburgh Magazine*, 48 (Sept. 1840), 310–11.

[100] See esp. *Correspondence and Table-Talk*, ii. 180–1.

benefit the hero is sacrificing himself.[101] 'To appreciate it', wrote the critic for the *Morning Post*, in a discussion of the strange 'isolation of the figure',

we should regard it rather as a portion than as a completion, and as a portion of that which was never intended for the exhibition-room. Consider it as a single figure in the crowded forum—the priests, senators, soldiers, maidens and matrons of old Rome around, breathless at the devotion exhibited by the self-renouncing sacrifice, and you would have the picture, as Haydon imagined it if not as he has painted it.

There is no reason to believe that Haydon ever did imagine the painting as the representation of a hero in active relation with a society—and certainly not a civic republic like the Rome of Marcus Curtius. In October 1843, following the Cartoon Contest and the profusion of historical works it had stimulated, Haydon disclosed to Elizabeth Barrett the politics of this solitary sublimity. 'I have a horror', he confessed, of

the Ultimate republican vulgarity to which we are tending—What is high art become? A beastly vulgarity already—the solitary heroism, the mysterious sublimity, the awful singleness is gone!—every body now is profaning—I can no longer stride my room at midnight & glory in feeling *alone* in my pursuit, from its dangers, its risks, its isolation! ... Upon the whole, I sympathise with the irresponsibility of a despotism, rather than the legal submission to law which characterises a Republic—this is my bond of sympathy with Napoleon & Alexander in preference to that namby pamby bit of moral worth Washington. In fact I am a contradiction my dear Friend, and to you alone I confess.[102]

This 'confession' is a brilliantly clear-sighted formulation of the contradiction I am trying to describe. By the early 1840s, the attractions of the role of republican painter were attractions only so long as his failure was assured; only so long as there was no republic to address, and certainly no *democratic* republic. Earlier, Haydon's civic stance is often directed at thoroughly civic, even democratic ends—his lecturing to mechanics'

[101] Michael Pidgley (*Tragi-Comical History*, 7) points out that Haydon's conception of the subject owed something to a conversation he once had with Sir Robert Peel, and which he recalled as he was beginning work on the canvas: 'Sir Robert Peel said to me once he thought subjects of *one* figure were always most effective. This was a sensible remark' (*Diary*, v. 127). *Curtius* was painted at a time when the good opinion of the Prime Minister was of the highest importance to Haydon—he was a member of the Royal Commission on the decoration of the Houses of Parliament—and Haydon may well have thought it no more than sensible on his part to be seen to be adopting Peel's advice. In its review of the British Institution exhibition of 1843, the *Illustrated London News* especially approved this aspect of the painting: 'We hope to see more of these single-incident pictures from this accomplished painter. We consider them far superior to his larger compositions, which, however excellent they may be in parts, are generally so overloaded with prodigalities of academic drawing and unchastened exuberances of fancy, that little more than the intention of the story is manifest.'

[102] *Invisible Friends*, 151–2.

institutes, his endless appeals to politicians to reform the Royal Academy, his tireless campaign for the establishment of schools of design, his willingness to look for support in that campaign among the provincial bourgeoisie as well as in fashionable London. But, as his writings everywhere attest, he was not to be satisfied by the mere *realization* of his schemes for public art and art education, if his own role in instigating and pursuing those schemes went unrecognized; as the *Art-Union* put it, 'Mr Haydon has always presented himself a foreground figure in his sketches of the levelling of academies.'[103] The identity of civic artist was adopted as much for the occasions it offered for heroic leadership as for the opportunity to promote the public good. When the two main objectives he campaigned for were finally achieved—the establishment of schools of design, and of a system of public patronage based on the decoration of the Houses of Parliament—his contribution to those campaigns went unrewarded. In the 1840s, therefore, he was increasingly obliged to make a virtue of the solitary sublimity which was almost all that was left him. The self-image of the alienated artist, 'solitary & glorious',[104] became of more value to him than the ideals of a civic art obliged to adapt itself to an increasingly democratic age: better to be a tyrant, an enemy of the *polis*, a hero who believes in nothing but his own heroism, than the inconspicuous member of a democracy, unable to make manifest that 'superiority' which God had given, so Haydon believed, to the hereditary aristocrat as much as to the genius.[105] That is the contradiction which impelled Haydon's painting in the 1840s, and which is figured in the *Curtius*, the image of the civic hero who, like his art, is finally coming to nothing—is 'passing like a Comet', as Haydon described him, 'to Death & ruin'.[106]

[103] Review of Haydon's *Lectures* (first vol.), *Art-Union*, Jan. 1845.
[104] *Diary*, v. 407.
[105] This theme is everywhere in Haydon's writings: see e.g. *Diary*, v. 203, and *Lectures*, ii. 195.
[106] *Diary*, v. 220.

INDEX